PRAISE
My Life with Earth

"A powerful and substantial memoir. book is more than a chronological tale of a career; it's a quest for meaning. . . . The memoir captures a life of determination, positivity, and success tempered by depth and humility."

—*Publishers Weekly*

"*My Life with Earth, Wind & Fire* is the candid and intimate odyssey of a man whose music and ideology continues to have an immeasurable influence on artists and audiences world-wide."

—*Philadelphia Inquirer*

"The musical elements [of Earth, Wind & Fire] would not have existed without the singular drive of Maurice White. And his words here provide one magical mystery tour."

—*Houston Press*

"White's book is practically a how-to manual for leading a band. . . . Aspiring musicians could certainly learn a lesson or two."

—*New York Times Book Review*

"A long-anticipated tome that will have fans riveted as [White] openly and methodically peels back the layers of his life, answering so many of the questions and solving so many of the mysteries long held about him and one of the greatest bands—critically and commercially—in any genre of all-time. . . . Writing this book so many years after Earth, Wind & Fire's peak coupled with his spiritual, analytical, and introspective nature all gave White a platform to be as thorough, thoughtful, and honest about all aspects of his life."

—The Urban Music Scene.com

Praise for Maurice White

"With his brothers and bandmates of Earth, Wind & Fire, Maurice fused jazz, soul, funk, and R&B into a quintessentially American sound that captured millions of fans around the world. "

—Barack and Michelle Obama

"King. Genius. Leader. Teacher. Producer. Arranger. Multi-instrumentalist. Motivator. Mystic. Through his music and artistic expression, he taught me a lifetime's worth of knowledge. He's at the top of the list of all of the greatest masters."

—Lenny Kravitz

"Maurice White and the great Earth, Wind & Fire were a massive influence on me and represented my highest aspirations for the Red Hot Chili Peppers."

—Flea, bassist for the Red Hot Chili Peppers

"Great music, energy. Great spirit." —Bette Midler

"Thank you, Maurice White, for being the architect that put together such an incredible band!"

—Earvin Magic Johnson

"Your contributions to music will be kept in our hearts & souls 4ever."

—Quincy Jones

MY LIFE WITH

EARTH, WIND
& FIRE

Amistad

An Imprint of HarperCollins*Publishers*

HR 01 30 2023 0842

MY LIFE WITH
EARTH, WIND
&FIRE

MAURICE
WHITE

with HERB POWELL

This book is dedicated to my children,

Kahbran, Eden, and Mimi,

as well as all those who are moved to fan the fire.

A hardcover edition of this book was published in 2016 by Amistad, an imprint of HarperCollins Publishers.

MY LIFE WITH EARTH, WIND AND FIRE. Copyright © 2016 by Maurice White. All rights reserved. Printed in the United States of America. No part of this book may be used or reproduced in any manner whatsoever without written permission except in the case of brief quotations embodied in critical articles and reviews. For information, address HarperCollins Publishers, 195 Broadway, New York, NY 10007.

HarperCollins books may be purchased for educational, business, or sales promotional use. For information, please email the Special Markets Department at SPsales@harpercollins.com.

FIRST AMISTAD PAPERBACK EDITION PUBLISHED 2018.

Designed by Paula Russell Szafranski

Library of Congress Cataloging-in-Publication Data has been applied for.

ISBN 978–0–06–232916-5

23 24 25 26 27 LBC 7 6 5 4 3

CONTENTS

Introduction

TIMELESS

STEVE HARVEY

To write about how I feel about Earth, Wind & Fire, a musical group that has meant more to me than any other, is a true blessing. The band's music is stored in my soul. I first heard the group when I was in high school. I'll never forget the power of the album *Head to the Sky*. The song that I absolutely loved was "This World Is a Masquerade." It remains my jam.

By the time I got to college, I was all over them. As a freshman at Kent State, I vividly remember walking into a store called the Cucumber Castle and buying Earth, Wind & Fire's *That's the Way of the World* for $3.95. At the time, it broke me, but it was well worth it. More than four decades later, Earth, Wind & Fire's music is by far the most-played music of my life—"Love's Holiday," "That's the Way of the World," "Can't Hide Love," and "Be Ever Wonderful" are in my personal top ten.

Earth, Wind & Fire is simply one of the greatest living groups, period. No one put together lyrics to a melody like they did; no one put harmony to sound and rhythm like they did; no one added horns in the way that they did; and no one, but no one, messed with our minds about love and life like they did. They remained so thoroughly committed to soul, yet had a universal sound—and appeal. On top of all that, they knew how to show!

I can't express how fully and completely this band has touched my being. They have moved me beyond words over the years. Their lyrics interpret and convey my emotions—and in harmony. They sing my feelings exactly as they are, in words that could not have said it better. I've shared the music with my three sons, age ranging from almost an adult to their mid-twenties. I was excited when they all put several albums in their iPods. It made me smile.

It's an honor to be asked to endorse Maurice White's amazing life story of how he took his band from conception to legendary status. The book is rich in tales of brothers in song—that damn Verdine "The Bass" White, Philip "Have Mercy" Bailey, and the rest of the heaven-sent band. God was right on time when he hooked up their skills. My interpretation of the elements: Earth because they grow on you; Wind because they move you in one loving direction; and Fire because they set your heart aflame.

Hands down, Earth, Wind & Fire is the greatest group of all time.

Maurice, I love and appreciate you at the highest level. This book made me smile over and over again: learning the behind-the-scenes of your music, getting a chance to hear the thoughts behind the lyrics, and matching them up with mine.

Maurice, thank you for all that you have done for the world of music. Thank you for the insight. Thank you for your gift, not only to me but to us all. Thank you for honoring love the way you did, for real music that will never die, fade away, or go out of style. This thing you did is timeless. Thank you for letting God use you to do what you were born to do. Most people go through life never knowing what they were brought here to do. But you did it, man, and you did it like no one else—not before and not since.

I'm just glad God allowed me to live to hear it for myself, because Lord have mercy, there ain't nothing like your music!

Foreword

A TRUE AMERICAN TREASURE

DAVID FOSTER

Music history will affirm Maurice White's unique contribution to rock and roll. Most will extol his many hit records, his leadership abilities, or his God-given talents as a producer, drummer, and singer, but it would be a disservice to limit his contributions to these well-known accomplishments. Maurice White was more; he was a catalyst. Through his creation of Earth, Wind & Fire, he changed the musical and performance landscape of pop music forever.

It was foredestined that the first of my sixteen Grammys should be awarded for the song "After the Love Is Gone," not because the song meant more to me than other hits that would come later, but because the song was my vehicle into the world of my mentor, hero, and friend Maurice White.

I first met Maurice in early 1978. I was a session musician and arranger then, and had just started to produce records of my own. When I sat down at the piano and played "After the Love Is Gone" for Maurice, it was a life-altering moment for me.

I believe Maurice and I hit it off so well because we both believe that being a good musician is a fine thing, but greatness is always the goal. In fact, my mantra is that good is the enemy of great. As I expected, I saw nothing but greatness in him dur-

ing our first meeting; I somehow knew being around him would make me better. When you come from Canada, as I do, you have to work twice as hard to be taken half as seriously as a musician, and my work benefited from the ultimate guide—the music of Earth, Wind & Fire. I learned so much about how to fuse the different genres of R&B, jazz, and classical and still retain my own signature in the final product.

I was also a normal, everyday fan, one of those thousands of people who stood in line at Tower Records in Hollywood so that one minute after midnight I could get the next Earth, Wind & Fire album.

For so very long I wanted to tell the world about Maurice's contribution to my life. At one point I entertained the idea of having a big testimonial dinner in his honor. I should have known: Maurice, being the very private man he is, wasn't having any of that. But in October of 2010, at my latest *David Foster & Friends* television special for PBS, I finally did get the chance to publicly tell him, and the world, how I felt. I think my words that night summed it up:

> There is also someone here tonight, a man who taught me more about making music, about decency, about calmness, about well-being, and about the true spirit of music than any other human being on the planet.
>
> One thing I know for sure, if he hadn't been born, pop music would sound a lot different today. That man is the genius behind Earth, Wind & Fire. Ladies and gentlemen, he's here with us tonight in a rare public appearance—Maurice White, my hero, my mentor, and a true American treasure.

That was a special moment for me: cliché as it may be, I think it's important to give credit to those on whose shoulders you stand, and—when life permits it—to give that credit directly, face to face with the ones you owe. As you might imagine, being

able to do that in person in front of eight thousand people felt better for me than it probably did for Maurice.

Now, after reading Maurice's memoir, I finally understand how a humble Memphis upbringing gave the world the electrifying and optimistic music of Earth, Wind & Fire. His story is not a lurid rock-and-roll story about "the leader of the band" but a subtle, beautifully told one about clarity, core motivations, courage, and, above all, music—all told through the eyes of a private man dedicated to using music to lift the spirit of the listening world.

This textured narrative is a testament to the musical boundaries Maurice White erased and the different people he brought together, a testament that shows who he is personally and professionally. For me, it recalls the many creative bursts we shared— moments I will always cherish.

This is the story of a true American treasure indeed.

PROLOGUE

On March 6, 2000, I stepped to the podium at the Waldorf-Astoria in New York City to accept Earth, Wind & Fire's induction into the Rock and Roll Hall of Fame. In my acceptance speech, I told the audience that establishing the band's place in history had been a hard road, but a good road. I considered the honor a small capstone to a long career in what I believe is the highest form of creative expression—music.

The long and winding road that led up to this moment started in a series of dreams I had in 1969. These dreams, which I believe were given to me from the Divine, inspired me to form a band that would uplift the human spirit, whether through celebrating the benefits of developing the inner life or simply creating joyous musical moments.

I've given the music of Earth, Wind & Fire everything I have: mind, body, and spirit. When I hear those songs today, on the radio or coming from the television, the lyrics don't bring back memories of writing, recording, or even performing them. Rather, they remind me of my personal life journey.

My odyssey with Earth, Wind & Fire has taught me that the significant events of our lives become our spiritual story. I hope

that when you read my story, you will be inspired to live your own life with gratitude and purpose. My Memphis Christian roots, which evolved into my belief in the universal truths of all the faiths and the wisdom of the stars, have guided my path. But it's the lessons of my spiritual story that have made me a survivor and kept my head to the sky.

PART I

MEMPHIS
WONDERLAND

PART

1

MEMPHIS
WONDERLAND

1
Mother Dear, Mama, and Me

Your children are not your children. They are the sons and daughters of Life's longing for itself. They came through you but not from you and though they are with you yet they belong not to you.

—KAHLIL GIBRAN, *THE PROPHET*

Although I was only four years old, I clearly remember my mother, Edna Parker, explaining to me why she had to leave Memphis for Chicago and how I would become part of a new family:

"I can't get a job here unless I'm scrubbin' some white folks' floor."

Her work schedule wouldn't allow her the time to take care of me properly. She didn't know where she was going, but she knew that she didn't want me to be raised by babysitters. The job opportunities for poor black women then were slim to none. Even though Memphis was a hub for people coming from the surrounding rural areas to find work in the factories, that work was mostly for men. I easily accepted the move, as it seemed that everyone around me in Memphis was moving north, to Detroit, Chicago, or New York.

Staying with my birth father, John White, who died when I was five years old, was not an option. White was originally from Mississippi. When he moved to Memphis, he opened a club on Beale Street. He wasn't the kind of guy who was going to work at the big forty-acre Firestone plant in north Memphis, nor was he going to become a Pullman porter. According to local legend,

he aspired to be the "Al Capone of black Memphis." He became a gangster, a mean gangster. In my limited interactions with him, he was also a mean father. On one occasion, trying to escape a beating, I ran into the closet and hid in the corner, concealed by hanging clothing. Looking down, I saw a pair of bright green shoes. They looked magical. I was captivated by them.

When my mother left Memphis at the age of twenty-one, she put my small yellow hand in Miss Robinson's big, soft black hand. "You mind Miss Robinson now," she said with tears in her eyes, leaning down to give me a kiss on the cheek. Somehow her face seemed smaller, and the room seemed larger.

Elvira Robinson was a wide lady, just over five feet tall, who I would call Mama until the day she died, while my birth mother became Mother Dear. Mother Dear had God on her side, which gave her the good instinct to leave me with Mama. Since Mother Dear was only seventeen years old when she had me, being left with the mature Miss Robinson turned out to be the first blessing of my life. Sweet, tender, godly, and strong, she was a gift to me.

For black people born in the 1930s and '40s, it was not uncommon to be raised by your grandmother, and for many years I would refer to Miss Robinson as my grandmother. It offered a neat and tidy way to explain my upbringing in Memphis, away from my birth mother.

I got my strength from Miss Robinson. She had a lot of wisdom. Book education is one thing, but wisdom is something different. She was always saying things like "Be true to yourself," "Keep your life clean," "Keep the house clean," "God is always with you," and "Keep stepping," meaning moving forward. She didn't treat me as a child, hugging on me and all that, but her words compensated for the lack of physical affection. "Whatever you have, God can use," she would remind me. Most of all she would tell me, "Sandy"—my nickname was Sandy, because of my blond hair and fair skin—"you are going to be a successful man, and you're going to get the world's attention."

I think Mama had a sixth sense. She instinctively knew I needed those affirmations. I was a profoundly shy child. I don't know if I was born that way, or if shyness was awakened within me when Mother Dear left.

Mama stressed order on every level. She would only need to gesture to me to clean up. She'd look down at the floor and raise her hand and slightly point, as if to say, Pick this up and put that away. I am a neat freak to this day, as a result.

As part of our routine, every evening the shabby spring-loaded screen door would fly open and loudly slam against the house. A second later I'd hear her voice ring out, "SAANNNDDY!" like an air-raid horn. Everyone on my street could hear her calling me in for dinner.

Mama worried about me being out in the streets. She had a strong presence in the neighborhood, which provided some safety early in my life. She also had strong skills with a switch. I had to be home at a certain time, or there would be hell to pay. I didn't get away with anything.

One winter, my whippings came to an end. I had missed my curfew the night before. I was twelve years old, and it was cold in our meager apartment that morning.

"What time did you get home last night, Sandy?" Mama asked.

"Mama, I was only about fifteen minutes behind," I said, although I'd really been over an hour late.

"Well, go get the belt."

I got up from the table, walked that long stroll of eight steps, opened the closet door, gave her the dark brown leather belt, and sat down. I knew what was coming. She started walking toward me. I don't know what came over me, but I wasn't in the mood for a whipping. I stood up and said, "I'm bigger than you, I'm taller than you, and you can't even get your arm around me. I'm sorry for being late—but I ain't taking no whipping." I sat down and ate my oatmeal.

It was one of only two times that I ever challenged Mama's

authority. I grew up in a time and place where the mother was king. While men and fathers were around, they were not dominant. Women worked. Women controlled the home. Women controlled the neighborhood. Many of the black women on my block also went to jobs where they fed, raised, and socialized white babies. Some of the women were lucky enough to get jobs in the many laundry service companies, like Loeb's Laundry and Krause Cleaners. The work was hot and dirty, but it still paid better than being a domestic like Mama, and was socially a step above.

Mama loved Mahalia Jackson. She would play Mahalia's popular "Move On Up a Little Higher" over and over again, especially on the weekends. Mahalia Jackson's voice was definitely my introduction to music. I knew when Mahalia was singing about being up in glory, that meant after you die. I was scared of the concept of death. When Mama would sing along with the record, I thought it meant Mama was going to die.

Later, Mama bought Ray Charles's "It Should Have Been Me." I could tell by the way she sashayed her hips back and forth and bopped her head that this type of music made her feel something different than Mahalia's songs. As I heard more and more Ray Charles, I began to distinguish the patterns of the repetitive piano, drum, and saxophone parts. There was other music, but Mahalia Jackson and Ray Charles became the sound track of our house.

The music wasn't just at home. Mama would take me to church every Sunday and every Wednesday. I can recall the muffled sound of the upright piano playing as we walked up to the church. Gospel music had a melodic rhythm and rhyme that hypnotized me. There was a strong Negro tradition of spontaneous singing—someone would stand up and start singing, and the pianist and all the congregants would fall in. These were songs every black person knew—"Have a Little Talk with Jesus," "Don't Let Nobody Turn You Round," "We'll Understand It Better By and By," "Rock of Ages," and a hundred more. It was

hard not to be swept up by these powerful songs. I felt them in my bones.

I felt gospel music deeply at Rose Hill Baptist, but I didn't see the point of all of the churchgoing. I heard a lot of fire and brimstone from the pulpit, a lot of do this and don't do that, give yourself to Jesus or God is going to burn you to a crisp forever. Something about it just didn't sit right with me. I had a healthy respect for the Creator, but I never, ever believed in the God of fear. The notion that God favored some and didn't favor others rang false. I questioned not so much what was right or wrong but what was the way to actually know God.

In the Pentecostal church, women screamed and briefly fainted, which actually scared some of us kids. Avoiding the scene, I sometimes, to Mama's disappointment and anger, would sneak out of the church and hang out with my friends.

Memphis during my youth was tough. Mama had a brother named Tuck who was a nasty dude. Big and black, he had a hell of a negative presence. He was loud, boisterous, and rude, and he also constantly had alcohol on his breath and a half pint of liquor in a brown paper bag sticking out of his pocket. He always carried a razor, the old single-edge barbershop style, which he would whip out at a moment's notice.

"See this razor, boy, dis is why nobody fucks wit me," he said to me more than once.

I didn't want to look at the razor, or at Tuck. He was like 90 percent of the males around me at that time, guys who would talk a lot of foolishness, spend their paycheck over the weekend, and not have any cash come Monday. They also would beat their women, sometimes unmercifully, then cry and ask for forgiveness. They were such jive-ass cats.

In contrast, Mama's younger sister Edna epitomized cute. I would overhear Mama tell her friends, "My baby sister is pretty and a little fast." She got a lot of male attention and always had a boyfriend. One of her boyfriends went by the name of Son. I repeatedly had run-ins with the forty-five-year-old Son, who

didn't like me from day one. I avoided him like the plague. Sometimes I was successful, sometimes I wasn't.

"Hey, half-breed," he'd say.

"What?" I'd say, turning away from him.

"Stay out of my motherfuckin' way."

I said nothing.

"You better say something, or I'll beat your high-yellow ass right now."

I nodded yes.

His threats and name-calling were one of the first indicators that my fair skin was unacceptable. There were not many kids around with my skin tone. Over time, I would become aware that black folks had a hierarchy based on skin complexion. I didn't know what the categories meant historically or psychologically, but I knew they suggested something serious. I saw a picture of Ralph Bunche in the newspaper, probably after he got his Nobel Peace Prize in 1950. I said to myself, He looks like me. Why am I not OK?

The run-ins with Son were balanced by visiting an older guy named Hundee. While sitting on his porch, corncob pipe in his mouth, rocking back and forth, he'd tell jokes. Short jokes, long jokes, corny jokes, and a few off-color jokes. I'd sit at his feet and just laugh and laugh. His jokes have never left me. Perhaps it was his heavy, slow Mississippi drawl that amused me, but I remember those moments as pure joy. I never left his presence without a smile on my face.

King Cotton was a huge part of the Memphis economy. The city's location on the Mississippi River had made it a hub for the lucrative cotton trade for decades. Several months out of the year I spent time away from Memphis in Osceola, Arkansas. Mama's sister Edna (not the Edna who was my birth mother) would sometimes stay there. I think Mama, being the older one, felt an obligation to follow her around and keep an eye on her. Edna somehow convinced Mama that a good living could be made picking and chopping cotton.

Osceola was the country, the real country. Beyond the beautiful courthouse on the main drag, this was rural living like I had never witnessed—and I hated it. Wide-open spaces connected to mile upon mile of wooded land. I'd wake up with mosquito bites all over my body. I had to keep my eye open for poisonous cottonmouths and copperheads lurking in the high grass. I used to fish about every day in Osceola—not for sport, but for food. I caught, cleaned, and ate enough fish to last me two lifetimes. My hands would be raw with those tiny fish-scale cuts.

There was outdoor plumbing too. The little dark outhouse scared me. Sitting on that flat piece of wood with my butt not fully covering the hole, I'd feel like I was going to fall into its stinky abyss. Newspaper or the Montgomery Ward catalog served as toilet paper. Osceola had its benefits, though. On the porch of the general store there was a black man with a beat-up brown acoustic guitar who would sing primitive blues, wearing bib overalls and a white V-neck T-shirt. White folks would stop and listen a minute or two as they came in and out. The racial barrier between whites and blacks was even stronger in Osceola than in Memphis, but I felt that these white folks respected his talent as they smiled and tapped their feet. He had a bottleneck on his finger that he would slide up and down his guitar neck. That sound blew my mind.

During our stays in Arkansas, sometimes we traveled a little ways from Osceola to the town of Joiner to pick even more cotton. Joiner was so tiny that it just had a sign that said "Joiner" on the main road, and as soon as you passed its turnoff, you were out of the city of Joiner. The long main road had nothing but cotton fields on both sides. I was there to bring buckets of water to everyone picking cotton in the hot, oppressive southern sun. I'd watch the pickers bend over and efficiently pull the cotton out of the husk, depositing it in big brown burlap sacks that they all had hanging from their sides. As they moved down the field row, the sack would get longer and wider until a lady arrived to empty the contents into a huge wicker basket that she carried on

the top of her head. This hard-ass, backbreaking work went on for twelve hours. I learned how hard my people worked to build this country.

On one of my walks back from getting water, with the work group at least a half mile off in the distance, I heard a clear, strong voice saying, "Stop." I believed this was the voice of God.

"Why do we have to die?" I asked.

"You will live forever, you are immortal."

I was a little scared at first, but then a refreshing cool wind blew. A sense of calm came over me that I continue to seek to this day—an awesome, peaceful feeling. The only words I knew then to describe this overwhelming experience was the Holy Spirit that they talked about in church. I had a deep knowing that everything was going to be all right. I knew I could depend on God. Even if I couldn't depend on anything or anyone else, I could depend on him. It seemed like we made a covenant together that day, and he became my friend.

> Master told me one day
> I'd find peace in every way
> But in search for the clue
> Wrong things I was bound to do
>
> Keep my head to the sky
> For the clouds to tell me why
> As I grew, and with strength
> Master kept me as I repent and he said
>
> Keep your head to the sky
> —"KEEP YOUR HEAD TO THE SKY," *HEAD TO THE SKY*, 1973

The following fall I was back at La Rose Elementary School in Memphis. I hid, fought, and ran away from kids, as many of them were teasing me about my high-yellow skin. I certainly couldn't identify with the whites. To them, I was just another

nigger. I also couldn't identify with the blacks, because of the half-breed status bestowed upon me. I tried to compensate by trying to be more "black." I tried to play it elementary-school cool, but it didn't stop the taunting and teasing.

I was fighting damn near every day. I didn't start fights, but as time went on I didn't back away from them, either. I had a mouth on me. I talked cash money stuff, and my tongue became the provocateur. There were one-on-one fights and group fights. First there would be pushing and shoving matches, usually ending with some cuss words and the threat of another fight tomorrow. Later it evolved into full-on punches thrown, cuts and scrapes. If you cried, that guaranteed that you would become a target for any boy who wanted to show he was tough.

It felt like I could not count on anyone except God. Boys don't go to their mama for this stuff. You suck it up. Still, I was exhausted by the regular confrontations. I was convinced it wasn't the bullies' fault, that my yellow skin alone was to blame. The duress caused by the bullies was spiritually transformative for me. I prayed, pleaded with God over and over again, that I would wake up in the morning and my skin would be dark. This went on for years. I didn't realize it then, but in my unanswered prayer, my concept of God was gradually starting to form. I came to see God as steadfast and still sovereign; he provided for me, and yet he was not beholden to my prayers. This kept me in my head a lot, as I continued to pray, kept on appealing to God about my complexion. Eventually I would learn that it was the personal relationship with God that mattered most.

I was also teased about what I wore. It seemed everybody had better clothes than me. The clothes I had were either stuff that Mama got from white folks she worked for or hand-me-downs from other sources. My pants were patched on the inside and the outside, and they rubbed and scratched my legs. My shirts were often too big. Even though Mama always demanded that my clothes be clean, neat, and pressed, I still felt ashamed, since early on I took pride in being well groomed.

Some years before, when Mama came home from working for a new white family, she'd carried an overstuffed brown paper bag through the door, saying, "Come here Sandy, I got some clothes for you." Even though I was always happy to get an upgrade in clothes, I was not impressed with what she was pulling out of the bag until she held up a cowboy outfit. It was beautiful—a poncho with a red-and-yellow plaid design on the lower half. The pants had a white line down the sides. It came with a holster and two toy guns. What boy doesn't want to be a cowboy? It quickly became my most prized possession. I pleaded with Mama to let me wear it to school. Of course the answer was no, and she even limited the time I could wear it on the weekend. Even in the hot Memphis summers, I wanted to wear my cowboy outfit.

Time passed, but my desire to have cool clothing continued throughout my childhood. One day I saw a drum and bugle corps marching through my neighborhood, and they had these beautiful shiny uniforms—shiny buckles, clean stripes down the side of the pants leg. They looked like the dress blues of a military general. I absolutely had to have one. I already had toy drumsticks, which I beat regularly on the front porch. I auditioned for a snare-drum position. To my surprise I was accepted in the drum and bugle corps, even though, at the time, my biggest goal was getting one of those uniforms.

The neighborhood I grew up in in Memphis was called Third and Virginia. The houses were nothing to speak of. None were professionally built. Some of the floors were uneven to the point that when you walked from one room to another, you had to step up or step down a little. Many of the houses were set on cinder blocks, with stacked cinder-block steps, which made for easy access to the front porch. We blacks lived on one side of the railroad tracks, and on the other side were the white folks, who we unaffectionally called peckerwoods. I developed a friendship with David Porter, who lived on the other side of the hill. We made mud pies together, rode horses with broken broomsticks and string.

David and I got the music bug early. We weren't obsessed with sports like other kids. He and I had a little gospel quartet with a couple of brothers with the last name Cunningham. When I was six years old, we sang at a church at the top of the hill, the Rose Hill Baptist Church. It was the seed of our mutual musical beginnings.

Around the time I turned twelve, Mother Dear wrote me a letter, requesting that I come to Chicago for a few days. It had been eight years since I had seen her face. I hadn't heard from her much—almost not at all. She seemed overjoyed when I arrived. She had some people she wanted me to meet. Leaning down and extending his hand to me was Dr. Adams. She then introduced me to my new brothers and sisters: Verdine, Geri, Monte, and baby Patt. They all looked at me with stark curiosity as if to say, Who is this? I didn't stay long. After I returned home, I would receive letters from Mother Dear more often—still not a lot, but more.

That same spring I came home from school to find a gigantic box in the living room, "Maurice White" written in large letters on it. I stood there and looked at it for a little while in awe before tearing into the thick cardboard with Mama's help. I was shocked. My stepdad had sent me the most beautiful thing I had ever seen in my life—a burgundy bicycle with a shiny black vinyl seat and sparkling chrome handlebars. It was awesome, the cat's meow and the dog's bowwow. The bike symbolized so much to me. I felt like somebody who I didn't even know loved me, and loved me a lot. Even though it was a material gift, with that gift Dr. Adams became my dad.

The gesture did so much for my self-esteem. It was my first taste of a tangible sense of self-worth. I rode that bike every day. I felt independent. I could say to my friends with authority, "I have a daddy, he lives in Chicago, he sent me this bike." I stood a little taller, and I smiled a little wider.

2

As I Yearn, So I Learn

Once upon a time a child was born
With a light to carry on,
Didn't know what he had to be, had a feelin'
He was bound to see
—"YEARNIN' LEARNIN'," *THAT'S THE WAY OF THE WORLD*, 1975

Right before Dwight "Ike" Eisenhower was elected president, David and I both moved from Third and Virginia to the new twenty-six-acre Lemoyne Gardens housing projects. We went from living down the street from one another to living straight across the grounds of Lemoyne Gardens. With the hundreds of families that lived there, we were a stone's throw apart. I considered it part of our shared destiny that we moved there almost at the same time. The government-subsidized apartments were not "the projects" of today. They were brand spanking new. Our unit was a one-bedroom. Mama gave me the bedroom, and she slept in the living room on a pullout sofa. It wasn't much, but 919A Memorial Drive defined a big step up for Mama and me. Mama went out and purchased some furniture, and that shit was so cheaply made that it didn't even last nine months.

We lived in the front of the complex, where there was a playground with lampposts that would illuminate a small portion of an otherwise very dark area. When I was fourteen or fifteen years old, we'd stand around those lampposts and sing songs by the Flamingos, the Dominos, the Drifters, and others. Or, as I used

to say on tour, "When the streetlight was the spotlight and the corner was the stage."

We entered Porter Junior High School in the fall of 1957, and David and I were deep under the spell of music. I fell in love with the Spaniels' velvety harmonies. This was the doo-wop era, which had grown out of the Mills Brothers and Ink Spots days of the 1940s. Doo-wop had more gospel and early rock-and-roll influences, using group harmonies, usually with a high tenor or a low deep bass voice as the featured singer. From boyhood through my teenage years, this music dominated the radio. As much as I loved singing, it was the grooves that turned me on. When the drumbeats were out front on a hit record like Johnny Otis's "Willie and the Hand Jive," I took note, learning the tom-tom rudiments by beating on schoolbooks with my drumsticks.

The tall beige hallways of Porter Junior High were a place of change for me. Previously, I hadn't taken teachers too seriously, though I wasn't rude or boisterous. I couldn't be—teachers did not tolerate foolishness in my day. The paddle in the principal's office looked like a boat oar, and he wasn't afraid to use it. Schools weren't having it, and parents backed up the schools' discipline.

My lack of seriousness was not lost on one of my teachers, Mrs. Gossett. Short and stout like Mama, and dark-skinned, she had those scoop glasses that she would look over and down at you. She was a pleasant lady, but she was always on my ass. "Straighten up, White," she told me, "you must apply yourself more." I quickly began to see her as more than a giver of grades. She cared, and I wanted to please her. She made me learn all the state capitals. "Know your country," she would say. She stressed the importance of reading as the way to a better life. "You want to go to Paris? Pick up a book and go there in your mind," she'd say. I credit her with sparking my lifelong love of reading.

Walking into the band room at Porter Junior High, I saw a clean-cut kid practicing scales on the saxophone with speed and accuracy. Looking up, he immediately stopped playing.

"Don't stop, you sound great," I said.

"Just practicing," he replied.

"I'm Maurice White."

"I'm Booker Jones. Do you play?"

"I play drums."

"We should play together sometime."

Nothing was the same after I met Booker T. Jones. My musical spirit awoke in a new way. Booker radiated creativity and was way ahead of me in his musicianship. I was in the eighth grade, and Booker was probably a grade or two lower. I had just started formally playing drums. Booker could play sax, bass, trombone, clarinet, and very soon piano—and of course, later, organ. He was always studying music and taking formal lessons. His dad was a science teacher and his mom was a school principal, which made him well-to-do. At the time, I didn't know of anyone who had two parents who were both professionals. Mostly, in the 1950s, black kids' parents had blue-collar jobs. The Joneses lived in a nice house on Edith Avenue, and his dad had a beautiful car. Booker was well-spoken. He was classy, like his parents.

Booker T. and I became fast friends, spending most of our spare time together. Booker was shy—even shyer than I was, and that's saying a lot. As we spent time together, gradually I started to become more outgoing. I think we both did. Booker's musical passion, along with his quiet temperament, kind of opened me up. He was like the brother I never had.

As I approached high school, my hair started to get darker, turning from blond to brownish red, and became less straight and kinkier. Thank God! This was a big deal to me. I was tired of being teased. Around this time I started to become popular, since I played the drum kit at school. I got good pretty fast. The drummer is the jet engine of a band. He holds the groove and controls the pace. I could push the other musicians forward or break them down to a whisper. This made me the musical captain. I had power and control, and I liked it—I liked it a lot. Between my changing appearance and newfound sense of power in banging on the drums, I felt blacker, hipper, and less like an outsider.

Music. The word became the glue between myself, Booker T. Jones, and David Porter. We started to reveal our dreams to one another, and music was blossoming into our shared destiny. Every performance each of us had together or apart sparked our imagination about the next gig.

David had been in singing groups since junior high, which made him all the rage with the girls. My love for the Spaniels and, more importantly, David's popularity with the girls made me want to form a singing group with him. The Marquettes consisted of David Porter, Tyrone Smith, Robert Davis, and myself. We entered many talent shows. Tyrone was a short guy who had a piercing tenor voice. He would sing so velvety that the girls would lose their minds. Like many boys my age, I heard those girls' screams as the ultimate seduction to stay on the stage.

The talent shows at Booker T. Washington High School were like Hollywood coming to Memphis for us kids. Many of our dreams of stardom were born right there on that stage. It was a beautiful auditorium, and the stage seemed professional, with lights that flipped out from the floor and more lights hanging from the ceiling alongside the curtains. The auditorium was made for show business.

Music education classes were just starting in black schools when I was a boy. It began with singing folk songs in elementary school. In middle school there was a choir class, where we would perform for different events. In junior and senior high we graduated to band, where we could pick an instrument and learn how to read music. Music education gave us discipline, increasing our concentration skills. Music education also gave me an appreciation for all that is beautiful in the world. Understanding the mechanics of reading music—the soft tones and hard tones—built my sensitivity. It also gave me and many black kids of the early 1950s in this music city of Memphis, Tennessee, dreams. Would any of us become the next Drifters or the next Spaniels or the next Big Joe Turner?

During this time, Booker T. kept prodding me to play more

and more drums and do less and less singing with the Marquettes. "You should hang around older musicians," I recall him saying to me once. It was as if he was calling me into being more serious about music. Singing for us came natural, but to be good on your instrument required practice and time. With Booker's push, I started to play not just in school but also in other spots around Memphis. I worked for a funny dude named Squash Campbell. His group was called Squash Campbell and the Mad Lads. My gig with them had come about because their drummer, Joe Dukes, was leaving.

"Hey, boy, I hear you're getting pretty good on the cans," Joe said.

"I'm trying," I responded.

"Don't say you're trying, just say I'm good."

"OK. I'm good."

Joe laughed. He had a wide smile framed by a perfectly groomed mustache.

Joe was a first-class drum-playing cat. He quickly became my idol. He lived four doors down from me in the Lemoyne Gardens projects, and I'd see him going out to gigs in a tuxedo—the first live black man I ever saw in one. Besides his fierce drum playing, he could also sing. Joe had a vocal quartet called the Four Dukes, and they'd sing at the VFW, Elks, and other social clubs. He was the most respected musician from my neighborhood

Joe's powerful personality exemplified strength, but his temper generated conflict. He had quit a lot of gigs because of his hot head, and I would be right there to pick up the leftovers. I followed in Joe's footsteps for some time, and I longed to take his drumming ways to heart. Joe was old school. A showman. A ham. He knew how to bring a crowd to its feet with his beats, and yet he played the drums melodically. He took time to carefully tune his drums. Watching Joe play gave me permission to be even more expressive, because his approach was so unique.

The Squash Campbell gig launched what I would consider my first fully professional job. Squash was a tenor sax–playing

fool with very strange mannerisms. He could contort his body so that it seemed like he was having seizures. It was cool to his fans, and allowed him to hustle a lot of gigs. As a result, he received the opportunity to play at colleges like Mississippi State and a bunch of others in the Tennessee–Mississippi–Alabama–Arkansas corridor in the late 1950s. Squash was also positive and encouraging. "Boy, you got the stuff," he said to me a lot. His confidence in me made me want to reach higher with my playing, so I became a bit flashier, with my trademark stick twirling and moving my body to the groove. But most of all, Squash taught me the valuable lesson that I could be a bandleader if I could hustle gigs and keep a band working.

Later that spring I came home from high school and found Mama on the floor in serious pain. Her teeth were clenched together, and she was moaning not loudly, but deeply. This pain was incapacitating. "I'll be all right, Sandy," she insisted, but I knew she was only trying to put my mind at ease. She looked helpless, lying on the floor, propped up at the end of the couch. I sat beside her quietly, the only sound her moaning. I felt vulnerable, my mind racing. Was she really sick? Who was going to take care of us?

I knew I had to do something. Within a week I got a job delivering papers for the *Memphis Commercial Appeal*. My route was long, taking me across the railroad tracks into the white part of Memphis. Without my bike, I could have never pulled it off. When I got back home, I told Mama, "I got a job, and you don't have to work anymore." She protested, but I proclaimed, "I won't allow it, Mama. That's that!"

A little over a month later, standing in our living room, the windows open to the sounds of other kids my age outside playing, I handed Mama the rent money. Her chubby hands reached out and received it graciously. I felt older in that moment. I didn't have the wisdom to articulate it, but something significant had changed in me. But if the test of a man is to provide for his family, I guess you could say I became a man that day. Giving Mama

the rent money was like a rite of passage. I bought the groceries, continued to pay the rent, and started to learn how to budget. Although Mama got a little better over the next few months, we pretty much existed on the money I made from my paper route and the growing cash I made from playing with Squash Campbell and the Mad Lads almost every Friday and Saturday night. Dad sent Mama money from Chicago too.

I quickly learned that my budgeting skills left a lot to be desired. That summer, after getting the paper route, I was able to make a $30 down payment on a drum set—a beautiful Trixon set of gold drums, which the jazz great Lionel Hampton endorsed. I really wanted those drums, and was excited when I got them. Two weeks later, the next payment came due, and I didn't have it.

The owner of the music store came knocking at my door, chomping on a foul-smelling cigar.

"Do you have the money, son?"

"Sir, I just need two more weeks, and I promise I'll have it," I pleaded.

"Sorry, son, rules is rules." He snapped his finger and pointed inside the apartment, signaling for his worker to come in and repossess the gorgeous set of drums. The worker, a black man, felt bad for me. He didn't say a word, but he knew I was almost to the point of tears. Watching him pick up that drum set and carry it down the steps was heartbreaking. I will never forget that feeling of loss. I was hurt, but I tried to act like I wasn't. I kept it all locked up inside. I went back to my makeshift drum set, with its mismatched bass and snare drum, and borrowing what I could from school. Damn!

Part of being a black man in the mid- to late 1950s in Memphis was the way the white establishment did everything it could to impress upon us that we were not men at all. This reality crystallized for me one day while I was delivering papers on the white side of town, slinging them from my bike. Dusk was falling fast when these cops slowly drove up beside me.

"What are you doing over this side, boy?" they said.

"Delivering papers," I responded, my voice low.

With that, the two cops got out of the car and started beating my ass. They said nigger this and nigger that and how they were going to teach me a good lesson. When they finally stopped, they calmly got in their cruiser and slowly drove off. I could hear their laughter fading as they got farther and farther away. Once I got up, I just stood there sweating and shaking in the cool evening air. I had urinated on myself. I vowed that if I got stopped again by the police, I would run and cut through somebody's backyard. The fear haunted me for several months. Abuse of black men was a regular occurrence in Memphis. The white power structure had a steel grip on us black people. You could get your ass beat bloodied raw for no reason whatsoever—just another day for a Negro in Memphis.

The beating shaped my attitude and understanding of my environment. The racial tension in Memphis was evident in every aspect of life. Memphis was still very much segregated in 1958. There were nine black police officers, but they were not allowed to arrest white folks. At the time, blacks were organizing, fighting to join unions to get better jobs in the factories. Some police brutality was a backlash against the progress blacks were making in standing up for their rights.

Although adjusting to being the breadwinner of the household was difficult, I was finding a lot of musical opportunities. In the late 1950s, the Memphis music scene was booming. There were many places to perform, all centered around Beale Street. As in most American cities, there were areas where black folks gathered. Beale Street was the Harlem, New York, of Memphis, Tennessee, and something more—it literally meant music. Memphis is the birthplace of the blues, and consequently the birthplace of rock and roll, and Beale Street is its womb. Jazz, soul, early rock and roll, rockabilly, and blues were all there. Music was just like water and sunshine in Memphis: it sustained an essential part of life. Young and old, everybody talked about

music, from the corner store to the shoeshine stands to the barbershops to the bus stop.

Radio was just as crucial. On Saturday nights I sat on the floor listening to *King Biscuit Time* with Sonny Boy Williamson, airing on KFFA from Helena, Arkansas. WDIA played blues and gospel; WHBQ played rockabilly and blues. Saturday-night party music and Sunday-morning gospel songs on the Hammond B-3 organ were a big part of black culture back then.

I became obsessed in particular with WDIA, which became a part of my daily life. WDIA was the first radio station in the country completely dedicated to black music. It boasted 50,000 watts and could be heard all the way to St. Louis in the north and to the Gulf Coast in the south. Rufus Thomas was a DJ there. B.B. King's career started there. I loved every minute of what was coming out of my little radio from WDIA. Nat D. Williams, the main DJ, was hip, and even the gospel DJ, Theo "Bless My Bones" Wade, was a character. The radio was on WDIA in the apartment every morning and every night till Mama said, "OK, Sandy, turn it off."

I wanted to be part of the music world that I heard on WDIA, and in that pursuit I continued to find an ally in Booker T. As a result of our shared shyness and love of music, Booker T. and I were becoming as thick as thieves. He would stop by my apartment on the way home from high school, and my place became our main hangout. We also befriended a great young piano player named Richard Shann. This trinity, Shann, Booker, and myself, were buddy-buddy, sharing the same likes and dislikes for all kinds of music. Our friendship seemed like a big step toward our creative expression, personal growth, and psychological intimacy. I was excited to discover jazz. Icons like Miles Davis, Thelonious Monk, and John Coltrane blew our young, fertile minds. In our idol worship, we were laying the groundwork for who we would become as young adults, and later as men. Music wasn't just our world—it was our universe.

Booker and Shann were instrumental in expanding my musi-

cal education, playing jazz records for me that I couldn't afford to buy the way they did. Even when we weren't together in person, we talked about music on the phone every day. Shann was the first to turn me on to Art Blakey, Roy Haynes, Max Roach, and the one and only Elvin Jones—the top drummers in jazz, bar none.

My obsession with music accelerated a deep personality change in me. This period was one of the few times in my early life when I felt naturally outgoing. Maybe it was in comparison to Booker's very laid-back demeanor, but during our conversations about music, for the first time I started to feel comfortable in my own skin. I felt comfortable playing the drums. And the way we talked about music—with the energy that only youth can bring—took me to a higher level of self-acceptance.

We formed a little combo with Shann and started rehearsing in Booker T.'s den. His parents were so supportive. His dad would pick me and my drums up from Lemoyne Gardens and drive me to his house, or to gigs in such towns as West Milford, Arkansas, while Mrs. Jones would make sandwiches for our travels. Booker T. Jones Sr. never missed an opportunity to tell me about the importance of education. If it wasn't education on his mind, it was people like Jackie Robinson or Martin Luther King Jr. Sometimes when we couldn't get Mr. Jones to take us, Booker T., being a faithful friend, would carry the drums down my steep apartment steps to Mississippi Street and all the way down to Beale Street, then up the stairs to the VFW club where we often performed.

Booker and I formed several groups in those early days of high school, in addition to the combo with Shann. In every group, Booker T.'s musical role was undefined, because he could play damn near everything. By now Booker T. was clearly the most talented and proficient young musician in and around Memphis. We had a nucleus of young musicians—Louis Keel on sax, our pal Rudy on trumpet, me on drums, and Booker on everything. We played for just about every dance, talent show, sock hop, or school event associated with Booker T. Washington High.

Together with David Porter, we had a built-in fan club that followed us to other performances. It was sooooo cool. We would put on performances downtown at Ellis Auditorium, sponsored by the school, big events with dancers and intense choreography.

Yet despite all the gigs we played, jazz, by my senior year in high school, had become my passion. The freedom of expression in jazz, with its complex chord changes, rose high above what I considered the "commercial" music world of 1960. Everyone had the 45 "The Twist" by Chubby Checker. I was mesmerized by Art Blakey's 1960 album *The Big Beat*. By this time, Booker T. was fully committed to the piano and organ. We formed yet another group, a so-called jazz band. We stretched out and experimented musically, enlisting an older cat named Tucker who had more experience in jazz than Booker and I to play bass with us. He had an amplified upright bass, so everyone could really hear the bass, which was unusual. This combo felt like the culmination of all the musical training I had. I knew jazz was the top of the mountain.

In the spring of 1961 I graduated from Booker T. Washington High School. That day would be one of the most traumatic moments of my life. There I was in my robe on the auditorium stage, where the graduating class stood in those days. I looked out into the audience, and sitting in the front row, dead center, was my birth mother, Mother Dear, staring at me with a strong, purposeful glare. She looked just like me, and it was intimidating. I had not seen her in six years, since that brief trip to Chicago, and I had no idea she was coming. My scant memories of her exploded. She represented gaps, empty space, and emotional and psychological holes. I was flustered. I didn't know what to feel. Happiness? Sadness? Hope? Fear?

At the end of the ceremony she pulled me aside. "I want you to move to Chicago. I want you back, Sandy."

Her voice had a tone that I didn't recognize. It was not motherly; it was more like a sibling or a friend. She also sounded

needy. All I knew was that it was a ticket out of Memphis. I had no problem leaving. I was tired of the racism—from whites and from blacks, because of my fair skin. My spirit stood ready.

I had to get my stuff together pretty quickly. I felt as if I were packing myself into that round arch-top wooden trunk. The drumsticks, the shabby clothes, the music lesson books, the snare drum, the records, the one or two pictures I had, and the scrapbook that contained all the programs I played on at Booker T. Washington High—all the little pieces that had become my life since Mother Dear left fourteen years earlier.

Surely, there were people I would miss. I had a girlfriend, DJ, who I was crazy about. DJ was the cutest girlfriend I ever had. She was a short, sexy, high-yellow thing with a smoking body. Her butt was big and beautiful, just perfect. She loved that I played the drums in my flashy way, which I'm sure had been a factor in my overcoming my shyness to first ask her out.

Also, David Porter and Booker T. and I were the closet things to blood brothers that I knew. They represented my musical family—my real family. I think my leaving was tougher on Booker and me than on David. David was more outgoing and had a wider cache of friends. That wasn't the case for Booker T. and me. Booker and I were such close friends that every girlfriend he had I knew about, and vice versa. We were kindred spirits and similar in our dispositions. There's a quality to those formative years that's deeply bonding. It's different than the friendships you have with people you meet later in life, in college or early adulthood. My friendship with Booker and David is imprinted on my soul—it can't be erased. I was happy for the unknown new life awaiting me, but sad to leave my soul brothers.

A week later, when it was time to leave, I went to say good-bye to Mama. She sat there quietly as I stammered over my words. She kept her head down, not looking at me. I initially thought she was hardly paying attention. But when she looked up, I could see she was devastated. At that point, in 1961, I was her care-taker and the breadwinner. I believe she'd never thought Mother

Dear would come back for me. I knew her health was deteriorating, but I didn't know to what extent.

Mama grabbed my hand and said, "Sit down, boy." She swallowed deeply. "Sandy, ain't no opportunities here for a boy like you. You won't get nothin' staying round here. Memphis ain't the place for you. I've always told you to keep on movin', and if you don't go now, you'll never get out of the South."

Mama always had a forward-looking quality, and now she was looking ahead for me. Still, she wasn't that good of an actress. That she really didn't want me to leave was written in the folds of the skin on her face.

I left her in a sad mood. How I wish I could let go of that picture! I wish I'd been able to get back to Memphis and see her when I got on my feet, but it wasn't meant to be. I guess Mama would say, "I've done the work the good Lord wanted me to do." Within six months of my leaving Memphis, she would be gone to cancer.

All the strength I have now, over fifty years later, is because Mama simply loved me enough to take me in. I was not her blood, but I was her son. Her wisdom and her vision that I would "get the world's attention"—something she said to me over and over again—were the genesis of my drive, my commitment to positivity, even before I had a vision of my life's work.

Some nights, when I think of her, I walk out to my deck overlooking West Los Angeles and look up to the stars. Mama, thank you, I whisper. Your soft black hand got me over the fear of being left behind. Your steadfast, move-forward personality is my inheritance. I love you.

Through devotion blessed are the children,
Praise the teacher that brings true love to many
Your devotion opens all life's treasures
And deliverance, from the fruits of evil
—"DEVOTION," OPEN OUR EYES, 1974

Booker T. slowly drove me to the train station. I saw a beautiful train, *The City of New Orleans*, which ran from New Orleans to Chicago, dark brown steel with ILLINOIS CENTRAL painted in bright orange on its side. I can still close my eyes and see it. Its largeness, its modernism, represented to me change itself—moving forward, a new day.

My girlfriend, DJ, and I were crying like babies. It felt like we were in one of those classic black-and-white movies where two lovers are parting. The train was loudly hissing, and we were kissing and hugging. It was youthful, romantic, and bittersweet all at the same time. Booker stood on the platform watching us, saying with his slumped shoulders that he did not want me to go. A part of me—albeit small—wanted to stay too, if only to make him happy and continue our musical journey together. He was even more emotional that day than I was. He knew, I knew, that our little world was coming to an end, and that I would probably never return.

Suddenly I heard "All aboard!" I shook Booker's hand and then gave him a hug before walking up the narrow shiny metal steps. I looked back one last time.

3 I'll Never Lose Chicago Blues

There is only one corner of the universe you can be certain of improving, and that's your own self.

—ALDOUS HUXLEY

The Illinois Central slowed down into Union Station Chicago. The concourse was even bigger than I remembered it. Mother Dear saw me first and yelled my name. She ran to me and hugged me tightly. Her smile said she was happy to have me in her world. I was glad to be there.

I felt brand-new. Chicago was larger than Memphis in every way—big buildings, wide streets, and lots of noise. Walking down Michigan Avenue for the first time, I saw white and black people brushing up against one another, hurrying by. In a shock to my Memphis, Tennessee, mind-set, these downtown black and white businesspeople almost looked like equals. Between car horns blowing in the congested traffic, I could hear the slowly passing cars blasting hit songs on the radio: Bobby Lewis's "Tossin' and Turnin'," Ray Charles's "Hit the Road Jack," and most of all the Shirelles' smash "Will You Love Me Tomorrow" seemed to play on an endless loop. I was hypnotized by all this big-city modernity.

Back at Mother Dear's, after a few weeks it became apparent that we really didn't know each other that well. I started to feel more like her brother than her son. It would be our dynamic for the rest of her life.

Over the years, while I was still in Memphis, we had built up somewhat of a friendship through letters. I hadn't conceptual-

ized her full role as a mother on my short trip to Chicago years earlier. It didn't take me long to realize, however, that she was custodian over everyone and everything in the household. She had six other children—with two more soon to arrive—so it was an active household. She was also wife to Dr. Verdine Adams Sr.—"Adams," as she called him. I learned that he was a podiatrist, and called him Dad.

Dad had a high degree of worldliness: he was articulate and spoke five different languages. He was a prince among his peers. Tall, lanky, and dark, just as his son Verdine Jr. would be, he was a brilliant man. I quickly got to know him, and came to respect him a great deal. Dad was always reading. He had a lot of books in the apartment, many of them medical but also on subjects as diverse as world history and sociology.

Mother Dear was b-u-s-y, always preparing meals and managing our household in the Henry Horner projects of Chicago. The projects, built in the early 1960s, were adequate; this was long before the degradation of the mid-1970s and the hellhole they became in the 1980s, with all the gangs, drugs, and violence. Back then, it was actually a cool place to live. The apartments were clean and orderly, and parents did in fact parent.

Dad and Mother Dear had, it seemed to me, the best apartment in Henry Horner. They lived in one of the shorter buildings, with only seven floors. Most of the other buildings were taller, fifteen or twenty floors or so. The walls in apartment 104 had a white cinder-block look to them, much more attractive than Lemoyne Gardens in Memphis. There were four bedrooms, two bathrooms, a kitchen, a living room, a very long hallway, and a laundry room in the basement. Mother Dear gave me my own room. Although I was grateful to have my own space, I felt kind of bad, because I knew Monte and Ronald were being displaced.

But this was still Chicago. It was still the Henry Horner projects, with its share of thugs and all the ills of society. And as with everything else in America, whatever the ills may be of mainstream society, they're always worse for black folks.

After about six months in Chicago, Dad got me a job at St. Luke's Presbyterian Hospital. Due to his connections as a doctor, I was given a decent-paying job as an orderly in charge of central service. When I got my first check from the hospital, I was happy, but not for long. Dad informed me that I had to share my entire check with the family. Even though I'll always be grateful to them, this arrangement was not going to work for me. I understood the expectation to fork over the money. There were a lot of mouths to feed. And at eighteen I was a grown man. Men provide. The household needed the cash, plain and simple. But I had big plans for my earnings: first, to buy a professional drum set, and then hustle to find gigs. I wanted to build a life of music. Money represented the freedom to do that. Freedom was important to me, then and now, so I quickly moved out.

Mother Dear did not want me to leave. She cried uncontrollably, which made me uncomfortable. She felt she was losing me, yet again. She confessed her fear that I didn't have enough street savvy to go out and compete in the world. Chicago was an unforgiving place, especially for naive Negroes from the South. She thought I would end up in a ditch or alley, dead.

Dad tried to reassure her. "It's OK, Edna, he'll be back in six months," he said. I was determined not to fail and have to return home. I was ready to face the world head-on.

I was lucky that I immediately found a roommate. James Bowen was a streetwise cat. We got a place on Van Buren Street, and my portion of the rent was $90. I'm ashamed to admit that my silverware, sheets, dishes, toilet paper, and towels were all courtesy of St. Luke's Presbyterian Hospital. I was a skinny man with a BIG coat. I'm surprised they didn't hear me clanging my way out the door!

Bowen and I had a good time. James could really pull the women in, and Chicago had a lot of women to be pulled in. I understood what it truly meant to be a player for the first time. Not in an exploitative sense, but in grasping how to talk to adult women with a confidence that exuded manly sexuality. I learned

the delicate art of showing women total courtesy on the surface but also letting them know that I was completely incorrigible in the bedroom. Women seemed to love that. Even though I was still too shy to fully enjoy the hookup aspect of my living arrangement with Bowen, I did start to have a manlier swagger.

After getting settled in my new living arrangement, I made my first big purchase: a beautiful set of Gretsch drums. I got all the accessories new: hi-hats, cymbals, hardware, and pedals. I paid for the drum set in full to prevent anyone from coming to repossess this set like they had when I was fourteen. Gretsch drums had bigger shells than most, which gave them a deeper, more distinctive sound.

Even though I had bought these drums, the drum thing kind of faded into the background during those first months. I was obsessed with making a living and making my way on my own. Within a couple of months of getting the place on Van Buren Street, I enrolled at Crane Junior College (now Malcolm X College) on the West Side. It was in this period that I set my sights on a career in medicine. Since I did not have any impressive male role models as a child or young man, I naturally gravitated to Dad's profession—for all the right reasons, I thought. A black man who is a doctor is a prince. Not unlike a preacher, a doctor is revered and respected in his community. Who wouldn't want that for himself? Not to mention that if I followed the set path of college, medical school, and then residency, I could guarantee a decent living. There was very little risk.

Dad being such a renaissance man also pulled me in. Observing him speak to people in different languages in the sterile white hallways of St. Luke's Presbyterian was a turn-on. Even then, I was attracted to people who knew something about everybody—and that was Dad. Though I didn't really know him at all, he was the father that my soul deeply wanted. *Father* had been just a word to me, an idea. When Dad sent me that bike years earlier to Memphis, he had become my idea of a father. Going to medical school was my way of embracing that full-fledged relationship.

At Crane I met bassist/trombonist Louis Satterfield and saxo-phonist Don Myrick, who would be with me for the next thirty-five years as friends and later as the core members of the Phenix Horns, Earth, Wind & Fire's horn section. A great cat named Chuck Handy was also a part of our little circle. But it was really a God-sent angel named Fred Humphrey, a pianist who would ultimately go on to help me define myself as a musician and a man, who would profoundly change my life.

Fred read everything. Mysticism, health food, yoga, Afrocen-tric studies—anything of interest to him, he ingested. "Maurice, you need to check this one out," he would often say just before squeezing a book under my arm. He opened my mind up to new paradigms of thinking, new and different ways of looking at life. Fred and I would rummage through Rose Record Store and Sey-mour's Jazz Record Mart, both on Wabash Street. Seymour's had a big brown bulletin board where musicians tacked up phone numbers, a community service for people trying to find musi-cians and musicians trying to find gigs. Rose Records boasted of having any record in any genre at the best price. We would thumb through rows and rows of albums and 45s for hours. Fred, always the pioneer, was interested in the relatively new form of avant-garde jazz. He picked up Ornette Coleman's album *Free Jazz* and said, "This is this kind of stuff you should be listening to, Maurice—this will open you up." I seemed to be a sponge to Fred's living water, soaking up everything he put before me.

Fred continued to distinguish himself as the greatest influ-ence over my life, and even that feels like an understatement. I didn't realize it at the time, but he was my guru. Just being in his presence was transformative. After hanging around him for about six months, I thought a lot about the choice I'd made to study medicine. I wondered whether I was doing it to please Dad or please me. Dad emphasized security. Who could argue with that? Being a musician seemed flighty, of course, unless you made it. Dad knew and I knew that making it in music was a crapshoot, at best.

I had grown increasingly restless. I didn't talk to Fred directly about this uneasiness. I probably talked around it, in circles or riddles. However, I think he knew what I was going through. Fred just naturally encouraged me. His words were perpetually, "Be your own man." "Honor your heart." "It's your one and only life."

The music life began to scream at me, sometimes through my nocturnal dreams, sometimes through the feeling I got when I practiced intensely. By early 1962, I knew something had to give.

"Dad, I have something to tell you," I said.

"What, Sandy?" Dad asked.

"I don't think medicine is for me."

"What in the world do you mean, not for you? Isn't that what you want?"

"Well, actually no. Music is what I'm supposed to do."

I think it was those words, "Music is what I'm supposed to do," that stumped him. It said that I believed this was my calling, something higher that I had no control over. He didn't respond affirmatively, but he didn't respond negatively either. He was neutral. He patted me on the back and said, "Do your thing, boy."

If it hadn't been for Fred's spiritual light, I wouldn't have had the strength or the courage to chart my course back into the drums. He inspired me: after being around him, I had all the confidence in the world. It was like a bright light turned on in my consciousness, showing me that music would be my destiny. I knew that I would stay with it, come what may. Fred Humphrey was the soul who transformed me from Sandy White of Memphis, Tennessee, to Maurice White of Chicago.

Fred gave me yet another book around this time, and it became my Bible. *The Laws of Success* by Napoleon Hill changed me forever. In fact, it's not an overstatement to say that it fundamentally altered my mental and spiritual DNA. The principle that contained the most force for me was that you have to have a definite chief aim for your life.

What I did know for sure was that I wanted to be the best musician. I wanted to be cool. I wanted to be one of "the cats." Fifth Jacks was a jazz club around the corner from my spot on Van Buren Street. All the hot musicians would come from all around to sit in. It was a highly competitive atmosphere. Everybody smoked non-filtered cigarettes and drank booze. Guys would sit around a large round table and loudly pontificate about who played the best solo, who had the most technique, or who had the greasiest feel. I would go there just about every night after work, soaking it all up, then foolishly wander the streets after Fifth Jacks closed. Block after block, I would fantasize about being Philly Joe Jones or Art Blakey. I wanted to be respected and revered like they were. My fantasies weren't limited to my street wandering. Falling asleep, I would have dreams about playing at Fifth Jacks and being the newly crowned star of the night. In those dreams, I would be unknown to the audience. As I took my seat behind the drums, the white spotlight would hit me center stage, and I would just play my ass off, sweating and gyrating with the crowd cheering me on. All this enthusiastic tension was building and building in me. I practiced a lot. After a few months of this volcano brewing inside me, I felt I had enough skills to take my sticks down to the club.

> *We tried to be cool*
> *Flat tops up stove pipes down*
> *Finding out the good stuff*
> *You never gonna learn in school*
> *Comes easy in this part of town*
> *I brought my sticks, we're sittin' in all night*
> *Better be quick, gotta hold on tight*
> *It's gonna be a real jam down delight*
> —"CHICAGO (CHI-TOWN) BLUES," MILLENNIUM, 1993

When the fateful night arrived, I stepped toward the bandstand and said confidently, "Let me sit in." The pianist looked at

me with great skepticism, a cynical smirk on his face. It was clear that he did not like me. He quickly shouted out "Cherokee," the jazz standard that Ray Noble wrote and Sarah Vaughan, among others, had recorded. The version I knew was Charlie Parker's, which was pretty fast. The pianist counted the song off faster than I had ever heard that song before or since. I tried like the devil to keep up, but I couldn't. I'd blown it. The piano player sneered at me and said, "Get off the stage, kid." My shoulders slumped, and I got up from the drum set, grabbed my coat, and got out of there as fast as I could. My head hung pretty low walking home. I was embarrassed, humiliated, and hurt. I can still feel that sting fifty years later.

As in all disappointments, there is the possibility of redemption. That's how I have always looked at life. I started practicing drums at a level previously unknown to me. Everybody in the jazz world knew about the long and intense practice sessions of Charlie Parker and John Coltrane. They would shut themselves off from the world, removing any distractions while refining their gift. Sometimes, through the power of repetition, they would almost become catatonic. I used what I heard about them and made it my own, not letting anything get in the way of my practice ritual. It was grueling. It reminded me of the hardworking days in the cotton fields under the sun in Osceola. I was practicing in nonstop three-hour stints two times a day, four on the weekend. I could wring the sweat out of my T-shirt like it was a dishrag. I was young, strong, and most of all persistent, with an incredible desire to be the baddest drummer going. It was an education in hanging tough.

Early in 1962 I met James Mack, the band director at Crane Junior College. James was an instructor of the highest order and a true "music man's man." Well versed in jazz and classical, he still knew what was on the pop charts. He went on to be one of the principal arrangers at Brunswick Records, as well as working for Chess, Capitol, and Columbia Records. James was a big guy in size, but one of the gentlest spirits I'd ever

met. That man is the godfather of much of the significant talent that came out of Chicago. Willie Henderson, Leo Graham, and Tom "Tom-Tom" Washington, who would later become one of Earth, Wind & Fire's principal arrangers, all studied under him.

Mack pushed six of us—Fred Humphrey on piano, Louis Satterfield on trombone, Don Myrick on saxophone, Chuck Handy on trumpet, Ernest McCarthy on bass, and myself on drums—to form a group called the Jazzmen. We spent many hours together rehearsing nonstop, reading the music for accuracy, adding showmanship, and practicing routines. This was new for me. Much of my enduring musical work ethic was born right there.

"You kids are getting good," said James Mack when he walked in on a rehearsal one day.

"We know," Satterfield responded jokingly.

"I think you guys are ready for a challenge."

The Harvest Moon Festival was an annual music contest that was sponsored by the *Chicago Sun-Times*. It was a big deal. Eddie Fisher was the headliner that particular year, performing for the big finale after the contest. The odds were against us: there were many more experienced performers. We took to the stage and played our hearts out, giving it our best. Amazingly, we won, in a validation of our talent and what could happen when we worked hard. That night Satterfield was bigger than life. Though we were all young men, Satt was still like the daddy, saying, "We fucked 'em up, didn't we?"

The victory put enough wind in our sails to encourage us to enter the 1963 Collegiate Jazz Festival, a two-day event on March 29 and 30 at the University of Notre Dame. Steve Allen, Stan Kenton, Henry Mancini, and my future good friend Quincy Jones were all advisers to the prestigious competition. The great arranger Manny Albam, who did arrangements for Count Basie, Stan Getz, Dizzy Gillespie, and many other music stars, was one of the judges. *DownBeat*'s Leonard Feather was a judge as well.

We were all nervous, except for Satt, who confidently said, "We got this."

We won our division.

Not too long after this triumph, Satterfield became more interested in playing bass. He was a great trombonist, but he quickly became an absolute monster on the bass. In time Satt became to Chicago what James Jamerson was to Detroit—simply the best damn electric bass player around. Satterfield started to secure us gigs—me on drums and him on bass. I was shy, and Satt was strong. Satt taught me how to stand up for myself. I needed that motivation because in the brave new world of Chicago, in the early 1960s, I had to be tough, or I would have gotten run over. There was always someone trying to hustle someone else. If it wasn't to steal your stuff, it was to steal your mind and lead you into a darker life. "Watch that dude, Maurice, he's bad news," Satterfield would often say in those days. or "That motherfucker ain't worth a warm cup of spit." I always took his advice. He could smell bullshit no matter how well someone spoke or dressed. These hustlers hung around musicians because of the nightlife. Cash money was flowing in the nightclubs. There were women to seduce or women paid to seduce you. Of course there were drugs, which I detested. There were many traps that could have easily taken me off track, but all I wanted to do was play music and earn a living doing it.

I considered myself a groove master on drums, and Satt was a self-proclaimed rhythm king. In a band there must be chemistry between the bass player and drummer, or you have nothing. Satt and I interpreted rhythm in the same way. We were tight and complementary to each other's styles. We fluidly anticipated each other's moves. We morphed into one musician. We were soon working steadily, mostly on the weekends. When the gigs started to pour in, eventually we performed during the week. The folks at St. Luke's Presbyterian were cool in letting me often leave early. Running like the wind, I'd dash out the front doors of the hospital, dart up the stairs, hop on the L train, get

off, and sprint the six long blocks to my apartment. I'd grab the bulky military green bags in which I carried my drums, throw the big bass drum bag over my shoulder, grab the other two, and dash out the door and right back up to the L train. Occasionally a friend would pick me up, but that was the exception, not the rule.

Between gigging, Crane College, and working at the hospital, something had to give. I had a lot of gigs lined up. Since I was making more money performing, I quit the hospital. Then all my gigs fell through. I mean, *all* my gigs fell through. Just like that. Damn!

That winter of 1962 was grueling in Chicago. It was cold as hell, and I was more than broke—thirty cents away from having a quarter. As a proud man, I sure was not going to ask Dad or Mother Dear for help. No way. I also didn't believe in calling on my friends. In October that year, Booker T. had just had one of the biggest hit records in the country with "Green Onions." I mean, it was a smash. Even though it was an instrumental, it was all over the radio that winter, with that great Hammond B-3 organ opening lick. Although I was happy for Booker, his breakout success put doubt in me. I was like, Damn, did I screw up? Should I have stayed in Memphis? I could have been a part of Booker T. & the MGs. Or maybe I could have gotten a gig at Stax Records, where David Porter was just getting going and would soon write Sam & Dave's biggest hits, "Soul Man" and "Hold On, I'm Comin'." As I sat in my cold apartment, I knew they both would have sent me some money, but I was too invested in keeping up the grand facade that I was doing just fine.

I never wanted to ask anybody for anything—that was just me. It still is. But I was deep in the valley. I stared at my drum set with almost some resentment toward it. I kept my fear and worry firmly bound up. I was praying that my landlord wouldn't put me out. Self-doubt began to creep its way into my spirit. That's what fear, real or imagined, can do to you. No money, many days hungry, I was dropping weight like crazy. I had this blue-green

glass jar that I would put chump change in. Every day I would go down to this Greek restaurant. The proprietor, the huge hairy Greek cat, would cheerfully say, "Hello, my friend, same thing today?" They had this great deal: pita bread, some veggies, and a piece of meat, all for $1. I ate that way for a few months, one meal a day, one dollar a day.

Since I wasn't taking proper care of myself, I got really sick. I called it a bad case of the flu. Now I realize it was probably some kind of hellish pneumonia. I had never been that ill in my life. I was roaming the streets one day, and I stopped and sat at a bus stop on Cermak Road. My eyes were almost shut, like I had been in a boxing match. I was coughing up marble-size balls of mucus and wheezing so loud in my head that it was driving me insane. I must have looked pretty pitiful, because people were looking at me like I was on dope, drunk, or homeless. I put my head between my legs and cried out, "God, help me. Give me strength to endure. I know it's not supposed to be this way. Please, Father, lift me up, please, Father, please."

Within a week I had a gig.

Deliverance. Grace. Mercy. Whatever you want to call it, things gradually started to turn around. Remembering what God has already brought me through continues to give me the courage to press forward. Like my experience as a boy in the cotton fields of Joiner, Arkansas, Cermak Road has become in my memory one of those things that keep my faith alive. I cried out to God, and I know for sure he heard and answered my prayer. I don't believe that when the Creator answers our prayers, he just stops there. He puts in our hearts a new design, a new and unexpected direction for us to reach and expand to, inwardly.

Time moved on and then
Life and I became the best of friends
There's no limit to
All the smiles in life that's in store for you

So I found thru my desire
I could take it to the sky—baby,
Now my heart can fly
—"TAKE IT TO THE SKY," FACES, 1980

Through answered prayer, things started to look up. My reputation as a drummer began to expand. After my Cermak Road breakdown, I wasn't turning down any gig, anywhere, anytime. In late September of 1963 someone got me a gig at the legendary Vee-Jay Records. In my mind Vee-Jay was the record label bar none in Chicago. The fact that it represented the Spaniels had an emotional significance, too. There was no doo-wop group that I'd loved more than the Spaniels during my teenage years in Memphis. Vee-Jay was also one of the first independent record labels owned by black folks, the husband-and-wife team of Vivian and James Bracken. Calvin Carter, Vivian's brother, was the head cat/A&R man.

My first day of working for Vee-Jay, however, everyone in the studio was talking about the Sixteenth Street Baptist Church bombing in Birmingham, Alabama, where four little girls were murdered. Calvin said, "How some cracker could do that on the Lord's day, I'll never know." I was quiet as I set up my drums, reflecting the somber tone in the studio. For me, progressive Chicago seemed far away from the turmoil of the South.

Calvin Carter took an immediate liking to my playing. My experience with Vee-Jay was significant for me musically and businesswise. The Bracken and Carter family had built something that was theirs. They took the risk, and they were winning. It set a new idea in my head about what it meant to be in the music business—ownership. This became another new dream. One of the first records I played on at Vee-Jay was Betty Everett's "You're No Good." The song was a crucial moment in Betty's career. It peaked at No. 51 on the *Billboard* Hot 100 and No. 5 on the *Cashbox* R&B chart. But Vee-Jay being a force on Chicago radio, it was a much bigger hit in the Chicago area in

late November of 1963. Betty's first single flopped on Vee-Jay, but the success of "You're No Good" kept Betty in the mix until she had her huge hit with "The Shoop Shoop Song (It's in His Kiss)."

"You're No Good" was a major turning point in my pursuits. You know there's an old joke in the music business that if you are associated with a hit record in any possible way, that association will keep you working for years. You could be the janitor that cleaned up after the record was recorded or the guy who set up the microphone stand, the adage went; any affiliation with a smash record would always get you a gig somewhere. After "You're No Good," my work doubled almost overnight, and it was a huge confidence booster.

I was riding high. I had a hit record and a little bit of money in my pocket. More than once I said, "Yes, darling, that's me playing drums on 'You're No Good.' Want to come over to my place?" For many weeks I got gig after gig after gig. My smooth sailing came to a sinking end in mid-December, when I got drafted. Vietnam didn't dominate the news in 1963. The Kennedy assassination was still the all-encompassing story of the day, and would remain so for quite some time. But young Americans of every color were already burning draft cards in New York, Chicago, and Los Angeles. This was before the draft lottery that was supposed to make the draft more "fair." It was obvious to me and anyone else with half a brain that the most often drafted were the poor or working class. I was in shock when I received the letter, and scared to death. After an hour or so of brooding, I got myself on the L train and just rode, going nowhere in particular. As it clickety-clacked, I tried to think what in the world I was going to do.

I wasn't going to Canada. I wasn't going to hide, either. I was already pretty high-strung, and that would have driven me out of my mind. I didn't want to be labeled a conscientious objector. I then remembered a tale about a guy getting deferred by acting crazy. Mmmmm. Maybe? I continued on the train to the

Henry Horner projects, and to Mother Dear's. Dad had plenty of medical books. I picked up a couple on mental illness and psychiatry, jotting down the characteristics of paranoia, psychosis, and schizophrenia.

One week later, I went down to the induction center looking as disheveled as humanly possible. My hair was all over my head. I was unbathed and funky, wearing mismatched shoes. I tried not to overplay it, but I was definitely putting out the signals of an unbalanced person. As I waited, I rocked ever so slightly back and forth, mumbling softly under my breath. My eyes were shifty, like I was watching a tissue blow in the wind. I was drawing attention. Some sergeant came up to me and said, "Young man, do you have a problem?"

I responded with a stark stare and big bulging eyes. I didn't say a word. He tried again, louder this time: "Young man, do you have a problem?"

"Yeah, motherfucker, Africa is the problem," I said.

The soldier grabbed my arm, lifted me to my feet, and closely escorted me into another room. There were two other men sitting in the bright room, one black and one white. I waited and waited for what seemed like an eternity. When I was finally called, a soldier came in, stood me up, and walked me into another bright white room with a gray steel desk. The soldier sat me down and stood by the door. I guess it was a doctor who then walked in and sat across from me. He began to ask me a series of questions, routine ones at first: What's your name? Where do you live? Then he got to the nitty-gritty. "If you were given a rifle right now, what would you do?" Without skipping a beat, I said, "I'd stand up on this desk and shoot all you motherfuckers." The interview was quickly concluded. I got my deferment.

4 The Chess Lessons

Education is not the filling of a pail, but the lighting of a fire.

—WILLIAM BUTLER YEATS

In the winter of 1963–64, Satterfield and I heard that Chess Records was looking for a house band. With the success of "You're No Good," we felt confident or cocky enough to put a thirteen-piece band together to audition. We enlisted all of our buddies at Crane Junior College—Satterfield on bass, Gerald Sims on guitar, and myself on drums. We also put together a ten-piece horn section. We rehearsed the band like hell, causing some tension in the group.

It was an extremely cold Chicago day when we were pulling our equipment out of the car at 2120 South Michigan Avenue. Sonny Thompson, who was already established at Chess as a piano player, sat in with us at the audition. We played a twelve-bar blues. By the time we hit the last note, Leonard Chess walked in from the control room and said, "This is great! However, we only need a bass player, a drummer, and a guitar player."

The horn players were dejected and pissed with Satterfield and me, believing we had led them astray. But Satterfield, Sims, and I were on our way. The first day on the job, I formally met Billy Davis, the relatively new A&R man hired by Leonard and Phil Chess. The Chess brothers were two Jewish immigrants from Poland who had built their label from the ground up. Billy had been working in Detroit with Berry Gordy at Motown before

then. Billy was the epitome of class. He was a sharp dresser, well groomed, and most of all, extremely professional.

The Chess brothers and Billy wanted to establish a Motown production-assembly-line way of making records, so songwriters, producers, and band would be all on staff and in-house. When we first started, we actually had to punch a time clock! Once after a particularly grueling day, I said to Billy, "Man we gotta stop this punching-a-clock shit." He responded, "Don't talk to me, talk to Leonard." I walked into Leonard's office as he was loudly slurping a cup of coffee.

"What do you want, White?" he shot out in his usual caustic tone.

"Leonard, punching a clock doesn't work for us."

"Sorry, kid. I'm not paying one penny more than I have to."

"We're musicians, for Christ's sake, not assembly-line workers!"

Surprised by my insistent tone, he said nothing. There was about thirty seconds of silence.

"Well, what's it going to be?" I said.

"OK. You don't have to punch in anymore."

"Thanks, Leonard."

And with that, we officially became staff musicians at Chess Records. The guys were happy. In my cocky move, I recognized the power of asserting myself. I was still shy, but Fred Humphrey's encouragement had taken root. I started to feel more like a leader.

Several weeks after this happened, I became hypnotized by Billy Davis. He was behind the eight ball, but he seemed unfazed. He always appeared in control, though he had an enormous job and was faced with a huge challenge. Chess Records was a successful record label, but in the early to mid-1960s, music was changing fast. James Brown, the Beatles, and Motown were changing the public's ears. The blues records that had put Chess on the map were becoming old hat. Though he had help from Gene Barge, an arranger and incredible sax player, the deci-

sions on what songs and which artists to cut fell on Billy Davis's shoulders. Personally, I felt as if the musical sophistication of the Motown artists was the future of R&B music. The Beatles didn't even turn my ears until a year later, with *Rubber Soul*.

After the sessions were done for the day, if I didn't have another gig that night, I started hanging around the studio, talking to Billy, who was friendly and informative, taking me under his wing. He told me many Motown stories. His tales about the Four Tops, Berry Gordy, and Smokey Robinson fascinated me.

I soon found out that he favored me because I was critical to what he needed. Everybody at Chess Records was completely obsessed with the Motown sound, and that sound was largely about the beat. Whether it was the shuffling or driving the four beats on the snare drum, I had the Motown sound down. I had perfected that stuff. Soul music has by and large always been about the beat, and musicians, producers, and executives relied on me to provide that beat. It was serious business, and I was ready.

After one of my early sessions at Chess, pianist/songwriter Raynard Miner, who is blind, said, "Wait up, Maurice." Grabbing his white cane, he walked over to me.

"Maurice, you got that POP in your snare, that real hard-driving backbeat. I love it."

"Thanks, Raynard. That means a lot coming from you."

Raynard was a songwriter who worked hard and was serious about his craft. He was always improving. His acknowledgment signaled that my years of relentless practicing were paying off. One thing that made me different from other drummers was that I worked very hard at maintaining tempo, not dragging or accelerating. I practiced for hours on end with a metronome, raising my intensity but never losing the set tempo. It was challenging during that period to find a drummer who could give you both a big backbeat *and* a rock-steady tempo. I also tried to deliver what the songwriters wanted. A lot of musicians were ego-driven and kind of blew off the songwriters' suggestions. It was like they were saying, I'm the musician, you're just the songwriter—now

run along. I respected the songwriters. I think that helped me not only build relationships with the songwriters but understand their mind-set as well.

Chess Records had lots of artists, many of them characters—and no one was more of a character than Sonny Boy Williamson. During my second month of working, the studio door was flung open, and Sonny Boy strolled in, wearing a custom-made outfit. His outrageous garb was half blue and half tan. One leg, one arm, and everything else blue on one side, and tan on the other—straight down the middle! He also had a bow tie that was blue on the front and tan on the back. He stopped as the door shut behind him, allowing us to take a good look at his grandeur. I looked over at Satterfield, who glanced back at me with big wide-open bug eyes. There was a moment of silence and then an explosion of laughter. We didn't mean to embarrass or disrespect him, but we just couldn't hold it in. He looked ridiculous.

Sonny Boy sat down. Smiling widely, he pulled out a beautiful, shiny silver flask. He loved his gin. Taking a swig, he reached for his harmonica and started playing and tapping his big foot. Sonny Boy had large hands. He pulled the harmonica out of his mouth and sang the blues a capella. We all watched and listened with the reverence he deserved. Hearing Sonny Boy Williamson play and sing was like listening to a musical history of America. His blues were soulful, raw, and angelic. Yes, he was a character, but he was also a princely musician.

In the early days of working at Chess, I was like a sponge. I absorbed everything about recording. I learned about microphones, which ones to use for different things. I also watched Billy run back and forth between the studio and control room.

"Maurice, let's move your drum set three feet to the right," he said.

"Why?" I replied.

"The kick drum will have more air to move that way—it will resonate more."

Perpetually moving my drum set around, he explored how

the drums sounded in each particular song. Microphone placement was critical to him in capturing the vision in his head. The relationship between where the drums and bass amplifier were placed was critical in Billy's ideal "radio sound" of 1963 and '64. Distinguishing that sound also meant clearly defining the difference between the verse and hooks of songs. "Break the verse down fifteen percent more," he often said to me. He had to have his verses at just the perfect energy to set up his big hooks. Billy exemplified what would become the modern-day pop record producer, creating an atmosphere that ensured a perfect balance between pure calculation and pure spontaneity.

Never mind the education I was acquiring in music production, though: the biggest part of my instruction was focused on the business of music. Here too Billy was a great teacher. He started to hip me to the publishing game: songwriter royalties, publishing royalties, mechanical royalties, and how they were different from one another. He had started a publishing company with Leonard Chess called Chevis Music. This was significant to me businesswise, but also racially. Billy was one of those rare black men of that era who were truly seen as equals to white businessmen. This made a tremendous impression on me.

What was it about him? Was it his impeccable dress, his knowledge of the business, or his command of the English language? I realized that Billy understood where he was in his time. The civil rights movement was taking root in the South, and a lot of black folks in Chicago weren't taking white folks' racist shit anymore. Billy understood that, and applied it to the world of Chess Records. Historically, our best foot forward meant a subservient, lesser foot forward. In other words, no matter how perfect you were at your job, you were still resigned to being under the thumb of some white person, even if that person was less intelligent or less skilled than you. Even though Leonard and Phil were the owners, Billy asserted himself in the record company as a man with full-fledged and equal capabilities, without a hat-in-hand attitude.

I don't think Leonard and Phil Chess were bad guys by nature. They just had a dog-eat-dog mentality, highly competitive and, yes, on some level exploitative. I believe they thought that this was the way things were done. There were so many white record label owners, and they were not the worst. But I do believe that we as a people—black folks, that is—were way more gracious with them, meaning whites in the music industry generally, than they were with us at that time. Many white artist/ musicians would come by the studios to talk to the musicians about how to do this and how to do that musically. But many of them would not share with us how to do things, businesswise. They wanted to keep it secret, privileged information. I knew that I would have to learn the business of the music business on my own.

I did not want to become a victim. Many of the artists at Chess Records were lulled into a state of confusion. There was a family atmosphere at the office and studio. When artists needed money for rent, they went to ask Leonard for an advance—that is, payment against their future royalties. Well, I could pay my own rent, thank you very much. I started to view a lot of the cats at Chess as victims of the world. Most of the time they just sat around not talking about anything related to the business of music, just complaining about the situation they were in. I started to measure their complaints versus the actions they took to change their lot in life. Their inaction scared me. Many of the musicians fell into the "you're not smart enough to handle this, so I'll handle it for you" trap. Their lack of self-sufficiency led to all kinds of craziness. I did not want to end up like them. I resolved that I would learn all I could about how business is done.

The majority of the cats confused the outward signs of success with actual financial security. One day we were standing outside in front of 2120, and this beat-up Rolls-Royce pulled up. As the driver got out, we noticed that a rope was holding up the rear door. We fell out with uncontrollable laughter. The driver,

his hat cocked to the right side, paid us no mind as he walked around the car and proceeded to methodically unwrap the rope. He opened the door, and songwriter Tony Clarke popped out and pimp-walked into the building. The driver systematically wrapped the door back into place with the rope and drove off to park. Hilarious.

God bless Tony, though—a very likable guy, he was just caught up in that craziness I'm talking about. He had a hit with Etta James in 1963 with "Pushover," and he was behind the eight ball to get another. He wanted to show that he was still happening—a kind of keepin' up with the Joneses. Tony taught me a valuable lesson that day. Success, with all its trappings and seductiveness, is nothing more than a fog that appears and disappears with the next passing wind.

I knew for certain that I didn't want to be solely dependent on Chess Records. I was pushing to do as many gigs as possible, one of those lessons out of *The Laws of Success*. I wanted to keep myself independent. I believed it was the only way to survive.

I got a gig at the Hungry Eye on North Wells Street with Fred Humphrey and an exceptional bassist, Bill Terry. I worked there four nights a week for almost two and a half years. Great gig, great steady income. The Hungry Eye was known for having a more progressive, avant-garde, and modern lineup. There were tons of clubs in the area of Chicago known as Old Town—the Outhaus, the Plugged Nickel, and many more—offering music ranging from straight blues to folk and Latin. I believe my love for Latin music was born in those many nights spent on Wells Street. On one occasion I saw Sérgio Mendes and Brasil '66 at a club that I used to play and hang out in, Mother Blues. I liked his brand of samba, pop, bossa nova, and Latin music rolled into one.

Around that time I formed a group called the Quartet 4, modeled after the Modern Jazz Quartet. The Quartet 4 consisted of myself, Dick Sisto on the vibraphone, Bill Terry on bass, and the one and only Ken Chaney on piano. One of the by-products of

working with those guys in 1964–65 is that I met a wonderful guitar player, Pete Cosey. Pete, who was related to Ken Chaney by way of a cousin's marriage, was a guitar player without parallel. As fate would have it, Gerald Sims, the guitar player in the Chess rhythm section, left, and I got Pete the gig. Pete and I became fast friends, as we spent a lot of time together working and hanging out. Our Chess working hours were from 1:00 p.m. to 5:00 p.m., Monday through Friday. After work and on weekends we did sessions all over Chicago. In those days Chicago was what Los Angeles would become in the 1970s, the hub of the recording studios business. There was RCA, where Curtis Mayfield later recorded *Super Fly*, and Universal Recording, at that time the most technically advanced independent recording studio in the country. They recorded the Platters, the Moonglows, James Brown, Quincy Jones and his orchestra, Gene Chandler, and many other stars. There were also places like Paul Serrano's, where I would later record the Emotions, and Columbia, where we worked with producer Carl Davis. Major Lance's hit "Monkey Time" and Jackie Wilson's classic "Higher and Higher" were both cut there. Tons of record labels, tons of studios—and the Chess rhythm section worked in just about all of them.

One of the reasons that the Chess rhythm section was often hired was that we saved producers money. Satterfield, Pete, and I were tight as hell. Record companies knew we could get the proper groove quickly. As good as we were in those early days, my reading of music wasn't up to Satterfield or Cosey's. One of the things I would do was listen to a demo of the song and take a loooonnnng time setting up my drums—anything to buy time, so I could learn all the hits and punctuation of the song before I sat down to play. But this trick of mine got exhausting. I had to get my reading chops together.

I enrolled at the Chicago Conservatory of Music. The first day, I introduced myself to my instructor, Jim Slaughter.

"How good are your rudiments?" he asked.

"I'll show you," I confidently replied.

I sat down at the drum set and played many different rudiments on the snare drum. I played the double paradiddle, the flam accent, and the double stroke roll. I quietly laid the sticks down, believing I had knocked his socks off.

"Mmm, that's pretty good. Let me show you something." Jim sat down, took a deep breath, and went through maybe ten different drum rudiments. He played them on the cymbals, on the snare, and on the tom-toms—mixing them up, adding his own flavor, all the while keeping a four-on-the-floor bass drum beat. It was amazing. He stopped. Silence. My mouth was wide open. I was stunned by his technique.

"You'll be that good in six months," he announced.

I was, and I continued to study with him for a year. During my time at the conservatory, I was still working at a feverish pace. The rhythm section did a lot of sessions for Carl Davis at Okeh Records. We used to play for Walter Jackson, the Artistics, Major Lance, and a bunch of unknown groups. However, I never got the feeling that Carl Davis liked me. I think he was more into Al Duncan, a great drummer who played on all the Impressions stuff. Before I enrolled at the conservatory and got my sight-reading tight, I did my little trick of listening while the demo was playing to learn the song. I missed some of the cues on one session, and that pissed Carl off because we were on the clock. The whole point of hiring us as a rhythm section was to get us in and out of the studio as fast as humanly possible.

On the upside, there was Johnny Pate. Pate was a great arranger/producer whom I loved working with. He gave me a lot of freedom to play out; in fact, he encouraged it. He would come to my music stand, turn my music sheet over to the blank side, and say, "Just play, kid, just play." Other times I would come to his session and he would write over the sheet music in big letters: "PLAY!" I understand why Curtis Mayfield loved to work with him. Curtis was all about individual expression. Johnny Pate knew all the orchestral "correct" things to do, but he would often break the rules, which turned Curtis on tremendously.

I met Curtis Mayfield on a rainy Sunday afternoon in 1965. He was walking into Johnny Pate's studio as I was walking out. Sweetest man ever. In the years and decades that would follow, I tried to express to him over and over again what the Impressions' music meant to me. I often told him how his music injected into me the power of consciousness-raising through song. "Keep on Pushing," "People Get Ready," and "Check Out Your Mind"—it was music that lifted black folks up instead of tearing them down. Curtis's songs were spiritually and politically engaging, all wrapped up in three minutes and thirty seconds. They were like gentle short sermons.

One day in late August of 1965, I went to work like on any other day. Near quitting time, Billy called up a little Carl Smith/Raynard Miner ditty, "Rescue Me," sung by the talented young Fontella Bass. Fontella had a crisp voice that really cut through the music, and she was an outstanding piano player.

During the session Raynard and Carl were very specific about what they wanted—a Motown swing feel with big drum fills and a loud backbeat. I counted the song off, and by the second verse, the smiles on all of our faces showed that we had something special. We did two takes. When we finished, the room was silent. You could've heard a rat licking ice!

"Rescue Me" turned out to be a big-ass smash for Chess, one of the biggest hits in Chess Records' history. After the rhythm section had our names on that hit, we were wanted *everywhere*.

As important as "Rescue Me" was to my career, another musical association would greatly influence me as a drummer, producer, and performer. Billy Stewart was a young singer who was a performer unequaled by anyone. He could drive audiences crazy. Discovered by Bo Diddley, he already had one hit under his belt. Billy, a lovable guy, at first didn't have much faith in the studio band versus his own, but through Billy Davis's prodding and our musical abilities as a band, we won him over. Billy was a huge dude, I mean huge—maybe three or four hundred pounds—but that did not get in the way of him being a grace-

ful and agile performer. He could do microphone stand tricks where he threw the stand down to the floor at just the perfect angle so that it would bounce right back into his hand, a trick Joe Tex and James Brown would master. He could spin around and stop on a dime. A lot of people take credit for it, but Billy Stewart alone came up with that R&B stutter vocal lick. You hear imitations of it from Chairmen of the Board's "Give Me Just a Little More Time" to Michael Jackson's vamp in "Remember the Time." Billy had a beautiful high voice with a distinct style and supreme control over his gift. I played on two of his biggest hits, "I Do Love You" and "Sittin' in the Park." Both of those songs, especially "Sittin'," have big drum fills, which came from Billy standing in the middle of our rhythm section and pseudo-directing me. I was more than willing to accommodate him. He would lean forward like he was going to tip over. I don't know how he could be so large and yet so nimble. He was like one of those boxing toys that has sand in the bottom, so when you push it over, it quickly pops back upright. Billy Stewart taught me how to pull the best out of a rhythm section by just standing there, half directing, half dancing.

The biggest-selling and most important album of Billy Stewart's career was a collection of standards, *Unbelievable*, backed by the big-band arrangements of Phil Wright. The musical setting, with all of those horns, made the whole album spectacular and authentically pure. Nothing had really been done like that before, combining the contemporary R&B sound of the day with the great American songbook. We recorded "My Funny Valentine," "A Foggy Day in London Town," "Secret Love," and "Almost Like Being in Love." Stewart's cover of the Gershwin classic "Summertime" was a defining moment in his career, becoming his biggest hit. A little more than four years later he died in a car accident.

Our rhythm section had achieved the unique status of being able to play both jazz and soul. Back in those days there was kind of a divide in the music scene between what we call jazz

and blues and rhythm and blues. The jazz cats couldn't necessarily play rhythm and blues: they couldn't simplify their musicality enough. The rhythm and blues cats knew how to simplify to get that jerk or snap in the groove, but they didn't have the sophistication or training to handle free-form jazz. We had the jazz chops, and we had our ears tuned to the radio hits of the day. When it came to merging the two, we had no problem. We were starting to make real good dough, doing lots of commercials and outside gigs. Louis Satterfield bought himself a big black Mercedes. We used to kid him that he had the only Benz in the ghetto. Nobody would mess with his car, either, which was abnormal. He lived down on Thirty-Ninth Street, where cars were stolen like the wind coming off the lake. As a matter of fact, in my neighborhood, stuff was stolen out of apartments like it was nothing. Many people would come home, and everything—I mean everything—would be gone, the apartment completely cleaned out, like somebody had moved.

The burglaries were enough reason to make me move from Van Buren Street on the West Side to a much bigger, nicer place on Cornell Street on the South Side. It was a beautiful neighborhood. The new apartment had a vestibule, wood floors, and a wide, gorgeous view of the city. The numerous paychecks and new girls started to ease the insecurity that I had brought with me from my days of hand-me-downs and no money in Memphis. I was buying better clothes and spending more time with the mirror, grooming. Up to that point I had been gracefully insolvent all my life. I was reminded of that upon waking up the first morning in my new place. It was not an "I'll never be poor again" platitude, but a realization that through consistent work I could have a better and more comfortable life.

The first time I witnessed my baby brother Fred expressing an interest in music was on a visit to Mother Dear's, not long after I joined Chess Records. Mother Dear was in the kitchen, preparing food. Fred, around eight years old, was planted on the floor,

tapping some kind of plastic toy to the rhythm of a record on the radio. He was keeping good time. His tapping wasn't straight time either, it was syncopated. On my next visit I gave him a pair of drumsticks just as a toy.

That winter I picked Fred up and took him over to my new place. I was proud of my apartment. I kept it neat and organized, and wanted to show off a bit to baby brother. Fred walked in with a little awe on his face. "Wow," he said. At first I thought he was talking about the oversize mirror that hung in the vestibule, but when I turned around to look at him, he was transfixed on my little A-frame practice pad with two drumsticks sticking out of the top. He grabbed the sticks with all the vigor of a child and started playing. I just chuckled. I didn't give him any instructions, but it was evident that he was interested in the drums. A month or so later, Mother Dear called me.

"Sandy, looks like Fred wants to be like you," she said.

"The drum thing?" I responded.

"Yeah, he's tapping on everything. I just gotta keep him from beating on my living room furniture!"

Fred's interest in music drew Mother Dear and me closer. Simply discussing Fred's passion healed old wounds that we hadn't ever discussed.

Things were coming together for me swiftly. I wanted to share as much as I could with my family, just to make them aware that anyone can make it, no matter the obstacles. I looked at Fred as a part of me. I didn't want to push him into music or anything; I just wanted to show him love in the only way I knew how, which was through music. I brought 45s over to Mother Dear's, mostly test pressings of records that were cut at Chess. Verdine and the other kids played them on the stereo. I would watch Fred emulate his older brothers and sisters as they moved their heads to the beat.

After some time had elapsed, I could sense that Fred was indeed serious about the drums. One bright wintry Saturday morning, I picked him up and took him over to Drums Unlim-

ited. I introduced him to the owner, Bill, and told him this was my baby brother, and to hook him up with some lessons. Fred took to drums like a fish to water. He joined a drum corps in the neighborhood. I had developed a whole network of people in Chicago that could help him to get going musically. And boy, did he ever get going! Fred was a child prodigy as far as I was concerned.

5 The Ramsey Lewis Trio

We cannot work for others without working for ourselves.

—JEAN-JACQUES ROUSSEAU

Dick Marx was the king of the jingle business, creating songs for television and radio commercials. Chicago at that time was a hotbed for that industry because many of the advertising agencies were based there. Dick was a great arranger, pianist, and writer. He was also a salesman. Dick had thick, wavy black hair that he would slick neatly back. He kind of leaned in toward you when he talked, as if he was preparing to tell a secret. Often I would hear him talking to his clients: "It's going to be great, don't worry about a thing, people will be humming this one in their sleep." Dick was always saying reassuring, positive things to his clients. He complimented me, too, saying, "You play what is asked, and you're on time." I realized that there were stereotypes for the real good musicians—black and white. Because of their musical gifts, they felt they had license to be late and not listen to instruction. Dick's son Richard would become a big music star in the late 1980s.

I was quickly playing on commercials for soft drinks, cars, cigarettes, supermarkets, airlines, and a lot of Folger's Coffee. Until I worked with Dick, I never knew you could make a living doing just that. The advertising world was lucrative, providing another steady income stream for me. I loved this no-nonsense approach to music. Dick's formula was simple and straightforward, with little room for experimentation. All I needed to do

was musically communicate the concept of the jingle. It was a well-established road to financial success, and Dick Marx's execution was flawless. He knew how to grab someone's attention with a jingle. He also cared about his business reputation and was highly organized.

Ramsey Lewis demonstrated similar traits. He would be in and out of the Chess building frequently, and it seemed everyone treated him with respect, including the often caustic Chess brothers. Ramsey radiated class, character, and substance.

The Ramsey Lewis Trio song "The 'In' Crowd" was wildly successful. What was strange about its phenomenal success was that here was a cat playing jazz, and racking up million-selling singles. His trio was on the cover of *Cashbox* magazine in the first week of October 1965. The following year he won his first Grammy. Being my usual inquisitive self, I started asking him questions about how publishing companies work, how booking agents work, and what it was like to keep a group together. We had a natural, smooth rapport, my usual quietness overridden by my desire to pick his brain. Ramsey willingly answered my questions; he was always interested in expressing the ways he thought black folks should carry themselves. He believed in speaking intelligently, being dignified, respectful, and yet strong. He didn't just talk the talk, he walked the walk.

Meanwhile, in late 1965 and early 1966, I had quite a reputation going. I was the go-to drummer around town. Ramsey started popping into recording sessions that I was doing. He'd sit for a few minutes and then leave. After repeating this pattern several times, Ramsey asked me if I would do a gig with him in two weeks. I learned that his longtime bassist, Eldee Young, and drummer, Redd Holt, had left to form their own group, the Young-Holt Trio. I became Redd's replacement.

Ramsey and I traveled to Indiana State University, where the 10,000-person crowd was the largest audience I had ever been in front of. My heart was beating rapidly, and my skin tingled. I was nervous as hell. I had never heard my drums amplified

through such a big PA system. The sheer power of my drums was enormous. It was overwhelming, but the gig was a rousing success.

Back in Chicago, Ramsey called and asked me to stop by his office.

"Maurice, I want you to officially join my trio."

"If the price is right, sure, I'll join."

I was probably cockier than Ramsey deserved, but when it came to negotiating for my salary, I knew I was in a good position. I had several income streams—my Chess salary, commercials, and working for just about every studio and record label in town. Since I didn't need the money, I aimed high, asking for what I thought was a pretty hefty fee. Ramsey didn't even flinch, quickly saying OK.

I was leaving Chess Records at its peak. Leonard and Phil were preparing to expand their empire. They would soon buy an eight-story, 172,000-square-foot building at 320 East Twenty-First Street. They had it all, and now they were going to have it all under one roof—pressing plant, musicians, arrangers and producers, promotion and salespeople, radio station and record company. Of course, with my success, I felt that I had contributed in a tiny way to this expansion and should benefit. But the reality is that Phil and Leonard owned Chess Records. They started and nurtured it. It was their dream, and now it was their expansion. I knew that unless I became a songwriter or producer at Chess, I could never tap into the lucrative publishing world and grow financially. At least with Ramsey I would have one large salary, travel the world, and most of all play jazz, leaving R&B and pop behind for good. I believed that playing jazz, my first love, was my rainbow's end.

I rushed over to tell Mother Dear, and she was floored. "What? The Ramsey Lewis Trio? How did you ever manage that?" Mother Dear always seemed shocked when I played on a hit record or worked with this or that recording star. I knew she believed in me—I just think she underestimated my drive,

my hustle. We were still like brother and sister, not mother and son—she was forty-two and I was twenty-five.

"You move so far, so fast," she said, a vexed look on her face.

"It doesn't seem fast to me."

"You are something else."

The dynamics of my relationship with Mother Dear informed my life's aspirations. I wanted to show her I could excel and that I was worthy of achievement and recognition. I wanted to prove to her that Dad was wrong when he said, "It's OK, Edna, he'll be back in six months." I was never moving back to live with them. That was for sure.

Getting the Ramsey gig was certainly an example of being in the right place at the right time. My talent was also a factor. Some of my contemporaries said listening to me perform live was like listening to the weather. I could be a thunderstorm of sound or a dark moody cloud or even sunshine. I had major chops and was eager to let them shine. But to fail to acknowledge the grace, the blessing, of getting the gig with Ramsey would be spiritually counterfeit. I knew for sure it was a gift from the Almighty, the universe pushing forward the deep desires of my heart.

In preparation for my new life with the Ramsey Lewis Trio, one of the first things I did was buy a lot of suits. In the 1960s, if you were black in Chicago, you had to be clean, wear nice clothes, and be well groomed to be credible on a business level. Ramsey took it to the extreme. He had manicured nails and a collection of swanky cuff links, linen shirts, and mohair suits. His tapered pants were immaculately pressed, with perfect creases. He had several different tuxedos, including white dinner jackets. To me he was a fashion icon. He believed in putting the right face out to the public, and as a member of his band, I fell in line.

We played small clubs, big clubs, 1,000-seat and 15,000-seat spots. We also performed at black colleges and white colleges in just about every part of the globe. I quickly understood how he could pay me what he did and not flinch. He sold a ton of tickets.

Those first six months of touring were a major life adjust-

ment. Mama had prepared me well, though: I packed my clothes with precision, everything in its place. If Chess Records was college, the Ramsey Lewis Trio was my PhD. Ramsey had the big-time lawyer, the big offices in downtown Chicago, and his own production company.

I learned everything from Ramsey, from the mundane to the complex. On the basic front, I learned that it was necessary to have one person responsible for making travel arrangements. In terms of critical information, I learned more rules: If at all possible, get the money in advance! Have extras of anything and everything possible. Know the music stores in each city, just in case you need one. Next to the performance itself, sound and lighting checks were the most important part of our day. This was the first time I saw wide tape on the stage floor, marking where to stand so that the lights would hit you perfectly—and those lights could truly enhance your performance. Ramsey even taught me how to eat: have your large meal early in the day.

While very confident in my playing, I was still uncomfortable and shy in front of audiences. These were not the little clubs and juke joints of Memphis. They were classy venues from Los Angeles to London, university concert halls with big stages and upscale crowds. We even performed at Carnegie Hall in New York City. To a musician, Carnegie Hall sounds like Christmas Day to a kid. It is the top of the world. On this night I found a hidden spot and watched the people flood in. The men wore tuxes. The women glowed in low-cut gowns. My eyes and mouth were open wide in astonishment.

With his tall frame, Ramsey was a natural in the spotlight, strolling out onstage like a king, clean as the board of health. His cuff links glistened, reflecting the stage lights back into the audience. He displayed the perfect combination of cool, classy confidence. He was a man in full. He talked to the Carnegie Hall audience effortlessly, as if he were talking to people in his living room. This was the showbiz lesson of showbiz lessons.

I, on the other hand, continued to avoid the spotlight like

the plague. I raised my cymbals just high enough so that no one could see my face unless they had exactly the right seat. Even with his original trio, Ramsey had a custom that at the end of a set, all three of us would stand up and bow. I would kind of half stand up and half bow.

Whatever stage persona I lacked, I made up with my playing. Cleveland Eaton and I became a rhythm machine. Cleveland was a rhythmically pushy bassist, and I was a fiery drummer, and that mixture was like gas and fire. We had a lot of fun. It was gratifying because I was fully aware of what a blessing this was. I knew that as a musician you often had to play music that you didn't want to play to earn a living. But Ramsey, Cleveland, and I actually enjoyed these songs. This wasn't the music of mediocrity.

In breaks from what seemed like endless touring, we were continually in the studio. In that day, a jazz artist who sold as many records as Ramsey would record two, three, maybe even four albums a year. The first album we recorded as the new trio in June of 1966 was *Wade in the Water*. The album was successful, but the title-track single was a monster hit—a gold record.

Walking into Ramsey's house one day for rehearsal, I noticed a pile of books on the floor by the door that he was giving away. "Take what you want, Reece," he said. I went through them and found *The Autobiography of Malcolm X*. I took it home and read it and read it again, and I still couldn't put it down. I felt like Malcolm X was talking directly to me. I was stunned as he described the pig as the dirtiest animal around. Malcolm rejected the African American tradition of eating lots of pork. The book made me realize that taking care of myself was the ultimate sign of self-respect and self-love. I gave up pork and started eating more fish. In addition, I could feel through Malcolm's articulate and honest words his passion for spiritual transformation. His words made me ponder the courage it took to change deeply held beliefs. He made me question the Christianity that Mama had raised me with. I wasn't interested in becoming a Black Muslim,

as Malcolm X had, but the story of his awakening started my own search for a philosophy that would work for me.

Perplexity is the beginning of knowledge.

—KAHLIL GIBRAN, *THE VOICE OF THE MASTER*

The Autobiography of Malcolm X encouraged me to spend a lot of time reading and praying while I was on the road. I was asking the Creator to teach me the things I needed to know in order to excel. *The Laws of Success* was still my bible, but I also started to buy as many books as I could about universal consciousness. Probably no one spoke to me more during that period than Kahlil Gibran. Born in 1883, Gibran—known for his best-selling book *The Prophet*—is one of the world's most celebrated writers. Gibran was the mystic I had been longing for. Reading his work excited me, gave me energy. It was as if he was saying exactly what I wanted—or needed—to hear. He fully embraced Western and Eastern spiritual philosophies and rigorously questioned what organized religion was putting out there. It was a time of unprecedented spiritual growth for me.

At the same time I discovered astrology, which I believe reveals man to himself. I think a lot of people misunderstand astrology. As long as you don't start worshipping the creation over the Creator, it's a cool science to help understand how personalities work together. It certainly helped me understand my strengths and weaknesses.

By late 1966 I was adjusted to the touring life—planes, hotels, women, and eating right. I had embraced the most important words for a musician: "moderation in all things." Diet became a big thing to me. I started drinking kefir, a fermented milk. This was decades before the whole probiotics movement. I said good-bye to red meat. I started eating a lot of tofu, and I always carried fresh fruit. I started drinking carrot and beet juice whenever I could find it. I was deep into Jethro Kloss's classic book *Back to Eden*, which became my guide on holistic health.

Meanwhile, in addition to *Wade in the Water*, we recorded three additional albums: *The Movie Album*, *The Groover*, and *Hang On Sloopy*. The single "Hang On Sloopy," a cover of a hit by the rock group the McCoys, was yet another million-seller single for the Ramsey Lewis Trio. Ramsey was such a big artist that most of his fans were not jazz fans. He was like a pop artist in his own unique way. His popularity bestowed upon me a certain prestige in the music world.

The good money afforded me a brand-new burgundy Buick Rivera, for which I paid cash. Loved that car! It was curvy and sexy and ran as fine as wine. I use to love driving it around the South Shore with the windows down and the heat on. I also bought an upright bass from my pal from the Quartet 4, Bill Terry. I gave it to Verdine, who took to it right away.

I was drawn to people who were searching for enlightenment. I didn't like conventionality. The Afro-Arts Theater on the South Side was a hip place of non-conformity, filled with Afrocentric thinkers teaching yoga, music, and everything else artistic. The theater was a hub of "new thought" and a new kind of consciousness, which was being born in centers like that all over America. It was not a militant black power thing, but a place of black awareness, teaching us to fall in love with our culture, giving us an understanding of our rightful place on the planet and of ourselves. It was more than dashikis and Afros. It was spiritual, not religious. I met the poet/playwright/singer Oscar Brown Jr. and poet Gwendolyn Brooks.

One day I saw Phil Cohran, who was kind of the director of the center, playing what he called a frankiphone. It was actually a kalimba, a little wooden box carved hollow, with a sound hole in it like a guitar, and metal strips attached to it that are plucked with the thumbs (it's sometimes called an African thumb piano). I instantly fell head over heels in love with the sound of the kalimba. Its percussive and melodic tone just spoke to me. Its primitive yet futuristic sound gave different textures to all of the rhythms that I heard. Its African origins appealed to me as

well. I found one at Drums Unlimited downtown and started to practice on it religiously.

Saw it in a store one day.
Thought it might make me play
Future music all for you

Seen me through my hardest times
Thought it was 'bout time
To open up a new world just for you

Fills all my needs, gave me the key
Door was open for me to see
Playin' around the world
Touchin' all the boys and girls
With a new love to make them free

Kalimba, oh kalimba, play me a tune
Kalimba, oh kalimba, I'm glad I found you
Kalimba, oh kalimba, play me a tune
Kalimba, oh kalimba, sends a message to you
—"KALIMBA STORY," OPEN OUR EYES, 1974

One cold day I brought the kalimba into rehearsal. I was messing around with it, and Ramsey said, "We've got to use that in our show, it's perfect!" Ramsey was my boss. I had to do what he wanted. However, I still didn't want to do it, but I didn't argue with him. I had gotten too comfortable with my crutch—my shyness. Deep down, I didn't want to draw attention to myself, and playing the kalimba would put me in the spotlight. Ramsey was constantly trying to bring me out of my shell. That first night we stopped the music, and I put my drumsticks down, stood up, and picked up the kalimba, I played my ass off. I just killed it! It was an immediate hit with our audiences. They ate it up, but Ramsey was not satisfied.

"Reece, you've got to take a bow and a full bow after your solo," he said.

"Man, the audience doesn't care. They like it just as it is," I replied.

Ramsey looked at me in the most bewildered way. He was saying with his eyes, What in the world is wrong with you? "OK, Reece," he said, and walked away. Rams was patient with me, but he was pissed and wouldn't let it go. At the very next gig he had the sound guy put a microphone center stage. As we were walking out of the dressing room, Ramsey said, "Reece, that mic stand is for your kalimba solo. Just get up from your drum set, walk to center stage, adjust the mic, and play."

"But—" I said.

"Reece, trust me, you can do this."

"I don't know, but—"

He interrupted again, "This is good for the show."

Like a parent who knows what is best for his rebellious teenager, Ramsey knew what was best for me. That night I walked to the microphone and proceeded to play. The crowd went berserk. I was almost in shock. After doing this four or five times, I started to strut out to the microphone.

Ramsey didn't only help me with my shyness; he also made a cultural statement by showcasing the kalimba, which, as a primitive African instrument, gave a wink and a nod to the growing Afrocentrism in major American cities in 1966 and '67.

On the television, we saw riots breaking out all over America. In places as diverse as San Francisco; Winston-Salem, North Carolina; Buffalo, New York; and so many others, violent conflicts revolved around black folks' confrontations with police. Detroit would have a riot that lasted five long, hot days. Even ensconced in the Playboy Club–type world of the Ramsey Lewis Trio, I was not immune to the racial tensions.

One night after a gig in Indianapolis, Cleveland Eaton and I went down to the hotel lounge to chill. The area was filled with traveling businessmen in their Botany 500 suits and spit-

shined Florsheim shoes. I remember a lively night, surrounded by lots of cigarette smoke and waitresses in low-cut red outfits serving up drinks. There were these two well-endowed, and I do mean well-endowed, white girls working in the lounge. They had a little music/cabaret act. We invited them up to our room. We weren't doing anything, but the house detective knocked on the door. "Open up!" they shouted. I opened the door, and they pushed into the room.

"You're under arrest, boys," one of them said.

"For what?" I protested.

"For being in the bedroom with someone of the opposite sex."

"What in the hell are you talking about?"

With a smugness I have not forgotten, he said, "It's an old law, but it's still the law."

They arrested us black men for being with white women, some trumped-up charge from an antiquated law. In the police car Cleve didn't say very much, but I kept on talking back. "This is some bullshit and you know it!"

Once we got to the police station, pointing at me, the cop said, "Look out for that little one. He thinks he's bad. Thinks he's so tough." But I kept on talking back.

In reality, I was scared as hell.

It was Cleveland's quiet patience that calmed me down. Since this was late Saturday night—the weekend—we had to wait in jail until Monday before we could see the judge. That really scared me. I started to think about all those guys like the Scottsboro Boys and Emmett Till who got screwed over or killed due to the deep fear among whites of the idea of a black man raping or even flirting with a white woman. If those girls lied, we could be in a heap of trouble. Talk about miracles: all we had to do was pay a fine. Still, the experience made me uneasy, particularly since the Ramsey band was supposed to be straitlaced, and getting arrested didn't jive with that. After that incident, I was way more careful about the race of the woman I was with, depending on the city I was in.

For about seven years, my sole goal was to be the best drummer in the world. I had top role models—Joe Dukes, Art Blakey, Roy Haynes, and Philly Joe Jones. Elvin Jones and Max Roach were the absolute last word, and my greatest influences. In the mid-1960s Miles Davis got a new drummer who literally changed what it meant to be a great jazz drummer. Tony Williams was possibly the best jazz drummer of his generation, and he left an amazing impression on me. Like Joe Dukes, Tony played the skins "melodically," but he took it to a whole new level. He played freely, floating the time yet still keeping it all together. He would be playing in 4/4 and jump out into 5/8 and back into 4/4 without skipping a beat. I was completely inspired by Tony, and began to borrow as many things as I could from him.

But Ramsey wasn't into that. His style was more of an Oscar Peterson thing, which is not a bad place to be, but I was playing floating drums and messing with the time. This would throw Ramsey off, and he wasn't satisfied with that. Ramsey wanted me to play within the structure. I adjusted to avoid getting fired. However, I gradually discovered that I could still have the best of both worlds. I could try new things as long as my playing didn't become obtuse in any way. Ramsey again was patient with me, allowing me to jam through my restlessness.

In 1967, right about the time Muhammad Ali made his public announcement that "I ain't got no quarrel with the Viet Cong," Ramsey got really sick and took six or eight weeks off. This abrupt hiatus was a gentle reminder that I couldn't stay still. I had to keep it moving. During this downtime, I created Hummit Productions. I had a real good thing going with Ramsey, but I was always longing for something to call my own, an entity that was viable apart from Ramsey. Renting some office space at 1321 Michigan Avenue, on the seventh floor, I put together a team that could share the space and cost with me.

We called it Five Men. It was ours. The art director of *Ebony* magazine, Herb Temple, was part of this group. I ran into Wade Flemons, who a few years earlier had written the Dells' big hit

"Stay in My Corner." He joined me in the venture. Soon there-after, Don Whitehead joined too. "Head," as we called him, played bass in a blues band in my early days in Chicago, even before Chess Records. We had a photographer's studio, a mini recording studio, an art studio, and a huge rehearsal room in the back.

My aim was that this office/studio would be the launching pad for something creative and lucrative. I wanted us to write songs for other artists. I wanted to do commercials, like Dick Marx. We didn't get too much happening, but a few things came my way. I got a beer commercial, but breaking into Chicago's TV/radio commercial world was tough. Certainly some racism was in play. In retrospect, I probably should have hired someone white solely to beat the pavement to all the advertising agencies on Michigan Avenue. Someone like that fronting this venture might have gotten us more gigs.

Ben Branch, an old friend from Memphis, had moved up to Chicago. Ben was about twenty years older than me. From the time I was a little boy, he'd played at all the proms and at events on local radio. Ben was a captivating saxophone player and a strong bandleader who always seemed to turn up in the baddest bands in Memphis. Upon arriving in Chicago, Ben looked me up. We became well acquainted because, along with Pete Cosey, we formed a group together, the Down Homers. I was on drums, Satterfield on bass, Cosey on guitar, Burgess Gardner on trumpet, and Ben on sax.

By this time, Ben had become the bandleader for Operation Breadbasket Orchestra and Choir. Operation Breadbasket was formed by the Southern Christian Leadership Conference, or SCLC, and run in Chicago by Jesse Jackson. SCLC believed in collective non-violent action. They boycotted businesses where they felt blacks were not getting a fair shake in terms of jobs or respect. They were about uplifting black folks through economic empowerment. Blacks were telling America: If you're the moral country you say you are, put up or shut up. It was all

about blacks being able to freely integrate into the mainstream of American life.

While Ramsey was still recuperating, I got a call from Ben. "Maurice, it's Ben. Cosey told me you were in town."

"Yeah, Rams is taking some time off."

"I need a favor."

"What's going on?"

"My drummer flaked on me. Can you come rehearse on Saturday and play on Sunday?"

"Sure."

I played with Operation Breadbasket Orchestra and Choir for a month and a half, and after that any time I was off from Ramsey. The sermons I heard on those Sunday mornings were all about social responsibility being a part of the teaching of Jesus. Through that experience I had the opportunity to shake Dr. King's hand, a moment I will never forget and will always cherish. Ben Branch is remembered historically as the last person to speak to Martin Luther King before his assassination on that fateful day in Memphis on April 4, 1968.

Ben was a great sax player, but he was an even better bandleader—or, better yet, just a leader. He was funny, charming, and gracious and knew how to speak in a way that would awaken a vision in others. Through his example I learned that leadership is about the ability to motivate, not about position.

Ramsey eventually got better, and we recorded and released two more albums in 1967, *Dancing in the Street* and *Up Pops Ramsey*. All this happened despite a hectic touring schedule in America and Europe.

"Sandy, we got to get outta here," Mother Dear bluntly started a phone conversation in the fall of 1967.

Life for the family in the Henry Horner projects had become perilous. The building was in disrepair, damaged by vandalism and plagued by rat and cockroach infestations. In addition, Mother Dear and Dad were distressed by the culture of violence

that was starting to take root. Blacks were terrorizing each other for the sake of the drug trade or other vices.

I told Dad to pick out the place he wanted, and I would make the down payment and cosign for the loan. Dad made decent money, but it all went into the household. He definitely could not get his hands on $6,000 cash (around $43,000 today), but a few thousand dollars went a long way back then. In December of 1967 Dad moved the family into 6845 South Chappell Avenue, a nice two-story, five-bedroom house with a formal living and dining room and basement, in a community called South Shore.

It felt good to be in a financial position to make that down payment, and to see Mother Dear and Dad start a new era in their life. It felt good to see the kids running around and enjoying the house. I loved having money, and this experience made me want more of it. My elation reminded me of the bike Dad had given me. I had never thanked him for sending me that bike all those years ago. I had never told him what it meant to me, not only materially but also psychologically. Since I wasn't good at expressing my emotions outside of music, I think subconsciously helping with the purchasing of house was my way of saying thank you. It was for his family. I felt a sense of manhood, a sense of pride.

I studied, prayed, and meditated more during that period than ever before in my life. I took my books wherever we traveled, always packing them neatly at the top of my suitcase. Whenever possible, I retreated into my own personal ashram. Following the instruction given in Napoleon Hill's *The Laws of Success*, on Sunday, December 17, 1967, I committed to paper my definite chief aim. Committing an idea to paper would give it an intrinsic power, I felt; it would carve it in stone for me. I addressed what I wanted to do with my life—my commitment to myself and, more importantly, to the universe.

This kind of visioning is the closest thing a man can ever get to giving birth. Those years of gestation were necessary in order for me to ultimately form Earth, Wind & Fire. I started to keep

to myself pretty much. I didn't do things just because someone else was doing them. I was an independent thinker, with my own vision. I had a plan and knew where I was going.

Not long after this, Ramsey took the group on what would be the first of two trips to Asia. I walked out the airplane door, and bam! The most dense smog I had ever seen. It hung over Tokyo like a blanket. I was shocked to see so many people crammed into such small areas. Moving from city to city, I discovered how beautiful the people were. It also blew me away that they loved Ramsey's music. To see people who didn't speak my language jump to their feet behind my beat demonstrated how music transcended culture. As I banged on those drums, I saw the music incite crying and shouting. Music was the fundamental bridge between people. Almost no other shared experience could come close.

I liked the Asian way of life, of minimalism and order. Less is more. Less materialism. More open space. Less chatter. More calm. I also studied Buddhism a bit, and got a much bigger taste of it on my second trip. I found that Buddhism connected to many of the Christian tenets I had learned as a little boy at Rose Hill Baptist Church: that love can overcome hatred; that giving is better than receiving; and that I should not judge others. It made me see Christ and Buddha as divine brothers. The notion that to cling to anything is to suffer also resonated with me. I found that way of thinking—not clinging to the past, not clinging to the future, but living in the eternal now—liberating.

Studying Buddhism led me to look at even more esoteric religions, such as Tantra, Christian mysticism, astrology, Taoism, and the like. At the time it was as much about historical research as about spirituality; I wanted to learn as much as I could. I also started to look at the esoteric meanings of events in my life and in the world. I learned to follow my instincts as a reflection of my faith and devotion to myself, to the God within me, and to the world around me.

My intuition was telling me not to fall victim to the tried and

true traps of rock and roll, especially alcoholism and drugs, which were prevalent in the industry. Alcoholics were always around in Memphis, and many of the artists at Chess Records had alcohol issues. I knew about how Charlie Parker, Billie Holiday, and even Coltrane had chased the heroin dragon. Seeing some of the baddest cats I knew in the Chicago music world starting to get into heroin just blew my mind, and I had to cut them loose. Little Frankie Lymon, of Frankie Lymon and the Teenagers, was a precious sweet kid in the eyes of America. His hit "Why Do Fools Fall in Love" and his many appearances on early television made him a household name. When he died from a heroin overdose in Harlem in February 1968, it shook the music world and America something bad. His shocking death only confirmed what I already knew. Drugs will turn your life upside down.

It's a crying shame that in the music world there is so much romantic glorification of drugs. It's cool, it will free your mind to expanded creativity—it's all rhetoric. I wasn't the biggest square in the world. I tried pot, but it made me feel like I had a blanket over my head.

Drugs were on the stage, in the audience, and throughout society as a whole. The Chicago drug world of 1968 was symbolic to me. It seemed that the entire country was in upheaval. Bobby Kennedy was assassinated. Vietnam was on America's television every night. Richard Nixon was elected. And Dr. Martin Luther King Jr. was shot in my hometown of Memphis. The country was enraged. Riots broke out.

"A riot is the language of the unheard," as Dr. King put it.

Later that year, James Brown came out with "Say It Loud—I'm Black and I'm Proud." His anthem was so necessary. He was telling people that being black is nothing to be ashamed of, that they should stand up, be empowered, and love themselves.

Amid all of the chaos, Sly and the Family Stone burst onto the scene with the hit single "Dance to the Music," and music changed. I changed. Sly freed me up. I was emancipated by the way he completely abandoned any adherence to the status quo

of musical expression. It was permission to explore and discover anything I damn well pleased. Sly gave me the courage to put my own set of peculiar ideas out there, and put them out there with boldness.

Just before I discovered Sly and the Family Stone, it was as though I had an incomplete blueprint on how to become a great musician. His big sound, his offbeat nature, and his simple, uplifting messages launched a new movement in pop music. The music world of the late 1960s and early '70s can be largely described as before and after Sly. Sly and the Family Stone came with a whole new bag. The racially and gender-integrated band just blew apart how the world saw the African American artist. Even singing groups couldn't get away with conked hair and Botany 500 suits anymore. The Temptations' hit record "Cloud Nine" was in direct response to the Sly Stone phenomenon. The Tempts went from uniformed suits to psychedelic outfits. Everybody did.

I had great respect for Sly's concept. His message of self-empowerment wasn't limited to African Americans—it was for everybody. When Sly first hit, black folks really weren't into him. I think the psychedelic sound, the psychedelic imagery, and the interracial nature of the group took time for blacks to accept. I don't think it's a stretch to say that the integration dreams of the late Dr. King were expressed in some of Sly Stone's songs, and in the group itself.

All of the bands that came into prominence in the early 1970s, including Earth, Wind & Fire, are indebted to Sly. There would be no Mandrill, Kool & the Gang, Ohio Players, War, Commodores, New Birth, or later even Prince without Sly Stone.

In the late 1960s I sought out Mr. Black, the top astrologer in the Chicago area, who was known far and wide. Folks flew from all over the Midwest and East to get his counsel. I wanted a deeper understanding of the planetary positions of my chart. In my studies up to that point, I had found astrology to be true. I saw it

as a science, something that I needed to study to receive any benefits. I believe we are affected by the awesome universal energy of the moon, planets, and stars. Walking in to meet Mr. Black, I was excited. I was taken aback by how unassuming he looked. He was short, with bushy gray hair and bright eyes. He had the presence of an old, wise man who was comfortable in his own skin.

He put out his hand, and in a high, clear voice said, "Sit, son." Putting on his thick-framed tortoiseshell glasses and picking up a yellow pad, he asked, "Where you born?"

"Memphis, Tennessee," I said.

"What day?"

"December 19, 1941."

"What time of day?"

"Eight a.m."

He reached down to the floor for three books, which he placed on his lap. One of the books was so tattered and weathered, it looked as old as the Bible. He got to work. I sat mostly silent, occasionally getting up to look at the various books on his shelf. Roughly an hour later, he said, "Whoa, son, you have no water in your chart, only fire, air, and earth signs. That's a very odd occurrence. I've only seen a few of those."

"Well, what does that mean?" I said.

"It usually means a pronounced lack of emotion."

"Mmmm."

"But, son, this chart is to show you your natural tendencies—to be aware of them. What you do with the information will determine your life."

I thanked him and took the completed chart. I packed it away with my books and went back on the road with Ramsey. The discovery that I had no water in my chart had added another piece to my puzzle. Water is the emotion of the stars, and I knew that I could cut myself off emotionally pretty easily. It's not a good trait. This is when I realized how I had been trying to compensate for my lack of emotion by having an emotional relationship with my music.

I would continue to study astrology—a lot. Not to obtain forecasts and all that stuff, but for its psychological insights. I also discovered that astrology was at the root of the ancient religions of Buddhism, Christianity, Judaism, Hinduism, Islam, and the Tao.

Later that year, Wade Flemons, Don Whitehead, and I had gathered several songs we had written. I had tried to interest a few artists in recording them, but with no luck. Believing the songs were good, I thought we should just go and professionally cut them in a studio and hope for the best. I booked studio time at a great place, Audio Finishers Studios, a brownstone building on Ontario Street with great acoustics and great engineers. The guys who owned Audio Finishers had gotten their start at the legendary Universal Recording studio, where I did a ton of sessions.

I found an isolated part of the studio and silently prayed that things would go well. We cut five or six songs that day. Two of them were the instrumental "La La Time" and the song "Love Is Life," which I would later recut in Los Angeles with the original Earth, Wind & Fire.

We had a huge band. It was enhanced with a lot of horns, most of the same cast of characters that did horn dates in those days. But we still maintained that core: myself, Chuck Handy, Pete Cosey, Louis Satterfield, Wade Flemons, Don Whitehead, and Don Myrick. The great addition was the one and only Donny Hathaway.

Donny Hathaway had been in Chicago for a few years. It was either Curtis Mayfield or guitarist Phil Upchurch who introduced me to him. There wasn't a doubt in anyone's mind that Donny was everything an artist should be. He was the one person I knew for sure I wanted in the sessions, because he was creative, soulful, and sensitive. Donny played some of the keyboards and did all the vocal arrangements. It was his idea to hire the Dick Judson singers to sing with him. My baby brother Fred was there, and I put him on the tambourine. "La La Time" was

Fred's first released recording. A few years later, Donny Hathaway would ask Fred to become his drummer.

I decided to release "La La Time" under the group name the Salty Peppers. It got a little radio play in Chicago but stalled there. Fortunately, my pal Phil Wright, who had left Chess Records a few years earlier, landed on his feet at Capitol Records in Los Angeles. They picked the record up, and it branched out to be a little hit in the Midwest.

6 The World Can't Erase My Fantasy

There is something in every one of you that waits and listens for the sound of the genuine in yourself. It is the only true guide you will ever have. And if you cannot hear it, you will all of your life spend your days on the ends of strings that somebody else pulls.

—HOWARD THURMAN, "THE SOUND OF THE GENUINE"

A BACCALAUREATE ADDRESS

I started to become restless when I thought about Squash Campbell in Memphis, Billy Davis, Ben Branch, Vivian Carter's Vee-Jay Records, Booker T. & the MGs, and even Ramsey. Ramsey and Billy Davis were creative and successful. They were leaders. They were black men. These were all people who owned their own creative business endeavors. Spending those years with them planted a seed in my spirit that was starting to bloom. I knew that, like them, I wanted to have a musical situation that I could call my own. From the time I committed to paper my definite chief aim and after discovering Sly a desire started to grow in me. I wanted a band that could express how I felt about life, how I felt about God, how I felt about identity, and how I felt about love.

My subconscious manifested a series of vivid, color-filled dreams. In these dreams I had a band of nine people, and we played all over the world. The audience was of mixed races and religions, like in Norman Rockwell's painting *Do Unto Others*. In my dreams some people had on turbans, some looked liked nuns, some looked as if they were from the present day while others

looked ancient. In that night bubble I felt this band would represent clean living and be a force for good—no drugs, no booze, a respect for self, and a respect for your brother. In various forms, I had these dreams on and off for months. But the more I dreamed them, the more clarity I received. I awoke one night in a hotel room in Charlotte, North Carolina, quickly picked up a pen, and started to sketch this fantasy band of nine people, following the mental picture in the dream. The picture consumed me. I was obsessed with it. When I got in my hotel room in whatever city I was in, I would pull it out and prop it up on the mirror. I was strung out on the idea of creating such a band. For hours I would fantasize about leading this band, which would provide a sense of encouragement, a sense of peace. The vision dictated everything I did in my social life, my spiritual life, my professional life, my financial life—everything.

For the first time, creating a band that represented universal truths was primary, and the music was secondary. I wanted to uplift humanity. To achieve it would take time, prayer, and God's grace. To find the right individuals who could bring this dream to life would be a challenge. But as *The Laws of Success* say, an unfailing positive mental attitude would be the vibration I would have to stay anchored to, no matter what.

Shortly after this realization, I decided to leave the Ramsey Lewis Trio. It was a tough decision. I was earning $65,000 with Ramsey and another $15,000 to $20,000 at Chess and other studios. It was not easy giving up that bread. Foolishly, I had not saved much money. In good faith, I first had to let Ramsey know. I was confident in my decision, but it was still tough to tell him. He was my boss, but he was also my friend.

"Ramsey, I'm going to form my own group."

"Mo, that's great. Good for you. When are you leaving?"

"In three or four months. I'll let you know."

"So what kind of jazz will you be focusing on?"

"Oh, no, I'm not forming a jazz group, not at all."

"Well, then, what in the world are you doing?"

"Man, it's going to be bad. We're going to play pop, Latin, R&B, rock and roll, jazz, and soul," I responded enthusiastically.

"Ah, Rooney, go home, take some aspirin. Lie down. Get some rest."

"Rams! I'm serious, man. And it's going to be theatrical, too. There'll be dancing, and eventually I want to do magic!"

Ramsey looked at me with a bewildered stare, the same look he gave me when I didn't want to go to center stage and play my kalimba solo. Like he didn't understand what in the world was going on in that head of mine.

Ramsey's reaction was typical of many of the people I told about the diverse group that I wanted to form. A steady gig for a musician is pure gold, and there was nobody bigger in the world of popular jazz than Ramsey. I never doubted that it was the right decision for me, but other folks, especially musicians, thought I had completely and totally lost my mind. They thought I was crazy and financially stupid for leaving the Ramsey Lewis Trio.

Pete Cosey, my good buddy and guitarist from Chess Records, was particularly harsh.

"Maurice, you're a G-d damn fool. Do you know how many cats would love to be in the Ramsey Lewis Trio? What in the hell are you doing? This is a colossal mistake!"

This was especially hard to take, coming from Pete. He was my boy. He was my road dog.

The only support I received was from Mother Dear. She said, "Go on, Sandy, it's going to be all right."

Nothing I heard astonished me more. She had grown to really believe in me, trust in my abilities and my judgment. I gave her a big, long hug, the tears welling up in my eyes. She heard my sniffle and held me tighter, like a mother should, like a mothering I'd never known. During our long embrace, I felt the full weight of our years apart—her summoning me to Chicago, me leaving her home in Chicago, her belief that the mean streets would eat me alive, and ultimately my turning out OK. Our rela-

tionship had come a long way, and in that moment, I could feel her love for me.

My last gig with the Ramsey Lewis Trio was in Los Angeles at the Hong Kong Bar in the Century Plaza Hotel. As fate would have it, David Porter was in town, promoting a record and attended the show. The next day we got together. We were walking down Sunset Boulevard, just west of Highland, talking and catching up. I told him I was leaving the trio to form a new band. I asked him what he thought about the name Earth, Wind & Fire.

"Well, that's different, man," he said. "But it's fresh, too."

"Thanks, man."

"What kind of music?"

"Soul, rock, jazz, Latin—everything."

"Whoa, it sounds like you've thought about this a lot."

"Man, it's been heavy on my mind."

As we continued to stroll down Sunset Boulevard, I laid it all out for David. I talked about the unity of God, spiritual mysticism, and how I believed we could write songs about all this stuff. I rambled on about how our live show was going to resemble theater, with props, magic, and acrobatics. David listened, chiming in with a yeah and an affirming nod here and there. I know I sounded crazy, but all David said was, "Man, I know you can do it." David not telling me I was foolish was validating. It was obvious that he had grown into a man who was pure soul—southern, gentlemanly, warm, brotherly, and creative. He showed a lot of gracious respect for my dreams that sunny day.

At the hotel, I said good-bye to Ramsey. Shaking his hand, I thanked him for the opportunity that he had given me, and the graciousness he'd shown me over the years. Even though I knew he doubted this vision I had, he had given this shy drummer from Memphis, Tennessee, a lot of tools to pull that vision off.

I flew back to Chicago alone, ready to make the move to California. As confident as I was that this was the right move for me, that flight seemed to be the longest of my life. High above

the clouds, I thought about my move to Chicago from Memphis nine years earlier. It felt so long ago. The boy on that train had a lot to be desired in the self-love department.

The Laws of Success taught me that for anyone who has a calling, the success of fulfilling that calling has a lot to do with that person's faith and self-love. Making the decision to follow my dream was a manifestation for me of true self-love. I discovered that a lack of self-love is actually anti-God, dishonorable to his creation and a force of darkness.

> *Walk around, why wear a frown*
> *Say little people, try to put you down*
> *What you need is a helpin' hand*
> *All the strength at your command*
>
> *How's ya faith? 'Cause ya faith is you*
> *Who you kiddin', to yourself be true*
> *Spread ya love for a brighter day*
> *For what ya search, you'll find a way*
>
> *We are people, of the mighty*
> *Mighty people of the sun*
> *In our hearts lie all the answers*
> *To the truth you can't run from*
> —"MIGHTY MIGHTY," OPEN OUR EYES, 1974

PART II

BETWEEN THE VISION AND THE FULFILLMENT

BETWEEN THE
VISION AND THE
FULFILLMENT

7
Starting from Scratch

*"I will not follow where the path may lead, but I will go where
there is no path, and I will leave a trail."*

—MURIEL STRODE

I had gone from being part of the most successful jazz/pop
group in the world to starting something completely new from
scratch. My concept of Earth, Wind & Fire was that its music
would render itself to humanity by encouraging an investment
in the inner life. My self-love would project holistic and clean
living through diet and no drugs. My plan was to exemplify
a new brand of black masculinity rooted not in a super-black
power thing but in dignity.

On April 3, 1970, the original Earth, Wind & Fire left for Los
Angeles. Wade Flemons, Don Whitehead, and Yackov Ben Israel
drove a beat-up, broken-down Volkswagen bus I had bought for
$150. Sherry Scott and I drove in my badass 1966 burgundy
Buick Riviera. I took $3,000 with me. I had a strong signal from
Capitol Records that it was going to extend my relationship,
based on the regional success of "La La Time."

Our raggedy VW bus broke down smack in the heart of
mountainous Utah. We somehow found a mechanic to fix it,
which took all day. At dusk, he seemed to get nervous. I asked
him if he was having problems fixing the thing. He cleared his
throat and started rubbing his head. "Man, I'm just trying to get
you guys out of here before dark."

"What, the Mormons are going to get us?" I joked.

"The Mormons are the least of your worries, young man."

I got it. As soon as he pulled the bus out of the garage, the cats piled in, and, zoom, we were gone into the Utah dusk.

Within weeks I had moved into the infamous Landmark Hotel in Los Angeles. It was filled with pimps and prostitutes, drug dealers and drug users, as well as creative types of all kinds. Present also were gurus, psychics, and the one and only Reverend Ike, who lived above me at the hotel. He was trying to get his ministry going at the time, and we would come to exchange many books.

"How do you do, young man? I am Reverend Ike," he said.

"Nice to meet you," I said, extending my hand.

"You know who you are—I can tell by your firm handshake."

In trying to adjust to Landmark's energy, I began to appreciate the communal/spiritual feeling that came from its many different ethnicities—red, yellow, black, white, and brown. Leaving the limited black world and limited minds of Memphis for the expansive black universe of Chicago was the first change. Now I was leaving the super-black power structure of Chicago for the palm-tree-lined streets and eternal sunshine of Los Angeles. The spiritual diversity in the books I had been reading became tangible upon my arrival.

The Landmark was home to entertainers of every stripe: Archie Bell of Archie Bell and the Drells, Joe Zawinul before he started Weather Report, and the Chambers Brothers. Janis Joplin, another resident, would sit out by the pool, drinking liquor from the bottle. The Golddiggers, who were regulars on *The Dean Martin Show*, would lie out by the pool with timers to make sure their tans were white-girl perfect. Little Richard, who lived down the street, could often be seen there. It was an eclectic crew. There were even a couple of guys there that robbed banks. Everybody knew what they did, but no one turned them in because sometimes they would pay folks' rent.

Once I got settled at the Landmark, the first order of business was to go to the Capitol Records Tower and meet with the

people who picked up "La La Time." After waiting for at least an hour, I was finally called in to their office.

"We're not picking up your contract," one of them said.

"What, you're kidding, right?"

"We're not picking up your contract."

"Not for an album, but a single, right?"

"Not for an album, not for a single, or anything else."

"But . . ."

"Our decision is final."

It was a dreadful turn of events. Humiliated, I left quickly without even shaking their hands. I knew the music business could be a cold place, and I was freezing that day. I had brought all these cats out here to LA on the assumption that we had some kind of commitment from Capitol Records to at least do another single. Without a contract, we were truly starting over.

Black music in 1970s Los Angeles was heading into uncharted waters. Black folks for the first time in American history were achieving success equal to that of our white counterparts, but the record business simply wasn't yet prepared. The business still had the "race record" mentality of the 1950s, meaning that black people sometimes didn't get credit for songs they had written unless they had lawyers looking over their contracts. Most of the big labels didn't even have black music divisions, or if they did, they were small. Now, some of the majors did have deals with smaller black labels, but those labels weren't integrated into the penthouses and boardrooms of the big boys. Black groups, especially bands, didn't make a lot of LPs. They made many one-shot singles, perhaps, but not albums. Although Sly and the Family Stone changed what I coined the "drill team era," which was black musicians performing synchronized dance moves, in matching wardrobes, and delivering a unified sound, black music getting respect from the boardroom brass was still years away.

There was a great deal of creativity and rock-and-roll energy in LA. It caused a migration of sorts, as all of the important musical and business talent moved to the West Coast. Even Berry

Gordy moved Motown's operation to the City of Angels in 1972. Great, beautiful recording studios such as the Village in West LA, Kendun in Burbank, the Record Plant, Devonshire, and many others were just being built or starting to hit their stride.

I loved LA, with its eclectic people, eclectic spirituality, and, most important to me, eclectic music. Albums like Carole King's *Tapestry* could play side by side with Miles Davis's *Bitches Brew* on the new FM radio dials. I believe this was changing listeners' tastes. I also believe it was changing the mind-set of music business executives. It was signaling that people wanted to hear and buy all kinds of music, not just the Top 40 stuff that dominated the dying AM radio dials.

We—me, Wade, Don, and Yackov—would eat at this place called Organicville on Beverly Boulevard. Organicville was a restaurant, health food store, and bakery wrapped up into one. I can still smell that fresh-baked banana and pumpkin bread. I started to drink their fresh wheatgrass juice, and bought organic honey for the first time. Practically every inch of space in the small-aisle store was stacked to the brim with all things healthy. This was my introduction to a higher level of healthy eating. Since 1966 I had been reading *Back to Eden* by Jethro Kloss. At Organicville I was finally able to achieve what Kloss called a "clean diet." I could buy herbs and all kinds of soy-based products. I started calling myself a vegetarian.

We visited Organicville almost daily. I'm sure we stood out, as the other guys in the band were dressed in dashikis, necklaces made out of African bones, and leopard-looking pants. I, on the other hand, was dressed in jeans and a turtleneck. I probably looked like an insurance salesman compared to them. The cashier was fine as hell. She had long hair and a hippie-looking floral top that showed off the beautiful olive skin that peeked through. I widened my smile and approached her. I found out her name was Marilyn Orefice. Our private smiles and quiet flirtations went on for many weeks. One day I asked if she had time for a break.

"Sure," she said.

"Come walk with me out to my car."

Once she got into my car, I could smell her perfume, which was sweetly fragrant to me. I looked her dead in her eye and said, "Let me introduce myself. My name is Maurice White. I am a musician. I have a band called Earth, Wind & Fire. You haven't heard of me yet, but you will."

I learned that she had a man in her life at the time, but I knew we had a strong connection. Her eyes said that she liked me. We were both twenty-eight. Marilyn was sort of a hippie compared to me. Most people in the circle I was rolling in had Volkswagen Bugs and flowers in their hair. I had my big burgundy Buick Riviera. Marilyn named it "Jerome." She was a great communicator, with a loving spirit. She was also on a spiritual path that she took seriously, which gave us a great deal to talk about. I was persistent in getting with her, and she eventually relented.

The EW&F lineup I brought to Los Angeles consisted of guys who were my contemporaries. Whitehead, a keyboardist, played a little bass, but we didn't have a fully dedicated bass player. I thought my nineteen-year-old half brother Verdine might be up to the task. What he lacked in maturity, he made up in enthusiasm.

My brother Verdine Adams White was remarkable. Earth, Wind & Fire would have never become Earth, Wind & Fire without him. A huge part of what built EW&F was our live show. Verdine, the ultimate Leo, had the energy to sustain us. Verdine came to LA eager and ready for anything. He arrived with an Ampeg B-50 bass amp and an eggshell-colored Fender Telecaster bass. The Telecaster was a huge bass, and against Verdine's skinny black frame it looked odd and cool at the same time.

Even though Verdine and I were not raised together, and we're years apart in age, there was an enormous psychic bond between us, even beyond the blood of our mother. Yet we are

different in personality. Verdine's lively charisma onstage is still intact offstage. His vibrant, overshadowing personality gave me even more permission to be my naturally introverted self.

Apartment 119 at the Landmark was the soil in which EW&F took root. Walking into our crib, you would see a couch to the left and Verdine's bed to the right. We always had incense burning and little tablas (Indian drums) sitting in both corners of the flat. I slept in the bedroom in the back.

Eventually I introduced Verdine to my world. One night we went to a party and met Jimi Hendrix. Another night we met jazz cats such as Buddy Miles. I also took Verdine to health food restaurants and metaphysical bookstores. We went shopping, and I bought him some hip clothes emphasizing what colors looked good with his skin tone. This was Verdine's rite of passage to the California life. He quickly became a fixture in and around Hollywood, talking nonstop to everybody about everything. He was excited and completely open to his new life in California.

The group continued rehearsing and playing anywhere and everywhere we could. We even did a couple of bus tours. We added Michael Beal on guitar and a horn section with Alex Thomas on trombone, Chester (Chet) Washington on sax, and Leslie Drayton on trumpet. Leslie, a local trumpet legend, did most of the horn arrangements, giving me the bigger sound I desired.

Along with the expanded sound came the realization that I needed a manager. Not much later I met the one and only Jim Brown—the all-true man. Jim Brown is considered one of the greatest, if not *the* greatest, football players in history. When I first knocked on his door, Jim answered it buck-naked. Jim, being an athlete, was used to walking around other men naked; I wasn't. His sculpted biceps were intimidating, making me wonder if this brother was gonna kick my ass on GP (general principle). After letting me in, Jim sat in a plush chair, crossing one leg over the other while pressing the palms of his huge hands together. Staring straight into my eyes, he began to speak with

an eloquence not normally associated with a sports star. He said all the right things, not only about music but also about what blackness meant to him. For all his manliness, Jim was a smart, thoughtful cat. He understood creative personalities and the creative process. He also believed in what I was trying to achieve.

Jim Brown had an entertainment management company called BBC—Brown, Bloch and Covey. Paul Bloch was an entertainment publicist, Richard Covey, a lawyer. Jim was trying to help black men embrace their power. He was the person who got Bill Russell and Kareem Abdul-Jabbar to meet with Muhammad Ali when he refused to enlist in the army because it was against his Muslim beliefs, and the US government was trying to put him in jail. Jim was not afraid to stand up for something. He is what I call a real black man, a man of courage, not posturing. Brown's operation was professional, and he was not going to accept any sort of second-class treatment of black men. I signed a management contract with him almost immediately.

Jim thought power rested in personal dignity. He didn't appreciate buffoonery in any way, whether it was onstage, in a sports arena, or at the supermarket. "Black dudes need to become sports agents and lawyers, not just players on the field," he said. Jim believed in black ownership as the way forward for our race.

In the following months, things seemed to be going at a snail's pace. It made me feel we were not getting enough managerial attention. I didn't let on to the band that I was anxious—I already felt enough doubt from them. Wade Flemons demonstrated his apprehension by always being pissed off with me about something. I responded by trying to keep everyone's spirit uplifted, even though some days I felt like a fraud doing so.

Soon things picked up, though. Jim Brown had set up an informal audition for us with Warner Bros. and RCA at his house in the Hollywood Hills. Present were show business stars large and small. In addition, Celtics great Bill Russell was there, towering over everyone with his magnetic smile. Women were vying for the attention of Richard "Shaft" Roundtree. Bill Cosby was

in the room, too, chomping on a cigar. This was a Hollywood parrr-ttttay. There were two open bars and catered food. The room was full of sexual energy given off by super-duper fine-looking women. Everyone, across racial lines, was mingling together, sharing information. The evening had an incredibly positive vibration. Jim Brown attracted that kind of stealth-level networking.

We performed on the balcony, overlooking the city. The scene was magnificent, with LA spread out in the background. It energized our playing. Since we rehearsed all the time, everything we did was tight. Verdine pranced around in a leotard and no shirt, giving a good show. Our driving percussive sound created high energy and raw musical power. RCA Records passed, but Joe Smith, executive vice president at Warner Bros. Records, really dug us, thinking we were "jazzy and hip." Within a month, I signed a record contract with Warner Bros.

In early 1971 we started recording our self-titled debut record. The sound for the album we came up with was progressive, jazzy, and bluesy. All the songs were in tune with the concept of Earth, Wind & Fire: "Help Somebody," "Moment of Truth," "Love Is Life," "Fan the Fire," "C'mon Children," "This World Today," and "Bad Tune." Every song had a theme of social justice, spirituality, and self-reliance.

Don Whitehead's vibe was a big part of these songs. Head was more curious about world events than Wade and I, aware of what was going with Bobby Seale, Huey Newton, and even the work of Nikki Giovanni. Still, we all instinctively understood the black power philosophy that had taken hold. People were standing up for themselves, no longer waiting for white folks to give us a piece of the American pie. Our first album blended black power energy with a socially aware vibration, critiquing the political and social climate of the time. We also challenged our listeners to examine their inner life. I encouraged them to ask, What am I to do? Who am I to be? Where can I help?

After we completed the album, we began touring wherever we

could play and for whoever would have us. We did several gigs at the legendary Maverick's Flat on Crenshaw Boulevard in Los Angeles.

One of the benefits of being with Warner Bros. was that we had the opportunity to rehearse many times on the Warner back-lot. They were filming *Bonanza* on sets made of papier-mâché. James Garner and Lou Gossett Jr., who were filming the movie *Skin Game*, would regularly walk by our stage. While the atmosphere was exciting, being in the Warner family felt like purgatory at times: we were a black act and, in my estimation, treated as such. I wasn't feeling any love when it came to promotional help.

When Perry "PJ" Jones joined Warner, there seemed to be the possibility of getting some real promotional support. Perry Jones was one of the handful of African American promotion men in the record business at a major label. The record business ain't the record business without the promotion. His very first assignment was Earth, Wind & Fire. Perry was a hipster. With long superfly maxi coats, six-inch Afro, and knee-high equestrian boots, he was 1970s cool. He would wear driving gloves that went along with his racing Kelly green 1969 Triumph TR6. I don't think Perry had ever met a cat like me. I was a young man in full—or full of it, depending on how you took me. Confidently, eager to share my dream, I preached my vision of Earth, Wind & Fire to engage his business mind and his heart. I wanted to let him know that EW&F was unique, different in concept from any other artist.

"Perry, I want to make it crystal clear that we are getting ready to embark on something that has no boundaries, no guidelines," I said.

"OK, but what does that really mean?"

"Well, first I want to make music that is my spiritual truth."

"And your truth is?"

"One, that music can uplift people, and two, that all spiritual paths, at their highest, have a unity."

"That's a mouthful."

"Yes, but I believe that's a message that everyone can embrace, black, white, and everything in between."

Perry nodded in agreement, his big Afro swaying and glistening with Afro Sheen. He stood up and started pacing the floor, back and forth, still nodding his head. I knew I had him. I would have never admitted it at the time, but I was desperate. I needed all the business help I could muster. An ally on the inside at Warner Bros. could reap some real benefits for EW&F. Perry wasn't a vice president at the label, but having him as an advocate meant I got the skinny on what was going on at Warner.

My ability or lack of ability to persuade others was critical to my success in realizing Earth, Wind & Fire. I spent a lot of time relating my concept to Perry, the band, and anyone who would listen. My brainchild of hope, looking at life positively and believing in yourself, was one aspect of my soapbox. The other was to communicate in song recognition of our common humanity. I believed music was sacred—a powerful holistic vehicle that could carry us to a higher place, if we chose to use it that way. I believed then and now that humankind's problems are rooted in our denial that we are not all the same. Separated by race, class, and religion, we make our differences the gospel truth of who we are as human beings. I had deeply internalized the belief that we are not citizens, nor Buddhists, nor Christians, nor Jewish, nor African American people. We are human beings—each one connected to everyone else.

I was fine-tuning this concept to the point where if someone shook me awake at three in the morning and asked what the concept of EW&F was, I could give them an intelligent and compelling answer in a split second. My struggle was to get the band and everyone else around me on that same page. Verdine got it, of course, because together we lived and breathed all things EW&F.

But in terms of the rest of the band, I just didn't know. I knew from the mastermind principle in *The Laws of Success* that

I had to harmonize the minds of everyone around me to achieve this goal.

One bright spot was that Perry Jones continued to grow into my vision. He was becoming a believer. Raised in Des Moines, Iowa, Perry had not understood the level of struggle out there with civil rights. I helped him understand what it was to be black in the music business. I inspired him to ultimately want to transcend what blackness meant. I gave Perry all the promotional contacts I had from my travels with Ramsey and my days at Chess, in the hope they could help him promote EW&F. Our first single, "Fan the Fire," had only moderate success. "Love Is Life" fared a lot better, getting up to No. 43 on the R&B charts.

With only 40,000 albums sold, things were good, but certainly not stellar. For a new act, a breakout album would hit the 100,000 mark. Still, we were given the go-ahead to do another album for Warner Bros.

In between albums, I met Melvin Van Peebles, the actor/director/screenwriter. He told me about a film that he was working on. He was extremely passionate, and his energy was hard to resist. I easily agreed to work on the music for the movie.

Sweet Sweetback's Baadasssss Song is considered by many to be the first film of the blaxploitation genre. It tells the story of the evolution of a street hustler who tries to move from selfishness to something bigger than himself. Melvin had melodies and groove ideas about how he wanted the music to feel. He projected clips from the film he had already shot onto a wall in the studio. The engineer pressed record, and we played along to the clips. The images were violent, sexual, and dark depictions of black life. Over two days we recorded the entire score.

Few others could match what Melvin Van Peebles did on a shoestring budget. Melvin taught me about getting the shit done, even though the $500 check he wrote me is still bouncing! I was rewarded in other ways. *Sweetback* expanded the reach of the name Earth, Wind & Fire. Melvin, with his make-a-way-out-

of-no-way spirit, sold the Stax Records–released sound track in movie theater lobbies.

On the downside, right as *Sweet Sweetback's Baadasssss Song* was being released, Verdine got drafted into the misguided Vietnam War. The draft was going strong by 1971. Vietnam was now firmly in the minds of America, and especially black folks, as a kind of death sentence. If you didn't come back in a flag-draped coffin, you could come back maimed or, as some of my friends did, a heroin addict. We had to figure it all out pretty quickly; Verdine's draft number had come up in February, and he was supposed to report in late April. The notice came from Chicago, so it would take eight weeks to process it. He could go back, get drafted, then go to Louisville, Kentucky, for basic training.

I was scared for Verdine, for Mom and Dad, and for myself. Even though I had gotten my deferment by performing the acting job of my life, a lot of other guys I knew were not so lucky. V getting drafted seemed more personal to me than my own experience. I knew intellectually that I had nothing to do with his number coming up, yet I still felt responsible—psychically and emotionally. I felt Verdine had been entrusted to me by Mom and Dad.

To avoid the draft, Verdine came up with an idea: he would stop eating. At twenty, he was skin and bones already. He fasted for something like forty-five days, getting down to about 110 pounds. When he stepped on the scale at the Los Angeles induction center on Wilshire Boulevard, the indicator went way up, then way down, way up, way down.

The officer said, "Hang on a second, young man."

They put Verdine in a room while the officers whispered. The men had multiple beige files, which they opened and—*stamp, stamp, stamp*, and *stamp*, Verdine had a 4F. That was the Holy Grail. It meant he could never, ever be drafted. Ever.

Verdine called me afterward: "Come pick me up, *I'm out! I'm out!*"

Diving into the low front seat of my Buick Rivera, he kept repeating it. *"I'm out! I'm out!"*

I took him to a party that night, and he ate everything—I mean everything—in sight. I'm surprised he didn't overdose on food. It was a comforting sight, watching him gorge himself. The previous forty-five days had made him look like death on a soda cracker.

With V out of the woods, we got back on the bus and started to play everywhere we could in support of our debut Warner Bros. album. One of our stops was in Denver, to play at Twenty-Third Street East. It was a typical gig, but it was where Verdine and I met Philip Bailey and Larry Dunn, who were part of a little group that opened for us. I thought they were good, especially the cat with the high voice.

During this time we were working on our second album, *The Need of Love*. Once more, the record was a very jazz-psycho-funk affair, with only five songs: "Energy," "Beauty," "I Can Feel It in My Bones," "I Think about Lovin' You," and "Everything Is Everything." On both of our Warner albums Jean Carne added her wonderful voice to the background vocals, even though she wasn't credited. Radio picked up on "I Think about Lovin' You," a beautiful tune written by Sherry Scott. It made it into the mid-40s on the R&B charts. I was surprised that radio stations liked "I Think about Lovin' You" best of all the songs we had released. I now believe the song reflects the peace and love vibe that Sherry brought to EW&F. The new black consciousness growing in 1972 had been very masculine, bold, and pushy. Sherry's feminine voice in "I Think about Lovin' You" was a refreshing reprieve. She sang the song beautifully. I also think that many people didn't think of the peace and love movement as being authentic for Negroes. Many believed you had to be white and have flowers in your hair to be part of all that. But to Sherry it was real—idealistic, for sure, but still central to the social and political movement of the early 1970s.

In January 1972 I found out that our second album was on

par to sell about the same number of copies as the first, which was nothing to go crazy about. There were grumblings among the band about the album's lack of chart success and how I was failing as a leader. Wade seemed to be the most vocal. I was disappointed but undaunted. One of the first things I did to try to increase sales of the second album was to book a gig at the Gaslight Café in New York City, opening for Dizzy Gillespie. Warner Bros. picked up the tab for me to fly the whole band there and do this one gig.

Perry Jones and I put our heads together again to figure out how we could maximize the trip to NYC. It was helpful that we knew most of the promoters, big clubs, radio stations, and record stores across the country. Getting our hustle on, we took that one date and turned it into a three-week, multi-city tour. We did not have a budget from Warner Bros. to do this. We didn't have credit cards. We didn't have a so-called travel agency. And we certainly did not have any checks. Perry and I pooled together whatever money we could, even using Verdine's unemployment check. We didn't fill the Gaslight up, but by the time we got to Boston we were opening for another jazz artist, Gary Burton, and we had the place packed. We played Chicago, Detroit, and a few other cities before ending up in Denver.

Perry did a great job getting our product into record stores. Since he was trying to do things on the up and up, he didn't really have a chance to win the promotion game—EW&F didn't have the kind of juice to get the big brass at Warner Bros. Records to pass cash around. The black jocks, in many cases, were not getting paid—anything! Some of the record companies were giving them washing machines and refrigerators, which was just another form of payola. Only later did it extend to cash. There's an old story about a famous black disc jockey in Atlanta. When he died, they found a sparkling gold Rolls-Royce in his garage. He'd been too scared to drive it, for fear of the IRS taking notice.

Getting money was a problem for all of us in the business at some point. One time we were on a promo tour in Columbia,

South Carolina, and we'd just finished a gig. When I went to the venue office to get our money, the club manager tried to stiff me. "I ain't paying you a dime," he said.

I stormed out. The next morning I called Jim Brown's office. Richard Covey, Jim's partner, answered. I told him I was having problems, and I needed someone to talk to this guy. Covey said, "I don't think there's anything I can do, but hold on." He connected me to Leonard Smith, whom I had never heard of before.

"Hey, man," I said, "I'm Maurice White. I'm stuck down here, and this son of a bitch won't give me my money. I need it to get to the next town."

"Hang on a minute," Leonard said. "Don't move—stay right there."

I heard Leonard pick up another telephone and call Cecil Corbett, a promoter near Columbia whom he'd worked with in the past. "Cecil," he said, "I need a favor. One of my guys is having a problem in your neck of the woods. Will you call and straighten him out for me?"

Leonard picked my phone line up again. "Now, Maurice, just do what I tell you. As soon as you hang up this line, call Cecil, and he'll take care it."

"OK, brother, thanks!"

Within an hour of hanging up with Leonard, I was counting my money. I knew I needed this cat. Fate was in my favor; he was the road manager of the Friends of Distinction ("Grazing in the Grass") on Jim Brown's behalf. When the group decided to leave Jim's management company, Jim assigned Leonard to us. Leonard would be my right-hand man for the next eighteen years.

8 Hearts of Fire, New Desire

It does not matter how slowly you go as long as you do not stop.

—CONFUCIUS

Leadership requires accepting that you're always going to be challenged. I discovered that the band—minus Verdine, of course—had been having meetings behind my back. Bottom line, Wade Flemons wanted to be the leader of the band. Although everyone contributed to the band, I handled all the business from day one. When I was at Chess Records, I saw that decisions by committee never worked. Six years earlier I'd had to fall in line with Ramsey's way of thinking—the neatness, the classiness, the way he wanted things played, and the way he wanted things to run behind the scenes. Now my band had to fall in line with my idea of things, or it wouldn't work. I never, ever would have started a band without being the leader, which is why I financed everything from the beginning. Wade and I had a huge blowup over the direction and control of the group. After a good fifteen minutes of arguing, I reminded him that I owned the name Earth, Wind & Fire. Wade quit.

I started to make calls and begin rehearsals. To my surprise, when I called Whitehead, he said, "There ain't no rehearsal," and hung up. One after the other, my old bandmates all split, forming a new group called Colors. Michael Beal hung in with us for a little bit longer, but eventually he left, and it was just Verdine and me. The breakup was tough, but I came to understand that, with the exception of Sherry Scott, they were all older and

had already had disappointments in the business. I also recognized that my leadership style needed developing. I could have benefited from being more inspiring and encouraging.

I was determined, with a clenched mental fist, to rebuild the band. I believed the Creator would take care of me. He made me realize that I needed to know more about personality types. I believed astrology would help with that. I was also motivated by Mama's words: "Keep moving, just keep moving."

It seemed that everything around me was falling apart. The Landmark Hotel, where I lived, had developed a bad vibe. Drugs were more and more becoming the norm—and not just pot and cocaine. There were funny scents that I had smelled before in the alleys behind the clubs in Chicago—people smoking heroin. Marilyn, my girlfriend, would sometimes stay at my place when I was on the road. She was there when Janis Joplin died, and saw the EMTs take her body out. I wanted to start anew.

I moved into a nice house at 743 Westmount Avenue in West Hollywood in the hills above the relatively new Tower Records on Sunset Boulevard. Marilyn, who was becoming more a part of my life, moved in as well. We talked a lot and didn't go out very much. It was easy to be with her. We were a natural fit. Marilyn stocked the place with healthy food and made the house a home. I had a big piano, a fireplace, and mountains of records. Music was always playing in the sun-drenched house. Verdine had the bedroom downstairs. V had just started taking singing lessons and would spend his time singing at the top of his lungs "Wonderful, Wonderful" by Johnny Mathis.

But my new home was haunted. We learned from the neighbors that previous tenants had seen a ghost, which forced them to move out. Between Verdine's grandiose singing and unexplained "ghost" movements in the night, it was a fun, crazy, and lively place. This little house became the launching pad for the new Earth, Wind & Fire.

I wanted the band to be slightly different in this new rendition. First of all, the guys needed to be younger. I didn't want

them to have a lot of experience and be cynical and coldhearted about the record business. I did want them to be talented and full of promise. I had the shining star of Verdine's youth, positivity, and bright karma as a template for what I wanted the new band to be. Verdine was hyper. You couldn't turn him off. I was perpetually saying to him, "Be cool, man, be cool." I started to call him Mr. Entertainment.

At twenty-eight years old, I knew who I was, and I was feeling confident and competent. I felt in control of myself and ready to lead a new Earth, Wind & Fire. I was on a mission and had become even more clear about what I wanted to communicate to the world. In order to get my message across, I wanted a band that was as serious as I was about the craft. I also didn't want to teach people to be positive; I wanted to find positive people.

One of Michael Beal's last gifts to the band was that he contacted Ralph "Slick" Johnson to audition for the new Earth, Wind & Fire at Michael's house in Baldwin Hills. Verdine and I had already seen Ralph play at Maverick's Flat, in a band called the Master's Children. I wasn't big on the band, but I loved their name. Verdine auditioned Ralph and said I should take him on.

Ralph, a learned drummer, had technique up the yin-yang. I liked the way he played, and liked him even more. Soon after he joined the band, tension started to rise in rehearsals. We would be playing, and I would stop and say, Let me show you something. I'd move behind the drums, count the song off, and play it how I felt it should groove. Ralph listened with his poker face on. I understood his feelings, even if I acted insensitively.

Although he thought things should be played one way, while I thought they should be played another, we eventually worked it out. I'm glad Ralph was the first piece of the new band. It gave him and Verdine time to click. It's always vital for the drummer and bass player to form a tight bond, as they're the foundation of a band.

I still had a contract with Warner Bros. Records after the band

broke up. I didn't run over to their Burbank offices to tell them EW&F was no more, but Perry Jones knew what was going on.

I had gigs booked while I was putting the new band together, piece by piece. For a while, it felt like a revolving door—people quickly in and people quickly out. I enlisted Helena Dixon, a little tiny chick with a sweet voice. We held auditions with about eight or nine guitarists on one long day. No luck. Someone had mentioned they'd run across a cat back in Denver playing with Sonny Charles and the Checkmates that they thought was good. I called Roland Bautista and invited him over. Verdine and I alone auditioned him. Roland had a kind of a rock vibe, but he and Verdine hit it off. They had chemistry, not only with their playing but also in their physicality together, which made them good performance companions. Again, Verdine's endurance was so over-the-top, he needed as many bandmates as possible to keep up with him. Roland Bautista was in.

Perry Jones kept harping on me about Larry Dunn and Philip Bailey, the two guys Verdine and I had briefly met in Denver at the Twenty-Third Street East nightclub. Philip had moved to LA at Perry's request, and he soon became the Stovall Sisters' musical director. Philip at the time was living at Perry Jones's duplex on Crescent Heights Boulevard. This made me a bit cautious. It wasn't that I didn't trust Perry, but his house was truly a hangout for a lot of entertainment types. It seemed there was always a party going on. I had a built-in distrust for homes where people were constantly coming in and out. I hated hangouts. Little Richard or even Sly Stone could be over there, and I wasn't interested. I was also suspicious of drugs and guys who seemed to talk more shit than they got done. But Verdine saw talent in Philip Bailey, whom he'd seen at a gig with the Stovall Sisters, who were also on Warner Bros. Records.

Soon Philip's wife, Janet, joined him in LA. They had just had a baby boy, named Sir. Philip quickly moved from Perry's to an apartment on Gramercy Place. All of these factors made me see Philip in a better light. A young family man was more stable,

less prone to craziness. Verdine and I met with Philip, and the conversation was short and direct. He wanted to be in the greatest band in the world. I wasn't thinking so much about his talent when I offered him the job. I knew he had that. I was more interested in his receptivity. Could he embrace the concept? Could he respect my leadership? Was he flexible enough to deal with the inevitable ups and downs on the journey to greatness?

I was eager to start rehearsals with Philip. I wanted to incorporate his voice and conga playing into the band. During the first rehearsal I said to myself, Man, can the kid sing high—and hard. He had the classic falsetto sound of great singers of his era such as Eddie Kendricks and Damon Harris of the Temptations, Russell Thompkins Jr. of the Stylistics, and William Hart of the Delfonics. They all had sweet falsetto voices. But Phil's falsetto displayed a coarser edge, sweet but earthy. He could scream in falsetto—hit the high register of his voice, and still have control over it. It distinguished his voice in my eye. His falsetto voice installed in EW&F a sound that was a mainstay in soul music. Having a falsetto voice in a band, as opposed to a singing group, brought a unique element to EW&F. Phil's percussion chops only added to the pot. Phil's presence in the band was a relief to me; I had never wanted to be the lead vocalist of EW&F.

After Phil came on board, Perry Jones continued to talk up Larry Dunn. It wasn't so much that I was for or against the idea; it was just that I had a lot of other practical and business issues going on at the time. Some of the business revolved around me being cloak-and-dagger in my dealings with Warner Bros. Jim Brown was on Warner's ass to hire a black staff to handle black music. I didn't want to complicate things by letting them know I was changing band personnel until I had a new band firmly in place. Another concern was at least appearing stable. I started a practice of having individual meetings with everyone from band members to businesspeople, just to keep everything focused and sharp.

Phil went back home to Denver and saw Larry doing a show

at Manuel High School. His band opened up for the group War. According to Phil, Larry took an outrageous ten-minute Hammond B-3 organ solo, turning the crowd upside down. Under Perry and Philip's persuasion, I invited Larry out for an audition.

I didn't know how to respond seeing Larry Dunn walk through my door. He looked sooooo young, like he was thirteen or fourteen. He had much more of a baby face than I had remembered. I wanted young guys and all, but this was a bit ridiculous. I almost wanted to ask for a note from his parents. Larry sat behind the Fender Rhodes and played a few of the early EW&F songs, as well as Herbie Hancock's "Maiden Voyage." Larry had great nimble, talented fingers. He was a joker too, always keeping things light.

Meanwhile I told Doug Carn, a jazz artist I knew, that I was looking for a sax player, and he recommended Ronnie Laws. I knew about his brother Hubert, because everybody in New York was talking about his virtuosity on the flute. Ronnie came in and auditioned. He just blew me away. He was smokin'. He had the perfect musical foundation to accomplish what I wanted. I was always quick to compliment him. Often I would say, "Man, you were burning tonight!" I thought he was the best musician in the band.

Any way you look at it, putting a new band together is like cooking. You don't know what you're going to have until it's done. We had Ralph Johnson, Roland Bautista, Helena Dixon, Philip Bailey, Larry Dunn, Ronnie Laws, Verdine, and myself. Even though I drilled the concept of EW&F, everybody joined the band for different reasons: some joined because of timing, some liked the brotherhood, and some even liked the concept. But everybody wanted to be successful playing music. We were playing clubs, colleges, old arenas, and some of the big new arenas that they were starting to build, especially on the East Coast. I kept booking them, all with the hope that I could hold the band together, just to give us a chance to gel. We gradually started to open for bigger acts.

Yet things were still precarious. I walked through the brightly sunlit Los Angeles airport concourse many times to deliver the bad news to the guys that yet another gig had been canceled. That's how I would often get the bad news—right at the airport, right at the last minute. But I presented this information to the band with a strong tone of conviction. I was learning that composure is a big part of leadership. Anyone can drive the boat when the sea is calm. I would often say to the guys in times of disappointment, "The universe just has something better for us." I never wanted to communicate a drop of negative energy.

One of the more significant shows we played at this time was at the Uptown Theater in Philadelphia. A beautiful art deco building, the Uptown Theater was a historically significant place for black artists. It had been a part of the chitlin' circuit for decades. It gave many artists their start. It was considered the Apollo Theater of Philadelphia as a nexus of black entertainment. It was a traditional theater, with big, heavy burgundy curtains and ornate art deco wall carvings that gave it a grand feel. When we played there, the Uptown Theater was in its last days of glory—but it was still a big thing for us.

In those days at the Uptown Theater, they'd have two or three shows a day, with four on the weekend, consisting of several acts. We weren't used to that. One of my principles that I emphasized to the band was that we were a concert act, a band meant to play in arenas just like the big white acts of rock and roll. You play your show, and then you head to the hotel, to the airport, or back in the station wagons. I didn't want us playing clubs, or even theaters like the Uptown. It may have been a financial mistake not to take every little gig that came along in those days, but I had an unwavering belief it would be better for EW&F in the long run.

The legendary giant of radio, Georgie Woods of WDAS, put on the show at the Uptown. Georgie was king in Philly. More than a disc jockey, he was a promoter, a community activist, and—in my opinion—a barometer of all things cool.

We were always trying new stuff with our show, so I gathered the cats and said, When the curtain opens, let's all be sitting on the floor in the lotus position, staring at the audience. The band thought I had a screw loose.

That first night, when Georgie said, "Here's Earth, Wind and Fire," the curtain opened, and there we were in our lotus positions, looking like we came from some farm commune in northern California, glaring at the audience for what seemed like an eternity. They started to boo, throw things, and laugh. Then I picked up my kalimba and started playing. One by one we calmly picked up our instruments and started playing, and they gradually got into us. Before long they were clapping and feeling our musical energy. They were also staring at us, astonished by what we were putting out.

Black audiences in Philadelphia, New York, and Detroit were always very tough. It was an "If we can make it there, we can make it anywhere" kind of thing. It would take time for audiences and the band to buy fully into the concept. I wanted every creative impulse, whether in music or performance, to be consistent with the overall idea of EW&F's spiritual elements. By our last night at the Uptown, we were getting standing ovations. We stuck to our guns and laid a cosmic, spiritual thing on them. It was not common to see brothers sitting in lotus positions! The success of our odd opening allowed the band to start trusting me more. They began to understand what EW&F was about, and got a glimpse of what it could be. I was not afraid of the unconventional. If it was God-inspired, I knew I would be all right.

Around this same time, I got some disturbing news from Perry Jones. His boss had told him that not only did he not like black music, he didn't like Earth, Wind & Fire. And he definitely did not like Perry. Perry was devastated; personally and professionally, it almost broke him. I tried to encourage him not to take it personally, to let him know it's all in the game. I wasn't shocked by the news. Actually, I was pleased to know where I stood with

Warner Bros. Records. To hell with them if they didn't want Earth, Wind & Fire. My persistent affirmation of faith told me there was something better.

I had received a real good education from Chess Records and all those other record labels in Chicago. I knew how cold the record business could be. All this love you get one minute, then hate the next—it was all too terribly familiar. I didn't let the band know what was going on, even Verdine. I didn't want them to get discouraged.

A few months earlier I had met with a manager called Bob Cavallo, a short Italian American guy with a bushy mustache and lots of New York City chutzpah. He started out managing a club in Washington, DC, then had his first breakthrough managing the Lovin' Spoonful, who went on to have several hit records. Bob loved all kinds of music—jazz and especially folk. I told Bob that I wanted to write songs of optimism and hope for the future. I wanted to include jazz, Afro-Cuban music, blues—every musical genre you can come up with—in some amalgamation. I wanted a concert where the audience was 50 percent black and 50 percent white.

About a year earlier, Bob had come to see the old EW&F play at the Hollywood Palladium. He thought the music was good, but he didn't think I had the individuals to carry it out. I also believe that the heavy percussive sound, the African clothing, and the themes of self-empowerment scared some white folks, maybe even Bob. Many were fearful of this new big-city black consciousness they didn't understand. Lew Alcindor changing his name to Kareem Abdul-Jabbar, the Attica prison riot on TV, and everybody talking about the movie *Shaft*. Even with those worldly events, my vision for EW&F had not changed or diminished—but my band's personnel had.

I invited Bob to come and see the new band play. Backstage after the gig, I knew I had him.

"Maurice, I'm floored! The power, the movements, and the music was just . . . just . . . I'm speechless. Let's do a deal."

"Whoa, Bob, not so fast. I'm glad you dig it, but I'll sign with you on one condition."

"What's that?"

"That you get me out of Warner Bros. and get me another major record deal. And somewhere where I'm going to get paid. No Motown records."

I began to become a different bandleader about the time that Bob Cavallo joined the ranks. I discovered that saying no was as powerful as saying yes. Even though we were far from any meaningful success, I was willing to say no to anyone joining my business team without first proving themselves. Bob's proving ground was to not only get me out of my Warner Bros. deal but find me a new label in the process.

Since I had put the wheels in motion to change management, in good faith, I asked Jim Brown to release me from my management contract. I requested a meeting.

"Jim, I think I need a change," I said.

"Change? What kind of change?"

"In management?"

"What? Why in the world do you feel the need for a new manager?"

"I need a more focused attention on the band."

Silence.

He looked through the tinted window of his office and then suddenly shrugged his shoulders. "Well, that actually sounds legitimate. Truth be told, I have a lot going on right now."

"Yes, you do."

"I'll let you out of your contract on one condition."

"What's that?"

"That you hire Leonard Smith and give him a full-time job."

"OK—done."

I thought that was easy. But that was Jim Brown; always trying to help a brother out—in this case, Leonard. In the short time I spent with Jim, I was reminded of one very important lesson, the same lesson Fred Humphrey back in Chicago had

emphasized: Be your own man. Jim Brown was definitely his own man—big-time. He did things his way and garnered respect because of it. I will be forever grateful to him for the role he played in the Earth, Wind & Fire story.

I was excited to have Leonard Smith on my team. I would not be taking care of him; he would actually be taking care of us. For the band, the EW&F experience was college, and Leonard was dorm superintendent. To Leonard, the members of this young band were his children. He was like an uncle taking them camping. He made sure they had the basics of life covered. He taught them everything from how to talk to women to handling their banking. He even pulled their coattails when they got a little wild. They became men under his watch.

Indianapolis, Indiana. Hot as hell. Leonard and I walked across the street from the airport to the Holiday Inn. Leonard, sweating profusely, was dripping water on the counter. It was forming little puddles. He ran his hand across the length of his head and said, "Man, this hair has got to go." He shaved it off that night. Leonard was a big dude, about five-eleven, with broad shoulders, a powerful chest, and big muscles. Now, with his shiny Kojak bald head, he looked like a boxer or a bouncer in a nightclub. This was a plus for me. I liked having that brawn around. The road could be treacherous. We were always dealing in cash and people trying to take it. Leonard, having a military background, brought a sense of stability, discipline, and security to the band. I was a big believer in discipline. Leonard was just what the doctor ordered. "Don't worry about a thing," was Leonard's consistent response to just about every problem I brought to him.

I had witnessed musical groups back in Chicago that had always seemed to be in chaos. Their business practices were shoddy at best. They didn't focus on the logistics of being on the road. Who's in charge of travel and hotels? Who's the contact person at the venue? And, most of all, who's in charge of getting the money? The black music business practices of the

early 1970s weren't that different from the Chicago ones of the mid-1960s. The competitors we crossed paths with on the road didn't seem to have their shit together. They were in disarray backstage. They had no procedures in place. I was determined to be different. I presented myself as organized, as well as mentally, physically, and emotionally pulled together.

I was extremely committed to my health-nut regimen. I was physically fit. I could kick the top of my door arch from a stand-still. Yoga made me as limber as a rubber band. I had incredible endurance. I exposed the band to the importance of eating right, yoga, and meditation. I gave them books to read on subjects as varied as metaphysics, health, and quieting the mind. I encouraged everyone to drink more water and juice and to eat as raw as possible. I told the guys to allow their body's response to food to guide them. Don't you feel more tired, with less energy, after we eat at IHOP? Compare it to how you feel after you eat raw or steamed vegetables. As my money got better, I made sure these edibles were available backstage.

Early fall 1972, EW&F went through a grueling series of weeks. We missed planes. We had flat tires. Everything that could go wrong went wrong. The worst was when we arrived late to a venue depleted of energy, with a ninety-minute show to play. Leonard Smith said, "Come on, guys, let's get in a circle and pray." We did, and we were restored—resurrected. Leonard in that one moment started a ritual for Earth, Wind & Fire. After that crazy night, every time before we hit the stage, I shouted out, "Circle time!" We gathered in a circle, clasped our hands, bowed our heads or raised them skyward, and prayed.

Circle time was bonding; but still the greatest challenge was to consistently engage the guys in the EW&F concept and to try to keep things somewhat financially solvent. With all those demands, I still felt blessed. Where the band was by the winter of 1972 had taken a lot of God's grace. It had also taken hard work, faith, and perseverance.

Bob had interested Clive Davis, who was running Columbia

Records, in EW&F. In living color, Bob expressed that EW&F was a musical and spiritual concept. He told Clive that it was not the original EW&F, but a new group of younger guys that were more psychedelic and progressive-looking than the original Afrocentric lineup.

We needed a way for Clive to check us out that would be discreet and not in a rehearsal space. We had to do it on the downlow because Earth, Wind & Fire was still signed to Warner Bros. Records. This meant that Bob Cavallo wasn't free and clear to shop us to other labels. In addition, any label interested would have to buy out our Warner Bros. Records contract.

Bob had a client, John Sebastian. In 1972 he had been a star for a while as founder of the Lovin' Spoonful, a hugely successful band of the mid-1960s. John had gone solo. He was doing his own special blend of pop/folk music.

Bob asked John for a favor. John had a booked-out show billed as "An Evening with John Sebastian," which meant that no other act was scheduled to perform. The night of the event, the audience was expecting John and his little harmonium, Autoharp, harmonica, and acoustic guitar, but what the packed audience got was an opening by nine black cats. Clive listened to maybe three or four songs before he said, "Deal. Do it. Get someone to call me, but don't let Joe [Joe Smith, Warner Bros. Records president] know that I'm interested."

I was skeptical. My Chess Records education taught me that until the ink was dry on a contract and the check was in the bank, it was all talk. My feeling has always been put up or shut up. My reservation was confirmed when Bob informed me that Clive wanted to see us perform one more time, and in Los Angeles. I greeted his request with suspicion.

"Well, he wants to bring his lieutenants this time," Bob said.

I paused and thought about it. "OK, then. I guess we'll just have to knock his lieutenants out, too."

I looked at performing like a boxing match. I didn't want technical knockouts, just big solid punches. My goal was to leave the

audience spent, flat-out on the canvas with nothing left. I wanted this performance/audition to be even more energetic. In preparation, we rehearsed like the devil. I booked the big room at the Sunset Sound studios in Hollywood. Clive's lieutenants strutted in. Some had on double-breasted suits with those big 1970s-era Elvis Presley–looking sunglasses, while others wore white loafers with the big belt buckle. Their drag read, *I'm a record business power player.* By contrast, we had on full stage attire, with tights or bell-bottom pants; some of us had shirts and others didn't; some of us had on platform shoes, while others were barefoot. I was rarely nervous, but that night my mouth was tight and I was swallowing deeply. There was so much at stake. I had to have success to keep this new band together. We played a powerful forty-minute set.

I signed Earth, Wind & Fire to Columbia Records in early 1972.

Somewhere between the Clive audition and us getting signed, Helena Dixon quit, and Jessica Cleaves from the Friends of Distinction joined. I had been trying to persuade her to join us, but she wasn't into it until I told her we had a deal with Columbia Records. We started recording our first album for Clive, *Last Days and Time,* in April of 1972 at the Sunset Sound studios. Los Angeles in the springtime was splendid. It made those brutal Chicago winters seem a world away. I could relate to Los Angeles's energy. It was multicultural and less buttoned up than the East Coast. There were girls of every hue walking on Sunset Boulevard in cut-off shorts and open midriffs, eternal smiles on their faces.

I was in a good space. The new band and record deal had given me a renewed sense of purpose. This album needed to exceed the previous works. I wanted to musically broaden our base. A part of that broadening was to follow a long-held tradition in the music business of recording a song or two that had been a recent hit with another artist. We recorded "Make It with You," which a year earlier had been a No. 1 pop hit for the group

Bread. We also did a great version of Pete Seeger's folk classic "Where Have All the Flowers Gone?" The idea to cut those particular songs came from Clive Davis. Additional songs came from new sources. Songwriter Skip Scarborough contributed "I'd Rather Have You" to *Last Days and Time*. It was probably the most mature song EW&F had ever recorded up to that point. It's where the background vocals with that *ba-da-pa-da* thing originated.

From the beginning I wanted EW&F's album titles and cover artwork to be distinctive and personal. I wanted our Columbia Records debut to respond to America's political and racial situation. A lot of music artists were doing the same, releasing very personal music. The Staple Singers had moved from gospel to the secular with "I'll Take You There" and "Respect Yourself." Marvin Gaye had released his classic *What's Going On*. Marvin's decision to follow his muse and break out of his safe musical zone was courageous. Berry Gordy thought Marvin, as a Motown artist, was going to destroy his romantic image with "message" songs. Marvin stuck to his guns. *What's Going On* was a milestone in that it was one of the first hugely successful albums that questioned the political and social climate of the time. I was influenced by the seriousness of *What's Going On*.

I wanted our title to have a cautionary view of 1972. Vietnam had most young Americans feeling homicidal or suicidal. In Chicago and now Los Angeles it seemed to me that the military was just grabbing brothers right off the streets like it was nothing. *Hey, where did so-and-so go? Ah, man, he got drafted.* One day a cat was there, and the next he was gone. In conversations I had about the war there were a lot of side-to-side headshakes, as if there was nothing anybody could do, no hope for the future. Richard Nixon was running for his second term. This environment made *Last Days and Time* feel like the perfect album title.

At Columbia Records, I could pick and choose who I wanted to do the artwork for our debut album. While at Warner it was more like, This is your album cover—shut up and deal with it.

With the freedom and support of Clive Davis and the Columbia Records machine, I chose Mati Klarwein. He had done cover art for Santana's *Abraxas*, but I was especially impressed with his cover for Miles Davis's *Bitches Brew*. Mati's surrealistic thing was a step up for us. He did an excellent job of expressing on canvas the seriousness of the apocalyptic theme. It was just what I was looking for. Words, art, and music always went hand in hand when it came to Earth, Wind & Fire's album presentations.

Our first effort for Columbia was quite different from the Warner albums. Joe Wissert is listed as the producer, but I was producing by then. The direction of any album lies in the producer's imagination. I learned that from working with Billy Davis and Ramsey Lewis in the studio, so at Columbia I was ready, ambitious, and willing to fully take on the responsibility.

One of the big changes in the recording process was that we simply had more time. The budget was large enough that I didn't have to keep looking at the damn clock. We booked the studio in blocks of days rather than hours. We'd record a few days. I'd listen a few days, figure out the next step, and get back in the studio. There was less pressure, and I had more creative freedom.

For all the hard work that went into the album, the emphasis of Earth, Wind & Fire's life was not on recording but on performing. Building our base, we were constantly touring, trying to earn enough to keep things going. We rented Hertz station wagons over and over again. The people at the Hertz counter had to think, *Here they come again*, the bald guy and the red-haired hipster, for their four station wagons. I always sat in the front passenger seat. Leonard would be in the backseat with a big yellow pad, preparing for the next day's activities. Aside from the guys driving, every one would be asleep. We had walkie-talkies to communicate between cars. Many times we got lost, but I can count on one hand the number of gigs we missed. We were disciplined, and we worked hard.

Even though Columbia hadn't entered the full-on rock-and-

roll business yet (that's what Clive Davis was hired for), the label was huge internationally, with stars like Julio Iglesias. Columbia Records, like most labels at that time, didn't have full-time black music divisions. Of course it had distribution deals with other black artist-driven labels, most notably Kenneth Gamble and Leon Huff's Philadelphia International Records, which had a distribution deal with CBS/Epic and was beginning to make some serious noise.

Columbia did have a Special Markets Division. It was the department where EW&F landed after signing on. Back then, the Special Markets Division didn't mean that much to me, positively or negatively. They may not have been too knowledgeable in handling black music, but I didn't care. It was more important to me to be free of Warner Bros. Records. Columbia Records had commissioned the Harvard Business School to do a study in 1972 on black music and where it stood in the marketplace. Bottom line: the *Harvard Report* instructed major labels that if they wanted to get in on black music, they would have to buy their way in. Eventually Columbia did a distribution deal with Stax Records. Everybody in the business, including my best friend, David Porter, who was a big part of the Stax family, saw it as a disaster.

In late July of 1972 CBS Records had its international convention in London. We were invited to perform. It was a big deal because it was a sure sign that Columbia was committed to us. It was also an indication that we could possibly have worldwide appeal in our future. The four-day event featured several other acts: Azteca, Johnny Nash, Loggins and Messina, Argent, Loudon Wainwright, Maynard Ferguson's big band, and Andy Williams.

In the early 1970s, passengers still dressed up to take a flight. However, this was a plane carrying quite a few rock and rollers. Some of the cats from the other bands were loud and boisterous. Some were drunk. Some tried to feel up the stewardesses' skirts—very bad boys indeed. Conversely, my band members were all quiet and definitely not drinking. I knew I had a crew

who, as they used to say in Memphis, "had home training." We arrived and checked into the prestigious Grosvenor House, which is where the convention events were taking place.

People like Ringo Starr and George Harrison were in the audience when we played in the beautiful hotel ballroom. We opened up with "Power" as Clive Davis introduced us over the low rumble of our already-playing music. Clive stepped up to the microphone in a houndstooth sport coat and gave us the most wonderful introduction. He said, "This group is going to be around for a very long time, and they are going to make history." From the moment he left the stage, it was on.

Onstage, Verdine didn't have on a shirt, of course. Jessica wore a headband and a beautiful outfit that had an open midriff. Philip and Jessica did this great ad-lib exchange on the Bread song "Make It with You" that turned the crowd absolutely out. We were a force. We killed the crowd. Before the convention Azteca was the group everyone was talking about. Pete and his brother, Coke Escovedo, had just left the hugely popular group Santana, and consequently they had a huge buzz on their new band. However, after our performance it was Earth, Wind & Fire that had all the buzz.

I got back from London in early August of 1972. Marilyn had taken the trip with me. We were becoming closer. It had taken a little doing for us to get it together. From the time we met, we fell apart a few times, sometimes her fault, most times mine. By the fall of 1972, we were moving to solid ground. One of the reasons our relationship was working is that I think she discovered early on that I felt like that great bandleader Duke Ellington, who said, "Music is my mistress and she plays second fiddle to no one." In the early days, the band had to spend at the very least two hundred days a year on the road, which made it challenging to maintain a romantic relationship. But Marilyn endured right along with me.

I was excited by the response we had gotten from the London trip. Encouraged by this success, I called Clive Davis.

"You guys made me so proud, the energy, the movements, just outstanding!" Clive said. "I believe in your band, Maurice. What can I do for you?"

"Well, I need an equipment upgrade. High-grade amplifiers, stuff like that. Our gear is getting raggedy."

"Done."

I immediately asked Verdine, "What kind of amps do you want?"

He didn't skip a beat. "I want those Acoustic amps like Larry Graham"—slap-bass pioneer bassist of Sly and the Family Stone, and later creator of Graham Central Station—"has, the ones with the horn drivers and the built-in fuzz pedal."

Around this time, Ronnie Laws decided he wanted to leave Earth, Wind & Fire. When I presented him with my production company contract, it forced him to think about what he wanted to do with his career. I thought he really wanted to be a solo act, but he confessed that he had received an offer to play with Hugh Masekela. It was a childhood dream of his. Still, I was not happy. I loved Ronnie's playing and believed it was critical to our sound. I let him know my disappointment. Leonard, my enforcer, called Ronnie for weeks even after he left, continuing to express my disappointment that he hadn't signed my production agreement, asking him repeatedly, "Why would you just walk away like that?" But I had to get over it pretty quickly, even though I truly missed his playing. Years later I would come to call him "Little Coltrane."

After Ronnie split, we needed a soprano sax player fast. I wanted someone as badass as Ronnie. The soprano sax was an integral part of our sound in the early days, before our big horn arrangements took over. It's featured on "Power," our quintessential concert opening song. Just because someone is a great alto or tenor sax player, you can't assume that person will be a great soprano sax player. It's a slightly different set of sensibilities. Philip reached out to Andrew Woolfolk and asked him to join up with us. After some persistence he came to LA for an audition.

He played only one song, but that was all I needed to hear. He was in. Woolfolk was short but powerful. He was proud of his physique and worked out a lot. Beyond his playing ability, he added raw physical energy to our show. With him and Verdine on the two ends of the stage, we had vibrant energy encased by powerful bookends.

Not long after Ronnie Laws left, Roland Bautista did too. We weren't earning enough money to keep the guys committed. Moving forward, I would keep at the front of my mind the lesson I'd learned from Squash Campbell many years ago in Memphis.

To keep a band together, you have to have gigs.

9 Trusting in the Process

Yesterday is but today's memory, and tomorrow is today's dream.

—KAHLIL GIBRAN, *THE PROPHET*

I met Albert Philip McKay in Seattle, Washington, at the famous Black and Tan Club. The club's name came from the mixture of black and Asian folks who patronized the establishment. I was playing with Ramsey, and Al was playing with Charles Wright & the Watts 103rd Street Rhythm Band. During my early days in Los Angeles we did a session together. In my search for a new guitarist, I thought it was some kind of metaphysical sign that when I found Al, he was in Memphis working with my old friend David Porter's writing partner, Isaac Hayes. I told him about the EW&F concept. In another divine sign, it turns out that Jessica Cleaves, his high school classmate, had been filling him in all along. He agreed to come to an audition with us.

Al's audition was so easy, so natural. He just fell right into Larry, Ralph, and Verdine's vibe. It was like two rivers merging and strengthening as it flowed. I immediately understood Al's gift and his power. He was probably the most percussive guitar player I had ever heard. His strong wrist came from being a drummer all through junior high and high school. He also pulled and plucked his strings a lot, which added a push in his rhythm. The gig was his.

Al was born in New Orleans and spent his first years living above a bar, his bedroom right above the stage. He ingested a lot of that New Orleans Dixieland swing. Although he was later

raised in the San Fernando Valley of Los Angeles, that Dixie-land groove never left his spirit. As a kid, he fell in love with Elvis Presley, who was instrumental in him picking up a guitar. He knew Elvis's history so well that the band teased him about his reverence for the King.

Al quickly proceeded to change our rhythm section. We were jazzier and had more Latin influences than McKay's usual world. Al's powerful playing complemented that sound, giving it a more pop/centered feel. He played rhythm guitar differently from James Brown, Sly Stone, or Motown guitar players. More in between the grooves than on top of them, he redefined the role of rhythm guitar in pop, R&B, and soul music. Al could play a song but then lay his guitar groove back just a hair. This gave our music a unique feel. In our up-tempo and mid-tempo hits, Al's guitar polyrhythms can be heard chugging our grooves forward. Musically placed within the foundation of myself or Fred on drums and Verdine on bass, that core element became our musi-cal Gibraltar. From "September" to "Love's Holiday" to "Turn It into Something Good" to "Boogie Wonderland," our music sounds like a boiling stew. I can say this without any egotism, reservation, or exaggeration: we became the best rhythm section in music. At our peak, I would put us up against any rhythm sec-tion before us or since, in terms of feel, lock, and power. But at that time, we were just beginning to develop a groove that was steady, bouncy, and driving.

That groove was in full swing as we were doing one of our many East Coast swings of maybe twenty college gigs in thirty days. We had a show somewhere out west, San Francisco I think, when Al informed me that he couldn't make it because he had another gig. While playing with us, Al was still simultaneously working off and on for Stax Records, based in Memphis. As the music contractor, he hired all the outside musicians on *Wattstax*, the classic documentary film and concert, and he can be seen playing in Isaac Hayes's band in the film. Al was in demand. I was paying what I could. Since I couldn't allow anyone to miss

a gig to play with someone else for more dough, I had to let him go.

It looked like the revolving door was destined to keep spinning. There I was again without a guitar player, and I had several gigs booked. There was a cat in the band New Birth who had been telling me about Johnny Graham for a while. I gave him a call.

"Hey, man, I'm Maurice White, and I have a band called Earth, Wind & Fire."

"Fire who?" Johnny Graham had never heard of us. I gave him an abbreviated version of the concept of EW&F. He politely listened and then said no. He felt it was better for him to stay in junior college. To my complete surprise, Johnny called back a few days later and said he'd had a change of heart and wanted to give it a shot. I sent him all of our albums and made his travel arrangements to come to Los Angeles for an audition. Verdine and I auditioned with him. Johnny had a beautiful short-scale Gibson 345 stereo guitar and a Vox Super Beatle amp. Johnny's style was firmly rooted in the blues. While he played, he would stick his right foot out in front of his body. Clenching his teeth, leaning his upper body back, he would squeeze the neck of his guitar, pulling tones straight out of the Delta. His sound reminded me of watching a Muddy Waters recording session at Chess. Johnny Graham was in. I had learned my lesson: I signed him on with at least a year's commitment.

Johnny was a different kind of cat. He kept to himself. When he first joined us, he would wear this big Afro wig, which he never took off. I asked Verdine, who roomed with him, "Does he take it off when he goes to bed?"

Verdine said, "No, man, he's sleeping in it too!"

After Johnny arrived, we got on a roll. We were cleaning other groups' clocks every night. No band could match our pure energy onstage, or our left-of-center performance style.

The new rendition of EW&F had been together for almost six months. One Saturday night, at the Armory, right next to the old

RFK Stadium in Washington, DC, we opened for Funkadelic. The Armory had a huge arched ceiling. On that evening, the pot smoke rose up to that ceiling like a San Francisco fog. I yelled, "Everybody out there high enough?" This dude in the front row yelled back: "Damn right, motherfucker! Play some music!"

Funkadelic rolled over us that night. They tore our asses up. We completely bombed. We had that flower power, acoustic guitar, and peace and love vibe. George Clinton and the funk mob came out there with that *BAM! do do doot doot BAM! do do doot doot BAM!*—serving up that superstrong emphasis on the downbeat of one. They would play one groove for twenty minutes. It was like a slow freight train with a beat just rolling down the track. We were shell-shocked. We were the ones that were always rippin' other bands' asses. We were packing up our equipment while Funkadelic was still onstage. Their sound from the cavernous arena was muffled, but as soon as we opened the door to load a piece of equipment into the station wagons, we heard *BAM! do do doot doot BAM!* Every time we opened the stage door, that funk groove slapped us right in the face, pouring salt in our wounds. I don't think we ever packed up our gear so quickly.

A spanking can be a good motivator. I was eager to get back to Los Angeles and rehearse the band with a new imperative. I wanted to emphasize the basics. I reminded them of how vital a raw, animalistic, and tribal backbeat could be in moving an audience. Still, I had no desire to morph into a funk band. We were a world music band, full of rhythms from all over the world, especially Afro-Cuban.

The disastrous night at the Armory also made me realize that we needed Al McKay back. His funky rhythmic guitar playing provided a harmonic and percussive presence. Our grooves were tighter when he played with us. McKay glued our rhythm section together. I was pleased when I reached out to him and he agreed to come back to the band after he finished his commitment to Isaac Hayes. He missed us too. There was a brotherhood around the band that was fun, exciting, and unique.

Even after that early spanking from Funkadelic, our star was slowly beginning to rise. We sweated month after month in diligent rehearsing. We were pulling out all the stops onstage. During all of this time, we tried to keep an optimistic mind and spirit. Our rise wasn't necessarily due to the support, or lack of support, from Columbia Records. Despite the newness of the Columbia deal, my attitude about record labels hadn't changed much. No matter what things appeared to be, I knew I was on my own. We were gaining momentum as a result of our sheer sweat, hustle, and hard work. We also benefited from Bob Cavallo and Leonard "Bafa" Smith's willingness not to question me, but to work like crazy in charting a way for the band. They stood right beside me, whether I was turning down gigs or spending money they didn't feel necessary.

Early in 1973, after a show, Leonard knocked on my door. He seemed concerned. "Hey, man, are you OK?"

"I'm great," I said. "Why do you ask?"

"You disappear every night, and I was wondering, is something wrong?"

"Sit down, Leonard. Man, I've been on the road for seven years straight, nonstop. That hanging-out-after-the-gig guy is not me. It never was. Look at the bed."

I pointed out three or four yellow legal pads, a couple of books, and several of those old clear plastic Bic ballpoint pens in red, blue, and black.

"What are you doing?" he asked.

"Studying and planning. I need my alone time."

"Hey, Maurice, I get it. You never have to worry about me asking again."

Leonard remained sensitive to our conversation. Going forward, he would always give me the option to hang out, even though he knew 95 percent of the time I would retreat to my room. The guys were younger than me, and if I were in their shoes, I would have been hanging out too. At that time, some of the guys smoked a little weed. Some were more girl-crazy than

others, and the women were readily available. Mostly there was a lot of camaraderie. The guys never lost their sense of humor or general silliness. Larry Dunn's antics were always in effect. He was like a standup comedian, perpetually delivering one-liners. We seemed to be always laughing about something or other. We were professionals and never took anything other than the music seriously.

Earth, Wind & Fire's worldwide success was built on our playing hundreds of college dates—small and large, black and white. Between 1971 and 1973 it seemed that we were always on the East Coast. Our career momentum started to rise from that. We spent a great deal of time either riding in those four station wagons or moving our own equipment in and out of venues. Me trying to meet payroll, the guys trying to hang in there with me—it was a bumpy ride, but we had fun. One of the results of that consistent work was that by late 1972, we had a huge underground following in the Philadelphia–DC– Baltimore–Virginia/Virginia Beach–North Carolina area. It got to the point that we actually talked about moving to Washington, DC, or the Hampton/Norfolk, Virginia, area. Some colleges we played several times at—Morgan State University, William & Mary, Temple, Fayetteville State University, Shaw University, Winston-Salem State University, North Carolina AT&T, Hampton University, Bowie State University, Norfolk State University, Virginia State University, Virginia Union University, and Howard University—many of them historically black universities.

Bob was busy trying to get us exposure that I would go for. He would often say, "Maurice, you can't be so damn choosy." I would say, "Let me think about it," which really meant no. I was cautious. It had to be right for us. One day he presented me with a television appearance. *Soul!* was a groundbreaking show produced at WNET in New York City. It promoted African American artistry, but not in a least-common-denominator way. It had poets, celebrities, political/activist voices, and of course music.

Muhammad Ali, Maya Angelou, Curtis Mayfield, the Last Poets, James Baldwin, Pharoah Sanders, Donny Hathaway, and many others appeared on its five-year run from September 1968 to March 1973. We recorded our segment on December 16, 1972, and it was broadcast on January 10 the following year.

On that show, we featured Verdine's usual bass solo as a performance piece. He was like an animal or a circus freak, his body serving as an instrument. He laid his bass on the stage floor and dramatically stood over it. Straddling it, he started flaying his hand across the strings, producing thunderous tones. He was like an abstract painter. Even though I had seen him do this before, I watched in amazement. It was some of that real Verdine freak shit—shirt off, skinny as hell. As he was playing the groove, he danced. The studio audience was stunned. We also did this thing where we would be in a fiery, high-energy groove, and then suddenly we would stop playing but keep moving in a pantomime.

Al McKay returned to EW&F in January of 1973, just in time for us to record our fourth LP, *Head to the Sky*. The album was a declaration of the band's personal and professional transformations. We were shifting our ears toward jazz and world music. Latin sounds were also modifying our palette. The EW&F band in early '73 had the musicality, youth, and hunger we needed to expand into new musical horizons. The fusion movement was expanding rapidly, particularly because of such giants as Miles Davis, Carlos Santana, and my good friend Joe Zawinul, with his band Weather Report. *Head to the Sky,* cut in only a couple of weeks at Clover Studios, showcased our musical diversity, which was there from the beginning, even in the Warner Bros. days.

There was a new kind of masculinity surfacing in music. The music of the 1970s celebrated a sensitive, self-aware, and nurturing man. Songs such as James Taylor's "Fire and Rain," Cat Stevens's "Morning Has Broken," and "It Don't Matter to Me" by Bread were sung from a place of male vulnerability that hadn't been heard before. EW&F, too, put forth a new kind of masculinity. "The World's a Masquerade," "Build Your Nest,"

"Evil," and "Keep Your Head to the Sky" espoused conscious-ness. We wanted our audience to realize that to be young, gifted, and black, it was necessary to be awake and sensitive to the inner as well as the outer man.

The cover of *Head to the Sky* reflected what headspace we were in. It was the peak of our Flower Power days. We had abandoned the pea coats and turtlenecks of the Warner LPs and *Last Days and Time*. We were wearing more jewelry and took on a more ethnic vibe. Philip, Larry, and Andrew seemed to be getting "cooler" too. When they first came in the band, they were always smiling. It was annoying. I think, growing up in Denver, they were trained to look happy in public. Verdine and I, being from Chicago, were trained to have that slight street scowl, always looking serious but cool. The album photograph showed us wearing tights with no shirts. We bought clothing at Capezio, a store that sold outfits for dancing. We mixed everything up—silk with leather, suede with paisley. It worked for us as long as it was cool in our own idiosyncratic eyes.

One thing about Columbia Records, from day one, was that they never interfered, other than suggesting that one or two songs be included on *Last Days and Time*. They let me cut what I wanted. Even though Joe Wissert was more of an executive producer at this point, he also didn't have much input. I had my own artistic party going on.

I felt at home. Creatively, we were exploring all genres of music and further establishing who EW&F was as a band. Our albums were eclectic. We featured vocal-free, instrumental jams with a strong world music vibe. Our jazz fusion side was expressed on "Zanzibar." Written by the great bossa nova musi-cian Edu Lobo, it gave the new band a chance to stretch out. Studio legend Oscar Brashear has a magnificent trumpet solo. Oscar played on just about all the Earth, Wind & Fire records from the Warner Bros. days all the way into our classic LPs, but he wasn't officially in the band. Reggie Andrews also played some additional piano from time to time. Talented musicians were always

willing to lend a helping hand. It didn't matter who was playing, I liked this new world of mixed jazz, African, soul, and rock—the musical foundation we'd draw upon for our entire career.

The new song "Keep Your Head to the Sky" became our lighthouse. It's one of the few songs I wrote alone. I was sitting at the piano in the twilight of an overcast Los Angeles morning in the fall of 1972 when it came to me. It has given many people hope and optimism. At the time, it gave hope to young African Americans. I wanted the black men of Earth, Wind & Fire to inspire self-worthiness. I wanted to show confidence in our own heritage, but not stay stuck there. We wanted our black fans to stand tall and fulfill their highest potential from a position of cultural strength. My plan was to increase everybody's level of ethnic consciousness, forcing them to transcend into a philosophy that embraced all of humanity for the planet's highest good. Songs that would come later like "Mighty, Mighty," "Shining Star," and "Getaway" were written to that end.

"Keep Your Head to the Sky" was written for me. The song came out of a spiritual experience that I was going through. I had for the previous twelve years been searching for a purpose through music. God knows I loved music. Music was my friend. Music was my manhood, and Earth, Wind & Fire was my baby. Yet as vitally important as this was to me, I was growing to believe that ultimately music wasn't the rainbow's end. Prior to writing "Keep Your Head to the Sky," I'd been questioning my purpose. I was figuring out that my loyalty was to God—to hold on to my faith, to fight through my doubts. I wanted to keep believing that God was with me in spite of the challenges I was facing with the band. How far we had come was a blessing. "Keep Your Head to the Sky" is my response to that blessing, my true and heartfelt thank-you to God, my way of affirming that to walk through this life, so full of change, we need to stay grounded in our own atmosphere of faith.

I was forced to evolve as a man and bandleader. I was realizing that I was responsible not only for myself but for the entire

band. The organization was getting larger, and the payroll was gradually expanding. To protect the image of the band, however, I was becoming more and more selective. I turned down several gigs because the venue was too small, there were too many acts on the bill, or the promoter was unscrupulous. Still, no matter where we performed, I emphasized that we give the same effort. I believed being responsible in small things would inevitably reward us with the big things.

Success in the music business is a crapshoot. You need grace or luck, depending on how you look at it. I wanted to win, but win in the right way, without sacrificing my psychological or spiritual principles. I was giving it my best shot by eating right, meditating, practicing yoga, and exercising. I wanted us in top form. We rehearsed all the time. We rehearsed between gigs and when there were no gigs. I hated winging it. I took a purposeful approach to everything we did in building Earth, Wind, & Fire.

In early June of 1973, Bob called and told me that Clive was gone. Less than three weeks after the release of our second Columbia album, *Head to the Sky*, to everyone's surprise, Clive Davis had been fired as president of the CBS Records Group, accused of misappropriating money. It was all total bullshit. It wasn't about whether Clive did or didn't use company cash to his own end; people had been misappropriating funds before him at all the major record labels, and they kept on doing it and after him. It was no big secret that money was spent in corrupt ways at record companies: it was the way business was done. In Clive's defense, no matter what historians write about his managerial style and how it may have contributed to his downfall at CBS, he should forever get the credit for changing that label. CBS Records became hip with him at the helm. He completely set it up to become a powerhouse in the 1970s and '80s.

Still, like any other artist, my main concern was with what Clive's firing meant for my band. I soon got the word that Walter Yetnikoff was to become the president of CBS Records, although it wasn't official until a year or so later. Walter had a bigger-than-

life personality. He was the top dog and had the bark and bite to go along with it. Walter soon became our record man—the guy who knew the business in and out, from street hustling to getting your record played to being backslapper in chief. He assured me, through Bob, that everything was going to be OK for EW&F.

The power shift at Columbia took time to settle. In the meantime, within the band, certain members were becoming standouts. Everyone had stepped up their game. Jessica's out-of-this-stratosphere falsetto vocals at the end of "Keep Your Head to the Sky" and her musical expressiveness on "Zanzibar" established her as a serious singer. Verdine's bass style was starting to take on personality. On "Build Your Nest" he used notes that were outside the scale, which added an odd intensity to the track.

As electronic keyboard technology started to come of age, Larry Dunn dove right in. He got into the Minimoog synthesizer, which was literally the sound of the future—people in rock, soul, and even progressive jazz started to use it in different ways. No one could touch Larry on the Minimoog, when it came to getting the right sound. With its pitch wheel that could bend the sound of the note, presenting the opportunity for highly individualized expression, it was a game changer in music.

Larry couldn't have been more pleased when "Evil" was chosen to be our first single from *Head to the Sky*, released on June 22, 1973. His Fender Rhodes part kicked the song off and was dominant in the mix. For Larry, as the youngest in the group, being a featured performer on a song was a confidence booster. I loved the song because it was lyrically philosophical and driven by strong instrumental sections. It's a simple song about the human condition of our duality, how our light and our darkness walk side by side. Whichever side is leading the show ends up being our own personal story of cause and effect. Philip had been singing one melodic line, and we grew the song from there.

In the summer of 1973 Jessica Cleaves left Earth, Wind & Fire. She had gotten married to some dude who was out in Kan-

sas, and he wanted Jessica to come and be with him. This didn't pain me; in reality, it spared me a firing. Jessica had substance abuse issues, and she wasn't going to last long in the band anyway. From Sherry Scott to Helena Dixon to Jessica Cleaves, women had been an awkward fit in our band. Even though nothing went on with the boys, as far as I know, having a female in a group of young guys was a challenge. The simple practical issue of accommodations alone was difficult. I always had my own room, and so did Leonard. But early on, the band bunked two to a room. In groups with mixed genders like Fleetwood Mac or the Fifth Dimension, generally there was a romantic couple among the group, which made road life easier. But we didn't have that convenient situation.

Bob Cavallo was closely following the progress of "Evil." I would call, no matter where I was on the road, so he could inform me which stations had added it to their playlists. I was ecstatic to learn that "Evil" was becoming our first breakout single. This was largely due to WDAS in Philadelphia and DJs Georgie Woods and Joe "Butterball" Tamburro. Disk jockeys were all-powerful—Godlike. They could make or break a song, or your career. Many of the legends of the music business would have never become legends without a certain DJ in one city deciding to play their record. The DJs had autonomy. If a record label promoter could convince them to play a song, it had the potential to become a hit. One station in the right market could make your career. Today it's different. Corporations dictate what songs to play to the stations they own. DJs can't even pick their own music, which is a crying shame.

On August 13, 1973, at the 6,500-seat Bangor Auditorium in Maine, we started a tour with the British progressive rock band Uriah Heep. These guys were pure hard rock—great musicians and unique for their time. Bob Cavallo said to me, "You want to be treated like a rock band, well, here ya go, pal." As the opening act, we had about an hour to do our thing. To Uriah Heep, we were this weird black group with weird clothes and

weird movements. We slammed into our show and quickly had the audience clapping with the beat and singing with us in a church-style call-and-response. These audiences were 99 percent white, and they dug us. They called us back for encore after encore. When we left the stage, the audience was so worn out, so depleted, so tired, that they had nothing to give Uriah Heep. This went on for about a month before somewhere in the Midwest, we were unceremoniously told to go home. We'd been kicked off the tour.

The short-lived Uriah Heep tour garnered some publicity that we would not have gotten otherwise. Publicity meant record sales, and record sales meant we could charge more for an Earth, Wind & Fire concert. More money meant sustainability, which Bob reminded me of constantly. Still believing I was too finicky, he kept bringing me things that he thought would fit with my mind-set. Consequently, in late September 1973 we, along with the Rolling Stones and the Doobie Brothers, recorded the premiere episode of *Don Kirshner's Rock Concert* on ABC-TV. We performed "Evil" and "Keep Your Head to the Sky," wearing outfits designed and tailored especially for us by Martine Colette, an up-and-coming costume designer in Los Angeles. The outfits were flashy, but since they were made for us, it at least felt like an upgrade.

I wasn't pleased with the performance. We were rushed in and rushed out, and I felt slighted. Even though we looked scruffier, our performance on *Soul!* a year earlier had been more organic, more distinctive and quirky—more of who EW&F really was. The *Don Kirshner's Rock Concert* performance reminded me that television was an unforgiving medium. If we were to continue messing with TV, we would need some control over the entire process, including staging, lighting, and sound.

The next morning I went for a long walk up into the hilly streets behind my house. I looked over Los Angeles, feeling frustrated. The lessons I'd learned the day before were too clear to ignore. We were putting a lot of effort into our live show, and I

was still disappointed. Was I expecting too much? I realized that my expectations weren't too high, but maybe I was expecting too much too soon. I needed more patience. If I kept my vibration in the right place, the universe would ultimately bring us people and resources, and put me in the right place to get what I wanted from our live show. But I had to trust the process.

10 Step

Born of the Earth are nature's children
Fed by the Wind, the breath of life
Judged by the fiery hands of God

— "EARTH, WIND AND FIRE," *SPIRIT*, 1976

*H*ead to the Sky had finally made it to certified gold status. It was gratifying, but I was unsettled. I didn't want to get trapped in worldly success. I also didn't want some "suit" to say, You've jumped this high, now you must jump a little higher. That kind of pressure could cause someone to jump into the loony bin or to have low self-esteem and feelings of inadequacy. Chess Records had burned that kind of hurdle-jumping out of me. I've seen demands like these make guys lose their hope, pride, and direction. Of course I wanted all the success in the world, but I just didn't want to be shaped by it. I never wanted to be motivated from an outside source, only from within. I wanted to set, run, and jump my own personal hurdles, hurdles I'd created myself.

Our achievements inspired me to enhance our lyrical and musical dimensions. I wanted to publicly voice how I felt about God. I also desired to express my belief that overindulgence and too much hanging out was bullshit. I believed I had the right individuals in the band to pull it off, but I needed another ally to help me reach a higher musical dimension.

Verdine instinctively knew when I was up to something, and he couldn't help being nosy. "Who you talking to?" he often

asked. I told him, I've recruited Charles Stepney to help us out on this next record, and he's flying to Los Angeles next week.

"Man, this musical thing I'm getting ready to throw you into," I said, "it's going to make you a legend. It's going to take all of us to the next level."

"How?" Verdine asked.

"In every musical way possible."

Verdine liked hearing that. He always liked the feeling that we were off on yet another new adventure. He was consumed with being in Earth, Wind & Fire. His bright enthusiasm was present in everything he did, whether it was voice lessons or dance lessons.

Step, as I sometimes called Charles Stepney, was a brilliant musician. Whenever I was in Chicago, I would always check in with him. I never failed to remind him, "Step, as soon as I can afford it, I want us to work together again."

After Charles joined us in the studio, the guys recognized that he was not a man to mince words. Along with a short fuse, he had that Chicago bite that could be harsh, encouraging, and loving all at the same time. Years of producing experience had made him an expert psychologist. He instinctively had a feel for musicians' emotional makeup, quickly identifying their strengths and insecurities. I hired Charles because he knew the nuances of music. He quickly let us know what was working and what wasn't. He had a way of communicating with the guys so that they would not become defensive. Being a master arranger, he knew all the instruments. His sophistication as an arranger suited the band, and he instructed each musician in a way that made us receptive. He gave the guys a new understanding and appreciation for what they were doing musically. I think the guys got to the point where they actually wanted to please Charles, and as bandleader I benefited greatly from this paternal dynamic.

Charles sometimes, like Ramsey Lewis, called me Rooney Tunes—a takeoff of Looney Tunes, because, he said, I always had a new song. One thing he believed in strongly was the power

of the producer. He often told me, "The Beatles without George Martin would just have been a bar band." I didn't agree with that, but I got his point.

He also told me, "Rooney, you've got a great bunch of young talented guys here, but the more direction you give them, the better off you'll be." This advice wasn't a big revelation, but Charles was always trying to push me.

Going back to our Chess days, Step had done six albums with the Rotary Connection, an interesting band with a psychedelic soul vibe, kind of like Sly Stone meets the Fifth Dimension. Minnie Ripperton, their lead vocalist, had a five-octave vocal range. Minnie would later score a No. 1 hit with "Lovin' You," one of the simplest, sweetest, and most intimate love songs of the 1970s. Her vocal footprint is unique in American music.

Minnie's voice, coupled with Charles's arranging ability, contributed to his ability to work with high-pitched voices. Philip and I together had a falsetto background sound. With Charles as our guide, we learned to establish a sound together. Charles saw our voices as a tool he could use with his arrangements. One can hear it later on "That's the Way of the World." Andrew's soprano sax and flute against the high range of our background vocals on "Feelin' Blue" are an example of the many things that Charles introduced that would class up the sound of EW&F. He really knew how to voice piano chords in a way that they left melodic space for the vocals. He stayed away from cluster chords. His arranging ability gave my musical imagination the space to experiment, allowing me the freedom to be even more daring and aggressive with my musical vision.

Charles's presence brought a sea change to the life of Earth, Wind & Fire, forever altering our destiny.

When we started recording our third album for Columbia, I was on a mission. Finally, the revolving door of various band members had stopped spinning. This EW&F would be the configuration the world would come to know, as we strived to be the best band in the world. It was the start of a new era. In Novem-

ber of 1973 we chose the Caribou Ranch to record *Open Our Eyes*, intentionally selecting the pristine mountain environment to inspire us creatively.

Caribou Ranch was a recording studio that producer Jim Guercio owned on 4,000 beautiful acres in the Colorado Rockies. Some of the guys had trouble adjusting to the high altitude. Other guys struggled with the temperature. "It's cold as hell out here," I remember Al saying. Andrew and Larry were comfortable, as they were used to the weather. We were only an hour or so from Denver, their hometown. Ironically, even though Philip was from Denver as well, he did not like the cold weather.

Elton John recorded a few albums at the Caribou Ranch, as did Chicago, Blood, Sweat & Tears, and America. Bob was the one who suggested that we go away to do the album. It would help us to focus; we could work our craft without the distraction of telephones, visitors, and the crazy Los Angeles energy. The studio had opened in 1972, and we were the only black act who went up there during its early days. It was part of my vision of wanting to have the same opportunities as the big rock acts. Bob knew that it would send a message to Columbia Records that EW&F was not just another black act that it could treat as a second-class citizen.

Caribou Ranch, 8,600 feet high in the Colorado Rockies, was part studio, part retreat. We each had our own cabin. The cabins were nice, almost like a hotel. When Jim Guercio's wife, Lucy, ushered me into mine, before dropping the key in my hand, she said, "This furniture set belonged to President Grover Cleveland. I bought it at an estate sale in upstate New York." The cabin was beautiful. The dresser had a huge oversize mirror, and the floor was covered with expensive throw rugs. Additionally, it had a great sound system and a color TV. A huge stone fireplace was the focal point of the room.

A powerful incident shook me to my core my first night in my cabin. I couldn't sleep, and was tossing and turning in my bed. I opened my eyes, and there was this thing standing right at

the foot of my bed. At first it looked like a hologram, a projected image. Then it took the form of a tattered sheet with holes in it. I froze in my bed as the ghost stared at me. After a few seconds I picked up a shoe and threw it at the vision. The shoe went right through it. I yelled, "Okay, motherfucker. I'll get your ass." I threw another shoe. It passed through the ghost and broke the window. The image ultimately moved right through the wall. I couldn't believe what I saw. It wasn't a dream. It was real. Studio owner Jim Guercio said Elton John saw it, as well as one of the cats in the band Chicago. Charles Stepney said he saw it, too.

The next day, we started recording. Although I had obviously played straight-ahead jazz with Ramsey, Earth, Wind & Fire had never put anything close to that on a record. "Spasmodic Movements," a jazz tune written by sax legend Eddie Harris, was one of those songs that Charles guided the band through. Andrew Woolfolk, our saxophonist, played the melody. I had every faith and confidence in Drew, who'd studied jazz under Joe Henderson, but he was scared to death. "Spasmodic Movements" had similar chord changes to John Coltrane's "Giant Steps," and he didn't know if he was going to be able to do it. He loved jazz and all that, but he didn't feel that he was a John Coltrane. Giving him confidence, Stepney schooled him line by line, chord by chord.

Philip and I had written a song, "Devotion," steeped in a simple spiritual truth. Philip sang his ad libs a few times. His notes were fine, but not working on an emotional level. Charles stepped in. In addition to his technical training, Charles had a sixth sense about communicating with musicians, a necessary skill in the creative and sensitive atmosphere of a recording studio.

"Philip, I want you to try it one more time. But this time, think of your mother."

"OK, I'll try, Charles."

Philip closed his eyes and belted out the lyrics with a conviction that I had never heard from him in the studio. I had heard it onstage, but not in the studio. Step had gotten the emotion

and the believability out of him. Philip's vocal touches gave me chills. His performance was delicate and graceful.

Larry Dunn, our keyboardist, was challenged by Charles more than the other members because Charles was a stellar pianist. Larry wasn't the best reader when he joined the band, but he had a marvelous feel. Charles would stand behind him, closely observing his finger movements, saying, "That's good, that's very good, Larry." However, with the studio clock running, Charles's patience wore thin. He would take his butt and slightly scoot Larry from the piano bench to demonstrate how he wanted the song played. Larry would then carefully look over Step's shoulder and observe his technique. He was getting a university class in piano skills.

Charles was harsher with me than with the rest of the band. He would be all over me if I made the tiniest mistake on the drums. He didn't feel he had to spare my feelings, since I had a lot more studio experience, and he didn't have time for me to be screwing up. Privately he confided, "Man, if I get on your ass, the kids won't take my barking so fucking personally." It was always with a wink and a smile.

We pressed on with the sessions. I felt a slight sense of panic before I walked into the recording booth to do the lead vocal for the song "Open Our Eyes." The song was played heavily in Chicago by the legendary DJ Herb "The Kool Gent" Kent, who would play it at the end of his shift on the Chess-owned radio station WVON (Voice of the Negro). Written by Leon Lumpkins and made popular by Jessy Dixon and the Gospel Clefs, it's a beautiful song written like a prayer, a plea. Philip sang the lead first, but Stepney and I thought his falsetto sound wasn't right for the song.

I had tried for more than three years to avoid being the lead vocalist for EW&F, though I had ended up as such by default. Since the time I created the band, however, I had limited myself to up-tempo songs. I didn't trust myself with the vocal isolation of a ballad, especially a gospel ballad. For us black folks our

music conservatory is the black church. Singers that come from the church are some of the best in the world. On this night, I had to become a *singer*.

I stepped outside the studio to ask God to lead me through the song. My face was hit by the cold Rocky Mountain night wind. I was startled by its briskness. All of sudden, out of nowhere, I was consumed with thoughts of Mama. Pictures of her flashed across my mind. I was back in Memphis. I saw her in the sparse living room in the Lemoyne Gardens projects, rocking back and forth, humming with Mahalia Jackson on the Sunday-night gospel radio shows. I saw her at Rose Hill Baptist Church sitting in the pews, singing hymns in her alto voice while cooling herself with a paper fan advertising a funeral home. Call it the Holy Ghost, because right then my Christian roots fell upon me. Mama's spirit walked with me in the vocal booth. I closed my eyes and locked on to the melody.

> *Father, open our eyes, that we may see*
> *To follow Thee, oh Lord*
> *Grant us Thy lovin' peace, oh yeah,*
> *And let all dissension cease.*
> *Let our faith each day increase, oh yeah,*
> *And master—Lord, please—*
> *Open our eyes, open our eyes*
> —"OPEN OUR EYES," OPEN OUR EYES, 1974

I felt like my performance that night was my homage to Mama and the God of her understanding—the Christian faith that gave her strength to endure. "Open Our Eyes" represented a turning point. It showed me that I had come a long way from the Christian roots of my childhood. However, I did not disrespect my mother's religion. I honored her convictions. Her faith was a blessed gift to me.

In the months following our recording in Colorado, I found myself at a spiritual crossroads. Between my studies of God,

astrology, and numerology, I had hit a wall. I was spiritually rest-less. I felt alone. My anxiety was not about belief or non-belief. I still believed in a "Christ consciousness," which I define as a blending of divine mind with my own. I did not believe in Chris-tianity as defined by the dominant American culture. I was just unsure of where to place myself in the world of religion. Was there a space between the gods of cultures—American, Asian, Indian, and Israeli—that I could call home? I had long ago determined that I would never be involved in spiritual thought that relied on fear or had a God-is-out-to-get-you mentality. I was not interested in hellfire and brimstone or a hanging judge. God is not to be feared, in my book. God is to be respected.

I didn't see astrology or numerology as religion, but as divine sciences. I didn't see Buddhism, Christianity, Hinduism, Juda-ism, Islam, Native spirituality, Taoism, or anything else as hav-ing the exclusive rights on God. If God is a loving, celestial being—bigger, brighter, and more magnificent than I could ever imagine, bigger than culture—there had to be more to my spiri-tual path than the randomness of where I was born or how I was raised. I had a burning desire to once and for all get past the cultural specifics of God and simply get to God. I felt this was my destiny.

As much as I was seeking the Creator's guidance, I now real-ize that the Creator was also seeking me. I am not special. As in the biblical parable of the lost sheep, I believe he seeks out each and every one of us through a host of different paths, not neces-sarily religious. It could be just healthy psychological and emo-tional functioning. I like this acronym for God—Good Orderly Direction. I've always been mystified by the disunity of faiths. I was passionate about spiritual harmony. A special enlighten-ment for me was found in *The Sufi Message* by Hazrat Inayat Khan. In fourteen volumes, Inayat Khan lays out the principles of Sufism. Volume 9, *The Unity of Religious Ideals*, turned me out. He made plain the unity of all faiths.

Moving through 1974, I started to connect with Eastern/

New Age philosophies. I don't like the term *New Age* because so many of the great truths are actually ancient, but of course we should interpret spiritual literature to fit our present-day situation. Reading and studying books on Eastern philosophy, I became captivated by the premise of Metaphysics 101: Change your thinking, change your life. I started to realize that most of us, including myself, are bred into our beliefs, behaviors, and desires. I wanted to be truly free of the limitations handed down to me by the dominant culture. I wanted to be free in my mind and spirit. I wanted to embrace the mystery of God—a God who can never be fully known but only experienced—and to this end I started to see God in terms of energy. I learned about the chakras, the seven centers of spiritual power in the body that energy flows through. People's vibrations, thoughts, and energies were real. More than ever, I resisted people and situations I deemed to be negative.

★

TO SING OUR MESSAGE LOUD AND CLEAR

11 True Pride

Just be proud of the land
Where your blood comes from
No one can take away what you have done
Hold your head up high, cultures stand eye to eye
One people living under one sun

—"HERITAGE," *HERITAGE,* 1990

In 1974 African Americans were moving on up. We were getting jobs in corporate America. We were integrating neighborhoods. We had a greater presence on television, where seeing us became less of an event. Still, I was feeling that a lot of black folks were unhappy and depressed. Civil rights advancement is one thing, but healing is another. I was determined that EW&F's musical pulpit would provide some healing. Between "This World Is a Masquerade," "Keep Your Head to the Sky," and "Evil," the groundwork had been set.

I was also convinced that racism's legacy in America had left many black folks confused. Our history had been stolen and hijacked. Consequently, we were drawing our cultural self-respect from fraudulent sources. Our rich culture didn't start on slave ships or in cotton fields, and it sure didn't start in the Cabrini-Green projects of Chicago. It started in Egypt. Knowing where you came from gives you confidence and pride that can't be easily taken away. Egypt gave the planet mathematics, astronomy, science, medicine, the written word, religion, symbolism, and spirituality. Despite what centuries of distor-

tion have told us, the civilized world did not start in Europe: it started in Egypt. This is the core reason I turned to Egyptology: it encourages self-respect.

Many of the EW&F fans were attracted to our music simply because it made them feel good. I hope that my work has been a small part of the process of uplifting my own people, while ultimately touching the world at large in a positive and meaningful way.

I wanted EW&F to use the symbols of Egypt in our presentation, to remind black folks of our rich and glorious heritage. And not just African Americans: today we have scientific proof that all of mankind has African origins. We are all brothers. Everybody is connected. On some basic, primal level we all are a reflection of the universe, and in that reflection we are connected to one divine source, God.

On February 1, 1974, "Mighty Mighty" was released as the first single from our new album, *Open Our Eyes*. The song professed that people could overcome seemingly impossible obstacles with determination and self-belief. It encouraged listeners to ignore negativity. Our message of empowerment urged our audience to seek education and embrace solid values. The message was for everyone, especially African Americans, since some people feel that white folks' ice is colder than ours. I couldn't ignore racism. It was everywhere, from street corners to boardrooms. But I didn't believe that anybody should permit color to stand in the way of achieving goals. There may be a tiny bit of denial in that statement, but sometimes denial is the little extra edge that makes the difference between greatness and mediocrity. The principles of "Mighty Mighty" would be one of EW&F's recurring themes.

I was pleased when "Mighty Mighty" became our first breakout record. Bob Cavallo believed the song could have been bigger if some hadn't perceived it as a black power message—or, as he used to joke, "Mighty Mighty—kill the whitey."

Open Our Eyes, the full album, was released twenty-one days

later. By then the band was already back on the road, continuing to build our base. As "Mighty Mighty" started to gain radio traction, we never wavered from our plan: to expand our audience across cultural lines. Our college tours now went to 60 percent black colleges and 40 percent white ones. College kids were open. They weren't hung up on the race of the band. This was in direct opposition to the promoters of the day, who thought in segregated terms. I spent hours talking with Bob Cavallo about ensuring that Earth, Wind & Fire would not be regulated along color lines.

First, I knew that a diverse fan base would give us a far better chance to keep the businesspeople out of the studio and out of the creative process. I saw what interference from the suits at Chess Records did. I had heard the legendary stories about creative interference at Motown: *This is the song you are going to record. Period. Shut up and get in the vocal booth.* I didn't want any part of that—no way, nohow. I refused to stuff the band's musicality into a box. If we were successful, Columbia would not have the balls to demand that we mimic the musical flavor of the moment.

Second, in 1974 Columbia Records was just getting its feet wet when it came to what it considered black music. Clive Davis, who had signed us, came across to me as a "free music thinker," but he had been fired. I had to reignite my advocates at Columbia. This would be my first one-on-one exchange with the charismatic, irrepressible Walter Yetnikoff. Standing in Walter's large corner office, overlooking Manhattan, I gave him my long-winded one-sentence pitch, with artist references I thought he could appreciate.

"Walter, I want the world music vibe of Santana, along with the psychedelic/soul of Sly and the risk-taking jazz of Miles Davis, coupled with a firm commitment to higher thought in our lyrics."

"That's great, Maurice," he said, "as long as you have a hit."

His short, direct response sums up the way of the world

according to record companies. Columbia didn't care about my vision for EW&F, with all its diverse music and spiritual aspirations. Yetnikoff's knee-jerk reaction was another reminder that even with the power of Columbia Records behind me, when it came to my comprehensive philosophy of the band, I was still on my own. I was fortunate, however, that Sly and the Family Stone and Santana were on the label. At least a divergent music group wasn't completely foreign to Yetnikoff and his minions.

I began to accept that if I was going to pull off my dreams for the band, there would be no miracle moment—no one performance, no one song, no one album. It would happen in stages, in small and large deliberate steps in every area of our expression—recording, performance, and visuals.

In time it became clear that those deliberate steps would require bringing in outside musicians or more businesspeople. Sometimes it was tough on the band. Sometimes it was tough on my business associates. But it wasn't personal. One of our first challenges was with the drum chair. EW&F is a band of drummers. I played the drums, and so did Ralph, Philip, Al, and Fred. In the studio I commanded the drum chair. Ralph played on some songs in the studio, but not many, to save having to explain how I wanted things played. Ralph was the drummer onstage, and a good one—he's always had strong skills. But by this time, my baby brother Fred had started to gradually but persistently put the bug in my ear. "Hey, man, you're gonna need a strong drummer with a big bass-drum foot for this gig," he would say. "You need to let me do this one show." He didn't say he wanted to join the band, just, let me do this particular gig. Those gigs would always be the ones in the bigger markets, like New York, Chicago, and Los Angeles.

Fred had come a long way musically—and fast. As I remember it, he went from playing with sticks on the floor to being a real professional in no time flat. I gave him Donny Hathaway's first album. At the age of sixteen he got the gig with Donny. I was surprised that Mom and Dad let him go out on the road at such a young age. I think the fact that I knew Donny made their

decision easier—and Donny knew Dad wore a size 13 shoe. He would have kicked Donny's ass to Detroit if anything happened to Fred. Fred played in Donny Hathaway's band until the fall of 1972, when he moved to Los Angeles. Working steadily, he did sessions all over town and was starting to make a name for himself. Soon he was back on the road as the drummer for my friend Lowell George's band, Little Feat.

"What about Fred joining the band?" I asked Verdine.

"What about Ralph?"

"Ah, we can make it work."

"But Ralph . . ."

I didn't consider Ralph's feelings. It wasn't personal; I had to do what was best for the group. Verdine and Ralph were close, just as a drummer and bass player should be. Verdine called Ralph his "checkmate Charlie," always looking to him to see how we were doing onstage on any given night.

Bringing a new member into an established band is always tricky. It's not only about music, it's about personality and trust. Fred wasn't just another cat, either. He was my and Verdine's brother. I knew this was the right decision; the musical bond based on blood and psychic ties between V the bassist and Fred the drummer would be above anything that Ralph could ever compete with. Their kinship would show up in the music.

Fred had gotten off the road a day before meeting with Verdine. He had about seven newspaper articles that mentioned him performing with Little Feat, and was excitedly waving them at Verdine. V looked at the articles for one second and said, "We want you to join the band."

Our first gig with Fred was in Missouri at the St. Louis Arena. The impact was immediate. Everyone in the band could feel the difference. Fred's musical aggression turned up the heat, putting our live show groove on lockdown. Fred had perfected the same technique I had worked on more than ten years earlier—the ability to play energetically at slow and soft tempos. This made our entire show more intense.

The St. Louis show gave Fred a great introduction to the band. We soon had two drummers playing live: Ralph's drum kit placed stage right, Fred's drum kit stage left, with Larry Dunn's keyboard set up in the middle. I knew it was a challenge for them to get it together. Who would plays the fills? Who would play the backbeat? This was not an easy musical thing to do. It didn't help the situation at all that Fred was cocky, young, and a bit arrogant. Since I was bandleader and Verdine was really second in command with the live show, I think Fred felt nobody could tell him anything. Ralph Johnson gradually started playing the drums less and less and became a front man instead, singing background vocals at center stage with Philip and me.

Some of the band liked Fred, some didn't. Saxophonist Andrew Woolfolk and our production manager Frank Scheidbach said they were babysitting. Reluctantly, they both seemed to take Fred under their wing. Yet others took their sweet time to warm up to baby brother Fred. Given the musical and personality complications of Fred joining EW&F, I must give Ralph credit for being mature and having a spirit of graciousness and cooperation.

By and large the band cooperated with my choices. Earth, Wind & Fire never argued about what we were going to do next. The guys gave me their respect, as they all came to see the value of being in a band that was focused. Unlike in many bands, there was no voting. I generally met with the guys one-on-one. What helped me tremendously was that we didn't participate in excessive drinking and drugging. I led by example. I wanted to glow and be a shining example of the merits of the clean life.

The only constant activity in the band's life was gigs. The recording studio felt like a rest stop on an interstate highway. At every stop we'd handle our business and then get back on the road. Back and forth across the country we went. It was still exciting, but gigs started to have a sameness for me. This all changed in early 1974, when Bob Cavallo called.

"You won't believe where we got an offer to play," he said.

"Where?"

"The California Jam."

"The California what?"

Every decision, big and small, was having an impact on our career. According to Bob, the California Jam offer was in direct response to who EW&F was becoming, imagewise. At the time we had a cult following. As black guys, our lyrical commitment to higher consciousness and our support of meditating and healthy eating were starting to set us apart from our counterparts.

The California Jam was a concert for the rock elite that served a 95 percent white audience. These kinds of gigs weren't foreign to us. At that point, we were opening for ZZ Top, Faces with Rod Stewart, and others. As the only black act on the bill, we definitely represented a new kind of Negro. Society, in a variety of arenas, was becoming more accepting of a different kind of black man. In the previous year Maynard Jackson and Tom Bradley had been elected as mayors of Atlanta and Los Angeles. Significantly, white majorities had elected both. Atlanta being the hub of the South and Los Angeles being the king of the West, these elections signaled that white America was becoming more accepting of black folks.

We almost had to cancel the California Jam gig. We were on a cross-country flight back to Los Angeles, a week or two before the show, when Larry Dunn cut his finger badly on a razor-sharp paper towel dispenser in the plane's bathroom. There was blood everywhere. It took him a long time to completely heal. I don't know how in the world he played that gig with bandages and stitches, but he did.

Arriving a day before the show, I quickly realized that this was not just another outdoor concert. The hotel was so far from the staging area that we had to be flown in by helicopters. It was our first helicopter ride. We flew so close to the ground, I thought we were going to hit the trees. Then seeing the expanse of the area was awe-inspiring, if not a little nerve-racking. The stages were literally built on train tracks, so they could move them in and out

quickly. They had fifteen-story twin towers where the 54,000-watt sound system was placed.

The California Jam was a once-in-a-lifetime event. Featuring Emerson, Lake and Palmer, Black Sabbath, the Eagles, Rare Earth, Seals and Crofts, and Black Oak Arkansas, it was called the West Coast's Woodstock. Before we took the stage, someone tapped me on my shoulder: Jim Brown, who was hanging out backstage with two of the finest women I had ever seen.

"Reece, it looks like your vision is coming to pass," he said.

"What do you mean?"

"Man, this a fucking rock concert! This isn't some soul music festival."

It had been only two and a half years since I told Jim that I wanted to be treated like a rock act.

Taped for ABC Television, the concert was great exposure for us. We had just gotten some new outfits, and we were ready. There were at least 250,000 people at the Ontario Fairgrounds, which is fifty miles east of Los Angeles. As always for any of our shows, Verdine did something special: one of his outrageous bass solos. By the way, the whole idea of Verdine doing bass solos was from V and I going to see Fred play with Donny Hathaway at the Troubadour in Hollywood in the early 1970s. Willie Weeks, the bass guitar legend, took a bass solo that was sooooooo badass that I whispered to Verdine, "Okay, we gotta do that." But as always with V's huge stage presence, a bass solo just wasn't a bass solo; it was always an entertaining, theatrical performance piece. The audience loved it.

A short while later we got the opportunity to open for Sly and the Family Stone at Madison Square Garden. From the beginning, Sly was the only group I had to compare us to. I saw the way his music was universal and reached beyond color lines. He was what I aspired to for EW&F. We had opened for Sly before, but not on this level. This wasn't Greensboro, North Carolina, or a theater or some college. This was the Garden. This was New York City.

The moment Leonard said, "Presenting the elements Earth, Wind & Fire," my stomach was in knots and my legs were shaking. I don't think I had ever been that nervous for a show in my life. We did all we could to make it special. Verdine had acquired the actual harness that Mary Martin used in *Peter Pan*. At the appointed moment, he shot straight up in the air like a rocket and hung high above the stage, his legs wildly flailing in the air while he kept on playing his Fender bass. The Garden went into a full-on frenzy. We killed them—even Sly took a backseat that night. I don't recall many nights where I felt more appreciated and validated after a show backstage.

I talked briefly with Sly after the show, exchanging small talk about both of our bands' future plans. To my disappointment, I quickly realized that cocaine had taken over his life. He was coherent, but he went through about three different mood swings in five minutes. Sly had always symbolized genius to me, but now he symbolized excess and abuse. I felt bad.

Even though we had smoked a diminished Sly and the Family Stone, that performance gave us a lot of confidence. Not long after, we were doing an equal-billing concert with War at the Nassau Coliseum on Long Island, New York. It had previously been agreed that we would go on last, but their management got into an expletive-laden shouting match with Bob Cavallo, demanding that they be last.

Bob came to me on the bus. "They want to be the headliner," he said, rolling his eyes. I was silent. I thought about it for a second and then said sure, we'd open for them, which squashed the dispute. I motioned for Verdine to step outside of the bus and whispered to him what was going on. Verdine, the drum major, informed everyone else. We hit the stage and burned it down to a smoldering crisp. Competing only with ourselves, we kicked a little higher and played a little harder. We did one encore, and the audience was screaming and clapping in rhythm, more, more, more, more! To aggravate the audience, I said, "We'd love to play for you longer but we have to make way for War." The

crowd hit the roof! They started booing and throwing stuff, and half the audience just got up and left.

At that time War had way more hits than us. They had "Slippin' into Darkness," "The World Is a Ghetto," and "Cisco Kid." But we had something more than hits; we had energy, musicianship, and a theatrical sixth sense. The word got around quickly: you never, ever want to follow Earth, Wind & Fire, whether you are a rock, pop, or soul act.

I didn't have the showmanship one expects from the lead singer of a band. I couldn't dance worth a damn. But my movements became the Maurice White groove. I harnessed a great confidence that radiated. I was finally becoming comfortable as a lead singer, after a twenty-year journey that had taken place in stages. Seeing the girls at Booker T. Washington High go crazy for my friend David Porter and watching Joe Duke's flashiness and Squash Campbell's onstage antics were the first things that helped me conquer my shyness onstage. Witnessing Ramsey's confident yet smooth and controlled way of communicating with an audience was another stage. Recording "Open Our Eyes" was yet another. Finally I learned to put away my inherent shyness and to "turn on" by simply walking up the steps to the stage, waiting for the lights, and just doing it.

12 Accepting Life

Remember when life's path is steep to keep your mind even.

—HORACE

On May 24, 1974, Duke Ellington died. Duke represented the best of what America could produce. I went to the newsstand and bought every major newspaper so I could clip the obituaries for posterity. I was pissed off; I didn't feel enough respect had been paid to this American icon's passing. Duke—composer, pianist, and bandleader—was bigger than the president of the United States to me. Duke and Count Basie were guys who worked very hard to keep their respective bands together, and I saw myself in that tradition.

Once in the mid-1960s I saw Duke's bus parked on Michigan Avenue in Chicago. I looked with awe at the big letters painted on its side: DUKE ELLINGTON & HIS ORCHESTRA. My whole understanding of the word *bandleader* started and ended with Duke Ellington. He had the absolute highest musical standards, and nothing got in the way of his music. I heard many stories of his struggles to keep it all together once rock and roll was born in the late 1950s. But right up until his death, he kept his band working. I was a jazzster by heart, and his departure represented the end of an era to me.

Later I got some devastating news: Mother Dear had breast cancer. It hit the family hard, but Mother Dear was optimistic: "I'm going to have the surgery, and I'll be fine." Surgery was a radical double mastectomy.

Mother Dear talked to all of the older kids, but as best I can tell, she and Dad kind of kept the two youngest, Karen (ten) and Margie (twelve), away from it, trying to protect them. Her illness made my head spin. I wanted to spend as much time with her as I could to talk more, face to face. My excuse was the endless 1974 and 1975 tour schedule of two hundred–plus shows a year. I felt guilty. In my choice to be a musician, I had intentionally elected not to have a normal life—that traditional life where I would come home every night for dinner, raise a child, or be there for Mother Dear in her illness. I think Dad was doing the best he could to cope, but he had his limits, understandably. My sister Patt, who was almost finished with her studies to be a nurse, was really the point person in the family, whom we all turned to, to keep us updated. Thanks be to God, Mother Dear gradually got better.

Around the same time I found out that Evelyn, a wonderful friend whom I'd seen off and on since my Ramsey Lewis days, was pregnant—and I was the father. She was happy. Once I got over the shock, I was happy too. My only disappointment was that I knew I would not have the time to spend with Hemeya (Mimi), my first child, and my only daughter. Even though I didn't know what a father was in everyday practical terms, I had enough sense to know that not being around physically left me lacking from the start. To try to heal that breach, I bought Evelyn a house in Philadelphia so she would have a cool place to raise Mimi. Being a good provider is the first law of fatherhood, but it is certainly not enough. As a matter of fact, on a certain level it's not really being a father at all. You leave a child with a myth and wishes about who you are, as a man and as a father. And I became the enemy sometimes, because of that truth and because of some falsehoods. My relationship with my daughter has always been strained. I am not proud of it. I have some shame about it too. I take responsibility for the toll it has taken on her and myself.

I would have other opportunities down the line with my other

children to be a father who not only provided for my children's material needs but also was present in their lives. But the hard, cold reality is that if you are not physically present, you really can't be a total father. That's an issue I would be working out for the rest of my life.

The next major change in my life had to do with money. After almost five years of nonstop touring, things were starting to pay off. I got what I considered to be my first big royalty check, for $67,000. To get that at one time was significant. As much as I believed in myself and what I was doing, when I looked at those zeroes, I was convinced that we could make it.

The path from starting a band to rock-and-roll stardom is simultaneously complicated, rewarding, often disappointing, and glorious. The corporate suits would say your record is doing great or your record is a flop or your record sold this number of units this week—blah, blah, blah. I was trained to remain neutral and not to respond either positively or negatively. Chess Records had burned a stone-faced coolness in my psyche. The audience's response was my only true barometer for how Earth, Wind & Fire was doing.

We placed "Devotion" earlier and earlier in our set. We would abruptly halt the music, and the entire crowd would continue singing the lyrics: "You need devotion, bless the children." I think this first happened at the Civic Center in Pittsburgh. This affirming response continued in city after city as we moved down the East Coast. DC, Roanoke, Richmond, Hampton, Norfolk, Greensboro, Charlotte . . . on and on, the feedback confirmed our popularity. People were listening to the records! Fans showed that they related to us not with superficiality but with seriousness. After the shows, folks would come to us and talk about raising their consciousness. Conversations about diet and God went side by side with discussions about the night's performance. There was a scene developing around us. The guys felt validated by the kind of fans we were attracting. There are many things that can destabilize a band, lack of suc-

cess being the big one. And on the road at least, we were starting to feel successful.

We went back to the studio in June to sketch out some new ideas. Soon after, we headed back to New York for something or another, and I took the cassettes of those sessions. A couple of the tracks we had recorded I knew we were not going to use, but I thought they could be great instrumentals. I was really excited about a thing called "Hot Dawgit." It came to me in my sleep, as many of my ideas did, that this could be great for my old mentor and friend, Ramsey Lewis. I found him on the road in Washington, DC.

"Hey, what you doing?" I asked.

"Well, I'm actually in the studio," Ramsey said. "But we had to come play this date in DC. I'm going right back to Chicago and jump right back into the studio."

"That's kind of why I called you, because we just came out of the studio, and there are a couple of tunes that we're not going to use. I think they'd be good for you. In fact, one of them is a smash. This could be bigger than 'The "In" Crowd.'"

"Mmm," Ramsey said. I could almost hear his ears perk up. It was total manipulation on my part to mention "The 'In' Crowd," because that was a huge record for Ramsey, one of the first jazz records to cross from jazz to R&B to pop to rock. Without hesitation, Ramsey said, Let's do it! I understood Ramsey's vibe, and I believed this was the vehicle that would let him balance between the pop, jazz, and R&B worlds of 1974.

Verdine, Johnny Graham, Philip, and I left NYC and flew to Chicago while the rest of the guys went back to LA. On August 8, 1974, I walked up the steps into Paul Serrano's brownstone-looking studio. Ramsey greeted me at the door, and I gave him a big hug.

But once we got started, to my disappointment, the track was just not feeling right. I really think I needed Al McKay on this one. I had built up "Hot Dawgit" to Ramsey, and it wasn't working. We changed the tempo several times, and it finally felt good.

Thank God! In the end it took three days to wrap it up. Rams was pleased.

Feeling a sense of accomplishment, I said to Ramsey as the band was packing up, "Brother, I almost forgot, we got this other little song."

"What kind of vibe?" he replied.

"It's got an EW&F Latin rhythmic chug, and the melody's good."

"Is it as good as 'Hot Dawgit'?"

"Oh no! It could never be a single. It's really just a good groove for soloing."

"Let's give it a shot."

I quickly called my old roommate from Crane College, Don Myrick, who was living in Chicago, to come in and play tenor sax. I hadn't seen Don in a while, and I'd forgotten how much I loved his playing. Don always had touches of John Coltrane in his sound, which was my weak spot.

It took only one day to record what would become "Sun Goddess." We cut the track, and Don took an incredibly long, hot solo, which we just let ride. This was jazz, after all. Ramsey did a solo, and we forgot about the length of the song. We were feeling it. Philip and I did some percussion overdubs. We went back in the control room and listened to the track. I realized we needed some voices. Philip and I cut some nonsensical phrases— "Way-o, way-e-o"—and we stacked it a few times. Philip and I were in such sync vocally, it was effortless. The title "Sun Goddess" was a last-minute thing. The original idea was a track that I wrote with Jon Lind, a young up-and-coming writer that I signed to a publishing deal.

Columbia released "Hot Dawgit" first. Much to my disappointment, it sank like a stone. A few weeks later, I arrived in Oakland, California, for a show. Bruce Lundvall, head of CBS Records USA, called me at my hotel. He was so excited, I could barely understand his words over the phone.

"We can't keep it in the stores!" he shouted.

"What—what?" I said.

"Sun frigging Goddess."

"You're kidding. Really?"

"All the distributors are saying reorder, reorder, reorder."

"Sun Goddess" turned out to be one of those complete flukes of success. At first it was not released as a single. After all, it had ended up being eight minutes long! But the *Sun Goddess* album was selling like hotcakes. People were going into the stores and asking for the album with "Sun Goddess" on it. Black radio in the South had jumped on it first, and all the other major markets quickly followed, playing the song despite its length. Columbia Records wanted me to edit to make it shorter, but I resisted. I believed the album was selling because DJs were playing the full version. Still, against my wishes, they eventually did a 45 rpm edit.

The *Sun Goddess* album went No. 1 on the *Billboard* black albums chart, No. 1 on the jazz chart, and No. 12 on the pop chart. It was an unbelievable achievement for a progressive jazz record, Ramsey's greatest triumph following "The 'In' Crowd," and one of the biggest-selling jazz records of all time at that point. I couldn't have been more pleased with the success of *Sun Goddess*. It was like my life had come full circle, completing a cycle of a mentor/mentee relationship. Rams and I would remain close. The "Sun Goddess" win was yet another link in our many-decades-long musical bond.

13 That's the Way of the World

All labor that uplifts humanity has dignity and importance and should be undertaken with painstaking excellence.

—MARTIN LUTHER KING JR., *STRENGTH TO LOVE*

Y ou can't have an R&B album based on a Bible story!" This is what I was told more times than a few when I informed folks that EW&F was going to do a musical suite based on the fascinating biblical story of the Tower of Babel. It was another one of my ideas for EW&F to stay true to its idiosyncratic self. I put it on hold when I got a phone call from Sig Shore.

Sig wanted Earth, Wind & Fire to do the sound track to a movie he was producing and directing, *That's the Way of the World*. He had just scored a huge hit as a producer with *Super Fly*. Even though *Super Fly* is a classic of the blaxploitation film era, the sound track recorded by my Chicago buddy Curtis Mayfield actually made more money than the film grossed. Curtis did a great job in creating songs about the dark world of pimps and drug dealers with honesty, and yet with a strong moral clarity.

That's the Way of the World, the film, would be an often-told story of corruption in the record business. They wanted us to act in the film as a group simply called "the Group." The plot was that the Group would be upset because they were continually pushed to the back burner of the recording schedule. A saccharine, milquetoast group called the Pages was the record label's darling. Harvey Keitel played the lead, and even Bert "Here She Comes, Miss America" Parks was a member of the Pages.

In pulling together the sound track, my first call was to Charles Stepney, who ended up having several cameos in the film. "Rooney," he asked, "do you really think you should do this?"

"Well, actually, I've already committed to do it."

"You know, a lot of these things turn out to be nothing, and then you've wasted an entire album of hard work."

"I think it could actually help us."

"OK, but just remember, as goes the film, so goes your record."

Stepney could be rough, but I appreciated the way he always told me what he thought. Wise in all things musical, he had high standards and absolutely no patience for treating music like a stepchild.

That's the Way of the World would not be a sound track in the traditional sense. I made sure that the EW&F concept would be reflected in the score, which meant no departures from our established themes.

Before we started recording the album, Bob Cavallo had been riding me pretty hard. Bob liked to use the word *pal* when he wanted to persuade.

"This has got to be one, pal," he said.

"I know, Bob, I know."

"All that stuff you want to do, pal, with the magic and the sound, ain't going to happen without having a big one."

A big one. A breakthrough success. A million seller. Our records were hovering around 600,000 to 700,000 units sold per album, and that was great for any band, especially a black one. However, a million seller could broaden our audience, give us international acclaim, and more money to do the things I wanted to do with the band, especially live shows. I knew where Bob was coming from, and his intentions were noble. The only thing I could do was to try to create an atmosphere that would facilitate our best work.

Charles and I had breakfast in Beverly Hills. His plate was

piled high with bacon, scrambled eggs with cheese, and pancakes. I had fruit, boiled eggs, and toast.

"Man, you gotta stop eating that shit, Charles."

"OK, right after I finish," he joked.

We started talking about the record. Pointing his fork at me, Charles said that if I was going to do a score for a film, it should sound like a *score*—with a full orchestra on as many songs as possible. It was just a matter of getting a bigger budget from Columbia. This was not a problem after the success of "Sun Goddess." I could have asked for the moon.

I chose to return to Caribou Ranch in Colorado to record the basic tracks of the sound track album. Charles did not dig Caribou Ranch. He hated the food and it was too quiet and rural for him. So for this trip he had previously recorded the sounds of the Chicago streets on a cassette so he could hear the flavor of the city in his cabin when he slept.

That's the Way of the World was the beginning of our big horn-section sound. We also began to use a full string section from this album forward. About four years earlier, when Marvin Gaye's *What's Going On* was out, Verdine said, "Man, I hope one day we can cut a record like that." "We're not ready yet," I said. "We ain't lived enough yet." But on this return to the pristine Rocky Mountains, we were ready. The band was rock solid.

To complete our unit, I added a new member to the team who represented a big leap forward in terms of sound and technology. Back then George Massenburg was a young, nerdy, pimple-faced kid who was polite and modest. He traveled with us to Caribou, serving as our full-time recording engineer. George would ultimately become integral to the EW&F sound. He had an impressive work ethic, and in every studio we went into, he was always modifying a piece of equipment or tearing it down. He required that things work to his specifications. When I first hired him, George seemed perpetually frustrated and restless. As I got to know him, I realized that this agitation was actually his creativ-

ity breaking through. He was raising the standards of recorded music with his innovations.

George was thrown into my world unceremoniously. He endured a lot at the beginning. I remember Charles barking at him, "Shut up, you white motherfucker." He had recorded one song for us, and we were all in there listening to the playback. One by one, the band left the control room. When I stepped out in the hallway, they cornered me. "Reece, this white boy ain't happening."

"Man," I said, "he's a cool cat, give him a chance."

I thought all they needed was the playback turned up louder. George would gradually gain everyone's trust and respect, even Charles's, as they came to recognize his competence and creative genius. George may have looked young, but his technical skills made him wise beyond his years.

That's the Way of the World was a tough record for us to cut. Everybody had to play with more discipline, restraint, and focus. We began a practice that we would continue for the following five albums: recording maybe eight to ten takes per songs, picking the best one later. Charles needed a rock-solid foundation from the rhythm section to complement his expanded orchestrations. At the same time, I didn't want to lose the band's vital, primal energy. My conviction only strengthened the cooperation between us. We were all taking good direction from one another. Larry Dunn and Philip Bailey had written one of my all-time favorite EW&F songs, "See the Light," which starts out in the odd time signature of 7/8. Larry showed Verdine how to approach it on bass. Al McKay was an absolute master at setting tempo, guiding the rhythm section perfectly into the groove, and Charles and I were instructing everybody on everything.

With the addition of George Massenburg, our sound became richer, larger, and full of more depth. Between George's technical ambitions, Charles's arranging passion, and my all-around guidance, the band had written most of the songs for *That's the Way of the World* in a few weeks. The song "Shining Star" was

born out of a hook Larry Dunn was working on. I delivered some vocal rhythms, and Larry put chords under it, working out the harmonic and chordal structure. The title and theme came out of a walk Philip and I had in the Colorado woods late one night. The moon was real bright, to the point where it looked like daytime. We were looking at the stars, and we could see the whole Milky Way. It felt like we were close enough to reach up and grab one. We had a pleasant conversation, talking about women and life. The atmosphere set the tone for a creative spark. The remaining melody and lyrics flew out of us. It was a perfect Earth, Wind & Fire song. My hammering in of the band's concept was bearing fruit. There's a kind of creative grace when you understand your creative identity. For Philip, Larry, and me, writing "Shining Star" was easy, because we knew who Earth, Wind & Fire was.

Outsiders saw us as a cohesive unit, always working together. That's a part of the romantic mythology that often surrounds bands. In real life, though, there were subsets; some members worked better with one another than others. In addition, each individual had his own personal struggles and successes within the structure of a band. And musically, some cats just had it harder than others.

Back in Los Angeles, I know Andrew Woolfolk had it tough when we expanded to our big horn-section sound. Drew was bad. He could play his ass off, and he was explosive onstage. We went into Sunset Sound on a Monday afternoon to do additional recording for *That's the Way of the World*. I had hired all these older, weathered studio session guys for the horn overdubs, and I could see that they had a little chip on their shoulders when it came to the young Andrew. Even though he was a member of EW&F, they treated him like the new kid on the block.

Andrew felt like a rookie on a football team, the guy who always catches hell. He sensed that the hired guns thought he didn't deserve to be there sitting with them. The very look on their faces questioned his playing ability. From the first day

of recording the brass section on *That's the Way of the World*, Andrew did not get a welcoming vibe. The horn players were as cold as ice to him. It was scary for him at first

On this particular day the studio was chaotic. Several musicians had brought flunkies, hangers-on. After those were kicked out, I got the true vibe of how the players were treating Drew. I didn't say anything, figuring he could handle it. One of Andrew Woolfolk's distinguishing traits was that he was highly competitive, almost to a fault. He always wanted to outdo everybody, whether it was basketball, tennis, or chess—everything! Tell him he couldn't, and he'd show you how wrong you were. Drew didn't let the old veterans push him around for long, but quickly shut them down with the power of his saxophone. He let the outside musicians know that this was his band.

In that session there was no doubt: Andrew embodied the raw energy that surrounded the band. EW&F often carried its energy from the stage right back into the studio. "Happy Feeling" was composed out of that straight primal jam-band energy. Written by myself, Al, Larry, Philip, and Verdine, the song was an organized jam driven by Verdine's running bass line, my kalimba, Andrew's tenor sax octave-jump melody, and the anthemic falsetto background vocals of me and Phil. We recorded the anthem in the studio, but we also recorded a live version with a mobile recording truck at a roller rink in Camden, New Jersey, for a scene in the movie. That version was so hot and joyous, we ended up using it.

During our long hours together, I had meaningful one-on-one conversations with everyone in the band. The more downtime we had, the deeper the conversations became. "Man, this women thing is crazy," Phil said. "I like it, but I don't always feel good about it either." I knew Phil looked up to me, but I didn't have any real answers. We went back and forth, discussing the abundance of women always around us, desiring to hook up. The song "Reasons" was born out of that conversation.

The lyrics raise a simple question: Can we trust ourselves

with our sexual appetites? Are our romantic motivations just a lie we tell ourselves to get off? It was a struggle for all of us to be somewhat decent about our sexual appetites. So-called groupies were very real; they would follow us around for weeks. Some girls were so beautiful that they were damn near irresistible— what I called erection machines. But one thing I can say about my guys: they were all for the most part respectful, especially compared to our contemporaries on the road. This doesn't mean we sometimes didn't cater to our horniness. Certain guys carried guilt because of their marriage or relationship status. Still, on the whole, we just didn't look too bad having sexual dalliances. It was that old showbiz trick of trying to do the wrong thing the right way.

For all our good intentions, "Reasons" was completely misunderstood. People would use the song at weddings as a musical expression of endless, undying love, when in fact it's a cautionary tune expressing the opposite.

The music we recorded for *That's the Way of the World* was beautiful and energetic. The production took longer than most because of the many breaks in the recording schedule for gigging, but our bond with one another continued to grow throughout the process.

Our live show was gradually getting bigger. We were doing a trick with Larry Dunn's piano. While he played, we would spin the piano upside down and around and around. We were quickly adding more equipment, lights, and roadies. After a show in Mobile, Alabama, Leonard approached me as I was walking out a backstage door.

"Reece, last night two of the roadies jumped in the car before the band," he said.

"What is wrong with them?"

"They're just incompetent idiots."

Nonprofessionals were becoming a cancer inside our crew. We had roadies who were more interested in the after party and the women than in the incredibly hard work of moving us in

and out. Leonard Smith and I found a quick solution. We had three weeks off. In that time, I fired our entire road crew, top to bottom. Then we promoted Frank Scheidbach, who had been already working for us as our full-time production manager. Frank oversaw our entire live operation. A stable, reliable, hard-working professional, he would be the foundation for every great tour we had from that point on.

The first thing Frank did was hire top-drawer professionals who had tons of rock-and-roll experience. In 1975 our new crew was only around twenty-five or thirty guys. Though the new roadies cost a lot more, it was worth it because they were truly pros; they gave us a smoother, more comfortable feeling on the road. Everything we did was more efficient. With that said, even the best rock-and-roll crews of the mid-1970s could be a rowdy bunch.

At that time we were all, band and crew, staying in the same hotel. A typical setup would be the crew on the first and second floor, and the band on the third and fourth.

One morning not long after we hired the new crew, Leonard got a call from a screaming Holiday Inn hotel manager, saying that the roadies had destroyed his building, and he made no distinction between the crew and the band itself. "I'm going to sue you little Earth, Wind & Fire motherfuckers to high heaven!" he shouted.

"I'm sorry, sir," Leonard calmly responded, trying to defuse the situation. "I'll pay for any damage to the rooms."

Our new crew had torn up mattresses, made mud pies out of the cotton in the pillows, and punched holes in the wall. These were some rowdy-ass white boys. The road crew can get stir-crazy. The professionals we had hired worked at a demanding pace, and I understood that they needed to let off a little steam. Roadies don't get to see the sunset or the sunrise. Their heads are usually underground. We had eight tractor-trailers on the road. They were sleeping in buses and trucks, moving the band down the highway.

Leonard explained to Frank that he didn't want all that stereotypical rock-and-roll behavior to be associated with Earth, Wind & Fire. After the melee, Leonard and Frank started booking the crew and the band in different hotels, to separate us from that kind of activity. Still, Frank had amassed a great crew. After the ruckus, they calmed down and got on our wavelength.

In between gigs and periodic stops in the studio to finish recording *That's the Way of the World*, we filmed the movie. I played a character named Early, a disgruntled bandleader. My first scene was with Harvey Keitel, who played a record producer named Buckmaster.

> Early: "Let's get down and make some records."
> Buckmaster: "Man, we're gonna have to cool it for a bit.
> I have to record a new group. Now I'm going to try and
> finish them as fast as I can and get back to you in a couple
> of days."
> Early: "You've got to record a new group? Man, we've been
> waiting seven months. The cats are waiting on me down-
> stairs."

I rolled my eyes sarcastically as I finished out my lines with Keitel. "Cut," Sig said. I only had a few other lines in the film. It was abundantly clear to me that I didn't have any acting chops! The entire band looked pretty weird on-screen, though we tried to make it look as effortless as we could. I don't think the script was that bright, either, in our defense.

Hollywood Sound, Studio B, became my home away from home for the next few years. The studio worked for me because the management was not averse to George modifying its equipment. George was customizing my microphones, the outboard compressors—everything. I swear the top of Hollywood Sound's mixing console resembled some electrical mad scientist's laboratory. There were wires of every color in the spectrum sticking

out of boxes, little lights blinking on and off. It looked like a damn fire hazard to me. He started carrying around a Strobotuner, tuning Johnny's and Al's guitars and adjusting their bridges when they weren't around—a no-no, but their guitars started to fall out of tune less.

When we turned to the challenge of mixing "Shining Star," we had recorded a lot of tracks. Charles had done a killer horn arrangement that we recorded at Sunset Sound. Philip and I kept stacking our vocals to get a sound I was comfortable with. We wanted to sound like a group of different voices, like Sly and the Family Stone, but when George started to pull up all those faders on the console and reveal everything that had been recorded, it sounded cluttered.

According to George, "Shining Star" was the weirdest thing anybody had ever heard. He heard it as a mess, claiming we had heaped stuff on. Larry had cut an organ track doing this big-ass Billy Preston–type organ part—every bar of the whole song, verse and chorus, top to bottom. The drums were also too busy. The whole song needed to be cleared out. We accomplished that by having Fred White play a kick snare overdub with a simple, straight-ahead *boom chick, boom boom chick, boom chick, boom boom chick*. We gated everybody to the claps and snare drum, which prevented about twelve tracks or so from hitting on the backbeat. This cleaned up all the raging musical clutter that was preventing the pocket from coming through.

Starting with mixing "Shining Star," George and I established a method of working together on mixes. He would make some moves on the console, and I would make others. Sometimes we needed a third set of hands, but more often than not it was just the two of us. I breathed a huge sigh of relief when I heard his cleaned-up version of the track. When it came to mixing records, the proof is always in the pudding.

It took six or seven days to mix "Shining Star." Every day and a half we would finish a mix, and then we'd come right back the next day and try it again, starting from scratch each time.

These were the days before automated recording consoles with total recall. Two of the most distinctive elements of the "Shining Star" mix are the beginning and the ending. For the intro, I wanted an old boogie-woogie piano style, like the way the piano players would play back in Memphis juke joints. I transferred that style to the guitars, and Johnny and Al just nailed it.

The ending was a bit more technically complicated. I had an idea about fading the band out into an a cappella background, but when we tried it, the song was just too damn long. With the way George had creatively used drastically different reverbs, EQs, and echoes on the hook fresh in my mind, I said, Let's just drop them out as we get closer to the end. That effect turned out to be the shit. George kept carving away the reverb, a little less each time. By the time you hear "shining star for you to see what your life can truly be," the sound is right in your face.

When I played the finished mix of "Shining Star" for Bob, he said, "Pal, this is your first number-one record." I responded, "We'll see, won't we?" It wasn't that I didn't believe him, and I certainly did want a number-one record. But again my natural skepticism of a manager or record label executive telling me something was going to be the greatest thing since sliced bread had kicked in. I wasn't going to fall for all that hype.

"Shining Star" worked well as a radio-friendly record. The strong definition between the verse and the chorus helped lift the hook, a time-tested tool for creating hit records that gives the listener's ears a new dynamic to lock onto.

In addition to "Shining Star," "Reasons," "See the Light," and "Happy Feeling," the album was rounded out by "Yearnin' Learnin'," "Africano," and "All about Love." On "All about Love," toward the end, there is a speaking part that added to the idea that Earth, Wind & Fire was "deep."

You know, they say there's beauty
in the eyes of the beholder, which I say is a natural fact.
Because you are as beautiful as your

thoughts, right on. You know, for instance, we study all
kinds of occult sciences and astrology and mysticism and world
religion, so forth, you dig.
And like coming from a hip place, all these things help
because if you're inside your inner self—
Have mercy!
Now, there's an outer self we got to deal with
the one that likes to go to parties,
one that likes to dress up and be cool
and look pretty, all ego trips and all this.
I'm trying to tell you,
you gotta love you. And love all the beautiful things around you,
the trees and the birds. And if there ain't no beauty,
you got to make some beauty. Have mercy!
Listen to me.

In 1975 I was feeling sanctified and bold. I was examining the black man in me, the universal man. I wanted to articulate who I was becoming in my music. Our philosophical way of composing continued, with some good results. The song "That's the Way of the World" started as a basic track given to me by Charles. His melancholy yet hopeful chord changes set the tone. Verdine and I wrote lyrics that spoke about staying true to yourself and remaining young at heart. The song was written as the movie's main theme, but after the title, that's where the association stops. Verdine and I didn't pay any attention to the script; we just wrote what we felt. Johnny Graham's simple, haunting, bluesy guitar solo was the unsung hero of the song. There's something about Johnny's unique choice of notes that speaks out in the track:

You will find peace of mind
If you look way down in your heart and soul
Don't hesitate 'cause the world seems cold
Stay young at heart 'cause you're never old at heart

> *That's the way of the world*
> *Plant your flower and you grow a pearl*
> *A child is born with a heart of gold*
> *The way of the world makes his heart grow cold*
> —"THAT'S THE WAY OF THE WORLD," *THAT'S THE WAY OF THE WORLD,* 1975

It is truly the Creator's gift when something comes just when it's needed. Earth, Wind & Fire needed the song "That's the Way of the World." I believe Charles needed to write those melancholy chord changes. I know Verdine and I needed to write the lyrics and melody. And Americans needed to hear it. By 1975, Watergate had been dropped on our doorstep. We as a nation were finally coming to grips with the whole Vietnam experience. Our government had been dead wrong to get involved in the war, and it had been totally discredited. Its disgrace fostered the view that institutions could never be trusted implicitly. In fact, my stepdad, Verdine Sr., crystallized this to me. I went through my ritual of mailing him and Mother Dear an advance copy of our album. When I saw him soon thereafter, he said in a very fatherly tone, "Son, that song, 'That's the Way of the World,' is your national anthem."

It is our national anthem because "to sing our message loud and clear" meant that Earth, Wind & Fire had, I believe, a divine assignment. We were telling the world's people not to waver in their hope, not to waver in their heart's desire, no matter how crazy and out of control the world seemed around them. The world will tell you that nothing ever changes, that you're a fool to have hope—but it's each human being's divine right to hold on to hope and faith. I believe this was the ultimate message the band was created to give.

That's the Way of the World's big orchestral arrangements were definitely an upgrade in our sound. Charles had put his genius into the horn and string arrangements, and vocally Philip and I had never sounded better. During the drawn-out recording of the album, a lot had happened for us personally too. My first

child, Mimi, had been born; Philip's mom had died suddenly; and Mother Dear had been diagnosed with breast cancer.

A month before *That's the Way of the World* was released, Bruce Lundvall and I had a meeting. All the executive brass at Columbia Records agreed that we had made a great album, he said. "Personally, Maurice, I'm highly pleased. I can't lie—I was concerned." I know what he was getting at. I had spent some serious money recording the album. But, thankfully, it didn't matter.

Columbia Records was not so pleased when I refused to have the words "The Original Motion Picture Soundtrack" included boldly on the front cover of the album, as was the standard practice. It was an accepted marketing belief that this prominent banner helped album sales. This may have been true, but I didn't give a damn. I wanted the album to stand alone as an EW&F album, and stand at a distance from the movie.

This was a moment where I think Columbia may have believed too much in my public persona as the peace-and-love Maurice White and underestimated me as the bandleader/businessman Maurice White. They told me I was throwing away a great marketing opportunity. Maybe I was—but I was also protecting the brand of Earth, Wind & Fire. When they saw I wasn't going to give in, they finally relented.

My instincts were spot-on. Verdine and I went to a screening of the movie. I was devastated. We looked like clowns—like idiots. Uncharacteristically, I panicked. Shit, Charles was right—this was going to ruin the album! The movie was going to kill all the work we had done.

"Man, this is not good, V," I said. "This is not good!"

This is one time where Verdine became the older brother. Putting his arm around me, he said, "It's going to be all right, Reece. It's going to be all right."

I put it in God's hands. I called on him and waited. His response was not unlike Mama's prevailing mantra—just keep moving forward. I did. The final preparations for the album's

release culminated in recruiting a then-new photographer, Norman Seeff, to shoot the gatefold cover art. He set a double stack of four queen-size mattresses on his studio floor and had the guys jumping and being dropped down on the soft surfaces. He then superimposed them on a clean white background. In the final product, only Verdine and I were standing straight, me smiling with open arms and Verdine with resolute clasped hands. He and I were still Chicago cool.

14 Expansion

*Man maintains his balance, poise, and sense of security only as he
is moving forward.*

—MAXWELL MALTZ

I n many ways the defining part of my career as a bandleader,
singer, songwriter, and record producer was just beginning in
1975. The majority of the year was spent—where else?—on the
road. The year before I had begun, with Bob Cavallo's help, to
set up the band to be run more like a business. We had started to
make a decent amount of money in '74—not anything to write
home about, but a reasonable sum. A big part of this restructur-
ing was that I hired a corporate accounting firm. It came in and
set up entities, companies, and corporations on my behalf. In
those days I ran Earth, Wind & Fire as a sole proprietorship:
Maurice White doing business as Earth, Wind & Fire. The firm
set up Kalimba Productions, a company that would lease out my
services as a producer. It also set up another company relative to
my publishing interests, Saggifire Music. Art Macnow was the
accountant who worked with me.

I could have ignored Mother Dear's repeated plea, "Sandy,
take care of your brothers and sisters," but I couldn't. Part of
the ever-expanding team around me included two of my half
siblings. Geri and Monte moved to California to work with
EW&F. Monte became a road manager, and Geri worked at our
new office on Charleville Drive in Beverly Hills. Their join-
ing the team wasn't nepotism or sacrifice; they were both very

capable, and wanted to do the best job they could. Plus I trusted them.

I loved having my half siblings along on this creative business journey. However, I do have one major regret where they are concerned. When Verdine came out to LA, he took my last name, White. We identified ourselves as brothers because we got tired of explaining the relationship over and over to others. Dad was gracious and cool about that. I think he understood that it was a Hollywood thing, so that Verdine could be identified as my younger brother early on. What I deeply regret is not discouraging Fred, Geri, and Monte from using my last name, instead of their birth name, Adams.

One time after a show in Chicago, a guy in the band called Dad Mr. White. I strong-armed him, pulled him aside, and said, Hey, man, his name is Dr. Adams! Dad was a big man in physicality, heart, and spirit. He never said anything to me about feeling slighted by the surname change, but, looking back now, I believe I should have put my foot down.

As we toured back and forth across America, the band members were getting more ambitious and increasingly communicative with one another. They were gaining more and more confidence, feeling that we had the upper hand over our contemporaries. I contributed to this feeling too. I said it over and over: Man, you brought the right vibe tonight. I kept on trying to be motivator in chief, though now everybody was motivating everybody else. It was gratifying.

We chartered a few flights, but we didn't have our own plane then, so it was late nights onstage and up early in the morning to get to the airport or back on the bus. We always knew who was calling at 5:00 or 6:00 a.m.: our road manager–gatekeeper Leonard Smith, with his usual line, "Get your feet on the floor, it's time to go." He could have put that line in his tape recorder: it was literally the same every morning.

By 1975 concertgoing was becoming big business. The arena-rock era was in full swing, and we were a part of it. Before this

shift, you had to have six or seven acts or more on the bill to consistently sell out the big arenas, but now Elton John and the Rolling Stones were selling out large venues, and so were we. Our audiences were gradually broadening along racial lines. Earth, Wind & Fire was the first black group to get paid the same kind of money, the same percentage of the gate, that the big British acts were getting. By this time we were continually sold out. As a result, we could call our own shots.

We started booking our own engagements. We had been using Premier Talent a lot, but that had to stop when things got bigger. We made it clear that we wanted to use some black promoters. Our motivation for this change was partly altruistic, to help up-and-coming black promoters. But it was also practical. EW&F had made it to this point because of the black college audience. When we moved into playing in arenas, we didn't want to upset those well-worn channels of black promoters to black radio to the black audience. They had helped build our popularity. We were the biggest black thing going, and for black promoters to have a piece of those dollars was significant for them. We had contacts in every major market in America, and even the smaller secondary markets. Premier and other agencies weren't going for hiring black promoters. I had nothing against the establishment concert promoter's world; as a matter of fact, we continued to work with them all, in different capacities. Bill Graham, Larry Magid, and Jack Boyle were powerful and did good work. It was clear that black promoters were never going to be able to promote white acts—for the most part, they still don't today. We could work with black promoters when possible, but only because we took control of our own concert promotion affairs.

Bob Cavallo and Joe Ruffalo brought in a young cat who was a hustler when it came to booking, Steve Fargnoli. Together we created the Brighton Agency, a company responsible for not only our bookings but those of the other artists in the Cavallo-Ruffalo world. You probably couldn't do that today because of conflict of interest laws.

In early April 1975, we hosted *The Midnight Special*, playing "Mighty Mighty," "Yearnin' Learnin'," and "Shining Star." I wasn't crazy about this performance, although I liked it more than *Don Kirshner's Rock Concert*. We needed a bigger live sound. This would require a horn section and adding three more salaries. If it hadn't been for the increased touring revenue from the success of *That's the Way of the World*, it would never have happened.

I reached out to my old friends from Chicago, Louis "Lui Lui" Satterfield and Don Myrick. With the addition of Michael Harris, they would become the Phenix Horns. Everybody liked what the horns added to our show, giving our sound more punch and power on the stage. Their integration into the band was an adjustment, however, and for me the adjustment was personal.

The main challenge was that Satterfield and Don saw me as I was in 1961—a shy kid. Satt was the one who taught me how to stand up for myself, but I had evolved a lot. Once I had looked up to him, but now I was in a position of authority. The Phenix Horns would consistently challenge my leadership. I would always have to gently but firmly let them know that I wasn't still that kid. I can't tell you how many times I had to pull them aside and say, Let me talk to you all for a second. There were a lot of mini confrontations. Some were about music, some were about money, but they were always about power. Both guys were born under the astrological sign Aries, and they felt the need to sit at the head of the table.

When I first left Chicago for LA, I had approached Satt about coming with me. He said he was going to stay in Chicago, since he had a good steady gig at Chess Records. Later, when the Chess Records thing fell apart, he came to LA to join up with me. It was a new chance for steady employment. Satt's sense of humor and his positivity tempered his Aries side.

My relationship with Don Myrick was different. Don was my roommate for a brief time when I was at Crane Junior College. When I left for LA, Don was already in the army. He played

on "Sun Goddess," but other than that, we hadn't spent any time together. My role as bandleader never sat right with Don. I didn't take it personally; even Satterfield used to say, "Don never really accepted leadership from anybody."

In Chicago back in the day, Satt and Don were also part of the Pharaohs, an eccentric jazz and soul group that was kind of a collective of different musicians at different times. Born out of the Afro-Arts Theater in Chicago, they had a very Afrocentric point of view, which was inspiring to me. They had made a couple of albums on their own, but Earth, Wind & Fire was the future for them. Since they knew I wasn't going to fire them, given our long history, I think they felt they could push it a bit with me, which meant I had to put up with a lot of stuff.

What I couldn't deny was that our new horn section was a shot in the arm to the live show. It gave our music more dynamics, more hot and cool moments, more musical drama, and more fire! Music overruled any feelings on their part or mine.

"Shining Star," the first single from *That's the Way of the World*, was released on January 21, 1975. The response was immediate and overwhelming. Everywhere we went crowds were singing the repeated tag at the end of the song, "Shining star for you to see what your life can truly be." Two decades later, on the *Today* show, Bryant Gumbel would credit us with inventing crossover. It all started with "Shining Star."

Crossover to the rock and pop and soul worlds of the 1970s meant, "Oh, you have a black face but you sell as many records and tickets as white acts and you have black and white fans." To be sure, if white audiences were digging us, it was because of the music and our performances. To me, it meant that we transcended boundaries. Still, we endured the same segregation as any other black artists: we had to get to the top of the black charts before we were worthy enough to be promoted on pop or "white" radio.

I would fight that reality my entire career.

We were the first black act to top the *Billboard* pop single and album charts simultaneously, on May 24, 1975. *That's the Way*

of the World would quickly sell almost two million copies. The success gave the band a new start. Long gone was the very personal sting of the first group leaving; long gone was the revolving door of getting the new and right guys. Hertz station wagons had become limos and custom buses. Holiday Inns had given way to four-star hotels.

Everybody who rides down this music business road is searching for that elusive thing called a hit record. It's what we all seek. The ego boost of it is like a drug. As a bandleader I can attest to the fact that there is nothing so good for the morale of a band as a hit—the audience response, the paycheck, and, in our case, feeling more and more like we were innovators. That moved us to the next level.

With greater stardom came more press, and along with that came misquotes. A British music magazine article quoted me as saying that I'd played with John Coltrane. I never played with Coltrane. I saw him many times, but never played with him. That rumor has gone on forever. Decades later I was sitting, waiting to board a plane, when a gentleman approached me and said, "McCoy Tyner wants to talk to you." I was ecstatic. McCoy, the legendary pianist, had been an idol of mine forever. I happily walked across the airport concourse, eager to meet him. He was with a couple of people when I approached.

He glared up at me. "I was with Trane a long time, and I don't remember you ever playing with him."

"I didn't," I said.

"Well, I heard that you said you did."

"Well, that's been a rumor around a long time." I turned around and walked away, dejected.

On another occasion, I was at a party. "You know, Maurice White from Earth, Wind & Fire is supposed to come here tonight," someone standing beside me said.

"Oh, really?" I responded.

"Yeah, he's a friend of a friend of mine. I'll introduce you if you want!"

I still laugh about it today.

Our music had begun to reach beyond the restraints of culture. Still, I wanted to find the right vehicle to break us out globally. Black acts like ours didn't go to Europe unless it was to back someone up, or with a conglomeration of six or seven acts as some kind of "revue." We used our relationship with the legendary promoter Bill Graham to help win the foreign market. With Bob's arm-twisting and Bill Graham's blessing, we went on tour to Europe with another big Columbia artist, Santana, in September of 1975.

Thirty shows in twenty-six cities—the experience was overwhelmingly positive. Carlos Santana was musically expansive. He allowed a generous amount of time for solos. The entire band had a dynamic and elastic sound, stretching out in whatever way the spirit took them. Carlos's mystical and spiritual vibe made us feel right at home. It was a perfect fit for us.

Although we had risen far beyond being an opening act, since Bill Graham was doing us a favor, and Santana was already wildly popular in Europe, we agreed to go on first. We still took no prisoners during our performances and continued to kill audiences. We had a scorched-earth mentality for our live show. Carlos and the boys, no punks, followed strong with raw musicianship. It was great! It was the first time we had played with guys who matched our energy and musicianship. Even though we did gigs with Weather Report, and they were musicians of the highest order, they couldn't touch us in our energy, or our performance-art thing.

Carlos's cosmic energy resonated through his musicians. There was a mystical quality to their performance. The audiences had a cultlike appreciation. There also wasn't any of that adolescent rock-and-roll nonsense. The guys weren't rowdy druggies, as far as I could tell. They didn't tear up hotels.

The performance venues were only six- to ten thousand–seaters, which led to a superior musical experience. The intimate environment actually allowed us to hear ourselves better. The

sound wasn't reverberating back from five hundred feet away, so we could really be in tune with the music onstage.

But we were still the opening act. Mounted like a monument on the side of the oversize black speaker enclosures was a clock—a big clock. It counted the minutes and seconds down like we were on a television game show. A red light at the top of it would light up like police flashers to indicate that our set was running overtime. It was intrusive.

Bill Graham, the promoter, became a friend to the band. In later years, when we'd work with him at the Cow Palace and Fillmore, he'd invite us over to his place for an after party. He had a beautiful rock-and-roll home, his walls decorated with Andy Warhol and music memorabilia. Graham, a Holocaust survivor, told riveting stories about his early life and his life in the music business. He didn't have wild parties, but relaxed sit-down dinners.

On the Santana tour, however, Bill had cut corners. As a result, I had to reduce my support staff. Graham was always carrying a clipboard. I would see Frank Scheidbach talking to him, and Bill writing stuff down feverishly. Scheidbach never wanted to bring me problems unless absolutely necessary. He was the most can-do guy in my camp. I saw him in Glasgow, Scotland, standing on a street corner handing out money. What in the world was going on?

"Frank, what are you doing?" I asked.

"I'm paying thirty pounds a man," he said. "We just don't have enough roadies."

"Damn," I replied.

"Do you believe this venue has no ramps? Really, no ramps—and no forklifts!"

They had a different way of doing things, the European venues and Graham. Frank didn't believe in twenty guys lifting a gigantic piece of gear. Rather than back injuries, he believed in forklifts. Even in early 1975 we were still carrying around a lot of gear—including a forklift. We were still hoisting Verdine in

the air, somersaulting the grand piano, and rotating the drum riser, which took a lot of energy, equipment, and planning. We needed hands, technicians, and knowledgeable people. The venues were much older and smaller than the ones in the States. We also didn't have that many days off. The entire time over there, we were constantly rolling. We endured the long hours because of minimal staff.

Despite the inconveniences, it was still a great tour. Santana would watch us play, and we would watch them. Even the sleep-deprived crew, who usually slept during show time, stayed up to watch the performances. Bill Graham started to increase our time onstage. The tour rolled on.

In early October I walked out of the bathroom at Pionir Hall in Belgrade. Looking far down the long hall, I could see several of the guys bending over and rolling in loud, raucous laughter. Satterfield was holding court, telling one of his stories. He was strutting around, eyes bulging, describing something obviously very funny. Cats were in tears. This was a sign to me that our new horn section members had fully melded themselves into the band.

Naturally, I love seeing that. I believe being across the pond, with all the different food backstage and all the restaurants, made it more of an experience of enjoying life, rather than just another tour. All the musicians from both bands were bonding on their various instruments. In the hotel lobby Ralph and Fred were walking toward me, beaming.

"Man, you guys sure look happy," I said. "What's up?"

"We just got back from the Paiste cymbal factory in Lucerne, Switzerland," Ralph replied.

"How did you guys get over there?"

"Ndugu"—Leon "Ndugu" Chancler, Santana's drummer—"took us and introduced us to the head guy."

"And . . . ?"

"Man, they laid some great stuff on us. Gave us every kind of cymbal you can imagine."

Ralph and Fred had their first endorsement deal with Paiste. Soon they scored another endorsement with Tama Drums.

When I look back on that Santana tour, I think it taught us more about being Earth, Wind & Fire than any other tour. We had opened for everyone—Rod Stewart, Sly, Uriah Heep, and every kind of act imaginable, black or white. But the Santana tour was an education in the veiled power of music. There was the finest musical interplay between our bands. We were enjoying each other's chops, yet competing. But as the years ahead brought more victories, I started to understand that you really compete with only one person, and that's yourself.

15 Gratitude

I believe that He belongs not solely to Christianity, but to the
entire world, to all races and people—it matters little under what
flag, name or doctrine they may work, profess a faith, or worship a
God inherited from their ancestors.

—MAHATMA GANDHI

The members of Earth, Wind & Fire evolved as musicians, songwriters, and entertainers. The guys were roughly ten years my junior by the time they came into the band. While they were still searching, I definitely knew the kind of man I wanted to be spiritually. I believed that my calling and purpose for the band were to shine a light on the beauty of the one God concept, which encompassed embracing the big truths of all the religions. In hopes of the message being further conveyed through our music, I continued to give the band books on diverse viewpoints that I found interesting. Firmly settled in my lifestyle of meditation, yoga, and eating the best things for my body, I avoided preaching my philosophy to the band, but I also wasn't shy about touting the benefits of calming the mind, positive thinking, understanding personalities, and eating right. Some of them embraced meditation and astrology, and some did not.

During the Santana tour of 1975, Brother Leon Patillo, the singer with Santana's band, showed that he was a magnificent Bible teacher. The guys in the band who were raised in Christianity felt a natural kinship with him. On several occasions Leon, who wore a turban, went to the back of the bus with his Bible

in tow and sat near Andrew Woolfolk, Philip, Larry, and Ralph. They were gobbling up Leon's teaching like hungry babies. His reading of the Bible struck a chord with them. Leon was giving them stuff out of the Good Book that they had never experienced before. The way he presented the message made it a living Bible to them.

Philip Bailey later told me that Leon had been teaching from the book of John the whole time that we were over there. Before he heard Leon's unique viewpoint, Philip had thought of me as his guru. Philip claimed that the whole band followed me. Though I emphasized things such as better eating habits and having the discipline to resist the temptation of drugs, the whole students-of-life thing could take him only so far. Philip believed that he found his own growth in realizing that I wasn't a little deity. Through Leon, Philip had found God in Christ Jesus, and I no longer held such a special place in his life.

I knew the band members looked to me for leadership, and they couldn't fault the positive lifestyle things I was sharing with them. But as Andrew, Larry, Philip, and Ralph got deeper into their Christian roots and more organized religion, they felt that our religious differences caused a rift in our relationship.

I didn't feel that rift. Maybe that was because my philosophy was the public philosophy of the band. Moreover, I never saw the guys who embraced their Christian roots as anything but positive. We may have debated here and there about history and origins, but as Gandhi said, I really believed that Christ belongs to Christians and non-Christians alike. His messages are too vast to be limited to one religion. I think the difference in the universal view of God is that it is open to other diverse viewpoints, so that it's always evolving, always growing. This is why I am not an organized religion guy. There will continually be a mystery in God, questions no human can answer. But within that mystery, I deeply believe, there is a unity. To believe in this universal path is not to wish to dissuade anyone from his or her personal creed, but to preach the commonality or communion of all spiri-

tual paths. In my humble opinion, mankind went astray when it started fighting over religious differences, rather than sharing our religions' commonsense values. That was my trip then, and it still is today, my calling to communicate to the world. As I've seen all kinds of religious fundamentalism and extremism grow, it's become evident to me that I'm on the right track.

Despite our religious differences, the band's bond was still tight. There was one thing we all agreed on: that music was sacred, to be taken seriously in our thoughts and our effort. After spending almost three hundred days and nights together, in 1975 we were more bonded than ever. Our alliance only grew because the band saw that our uplifting, spiritually minded brand of music was having a positive effect. Everyone in the band could feel that we were touching people's hearts and minds.

We returned to America feeling great, on cloud nine. The tour with Santana had been so validating musically that we felt a bit more cosmopolitan, too. But we soon found out that a part of our audience didn't give a damn what cosmopolitan status we thought we had acquired. And to crystallize that reality, Philip did something sooooo stupid.

Soon after returning from Europe, we played at one of our usual haunts, Hampton Coliseum in Hampton, Virginia. Before Philip started singing "Reasons," he went into this monologue: "We've just returned from Europe," he said, "and we've just gotta say that America is the greatest country in the world." The 50 percent black audience shouted out Boooooooooo, booooooooooo! We had never ever been booed—it was shocking. We were stunned. Philip froze—and forgot the lyrics!

I knew America was the greatest thing going, but in 1975 black folks didn't want to hear that stuff. Between the fall of Saigon, ending the war, and all the president's men starting to go to jail, black folks weren't identifying with the red, white, and blue. Instead, we were identifying with a black aesthetic. Ali had defeated George Foreman. Hank Aaron had broken Babe Ruth's record. We felt that we had an authority on what was true in

America, that our cultural, historical, and psychological consciousness was spot-on, even if we were the minority in a majority culture of white skin.

After the enormous success of *That's the Way of the World*, Columbia Records wanted another album like yesterday. We had just gotten back from Europe, and we were still in demand performance-wise here in the States. The tour revenue was coming in, and I wasn't going to turn down anything but my collar when it came to gigs.

But there was a solution. In getting material together for the movie, we had recorded our shows. Back then, multitrack mobile recording was just coming of age, and I took advantage of it. Multitrack meant that two 24-track machines could now be linked together in a mobile truck. This allowed us to record way more tracks, so in the end we could have a better, more discrete mix. Good ol' Wally Heider recorded many of our performances. Heider was a wonderful spirit and a recording legend who recorded many of the most important records of the late 1960s and 1970s. He single-handedly created mobile recording as we know it today.

With the recordings in the can, Bob and I, along with Bruce Lundvall, who was head of Columbia Records America, decided to put together a live album with a few new studio cuts, to be released before Christmas of 1975. The two-record set *Gratitude* would be the result.

The live *Gratitude* album opens up with the instrumental "Africano Power," a bass, saxophone, and percussion-driven jam we had been developing in the studio and on the stage since 1971. "Africano Power" incorporated jazz fusion, Afro-Cuban jazz, funk, and even more power than our fans had ever heard from us on a record. Another song that made the *Gratitude* album, "Reasons," featured a great churchy call-and-response between Philip's voice and Don Myrick's saxophone. It crystallized a special moment in time. Philip's line to the audience after Don's blazing solo—"He plays so beautiful, don't you agree?"—would become

a part of pop culture, a shout-out that would be Myrick's public introduction to EW&F fans. Like Peter Frampton's "Do You Feel Like We Do" and Marvin Gaye's "Distant Lover," EW&F's live version of "Reasons" became way more popular than the studio version, making Philip an African American legend in his own right.

Meanwhile, another gem from *Gratitude*, "Sing a Song," started out with Al plucking away in the backstage tuning room while we were touring in Switzerland. McKay and I wrote the song in probably no more than thirty minutes. Artistically, we worked extremely well together. Originally a drummer, Al brought all those percussive elements to his guitar playing. I was naturally in tune with his grooves, and our writing sessions flowed with ease. One of the jokes about "Sing a Song" is that you can barely understand what I'm singing in the verses, and that's OK by me. Just as someone can almost hear in your voice when you're smiling over the phone, I think people hear the energy of where you were when you record a particular song. From the first guitar lick that kicks off the song, you feel its positivity.

We were cutting grooves every time we had a break, and we would come off the road in an absolute frenzy. Taking those energies right into the studio, we recorded a little Latin-feeling number called "Sunshine." It's a simple song, but you can hear the chemistry of our band in a new way. Verdine absolutely crushed it on bass, and I loved playing drums on that tune.

One thing I knew for sure: Charles's and George's input on *Way of the World*, the Phenix Horns' arrival, and the Santana musical exchange had the band absolutely burning. We were stretching out. We were an R&B band. We were a jazz band. We were a pop band. We were a world music band. We were an Afro-Cuban band. We were feeling the power of our musical diversity, and so were our audiences.

"Sing a Song" felt like a natural EW&F song, joyous and hopeful. Still, as a bandleader, I knew I had to keep innovating.

Joyous and hopeful is great, but I believed that adding different colors to the song arsenal would increase our artistic range as a band. I wasn't competing, as such; I just felt EW&F should be a vanguard. To do this, I had to get new energy from sources outside of the band.

Songwriter Skip Scarbrough would always give me something that only he could give. His songs contributed to much of our signature sound. He had already written "I'd Rather Have You" on *Last Days and Time* and "The World's a Masquerade" on *Head to the Sky*, and later he'd give us "Love's Holiday" on *All 'N All*. But "Can't Hide Love" was a milestone. It was not one of our biggest hits, but it definitely defined a romantic tone for our songs. A group called Creative Source had recorded the song a few years earlier, but we completely changed it, as we almost always did with outside material. The original version was more of a Fifth Dimension kind of vocal sound. We slowed it down significantly and added a new vocal arrangement.

Skip had a gift for writing love songs that were not only romantic but sensitive to the spiritual and cultural nuances surrounding romantic love. Skip's way of composing love songs with a philosophical tone made me set a new higher standard for myself in songwriting. Still, a big part of the uniqueness of "Can't Hide Love" was Stepney's contribution. Step had known from the day I met him back in Chicago that I was the biggest sucker for John Coltrane. All he had to say was that this was something Trane would do, and I'd be all over it. When he first played the quick whole-tone ascending chord movement in the "Can't Hide Love" intro, he had me big-time. Ironically, though, it's the end vocal arrangement in the vamp of the song that people seem to remember. Charles had the strings playing a haunting, almost monastic melody, and Philip and I topped it off. To our fans, it sounded like Philip and I were monks chanting in an old monastery. This was another musical contribution to the EW&F mystique.

The double album *Gratitude* was released on November 1, the

single "Sing a Song" the following week. "Sing a Song" took off like a rocket, another crossover smash. Its immediate R&B and pop chart rise squashed any doubts about us becoming a one-hit wonder. *Gratitude* spent three weeks at No. 1 on the *Billboard* pop albums chart. We also won our first Grammy Award as a group on February 28, 1976, taking home the Best R&B Performance by a Duo or Group with Vocal for "Shining Star."

Beyond the music successes, important business changes were taking place at the Kalimba Productions office in early 1976. I was coming into my own as a business professional. In the fourteen years of EW&F, I can't remember once raising my voice. I always played it as cool as a cucumber with the band, employees, and business associates. Still, I was always discovering how to better relate to the people who worked with me, when to push them and when to back off. I was honing my communication skills, at least professionally. I was still woefully unskilled at delegating. Some of that was due to trust issues, and some to a desire to make sure things were done the way I wanted.

At times I didn't feel the band fully appreciated all the business mountains that were being moved, all the myriad choices, big and small, taking place—choices that strongly contributed to the rising of EW&F's star. In their defense, they were pouring themselves into the music, bringing our songs to life in the studio and onstage. Though I too was part of the group, as drummer, producer, and singer, their musical contributions were the distinctive ingredients of the Earth, Wind & Fire drink. Business decisions, however, were the straw that stirred that drink.

In those early days I ran Kalimba Productions like a record company, signing artists, paying advances, and issuing royalties. But Kalimba wasn't a record company. What I had was a distribution deal with CBS Records in which I knew what royalty rate I would get, a base from which we could negotiate with each artist. Some of the recording funding came from CBS/Columbia, and some came from my pocket.

The first artist we signed were three sisters from Chicago, the

Emotions. They were originally known as the Heavenly Sun-beams, a young girl gospel-singing group. Ron Ellison, an old associate from Chicago, knew their father, the very enterprising Joe Hutchinson Sr. I had a meeting with them and asked if they had any songs. "Yeah, we have lots of songs," Wanda Hutchinson said. She launched into four or five songs that would end up becoming a part of their gold debut album, *Flowers*. Wanda in particular was a great songwriter. One song that caught my ear was "I Don't Want to Lose Your Love." On the demo she had it at a very slow tempo, with about six or seven different verses. She sang with such raw emotion—she had such a greasy pocket. I could tell she was disappointed when I said, "Wanda, ain't no songs with six and seven verses."

"But Reece, it's a song about my first love that I broke up with."

"Then we're going to have to speed it up a lot."

Which we did. "I Don't Want to Lose Your Love" became a template for many songs that came after—punchy, up-tempo, with a very feminine sound on the top. It was very clear that the Hutchinson sisters could harmonize, I mean HAR-MO-NIZE! They had a natural blend and bend to their voices, making them sound like one voice with three different notes. They really had a unique sound, rooted in gospel. I wanted to take them to a place that was contemporary without destroying the church in their sound. One of the first songs I showed them was another com-position by Al McKay and myself called "Flowers."

"Wanda, check this out. 'We hold the key to the world's des-tiny,'" I sang to her.

"Oh, we're doing gospel," she said. "Great!"

"Oh no, no, no, it's not going to be like that."

"It sure sounds like gospel to me."

Well, it definitely wasn't gospel. But the girls were so deeply rooted in the church that the gospel flavor and lyrics would always be a part of their sound—never too far away.

Charles and I clashed more than usual when we were work-

ing with the Emotions. Charles heard them in a more traditional three-part harmony. I heard them in a more untraditional way—conventional three-part harmony in one place, unison in another, and even jazz clusters in another. I think all that jumping back and forth suited their voices better. Writing parts for them was easy for me. I heard their voices as horn parts, punchy in some places and smooth and long in others.

Every time there was a difference of opinion on harmony between us, I would tell Step, "Well, let's just listen to the girls." They were our judge and jury. If my idea worked, I'd say, "See, that's what I'm talking about." If Stepney's idea won, he would say, "See, Rooney, I told your ass."

As he went through the girls' harmony note for note on the piano, Stepney realized that the girls were using a lot of flat fifths and minor sevenths. With that knowledge, arranging and writing parts was easier for all of us.

Getting the Emotions' album off the ground was the real beginning of Kalimba Productions as a separate entity. I may not have been doing all the different kinds of music I wanted to do, but completing the Emotions album put new desires in my heart. Just like the Emotions, Deniece Williams, then one of Stevie Wonder's background singers, came into my orbit with great songs. She sent a cassette of seven songs to my office, hoping to get Earth, Wind & Fire to record some of them. She was a hard-core EW&F fan—she used to love to sing all that high Jessica Cleaves stuff from our earlier albums. But as I listened to her tape, song after song, her voice knocked me out. It was very feminine, almost bell-like and yet strong—I haven't heard anything like her before or since.

I quickly called her in for a meeting. "Deniece, these songs are great, but your voice is even greater. You need to record these songs, not EW&F."

She shook her head. "Oh, no, no, no, Maurice. I don't want to be a solo artist."

All of Deniece's career calculations had been based on her

experience of working with Stevie Wonder. Stevie was a star among stars. After working with him for a few years, Deniece knew for sure that she did not want the responsibility of being the star of the show. Her heroes weren't stars, they were songwriters—Ashford & Simpson, Carole King. She understood that songwriting and publishing was where it was at in terms of wealth building in the music business. Smart girl. But I kept on pressing her.

"Deniece, no one can sing these songs like you," I pleaded. "Let's do a deal, and I'll produce an album for you on Columbia Records."

"Maurice, my only music business experience has been working with Stevie."

"Stevie's my boy—he's great!"

"Yeah, but he's a bit loosey-goosey—not too organized."

"Look, I cannot attest to this or that. And no one, including me, can promise you a hit record."

"Well, then, what are you offering?"

"I'm proposing this: I will do everything I can to facilitate your success, and I promise you it will be a very orderly process."

I think I caught her off guard. She looked at me with some disbelief. I looked right back at her with all the resolute confidence in the world. I was no-nonsense. I think it gave her a whole different idea about the music business. I did everything I said I would for Deniece, but it all started with her songs, and she had plenty of them. Deniece wrote or cowrote all but one song on her debut album, *This Is Niecy*.

Signing Deniece Williams to Kalimba Productions was a business coup for me. Still, for whatever reason, I was still much more comfortable in the studio than conducting business in the office. The office always represented things I had to do, as opposed to things I wanted to do. In spite of this, I tried to carry myself with dignity. I was subconsciously referencing Billy Davis from the Chess Records days—a black man in a white world who stood above. Thoughts weren't far away either

of my friend Quincy Jones, who went from trumpet player to composer/arranger to Mercury Records vice president to writing musical scores for the movies. Billy Davis and Q were both dignified and organized, and that garnered respect from everyone.

In the early spring of 1976 I was working on several different albums simultaneously: Ramsey Lewis's *Salongo*, as well as the EW&F, Deniece Williams, and Emotions albums. Although I was organized, I had bitten off more than I could chew. Setting out to balance the situation, I tried to recruit as many talented people as I could to keep up with the workload. I coordinated writers, producers, coproducers, and arrangers to keep Kalimba Productions humming along, with Earth, Wind & Fire always the main priority. Other artists and writers would eventually become a part of the Kalimba creative family, like D. J. Rogers, Bernard "Beloyd" Taylor, and Jon Lind, who cowrote "Sun Goddess" and later "Boogie Wonderland." Besides the home creative team—Stepney, Larry Dunn, Verdine, and Al McKay— other cats like Jerry Peters and Clarence McDonald would do a lot of the Kalimba production chores. Clarence would later cowrite one of Deniece's biggest and classiest hits, "Silly."

16 Departure

All I have seen teaches me to trust the Creator for all I have not seen.

—RALPH WALDO EMERSON

When we started recording what would become *Spirit*, our sixth album for Columbia, I had no idea how much life was about to change for me and the band. After the breakthrough of *That's the Way of the World*, the crossover smashes of "Shining Star" and "Sing a Song," it was an exciting and demanding time for me, and for the entire EW&F and Kalimba Productions camp.

By early 1976 I was under siege with suggestions for songs to listen to and musical directions we should take. The band, management, and anyone around me would give me albums that were hot at the time, thinking that I needed to stay in touch with what was happening. Following my natural inclinations, I listened to sounds that moved me personally. I swear that every day that I could, I listened to Keith Jarrett's double record *The Köln Concert*. This live solo piano concert was a milestone in my musical life, and Keith continued to be a major musical influence. I know that may sound odd, but his dedication to improvisation on such a high and idiosyncratic level moved me beyond words. It was also calming and healing music for me. Even though we were in different musical landscapes, Keith Jarrett's music helped clear my head.

Now, of course, Earth, Wind & Fire could not do an album

like Keith Jarrett's, but we could be inspired by his uniqueness. By the time we started planning *Spirit*, the band had started to record demos religiously, so I kind of knew what was going to ultimately fly in the end product. But Verdine gave me a tape of a song by two young writers, Beloyd Taylor and Peter Cor, and it just blew me away. "Getaway" had everything that had become the EW&F sound, the spiritual as well as the musical. It was rare to receive a song so tailored for us.

> *Watch for the signs that lead in the right direction*
> *Not to heed them is a bad reflection*
> *They'll show you the way into what you have been seeking*
> *To ignore them you're only cheating*
> *So come, take me by the hand, we'll leave this troubled land*
> *I know we can getaway*
> —"GETAWAY," SPIRIT, 1976

The demo for "Getaway" had this blazing, almost jazzy bebop intro. It was long, and in my stupidity, I thought I should get rid of it. "Motherfucker, are you crazy?" said Charles. "That kicks off the whole song!" Needless to say, he was right. "Getaway" ushered in a new era in the power in our sound. Its percussive horn punches are almost frantic. From that point forward that kind of sonic kinetic energy would be a part of Earth, Wind & Fire. *That's the Way of the World* was a career turning point, but "Getaway" was a musical one. It really put the heat in the Earth, Wind & Fire sound.

While all this was going on, I did not realize that Charles was sick. We were together damn near all the time when I wasn't on the road. Charles smoked and ate with reckless abandon and drank soft drinks almost constantly. He also perspired a lot and sometimes seemed winded, and he'd started to put cotton in his ears to alleviate the pain. Years later, I discovered that ringing in the ears is a sign of high blood pressure.

One day Charles said out of the clear blue, "Hey, Rooney,

if anything ever happens to me, call Tom-Tom"—Tom-Tom Washington, an arranger we both knew from Chicago. Although I thought his words were odd, I didn't respond.

We were recording at Hollywood Sound when Step got a call, probably from Rubie, his wife. He said something about his pills, and that he wasn't feeling well. He hung up the phone and said he was going to go back to his hotel, the Holiday Inn up on Highland Boulevard, and he'd return in a few. Later he was found in his room unconscious, but alive. He'd had a heart attack.

He was rushed to Century City Hospital. The doctor said his heart was very weak. Although he seemed to get better day by day, he realized he wasn't going to be able to finish recording *Spirit* with us. Charles had done all the string and horn arrangements for the album, with the exception of three songs. Tom-Tom Washington finished one song, but I thought Jerry Peters, who had written a song for the record, would take the arranging reins to round out the project. Jerry was another one of those cats who were part of the EW&F family. He had known Al McKay since the age of fifteen.

Jerry and I went to Century City Hospital to meet with Charles. As we walked into his hospital room, Charles was slightly dozing off.

"Rooney, what are you doing here?" he said.

"Man, I just wanted you to talk to Jerry about these arrangements."

"Rooney, pick up those scores on the table over there."

Charles used special scoring paper. Most score lines are a quarter inch apart, tops. His score lines were triple that size. He liked that paper because it was easier to see when he was conducting. I gingerly picked up the huge score, both of my arms extended out in front of me. I carefully laid it on his lap in front of him. He slowly put on his glasses and started turning the gigantic paper.

He looked over the top of his glasses at Jerry with speculative eyes. "Boy, you think you can handle this stuff?"

"I believe so, sir," Jerry responded respectfully.

"There are going to be a lot of people there. You've got to be sharp."

Charles wanted Jerry to know that this was a gig of confidence as well as skill—no place for meekness.

Charles got better, well enough to return home to Chicago. Before he left, he stopped by the studio. His sense of humor had returned, and he was joking and jiving around with Verdine and me. We all had big smiles. His playfulness reassured me that he was going to be cool. "See ya soon, Rooney," he said as he walked out of the studio.

Now that Charles was on the road to recovery, we got back to work. The sessions were going particularly well.

On Monday afternoon, May 17, I called Charles to see how he was doing and update him on where I was.

"Rooney, man, I was just thinking to call you," he said.

"Man, we just finished doing some overdubs on 'Getaway,' and it's burning, man—just burning!" I said.

"Man, that's cool. I should be out there in two or three weeks."

That same evening we were working on the title track of *Spirit* when a call came through from Rubie, Charles's wife. He had just died of a heart attack on the front steps of his home. Charles got out of here at the age of forty-five.

No matter how death comes, sudden or not, it's always a shock, and Step's death was so abrupt. He left behind Rubie and three young daughters.

That we were working on "Spirit" when we got the news that Step had died has always seemed providential to Larry Dunn and me. The song had an odd origin. The music to it was on a tape Larry had given me almost two years earlier. It just sat in my home studio, and I would periodically pick it up and play it at night. It was a beautiful piece of music. Its jazzy chords always seemed to make me feel melancholy. I had come to just listen to it for pleasure. In addition, Larry always said he had a strange, sad feeling when he composed the music to "Spirit" years earlier.

We must make our brother see
That the light he is shining on you and me
And the land he gave, roads we must pave
Looking through each other's eyes
Humanity will rise in love
And our spirits will be at one with thee.
—"SPIRIT," SPIRIT, 1976

I can still see Charles standing on his front porch; it's winter-time, and we're talking about music. Rubie, his wife, is telling us to come inside, it's too cold to be standing out there. We'd enter the house, passing by the baby grand piano, and head straight down to the basement. His basement was Step's heaven. Many times it was filled with smoke, but music overpowered the atmosphere. There was his Fender Rhodes, his Moog synthesizer, and standing in a corner, its pipes hanging down like a cathedral organ, his vibraphone. He didn't have a drum set, but he had boxes that I would occasionally beat on. There were all kinds of thick and thin books scattered around, on music orchestration and whatnot.

I can see the Emotions practicing in his basement, Wanda and Sheila's huge shiny Afros bouncing back and forth. I see Charles and me secretly chuckling behind the girls' backs, watching them stick their fingers in the air when they sing a high or low note. I see myself holding the door open for him as he walks up the steps at Paul Serrano's studio, right before we recorded the Emotions' first album. I remember him very gently tapping his right foot on the cabin wood floor while playing for me the first time the beautiful and melancholy chord changes to "That's the Way of the World" up at Caribou Ranch in the Rocky Mountains. I even remember his smile the last time I saw him in Los Angeles. I have lots of good memories.

By the time I asked Charles to come into the world of Earth, Wind & Fire, he had already written, arranged, and produced a lot of music. He had pretty much worked all the time after join-

ing Chess Records in Chicago. But in the snobbish West Coast music business world, a lot of people who didn't know the Chicago music scene thought Charles was an overnight sensation. It was insulting that he was seen as a Johnny-come-lately—he had such an illustrious body of work. It's just that EW&F took off in a way none of us could have ever imagined, even myself. But what is still of comfort to me is that he made it clear that he was glad I'd called him. The money he made with us, especially on *That's the Way of the World*, was significant to him. The money from Chess Records was one thing, but this was at a whole different level. I'm really proud that our work together in that short period was his most successful. If he had lived, he would have moved on from EW&F and gone on to be another Thom Bell or Quincy Jones. He just ran out of time.

EW&F had been a band for four years when I finally had the money to call Charles to the *Open Our Eyes* sessions. It was my old friend coming to lend a hand to my cause. Charles had a grasp of music that couldn't be denied. He could write music for the Chicago Symphony one minute, jazz the next minute, and deepest soul music after that. He could listen to a song one time and transcribe it immediately. He brought all that musical maturity to a young band's boundless energy.

He was hard on me. I hated being called Red, that southern term for fair-skinned people like myself. He would occasionally call me that—and, trust me, he was the only cat who could. Or sometimes he would call me Rooney Tunes because, as he would say, I always had a song in my heart. We laughed a lot. He was friend, coach, collaborator, and—most of all—he represented for the band a towering musical standard, helping everybody grow, keeping our true north. It was more than appropriate that his last album with us should be dedicated to him.

I wrote on the album sleeve:

With every man, the departure of spirit must take place. It is a destiny that is inevitable. We, EARTH, WIND

& FIRE, were blessed to have had a gifted spirit work among us. He has now departed to the next plane. He left us with much beauty and inspiration for humanity to feed upon. The works in this album are dedicated to Brother Charles Stepney (1931–1976). May God embrace his spirit with love.

Gone too soon.

★

FULL-SPECTRUM MUSIC

17 / Musical and Spiritual Progressives

Sadness bears no remedy for the problems in your life
While you run your race, keep a smilin' face—
Help you set your pace

—"ON YOUR FACE," *SPIRIT*, 1976

I was fortunate that in the aftermath of Charles's transition, I had a lot to do. It kept me moving straight ahead and not dwelling on his absence. I coped with Charles's loss privately, of course. It was yet another example of my limitations in dealing with emotions. It might leave something to be desired for me personally, but it was what it was, and it is what it is. I did listen to the blues for some sort of healing after Charles left—more than I had in a long time. Pulling out my Chess Records Howlin' Wolf and Muddy Waters vinyl, I blasted it on my big new JBL home speakers.

I knew the band was concerned about what we would do without Step. Charles was coach, I was quarterback, and in their minds, Step was the guy who could put me in my place.

I continued to trust in music and immediately got back to work. We were way behind on the preparation for the new album release and subsequent tour. *Spirit* may or may not have been our best record commercially, but it was by far our most important one, solidifying Earth, Wind & Fire as musical and spiritual progressives. It was the right album at the right time and a foundational building block in our story, with the perfect blend of black church and mystical spiritual optimism. Another great

thing about *Spirit* is that it established a black masculinity for the band that was different than the one generally expressed in public. I wanted to show that black masculinity was evolving in America. As the civil rights movement gradually wound down after the deaths of Martin Luther King Jr. and Malcolm X, so did the militaristic Black Panther–type persona. *Spirit* introduced our new public persona as sons of a royal and noble Africa, a persona that we would continue to express in our album covers, wardrobe, and songs.

I had been carrying a mental picture for a long time that I couldn't let go of: an album cover with the band dressed in white, standing, eyes closed, in front of three huge white pyramids—meditative and spiritually Eastern in flavor. With the addition of some Sufi-style placing of our arms, this became the album cover for *Spirit*, another attempt to broaden our audience and appeal to a wider view of consciousness. Certainly some of my motivation was to awaken spirituality as opposed to religion—African Americans were already well versed in Christianity, whether it was the Pentecostal church of my childhood or a more subdued Baptist version—but it was more about me sharing me with the world. Egyptology, mysticism, Buddhism: these were all things I was discovering and was excited about personally. Our vibe was definitely Afrocentric, but not a separatist one; it was about community—the family of man. By the time our listeners had digested *Spirit*, it was abundantly clear to them that we stood for something. And that made our hard-core fans, at least, believe that when they supported us, they were standing for something too. This sentiment is essential to the life and legacy of Earth, Wind & Fire.

There is only one romantic song on the *Spirit* album, "Imagination," and even that has a philosophical slant. Everything else is our distinctive blend of social and spiritual progressivism. The first single, the driving ball of fire "Getaway," set a new tone for us. However, with the exception of "Getaway" and the instrumental "Biyo," the album is introspective. Even the other two up-tempo songs, "Saturday Night" and "On Your Face,"

are kind of laid-back. That mellow feeling was probably just a reflection of the cosmic vibe around us.

That cosmic vibe was also reflected through a feeling of confidence within the group. Things were flowing in our favor. With *Spirit*'s release, we felt like we really didn't have any competition, with the single exception of my friend Stevie Wonder, who had just released his classic *Songs in the Key of Life*. Our contemporaries— bands like the Ohio Players, Mandrill, War, Kool & the Gang, Cameo, the Commodores, Con Funk Shun, and Parliament-Funkadelic—didn't carry our cachet, which was partly musical and partly about business. The Isley Brothers made great albums, and they did it without horns, which was notable in that era. Song after song, they created classics, but their live show was boring. Mandrill, possibly the must unsung band of the early 1970s, had an Afro-Cuban vibe that was undeniable. Unfortunately, they just couldn't score the big hit that could have kept them moving higher.

But Earth Wind & Fire had reached a cruising altitude in 1976. The success of *That's the Way of the World* had given us stability. Our live album *Gratitude* gave the public a window into our arena concert experience, while it also robustly increased our ticket sales. More and more, Bob Cavallo, Verdine, George Massenburg, and Frank Scheidbach were starting to act as copilots— Cavallo with the business, Verdine and Scheidbach with the live shows, and George in the studio. Climbing and climbing, we started to experience a new level of respect among our peers and a cultural respect among our core fans. Within the band, the concept had firmly taken root. We had the power and the glory.

On November 8, 1976, we were featured in the relatively new *People* magazine in an article titled "'A Higher Force' Is the Tenth Member of Maurice White's Ascetic Earth Wind & Fire." To the public at large, EW&F would always be hard to categorize, but after six years our message and purpose had finally caught on.

I believed that diet was a spiritual practice that could raise my vibration. I read books about how healthy eating choices created

more oxygen in the blood. More oxygen means a clearer mind and less damage to your organs. The band members were taking better care of themselves, too, by managing their appetites. Some of us were strict vegetarians. In our riders—the demands a band specifies at their performances—we requested that the food supplied backstage for the band and crew consist of raw fruits and vegetables, soups with no meat stock, juices, and lean meats. In bold type, the rider demanded, "No Kentucky Fried Chicken"! A few of us exercised together like never before, while others picked up scuba diving and martial arts.

Spirit instantly became our most successful album to date; *That's the Way of the World* and *Gratitude* eventually all got to double platinum, but *Spirit* shot there the fastest. This quick success made me want to put on a tour that would be a step above any previous tour. I wanted an Egyptian-themed stage that reflected the album cover: three huge white pyramids with hydraulic doors that would open up and reveal the band waiting inside. At the end of the show, the band would return to the pyramids, and the hydraulic doors would close. A technical feat and a first in the rock-and-roll business, this staging was definitely ambitious. I can't say enough good things about my production manager, Frank Scheidbach, in making my theatrical dreams come to life. I gave him complete autonomy and financial freedom to do whatever he needed to be done. At one point the accountants were giving him grief about something he hadn't requisitioned the money for. Frank spoke to me about it, and I told the accountants, "If Frank wants something, it's the same as me saying it."

I had started down a precarious path, spending money I didn't have for tours. I got some money from Columbia for tour support but not nearly enough, and even that money was taken out of my royalties. In the ensuing years, this became not only a monetary problem but a psychological burden, but it was a sacrifice I was willing to make to create an amazing show. Being the boss was expensive, indeed, but there was no turning back.

I borrowed money from banks and other financial institutions. I borrowed money from myself. No one but maybe Bob and I knew what was going on behind closed doors at my meetings with bankers, accountants, and vendors.

Meanwhile Frank had recruited an art director, Joe Gannon, from my friend Neil Diamond. Joe was the first guy in rock and roll to create moving sets—sets that were fluid, strong, and still mobile enough to be taken down each night and packed into trucks. Scheidbach got Joe to throw together sketches and set designs. Verdine, the point man on stage production, worked with Frank. When they got it down to two or three choices, they brought me in. When I first saw the mini stage mockup, I said to myself, This is really going to cost, but, damn, it looks so cool.

This was our first real big set. Before that, we were just on risers, our speakers on stands to the right and left of us with a sash or thin curtain in front of them.

Building the set would not be without its challenges. It seemed as if every Thursday or Friday, the head of construction, John McGraw, would call Frank to complain about a problem. One issue was that the heavy hydraulic doors kept overlapping and hitting each other. Frank had to go back and forth to Boston to make sure it could work. On the plane, he would examine the stage model and diagrams. By the time he arrived in Boston, he'd have assured himself that the blueprints were correct. He'd share his ideas on fixing the situation and then head right back to LA. Frank flew to Boston six or seven weeks in a row, so much that the joke around the office was that he had the opportunity to become a member of the mile-high club.

On opening night of the tour, the stage was filled with three massive pyramids surrounded by fog. The lights rose as the hydraulic doors slowly opened, revealing us standing there, dressed in red robes, silently glaring at the audience. I had never heard anything like the roar of the crowd. It was an earthquake-like rumble that was deafening. I must admit the opening cheers made the financial sacrifice well worth it. We proceeded to put

on a spectacular performance. In 1976, this kind of elaborate production was extraordinary. The spectacle and the audience's response to it were gratifying, and helped to heal our minds after the loss of Stepney.

The *Spirit* tour, which went to eighty cities, ultimately was our most successful tour to date. We were outgrossing Elton John and the Eagles in most venues. In most markets our audiences were now firmly 40 percent black and 60 percent white. This started to complicate things along racial lines.

A lot of our black fans back then didn't buy tickets in advance. Black folks, accustomed to performers like Sly Stone and other groups canceling, had learned to wait until the last minute to purchase a ticket to be certain they weren't wasting their money. EW&F started out as a cult band, with a loyal following. The colleges that built our career paved the way for us to be the first black arena rock act. From there we went to doing multiple nights at the biggest venues in the world. However, when our audiences became more diverse, there were not enough tickets to go around. Two nights at Madison Square Garden in New York, three nights at the Spectrum in Philly, or four nights at the Forum in LA were not enough shows.

But nowhere was this more apparent than in Chocolate City— Washington, DC, which had always been one of our best markets for ticket and album sales. For years we played at the DC Armory. After "Shining Star," we started to play in the brand-new 22,000-seat Capital Centre on the outskirts of town, in Landover, Maryland. We would play there two or three nights in a row. Some folks thought they could come to the box office and buy a ticket, but we were sold out for all the performances weeks in advance. In 1976 there was a big riot outside before our show. People were breaking windows and vandalizing cars because they couldn't get tickets. It made the national news. Our fans eventually got the message: purchase tickets early.

The racial ticket challenges reflected the times. Full integration was just an idea in 1976. Black people could legally live

where they wanted, but that didn't mean they were welcome. In many cases debates about busing and affirmative action kept blacks and whites in neutral corners. In the very public arena of a large music concert, people could not segregate themselves. I know now that with our multiracial audiences, we were living out the great American experiment, a racial experiment where music let us rise above the barriers of suspicion and anger. The music and message of Earth, Wind & Fire, more than any other arena-music act of our time, naturally brought different races of people together, even if it was only for a night.

18 The Best of My Love at the Best of Times

Without a song, each day would be like a century.

—MAHALIA JACKSON

Writing songs is creatively rewarding, but so is recognizing when a great song drops in your lap. Putting the right song with the right artist is always a complex gamble, but it's a big part of being a record producer. Wanda Hutchinson of the Emotions was hanging at my home away from home, Hollywood Sound, Studio B, one day. I had been trying to piece together more songs for the next Emotions album. I had developed a bad habit of inviting folks—mostly songwriters who wanted me to hear a new song—to the studio for brief meetings. There were many people coming in and out in those days, waiting to see me—cats at the studio passed the time by playing pool as they waited for their session or meeting—and it made me uncharacteristically scattered. I was still biting off more than I could chew. My schedule was getting unmanageable.

"Go upstairs," I told Wanda that day. "There's a guy I want you to meet. He'll be playing the Wurlitzer."

She rushed back downstairs. "Reece, Reece, there's a short, light-skinned guy up there, but he's just sobbing and sobbing at the piano."

"Oh, don't worry about that, baby," I said. "That's Skip, and

he's got a smash for you. Let me quickly walk upstairs and give you guys a proper introduction."

She followed me upstairs.

"Hey, Skip," I said, "this is Wanda Hutchinson of the Emotions."

His eyes still red from tears, he said, "How are you doing, young lady"

"Skip, tell her about the song."

Skip looked down sorrowfully at the piano, touched a few keys, and said, "My wife and I separated."

"I'm so sorry to hear that," Wanda said.

"Her friends fed her stories about me—not one of them true."

I patted Skip on the back, as he was clearly depressed. He went on to tell Wanda how his wife didn't even talk to him. She believed the liars and just started divorce proceedings. He was heartbroken; he couldn't believe she hadn't come to him first. He then started playing and singing the song "Don't Ask My Neighbors."

The pain in Skip's voice was so strong that tears came to my eyes. Skip Scarborough was the most beautiful and sensitive of songwriters. In touch with his emotional side, he could put his most vulnerable feelings in song, and yet he was still an optimist. He was a musical and emotional teacher to me. I'm still trying to absorb his lessons about emotional availability.

> *You're wondering if I care about you*
> *Is there some cause that I should doubt you*
> *Oh, I can see, boy, that you don't know me very well*
> *You're so unsure*
> *And you run here and there to ask my feelings*
> *Friends only guess, they can't say really, oh*
> *Don't ask my neighbors*
> *Don't ask the friends I hang around*
> —THE EMOTIONS, "DON'T ASK MY NEIGHBORS," *REJOICE*, 1977

A few weeks after Skip played "Don't Ask My Neighbors" for Wanda, Al McKay gave me a cassette of a track he was developing at his home studio. It had a real nice and simple chord progression, but it was slow as molasses. At first I had a melody that sounded like a horn line. I sang it for McKay, and we kind of looked at each other, and neither one of us was enthused. After putting it aside for a few weeks, we revisited it, only this time we sped it up—and *bam*. After that I was quickly able to finish the melody and lyric to "The Best of My Love."

In early January we recorded the track. I knew it felt right. Beyond the punctuated intro to the song, to me the tune has one of the all-time great simple-but-oh-so-good bass lines. This bass groove was Al McKay at his finest. You can never truly tell what is going to be the smash, but when we cut the basic track, it damn sure felt like one. It had that Chicago swing, a plucky rhythm guitar line, an energetic gospel-like melody, and the EW&F horn pocket.

Clarence McDonald, who coproduced the entire album with me, would lend his piano-playing talent. Clarence and I had a kinship in the department of groove—he was always emphasizing the feel of a track.

Bringing the girls in to record the vocals was an adventure. I had recorded the demo for "The Best of My Love" an octave down from where I wanted it sung. When Wanda hit the first note of the first take, I quickly stopped the tape. I was like, Whoa—I didn't even know she could sing down that low and so distinctly.

"Wanda," I said, "you've got to sing it an octave higher."

"Reece, you didn't tell me that! I've learned it in the same register that you had it. You know I usually sing guttural, like Mavis. Maybe Sheila should sing this one, Reece—she's the high singer."

"No, Wanda—you can do this, I promise you. Remember, when you're doing the ad libs, you're in that high register anyway."

Poor sweet Wanda wasn't used to starting a song that high and with that level of intensity. She thought she would not have

anywhere to go energetically or melodically toward the end of the tune. She was more familiar with doing things like Gladys Knight and Mavis Staples—starting low and building. But I was adamant—the upbeat and positive "The Best of My Love" wasn't that kind of song.

A little pissed off, she stood in front of the microphone, hands on her hips, as if to say, I'm going to show you something, Mr. Maurice White. With a look of great annoyance on her face, she belted out that first take with an intense edge. It has all kinds of squalls, peaks, and pops. She showed her authority over her vocal gifts and delivered a hot and joyous vocal track. And, lo and behold, that very first take was the one we ended up using. She was surprised, and I was overjoyed. It was a remarkable performance.

On May 3, 1977, Columbia released "The Best of My Love," the first single from the Emotions' second album, *Rejoice*. Though its climb up the charts was slow at first, it remains the biggest single that I have been a part of: it went No. 1 pop, No. 1 R&B, and No. 1 disco. According to *Billboard* magazine, "The Best of My Love" is the fourteenth biggest song of the entire decade of the 1970s. An unconditional smash!

This made me hot as a firecracker. The invitations to work never stopped coming, and I turned down many opportunities to produce other artists. I was more interested in building up Kalimba Productions, where I had more control and more of the profit share. Still, Mo Austin, president of Warner Bros. Records, contacted me about producing Prince's debut album for the label.

The backstory to this is that before Prince signed with Warner's, he was shopped over at CBS. The company wanted Verdine to produce the record, and of course that wasn't going to work for Prince. I sincerely wondered if Prince wanted me—or anyone else, for that matter—to produce him. He sent a letter to his then manager, Owen Husney, stating that while he respected my worth, he wanted to pursue his own vision as an artist.

Years later Prince would tell me he looked at songs like a movie, feeling that visuals could be turned into sound. Prince was truly ahead of his time—a vanguard artist. Initially I thought his first few albums were old hat. But by *Controversy*, even I got it. He had hit his stride, a solidification of his musical and performance vision. Producers are to this day copying his combination of powerful rhythm guitar and a previously unheard-of creative use of synthesizers and drum machines. He also made inventive use of many different vocal sounds and textures—tenor, falsetto, and even a monotone low voice, in a vocal fusion reminiscent of Sly's band.

Prince's vision also had an open-minded sexuality that made people pay attention. Songs like "Soft and Wet" and "Head" paved the way for "Controversy." I give him a lot of credit for sticking with his concept. He caught a lot of hell because his persona and sound were so atypical. I remember well that a lot of black folks in and out of the business first looked at Prince with some embarrassment when he was strutting around in stockings and lace. Obviously, sexual stuff in song was never my bag, but I have major respect for anyone with a finely tuned idea who is willing to hold out until the world catches up. My brother Prince was courageous.

I believed then, as I do now, that you can't accomplish anything without courage. In my book, courage is a high spiritual quality. It gives you the freedom to let go of others' expectations of what you should do or who you should be. Prince's later fight with Warner Bros. over the ownership of his recording masters took fearlessness, and it was a fight worth having. Personally, however, I find his spiritual transformation most noteworthy. Leaving behind his public persona as a sexually free spirit to express his devout belief in a journey of faith took a lot of courage too, and I applaud him for it.

19 All 'N All

Nothing succeeds like success.

—ALEXANDRE DUMAS

After the *Spirit* tour and the completion of the Emotions' second album, *Rejoice*, and Deniece Williams's second effort, *Song Bird*, I had to face the fact that I was worn out. Nineteen seventy-six and early 1977 were draining emotionally, spiritually, and physically. I got a real bad case of hives. My doctor couldn't really find a direct cause other than stress and exhaustion. He told me to slow down. Fortunately, after a month or two the hives dissipated.

A year and a half earlier, with the financial fruits of *That's the Way of the World* and *Gratitude*, I bought a twelve-and-a-half-acre mountaintop property overlooking California's Carmel Valley. It was a great deal, and a truly beautiful and magnificent place. It would later become a family compound, with Verdine, Fred, and I all building homes on the land, but at this time, the homes were under construction.

I had to get away, and fast. The longer I stayed in LA, the more phone calls I'd receive, meaning more business questions, more responsibilities, more work. I chose to take what was really the first vacation of my life. I took off almost two months, which was a huge deal for me. I traveled all over South America—to Brazil, to Machu Picchu in Peru, to Buenos Aires, and to the breathtaking Iguaçu Falls.

There's a sound track to my memories of Brazil; every remem-

bered picture has a melody or groove. I had always loved Latin music, from those days down in Chicago's Old Town neighborhood, but the deeper rhythms and the Afro-Cuban influence opened me up. This wasn't Sérgio Mendes and Brasil '66. This was a tribal, earthy, barefoot-in-the-dirt experience. Brazil's music contained a heavy emphasis on drumming. I discovered there were these little drum schools all over Brazil. I visited three of them and roamed around those rooms like I was a hall monitor in junior high. The talented young musicians had amazing flavor: I soaked it up. I hadn't felt that way since I was a kid back in Memphis with Booker T. and Richard Shann, listening to the new jazz records of Monk and Coltrane.

I met two guys down there who would help me in the next musical voyage of EW&F. The writer/arranger Eumir Deodato embraced me. He and his wife invited me to his home, and we went out to dinner several times. We talked about music and life—which in Brazil, I realized, are one and the same. I also met the one and only Milton Nascimento. Since Milton and I didn't speak the same language, we would communicate through a funny sign language of sorts. Between those two incredible musicians, the rhythm in the country's very soil, the food, and the beautiful Brazilian people, I left there floating, fully inspired.

Brazil saved me. I enjoyed going there more than anything I ever did in my life. I returned to Los Angeles ready to pour that experience into the new record, to bring the sights, sounds, and smells of Brazil to the palette of Earth, Wind & Fire. The music of Brazil, hiring new arrangers, and the production assistance of Verdine and Larry Dunn would soon create the next musical reality for EW&F.

Even after the breathing spell of Brazil, I still had not learned to take time to get away, not just to my place in Carmel but to another place where perhaps I could have relaxed and rejuvenated myself. My calm and inspiration all revolved around music.

However, there was a positive change in my routine at this time: I got deeper into tennis. I had started playing a little in

1976. Now I was playing as often as possible. It got into my blood, and quickly became my principal form of exercise. I would take a tennis racket on the road, keep one in my car and one at the office. I had always enjoyed running and yoga to keep my cardiovascular health strong, but tennis was new and exciting to me. Once I had a handle on the fundamentals, another level of performance kicked in. I discovered you had to be relaxed and yet have an intense focus to succeed. It was like yoga in some ways: to become one with your body, you had to remain calm and concentrate. As I grew in this energy, tennis became another form of meditation.

I was spending a lot of time reading, and I didn't want for much. Still, music was first, and I was very much at peace with that. My relationship with music was what I trusted. It was my joy and, in turn, my connection with God. Everyone in and around my life knew my priority. I only came up for air when life demanded it. Some of my relationships were fractured because people needed more than I could give. With others, bonds were strengthened as they accepted where I was or where I was not.

At the time, it felt as if I were driving a very fast car and rushing to cross an unseen finish line, looking to neither side but only straight ahead, accepting what I could not control and controlling what I could. My hand was firmly on the wheel of the Earth, Wind & Fire rocket car. I watched for the signs that would keep me progressing. There was no looking back. Mama's "Keep moving forward" rang perpetually in my psyche.

The worldwide success of "The Best of My Love" increased my business opportunities. Bob Cavallo had convinced me earlier in the year to form my own record company through Columbia. This made compelling and practical sense, since Kalimba Productions was already running like a mini record company. What was key for me was that I wanted my own facility to work in. Not only state-of-the-art recording studios but offices with a rehearsal and sound stage. This venture was the result

of a relationship that had developed between Walter Yetnikoff, Bruce Lundvall, and my managers Bob Cavallo and Joe Ruffalo. EW&F's success had created an atmosphere where they had all become buddies.

Since I was in the middle of putting together our next album, *All 'N All*, I did not go to New York in the summer of 1977 to start to piece together the deal. Bob, Art Macnow, Joe, Eric Eisner (who would later be president of David Geffen's label), and Harold Berkowitz flew in to make the transaction. Berkowitz was the toughest, most prominent lawyer in Hollywood at the time. Known for his keen negotiating skills, he had been a heavyweight in Hollywood since the 1950s. One of the great things success brings is the opportunity, if you decide to take it, to deal with businesspeople with gravitas. Berkowitz really helped in that department. My team met with Walter and Bruce and their business affairs people at the Pierre Hotel. We had played the right card at the right time. EW&F by this time had a string of hits, and with the success of Deniece Williams and the Emotions, I was a consistent moneymaker for Columbia.

It was a huge deal for Columbia Records. They'd never done anything quite like that—buy a studio and all the rest, and give the right to use the name American Recording Company, the original name of Columbia Records and the oldest label in the world. While my team was working out the particulars of the deal, I was feverishly working on *All 'N All*, which some consider to be our best album. That Brazilian vibe definitely made it an exciting process, but I know it wasn't me at the helm. I felt like the Creator was just bringing the perfect musicians into my life at the perfect time.

A strong example of that timing was when Larry Dunn came by and played a project he'd produced on a jazz fusion band, Caldera, for me. Larry was proud of what he had done, and he should have been—it was stellar progressive work, truly some badass stuff. I told Larry to get Eddie Del Barrio, the cat who wrote that material, to call me. Larry and I had already started writing the

Latin-flavored instrumental "Runnin'," but we didn't have the bridge section. Eddie waltzed in and in no time flat wrote these beautiful jazzy South American–feeling chord changes. I told him to write it down and come by the studio the next day, and we'd cut the demo.

The next day Eddie got to the studio early. It was just Eddie, George Massenburg, and myself. I suggested that we try to write another song quickly before the guys arrived. I sat down at the drum set, closed my eyes, and thought about this one beat I'd heard over and over in Brazil. My version of it was slowed down, but the best way I can describe it is a samba-like shuffle on the hi-hat with a straight kick drum. It was almost the beat drummer Jeff Porcaro would years later make a career out of on songs like Toto's "Africa." Eddie raised his head, slowly closed his eyes, and began playing a series of chords against my groove. I started singing a melody, and we just flowed along for a good fifteen or twenty minutes. This brainstorm would ultimately become the song "Fantasy." We wrote the entire track and most of the melody, with the exception of the turnaround, in no time flat. It poured right out of us.

I was in love with the groove right from the start—overjoyed. I had sought music that was original and genre-expanding. With its combination of South American, classical, theatrical, and folky R&B sound, "Fantasy" was spot-on. I felt a pure, almost childlike excitement after our writing session that I hadn't experienced in a while. I put my arm around Del Barrio, pulled him toward me, and shoved a cassette into his hand. "Eddie," I said, "this is fantastic. Write out the changes, and we will cut a demo tomorrow—I don't want to wait!"

The next afternoon Eddie came into Hollywood Sound looking resigned, like he had lost his best friend.

"What's wrong?" I said.

"Maurice, I am honored that you want to record this song and all, but I've got to say *this is a total piece of shit*!"

"Eddie, this music works. It hits me right in my gut."

"I played the cassette over and over again last night. I may not be from your world, but I know for sure this sucks."

"I'm going to show you how wrong you are."

Larry and Verdine, who were production assistants on *All 'N All*, put the final touches on "Fantasy." Larry put a harpsichord intro down with George when I wasn't there. At first I didn't like it. Stupid me. The harpsichord set the whole classical backdrop of the tune and made all the other classical elements easier for the novice to swallow. But it would be Verdine and George experimenting in the studio that would bring added flavor to the intro. In the introduction, once the groove starts, there is this weird sound of Verdine doing these slides and distinctive plucks. George would use the frequency knob on his equalizer, going back and forth, creating this odd wah-wah effect. To me it sounded like a funky electrified cello.

The creative process of "Fantasy" took about two and a half months from the time we wrote the music. Verdine and I went back and forth over the lyrics. I knew what I wanted it to be about, but it didn't come together for me until I saw an early screening of the movie *Close Encounters of the Third Kind*. I was caught up in the symbolism and archetypal meanings. The aliens' implantation of a vision into the Richard Dreyfuss character and the mythic elements of communicating with a deity stirred my imagination. The film's acknowledgment of a primal spiritual yearning in all of us resonated deeply with me. What I liked most about Steven Spielberg's creation, though, is that it honors the free will of the eternal life journey. I had been reading a lot about reincarnation and past lives, how we are born into the future through death. All those factors and more led to what the song ultimately became about.

Come to see victory in a land called fantasy,
Loving life for you and me, to behold, to your soul is ecstasy
You will find, other kind, that has been in search for you,
Many lives has brought you to

Recognize it's your life, now in review
And as you stay for the play fantasy has in store for you,
A glowing light will see you through

It's your day, shining day, all your dreams come true
As you glide in your stride with the wind, as you fly away
Give a smile from your lips and say
I am free, yes I'm free, now I'm on my way
—"FANTASY," ALL 'N ALL, 1977

At the time, I didn't know that a day would come when even I would grasp a more esoteric meaning to "Fantasy," a meaning beyond the original intent of the lyric. In the early 2000s, Japanese filmmakers did an hour-long story about the song. The documentarian interviewed people, and in their own words they expressed what the song meant to them. Even though it's sung in English, "Fantasy" has become a Japanese national anthem or secular hymn of sorts. Somehow the melodies and music have come to represent the achievement of dreams. They play it often at sporting events. Wow, they picked up the vibration.

My Christian brothers tell me that if you replace the word *fantasy* with *heaven*, you will understand what the song is about. "Fantasy" is about heaven to Christians; to Buddhists, it's about nirvana; Muslims say it's about paradise. I like the fact that people hear it through their own life experience; it's a strong indication that we got it right. "Fantasy" is a continuation in a long line of EW&F songs that celebrate the equality and fellowship of humanity.

The heavily Brazilian-infused "Fantasy" would become one of our songs most played on radio. It represents how much we were in our own closed bubble. Disco was in full effect in 1977, and I paid absolutely no attention to it. One thing that I, the band, and anyone else who knows our music gets annoyed by is any idiot calling EW&F a "disco band." Disco music was trite to me, pedestrian and boring. Most disco hits were at around

125 bpm (beats per minute), which—along with the straight kick drum pattern—made the music feel predictable.

Our music was eclectic, not the boring, sterile, unimaginative monotone of disco. We had the best rhythm section in the world. The tracks minus their vocals or horns are intricate unto themselves. Looking back, it's hard to believe that "Serpentine Fire" and "Fantasy" got radio airplay at all at a time when songs like "YMCA" by the Village People, "I Feel Love" by Donna Summer, and "Dancing Queen" by ABBA dominated the airwaves. "Serpentine Fire," in particular, is profoundly odd, an idiosyncratic mixture of African music, tango, and gospel blues with an abstract lyric about kundalini energy. Its gospel calls of "Oh yeah, oh yeah, oh yeah" kinda make me feel southern and churchy. The underlying tone of the lyric comes off as a war of the flesh. It is our most ambitious single, because it is so musically abstract—the complete opposite of the disco that dominated the radio in 1977. It was almost as if, in our success, we were getting away with something. Our melodic blend of jazz, world, R&B, pop, and adult contemporary was leading a new sound. Some would later call the sound West Coast album-oriented rock, or modern soul.

As we were wrapping the recording of *All 'N All*, I started to consider what the album artwork would be. When we took the pictures for the *All 'N All* album poster, we had been burning the candles at both ends, and we all had bags under our eyes. Striving to stay out of the box, I put the word out that I was looking for something original that would visualize our musical and spiritual ideas. After meeting with a few artists, I settled on Shusei Nagaoka. We would start a professional association that would elevate us both.

Shusei didn't speak a lick of English, and I damn sure didn't speak any Japanese. When he arrived at my house, he bowed, I bowed, and I motioned him into the living room. I began to show him pictures out of some of my Egyptian coffee table books as well as books on UFOs, which have always intrigued me. He'd go

mm-mm, and I'd point to pictures, nodding. He'd then pull out his large sketch tablet and pencils. Lifting up the cover, he'd start to draw. We both started to point to the picture books and then to his tablet. I signaled for him to stop. I then gathered bits of paper, some of them chewing gum wrappers, and drew little religious and other iconic symbols on them. I started placing them in a pattern on the paper, and he started drawing around them.

Somehow we communicated. And I was stunned by how it came out. I never said that I wanted the gatefold inside to be about the one God who transcends all paths, but in the end that's exactly what manifested. I was fascinated at the detail, the color and expressiveness, of his work. It was delicious to my eyes. Shusei was an out-and-out genius.

Shusei gave me a deeper view of art in general. I started to understand how people think in images, which is why pictures are more universal than words. Shusei's many EW&F album covers meant an enormous amount to our worldwide audience, especially the Japanese and Brazilians. They were interested in every detail of his art and its symbolism.

20 Musical Theater, Magical Tour

Time to get back on the road
Gonna leave these troubles behind
Time to carry the load
Oh, but my life is a true design

<div align="right">—"BACK ON THE ROAD," FACES, 1980</div>

I'm not going to pretend that my desire to top our previous tour in terms of theater was not somewhat motivated by the fact that KISS and George Clinton had just raised the bar by producing some great rock-and-roll spectacles. I wanted our show to have added dimensions beyond just spectacle. I wanted our body movements to be eye-catching and our stage show dramatic in a way that had never been done by anyone in rock and roll. This would be the first time a black act would tour with a completely self-contained concert presentation of staging, sound, trucking, and all the rest.

The planning for the tour in support of *All 'N All* started immediately following the *Spirit* tour. I had the experience of seeing how technically involved this stuff could get, so I didn't want to be caught off guard. I hired two people who would change the theatrical life of Earth, Wind & Fire forever—magician Doug Henning and choreographer George Faison.

George Faison, a choreographer without peer, had just come off his Tony Award–winning work in *The Wiz*. On the phone, I told him that from EW&F's early days I had laid down a law that we would not be "a drill team," with choreographed group

moves like all those singing groups that had emerged in the early 1970s. The Temptations, the Dramatics, and the Spinners were all great, but that wasn't Earth, Wind & Fire. I wanted something that was artistic but still fit us as musicians.

Faison immediately flew from New York to Los Angeles. He quietly watched our rehearsals and hung out in the studio. We worked on the *All 'N All* album by day and rehearsed for the tour at night. We had our first sit-down meeting late one night in the control room of Hollywood Sound.

"George, our music is difficult," I said.

"Hold it, stop. Relax, Maurice. I'm not here to make you dance like Alvin Ailey or the *Soul Train* dancers!"

"Well, what do you see for us?"

"I'm going to create an internal rhythm for you guys."

"Internal rhythm—what do you mean?"

"You'll understand after about three weeks of rehearsal," Faison said authoritatively.

In those first weeks of rehearsals, George watched carefully, took notes, and listened. Then all of a sudden he flipped on some nuclear switch, aggressively inserting himself into the rehearsals and taking over. George Faison was a commanding presence, with a big smile. He was a rare breed—demanding and tough as hell, yet cool and bright. It took me a while to get used to his working style, and the band was kind of dismissive of his instructions at first. But that quickly ended as his shouting got louder.

If I hadn't understood what George meant by "internal rhythm" at first, after about two weeks of rehearsal, just as he'd predicted, I did. George would be on the spacious sound stage, circling us on a pair of roller skates. Round and round he'd go. All of a sudden he would holler out, "*Stop!* Everybody shut up!" He would pick up something in the music and create movements for us right there on the spot. Faison was a master. Every step and spin he assigned us made sense with what was going on musically in that moment. In time we all accepted that through

his hollering Faison was giving us choreography tailored for us. Still, you had to remember more things. There were the practicalities of spinning around while holding cabled microphones, or not letting a guitar neck hit you in the face, or knowing that an explosion was going to happen as soon as you took your assigned three steps to the right. He was more than a choreographer: he was staging us as well. When Al McKay strummed his acoustic guitar on "I Write a Song for You," Faison sat him down on the steps in front of Larry Dunn's keyboard rig. These artistic touches were not insignificant. They were a continuation of my desire to let everybody shine onstage.

George had the choreography talent, as well as the psychological skill, to help us become one physically and mentally. He put the guitar players together in a threesome, in which Verdine, Al, and Johnny Graham would rush to the front of the stage and do their gyrations. Then he had a threesome of myself, Philip, and Ralph Johnson, where we would rush up to replace them and do our prescribed movements. Faison transformed our performances, giving more of the theatrical presence we had been working on from the very beginning.

I was sitting in the control room of Oceanway Studio on Sunset Boulevard one day when the door opened to a crack and through the small opening peered a little smiling guy with buck teeth and shaggy hair: Doug Henning. Come on in, I said happily. Doug Henning was the magicians' magician, and now he was a Hollywood star too, due to his hit show on NBC-TV, *Doug Henning's World of Magic*. Henning had single-handedly resurrected magic for the masses. He was by far the most popular magician in the world. I cleared the studio so we could have a chat.

"Doug, magic is something I have longed for many years to bring to Earth, Wind & Fire—it's a big dream of mine."

"Well, Maurice, I love you guys' music, and I think I can help. But it requires a commitment from you to take my work extremely seriously."

"Of course I will."

"I hope you do, Maurice, because for the illusions to be executed properly requires an acting component, coupled with very precise timing. You and your band will have to be fully engaged mentally."

Some people in Hollywood thought Doug, with his funny hippie look, was odd—a weirdo. I didn't. I found him to be an interesting man, intense and highly spiritual. We talked a lot about meditation that first day. He took everything seriously: his work and his spiritual practice. An advocate of transcendental meditation, he made time to meditate for two hours, daily. After that initial meeting, I didn't see him much, but Verdine and Frank Scheidbach met with him regularly. Verdine, forever the cheerleader, grabbed me from behind when I was leaving the studio one night and whispered in my ear, "Maurice, this Henning shit is going to blow your fucking mind!" Doug would come into our rehearsals, and the band would be joking around, and Doug would shout, "Okay, enough! Calm down! Focus! We're doing this now." He would take over. Just like George Faison, Doug was the best in the world at what he did, and he didn't give a rat's ass that we were the majestic Earth, Wind & Fire. His contribution to the *All 'N All* tour was life-changing. No one in rock had attempted anything like this. First, we had to be sworn to secrecy, spiritually and legally. I've never told Doug's secrets to this day, even though he's been gone for a while.

But our collaboration would not be without major complications. First, all the magic required us to build and transport our own stage. This meant more setup time and about four additional semi trucks. We already knew that renting trucks was pricey. Consequently, we bought all the semis outright and established a trucking company. We would rent the trucks out when we weren't on the road. On top of all that, there was so much secrecy with the Henning camp that part of my contract with Doug was that I had to let his people build the sets. Frank Scheidbach, my production manager, was dead set against it.

"Maurice, we've never let anyone but McGraw and TFA build our sets," Frank said.

"Yeah, but Henning's people—the secrecy—it's the deal I had to make."

"I hope they understand this is arena rock, not some one-shot TV show production."

When Doug's contraptions arrived, Frank was not happy. In fact, he was pissed off. He said they'd used chintzy metal, shoddy cables, and inferior bearings. We had three-floor stages—a lot of elevators on the stage going up and down because there was always so much going on behind the scenes. Frank protested, but he got it up and working smoothly. A month into rehearsals with the new set, one of Doug's elevators came crashing down, smashing into a thousand pieces. I was not there to witness this disaster. When Frank gave me the news, I got quiet. I was not one to raise my voice, but still, there was probably more determination in it. Frank didn't say I told you so; he just laid out my options. We have to do it right, I told Frank. We stopped the show preparations for a few weeks and had Doug's equipment all rebuilt by people Scheidbach had found. Big money. Later my lawyer sued Doug for the expense of this rebuilding.

Meanwhile, across town in West Los Angeles, George Massenburg was developing an innovative sound system for us. Using a new kind of bass reflex cabinet, it would be a benchmark for all other rock-and-roll acts. Several hundred thousand dollars later, the mammoth 35,000-watt hi-fi system was ready. Most acts had loud but shitty-sounding systems. Ours was loud but clear. It sounded spectacular. Finally things started to come together. Our custom-built stage had a triangular point protruding out from the center. It made me feel that the audience was all around me. Between the new lighting technology, the dancing, and the explosions, the stage was actually a dangerous place. A few steps in the wrong direction at the wrong time, and it could be curtains. You could drop down a hole or get fried by the gunpowder-based explosions. We all had to concentrate a lot

more to make it seem effortless. This is when, to the best of my knowledge, the last of the Mohicans in the band gave up weed.

Doug created fantastic illusions. He devised an opening where we would arrive onstage from tubes hanging a hundred feet high above the stage. The tubes lowered to the stage, and we gradually became visible to the audience inside the cylinders. Then the tubes rose back to high above the stage, and we proceeded with the show. The tubes had to land within a quarter of an inch of accuracy every night. And since they were coming from a hundred feet in the air, our riggers had to have everything precise. It was our best show opening. Doug gave us another illusion in which hooded aliens with masks gradually joined us, and we then one by one entered a metallic pyramid, leaving the hooded aliens onstage. The pyramid would take off skyward and then explode. To the audience's amazement, we would then reveal ourselves as the hooded aliens, as if we had been somehow transported from the exploding pyramid to the stage.

But what we did with Verdine stands out as the theatrical milestone of the tour. Simply put, Doug created a way for Verdine to levitate above the stage.

The *All 'N All* tour was so technically involved that before we took it out, we had to have several run-throughs at Sunset Gower Studios, a movie studio with enough space. We had to fly the crew in. Many of those cats lived out of state. They needed practice in setting up and tearing down the complicated sets, to make sure that it would all work on the road. When Columbia Records found out what we were doing, they thought it would be a good idea to fly in journalists from around the world, as well as about three hundred friends and celebrities, to give them a shortened version of the show. It turned out to be an Arabian-themed media junket.

As Verdine said, "People left that junket and they didn't know what to think. It was that show opening, with those tubes coming down out of the sky. Then at the end of that show, when we wave good-bye and get in that damn pyramid and the thing explodes!

It was like we'll never be able to top our own damn self. God wrote that show. You can tell. That spectacle really converged everything. The record was right. The show was right. The audience was ready. And it had been a building process."

Some artists have a meteoric rise to stardom, but that wasn't the case for Earth, Wind & Fire. This slow, steady ride gave me an appreciation that I don't think I would have had otherwise. Being able to call on Doug Henning and George Faison was about the money to do so, but it was also about having the faith that I could see long-held desires for the band come to pass. During the years of this building process, our exploding popularity would give others a chance to ride our wave. Deniece Williams had quickly become a star. Verdine had produced his first act, Pockets, through Kalimba Productions. Both would serve as opening acts for the tour: Pockets would go on first, Deniece Williams second, and finally EW&F. Earth, Wind & Fire didn't need an opening act, but I was building a Kalimba Productions synergy, the idea being that EW&F's tour audience would become their tour audience.

The *All 'N All* tour opened on October 2, 1977, at Riverfront Stadium in Cincinnati, having sold out several weeks in advance. We always toured in the winter, and we had toiled in previous years to catch planes. I wanted everyone to be as comfortable as possible. I leased a plane, a Vickers Viscount four-engine turboprop. That model was a workhorse for a lot of us in rock and roll: Rod Stewart, Styx, Barry Manilow, Boston, America, Bad Company, and others leased the same model. It wasn't a very fast plane, but it was an incredibly reliable and comfortable one. We called the plane the tuna boat because it seemed the two stewardesses we hired were always serving us tuna sandwiches. It made things much easier for the band; we could leave immediately after the gig, get to the next town, and sleep. I'm very serious when I say that this was really the first time in years that we could get some serious sleep. We could play in NYC one night, do a gig in Philadelphia the next night, and fly back to NYC to

stay there because it was a better hang in the Apple. We also had a shiatsu masseuse travel with us because we were putting out so much physically every night.

Earlier in the year I had made a commitment to Robert Stigwood, the manager of the Bee Gees. Stigwood had resurrected their career with the history-making success of the *Saturday Night Fever* sound track. The sound track was still hot as a firecracker, being played all the time on the radio. My favorite song on it, "How Deep Is Your Love," would be the number-one record in the country at the end of the year. The very next week their song "Too Much Heaven" would replace "How Deep Is Your Love" at the top of the charts. Additionally, Stigwood had just produced another sound track, *Grease*, for the hit film starring Olivia Newton-John and John Travolta.

Stigwood seemed to have a golden touch. When he approached me about having the band appear as a guest in a movie musical based on the Beatles album *Sgt. Pepper's Lonely Hearts Club Band*, I said OK. But with the tight scheduling that I put upon myself, I had completely forgotten about it.

"Hey, did you cut that Beatles song yet for Stigwood?" Bob reminded me.

"Oh, man, I spaced—totally forgot about it."

"It's due in three weeks."

Since I'd waited until the very last minute, many of the songs they had given me to choose from had already been taken by the other artists. But "Got to Get You into My Life" was available, and Verdine and I settled on that. We walked to Sam Goody in NYC to buy the record.

EW&F packed a lot of activity into six days. We played two nights at Madison Square Garden on November 24 and 25, figured out a plan for "Got to Get You into My Life," and George Faison threw us a beautiful party at his home in New York City. He had me close my eyes and walk up to the front door, where Stevie Wonder, Valerie Simpson, and Nick Ashford said "Surprise!" He had the party planned weeks in advance. The recep-

tion was typical of the admirable way George Faison showed us love.

On Tuesday, November 29, we played a gig in St. Paul, Minnesota, at the Civic Center. We had one day off before we had to play on December 1 in Denver at McNichols Arena. We flew in immediately after the gig and arrived at the hotel, got a few hours of rest, and Larry Dunn and I found an old upright piano in the hotel ballroom to musically work out "Got to Get You into My Life."

"Man, give me some crazy shit for the intro," I said, "like bop, bop, bop, bop, bop, bop, bop, bop." I always thought in rhythm, and Larry figured out the notes in five minutes flat. I tapped on the piano and sang, and Larry played. I went back and forth, discussing the basic feel, and in about forty-five minutes we were done. We loosely rehearsed it in the ballroom with the rhythm section guys. George Massenburg flew up from LA and brought his usual bag of tricks of microphones, preamps, and everything else he would need to make things happen right. We chose a relatively new studio called Northstar in Boulder, Colorado. Our version of "Got to Get You into My Life" was all recorded very quickly—the whole thing, top to bottom, was done in probably a forty-eight-hour period. But it's a testament again to how in sync we were, as a rhythm section first, and then Philip and I vocally.

We burned through two shows in Seattle on December 16 and 17. Although we were scheduled to leave the next day, our longtime pilot Duke said we should get in the air right after the gig. Duke always looked at weather plans, but he followed his instincts too. We flew back home to Los Angeles. On my birthday, December 19, I drove to the old MGM backlot in Culver City, California, where we filmed our segment for *Sgt. Pepper's Lonely Hearts Club Band*. We had no real planning; when it came to filming our scene, all we did was bring the current road show to the soundstage. I made this scheduling tight as I could to get our scene in the can and give the band and crew some time off

for Christmas, because we had a three-night stand in Baltimore on December 27, 28, and 29.

After filming our scene, director Michael Schultz said to me, "Man, this was more fun than it was work. You guys having those tubes coming down from the sky and all, I felt like I was at an Earth, Wind & Fire concert. All I had to do is point the cameras and say cut!"

Beatles producer George Martin, who also produced the sound track for the film, ran to me the second we finished shooting and said, "Damn, we should have done the whole sound track like that!"

In essence, the other musical acts in the film tried too hard to be true to the Beatles' original songs, which I believe was their creative undoing. I revered the Beatles, too, but I decided to remain true to our rallying cry: any material that EW&F touched, we had to put our own spin on it. In the case of "Got to Get You into My Life," we swung it—hard. We cooked a jazzy, greasy Memphis groove with a touch of big-band swing. Verdine could have walked the bass line like he was playing upright bass with Count Basie—it was swinging that hard. I think it's one of Verdine's best bass performances on record, and, according to Paul McCartney, it's his favorite Beatles cover.

However, the word was out about the movie. A flop was coming. Sensing disaster about the film's fortunes, Cavallo called me. "Reece, this record is great, but I promise you, the film will absolutely kill it. Let's drop the record early," he implored.

"Don't I have a contract that gives them first dibs on the release?"

"Absolutely not!"

"Work it out with Columbia."

Bob did. Cavallo and my longtime lawyer Jeffrey Ingber were savvy guys. For the most part, I was well advised. Having the control over "Got to Get You into My Life," even though it was created for the film, was a small example of their attention to detail on my behalf. *Sgt. Pepper's Lonely Hearts Club Band* did

turn out to be a complete bust in every way. Critics panned it as one of the worst films ever—but we got another big hit out of it. "Got to Get You into My Life" had to have been the only successful thing associated with that film.

I think it had kicked in by now to management and the band that my dislike of overexposure had a good effect on EW&F's charisma, and consequently they stopped pushing me to do more television. But Natalie Cole and Bob urged me to do Natalie's TV special on CBS. Natalie had exploded on the music scene, becoming a big star overnight. She was a class act, too. In late March 1978 we taped a segment for *The Natalie Cole Special*. George Faison would help conceive and execute what I consider our best television appearance. George thought we could do a cinematic performance, with three wardrobe changes in our eight-minute appearance. For it to work, we would have to pre-record the music, which kind of annoyed me because I'd never been a fan of lip-synching. For this reason I wanted our pre-recorded music to have a live feel to it, with all the nuance and changes to the music that would naturally occur onstage. We did a medley of "Serpentine Fire," "Saturday Nite," "Can't Hide Love," "Reasons," and—with Natalie joining us—"That's the Way of the World."

The *All 'N All* tour never stopped rolling between filming *Sgt. Pepper's* and *The Natalie Cole Special*. For our crew, this tour would test their ability and work ethic. We had first-class roadies, and though our riggers were expensive, they were the best money could buy, highly specialized in arena rock venues. But just like so much in the mid-1970s, regulations were tightening. Right along with new smoking sections on airplanes, mandatory seat belts in cars, and mandatory helmets for motorcycles on interstate highways, the arena rock business started to be more regulated in terms of safety. Our riggers had to keep up with every new technique and regulation to hang speakers from arena ceilings and, in our case, to create complicated magical effects too.

This winter of 1977–78 was particularly grueling. Duke, our pilot, was always saying, "Maurice, it's going to take longer tonight—I've got to fly around yet another snowstorm." It was cold and nasty even out west. Our crew started to get really sick. We always used 80 to 90 percent the same cats due to technical requirements that were always evolving from year to year. Even with an advance team to get to the next venue early to do the preliminary work, it was still punishing. We also had a lot of one-nighters.

Frank Scheidbach knocked on my hotel door one time. "Maurice, the crew is on their last leg."

"What do you need?"

"We're going to need a doctor to meet us in each city."

"No problem—work it out."

We had three buses designated solely for the crew. A doctor in Seattle, Washington, suggested that we turn one of those buses into a rolling hospital where the sick guys could stay, in an attempt to quarantine the wicked flu bug/pneumonia being passed around the crew.

The pace of the tour was so fast that I had to be reminded what city we were in before we hit the stage. I think one time maybe Philip said we were in Boston, but in fact we were in Dallas. The tour seemed to go on forever. Demand was high, so dates kept being added. I don't know about the rest of the band, but like many things in life, I wished I had savored it more. It was such a great tour for us, even though it was a bitter winter. On the final night of the tour, I arranged for all the crew to come out to the stage, and I told the audience of our crew's major contribution to the show that they had just witnessed. The audience gave them very loud applause.

The *All 'N All* album and tour was a milestone, the best-selling R&B album of 1978. It was a great musical record, and the beginning of another phase for us.

21 | Beginnings and Endings

Somethin' happened along the way
What used to be happy was sad

—"AFTER THE LOVE IS GONE," *I AM*, 1979

The rest of 1978 would be full of beginnings, and beginnings of endings. For Marilyn and I, our ending had started a year earlier. By 1977 we were not getting along at all. Something was undoubtedly wrong in our relationship. I didn't want any more demands put upon me. No, I wasn't getting married. I wanted my freedom. I was drifting away, and so was she. It was obvious to everyone around me that we had hit a rough spot. Marilyn could be awfully pushy. She would come to the studio and get in my face. That really, truly pissed me off, even if it was only about appearances. I didn't want anyone to know anything about my relationships. I was private.

I had other women I would occasionally see, but not many. In my twenty-five years of being on the road, I tried to be discriminating, recognizing the intellectual as well as the potential sexual compatibility of the women I was meeting. Since I was turning down 98 percent of the women who were coming on to me, I thought I was being a very good boy. Beyond the other hands I held, I just wasn't cut out for marriage. There was an obsessive side to me. I needed to be obsessive to focus, especially in music—not just in writing it but in searching for it, recording it, traveling the world to perform it, watching the business to sustain it, and most of all having the quiet time to start the process all over again. It was very time-consuming.

Marilyn moved out of my condo in Beverly Hills. We were off and on, more off than on, for many years to come, though ultimately she would become one of my most consistent and closest friends—just rock solid. On the bright side, after Marilyn moved out, my sister Patt Adams, who had finished her nursing studies in Chicago and moved to LA for work, moved in. Patt would live with me for over twenty-five years, becoming my confidante and friend as life rolled on with its inevitable twists and turns.

Late in 1977, Leonard and I were grabbing a sandwich at the corner of Santa Monica and Palm in West Hollywood while my car was being washed at the Santa Palm Car Wash, when Ellene Warren walked in. Although I had known Ellene since 1972—she had designed some of my personal clothes in years past—I hadn't seen her for a while. She had always been talented. I asked her out for dinner, and not long after that, we were in a relationship. One thing that made Ellene special to me was that she had her own career and her own life that she was very much committed to. She also didn't ask me for any kind of certainty about our relationship, which was refreshing.

Even though Marilyn and I were apart, she was never far away. So there I went, putting women into compartments in my life. Why? Because I could. I felt a certain amount of entitlement. There were also other women in the mix. Now, however, I often wish that I had been more truthful with the significant women in my life. If I had been more honest about where I was—or more importantly, where I wasn't—there would have been less hurt feelings. Fewer expectations. More understanding. I didn't tell Marilyn about Ellene, and vice versa. Eventually, each would both know the other existed, but beyond that, I kept it cool.

There were two or three other significant romantic relationships along the way that had a lot of meaning to me as well, women I cared for and respected. But one was in New York, and another had a very demanding career that kept our rendezvous to a minimum. In the early days of EW&F, I would pick up girls after a show, but I quickly became a little weary of that. Conse-

quently, I started a practice of flying women in to meet me while I was on the road. These were women that I had kept in touch with, some even from my Ramsey Lewis days. Most were fun and breezy. Some were intellectual, and all of them were sexy. I didn't have the guilt demon at the door—I wasn't cheating on a wife. They would meet me in cities far and wide, hang out with me for a few days, maybe fly on our plane to the next city or two. Then I would fly them back home.

Of course there was the most casual of casual sex in the 1970s. The feminist movement encouraged women to break free of sexual norms. For some this meant exercising their power through taking control of their sexuality, even if it manifested as a tiny bit of promiscuity. There were women backstage that desired to give you a blow job just so they could say they gave you a blow job. I had several women show up at my hotel door with nothing but a trench coat on. I had one who broke through security on the airport tarmac and grabbed me from behind. For the musician on the road, the sexual revolution of the 1970s was a mere extension of the "artistic nightlife," where you deluded yourself that creativity and "free love" were inextricably entwined.

With all that said, I still can't bring myself to reveal to the public all I felt about my romantic or sexual relationships. I believe that one of the reasons that people in my line of work are always getting married, separated, divorced, and married, separated, and divorced, over and over again, is that they never come to terms with who they really are. This may sound selfish, but the truth is that I didn't want to wake up with the same woman day after day, year after year. I was not attracted to the normal household as defined by the dominant American culture— married or not.

I like having my own space and my own set of freedoms. Furthermore, I was truly, madly, deeply in love—caught up in the rapture, if you will—with what I was doing. It was more than just a job to me. I really believe it was what I was born to do. I never was one to analyze why this or that person was in my life. I

believe people come in for a season, and when it's done, it's done. I went with my feelings. Being single was not a problem for me; it was a pleasure, in fact.

At this point, whenever I could, I would spend time at the compound in Carmel. It was a beautiful, well-appointed, very relaxing place to be.

What I came to cherish most about Carmel was its silence—and its solitude. The quiet mountains seemed to help me hear things that the static of life drowned out. Listening to the quiet helped me to relax. I had accepted a long time ago that I was highly strung. Carmel's muted atmosphere seemed to release some tension. At night it took on an added still beauty. The stars and moon seemed so near, shining off the deep blue ocean far in the distance. This beauty had become my safe refuge from Los Angeles. I had been meditating for some years, but Carmel's very mood took me to another level. I breathed more deeply; I seemed to relax in a way that had been elusive to me. Its rolling hills were becoming my sanctuary.

At the same time that my place in Carmel was ready to be lived in, Marilyn told me she was pregnant. I was excited, then nervous, then excited, then nervous. The reason for this roller coaster of feelings was that Marilyn and I were on very shaky ground. When she moved out in 1977, we never lived together again. Naturally, I told her I was happy, but as with my daughter Hemeya's birth, it pained me subconsciously to know my child wouldn't see much of me. My son Kahbran, his name derived from Kahlil Gibran, was born August 1, 1978. When I saw my newborn son, it was one of the happiest moments of my life.

That fall there was another beginning: my label, the American Recording Company, or ARC, was officially launched at the CBS Records Convention in Los Angeles, although the label's first release wouldn't be until early winter. It was an exciting and ambitious time. The initial artists on the roster were EW&F, of course, the Emotions, D. J. Rogers, Weather Report, Deniece Williams, Reggie Knighton, and Valerie Carter. The label would

get off to a great start, but one of the first blunders I made was that I did not hire a strong musical A&R executive, someone to sign and develop artists and produce them if necessary. It's not that I didn't try. I wanted the writer/arranger/producer Jerry Peters to run the label, but he turned me down. Still, he did produce some of our artists, like D. J. Rogers. Another problem was that I was on the road with Earth, Wind & Fire all the time. The band was my baby, and I would always give it the first fruits of my musical and business energies.

Verdine and music executive Carole Childs, who was working with Cavallo at the time, introduced me to two young and highly creative people, Allee Willis and David Foster. I had heard a few things Allee had written, and I liked her style. Allee was eclectic in her look and creative expression—a true one-of-a-kind. She was a stickler for details who cared about every word she put down on paper. I thought that if she got a little exposure to my world, we could do something special.

We were scheduled to rehearse in a studio in Hollywood. Allee was nervous when she arrived. We had been playing what would become "September." Taking a break, Al McKay, Allee, and I went into a separate room. I told her this song was the last in a trilogy of songs Al and I wrote, which were all coming from the same groove and feel. Those songs were "Sing a Song," "The Best of My Love," and now "September."

In short, even though I had reservations, I told Allee that I wanted her to help write the next EW&F album with me. I had developed a very bad habit of saying I wanted to do this and that, throwing my words around when in actuality I wasn't sure. I gave some artists and writers expectations that I could not deliver on. I just didn't have the time. Life and business were always changing quickly, and it was challenging to keep up. However, I did want Allee's lyrics to succeed because she was earnest and so sincere.

"What do you know about Eastern philosophy?" I asked.

"Nothing, really."

"I'm going to write down a few books I want you to check out."

She looked at the list. I could tell by the bewildered look on her face that she thought she was in over her head—but I knew she wasn't. I underlined *The Greatest Salesman in the World* by Og Mandino.

Ironically, the first song Allee worked on, "September," didn't have anything to do with philosophy. It's a very simple lyric—yet it took about a month for me to calm Allee down about "September." She detested the *ba-de-ya* hook in "September," thinking it should be a real word, and perceived it as a slight to her lyric-writing abilities. *Ba-de-ya* overwhelmed her thoughts. She rode my back for three long weeks, finally protesting, "You can't leave the *ba-de-ya* in there, it makes no sense!"

Sorry, Charlie. I should have told her from the start that I was never going to change it; I just tolerated her emotions to be pleasant. Try as I might, I couldn't get her to understand that good music is all about the vibe, and some things work better toward that vibe. Still, she was almost in tears. I just put my arm around her and said, You gotta trust me on this one—I can't let a bulky lyric get in the way of a melodic groove.

One thing that I wanted Allee and all the people who collaborated with me to understand is that non-conformity and curiosity always lead to a heightened creativity. The reason I wanted her to read certain books was twofold. One, it was not so much to hip her to this or that as just to expose her to different things, break her out of the norms of conventional thinking. Inhibitions kill imagination. Mysticism helps keep it alive. Secondly, I wanted to give her a language that would hip her to write lyrics in a philosophical manner, even so-called love songs. That language would really manifest itself in the song "In the Stone."

"September" was the American Recording Company's first release, and an across-the-board smash. It would be the leadoff single to our first greatest hits package, *The Best of Earth, Wind & Fire, Vol. 1,* and it continues to be one of Earth, Wind & Fire's

most memorable songs. Al McKay's distinctive guitar-string pulling in the introduction, coupled with Tom-Tom Washington's horn arrangement, gave the song a Latin fanfare appeal that perfectly complemented the nonsense *ba-de-ya* melody. It has all the feel-good, anthemic qualities that we were working hard to achieve in song and on the stage.

I was now calling this feel-good musical quality "spectrum music," because it touched all the music of the world: classical, soul, pop, blues, Dixieland, African, and rock. But all music is folk music to me, in that it all springs from a primal root. For Earth, Wind & Fire, that root was an emphasis on the musical feel or groove, and on maintaining a level of quality in our recordings and performances. We were winning. In late 1978 Bruce Lundvall, president of CBS Records, told me that by every measure—record sales, Grammy and American Music awards, touring numbers, and worldwide acceptance—we were the biggest band in the world. No one could touch us.

Although we were the best, period, matters of blackness still could not be avoided. Many of the rock critics didn't get us. If you're black, seeking excellence, that's a hard pill for some of them to swallow. We were successful, yet to the press we were elusive, and consequently we were often seen as uppity, pseudo-spiritual Negroes wrapped in shiny outfits. Some of that is a reflection of the gaudy 1970s, but some rock critics wanted to label us as just another funk band. Funk was more in line with their caricature of black music; it was something they could at least pretend to understand. In their minds, black music of the 1970s was good-time music, something to shake your ass to, not to be spoken of in serious critical terms. Our up-tempo grooves did indeed feel good, and they may have made people want to move, but our lyrical content, vocal harmonies, musicianship, instrumentals, interludes, orchestrations, and polyrhythms were wrapped in a musical setting that some critics couldn't easily explain.

Many of our white competitors and acquaintances—the

Eagles, James Taylor, Paul Simon, Fleetwood Mac, Elton John, and Led Zeppelin, to name a few—were looked at as "real artists" with "real artistry," by contrast. They received critical acclaim as well as commercial success. But in many cases music writers couldn't give us an honest critical assessment; they talked about EW&F only in terms of funk because they could not grasp the internal complexities of our Afro-Cuban, jazz, gospel, pop, Latin, and R&B influences.

22 A Hell of a Left Hand

Talent is a flame. Genius is a fire.

—BERNARD WILLIAMS

I was perpetually on the lookout for new songwriters. Many times I'd hear, "I have a great song for Earth, Wind & Fire," and most times it wasn't much. Carole Childs, an unsung EW&F hero, said there was a young session ace who had a song for me. We were up at Sunset Sound, recording, and in walked this skinny kid, David Foster. I didn't expect much. I could tell he was nervous, and I tried to put him at ease.

David sat at the piano and launched into "After the Love Has Gone." I liked it immediately, and knew it could work for the band. What I really dug was his playing, the way he voiced his chords. Over and above all of that, he had a hell of a left hand. Most pianist have a good right hand, but what separates the men from the boys is when you can play bass parts in your left hand with the same precision and dexterity as you have with the right. David had that in spades. I made a decision on the spot that I wanted to write more songs with him. And unlike some other snap decisions I've made, I knew this one was right.

I invited David up to my place in Carmel. He got there in the afternoon, and we started writing immediately. I hate clichéd statements like "Magic happened," because it diminishes the training and artistic openness it takes to create. But David had talent, diverse musical sensibilities, and so much enthusiasm that we just locked into a creative rhythm. Conversely, I

think he correctly understood that I wanted every genre he could give—classical, pop, R&B, and rock. It was freeing for David to be given absolutely no rules. And the further I pushed him to go out of bounds, the more I loved it. He helped me to further expand our spectrum music.

I don't suffer fools well, and David was no fool. He was focused on creativity and not intimidated by my pushiness. David *was* a fool when it came to taking care of his body, though. He smoked like a chimney and ate poorly, which kind of drove me crazy. He had so much talent, and I didn't want to see it squandered. To demonstrate how much we flowed creatively, I let him smoke in my house—and I never, ever let anyone smoke in my house! I offered him some food, but he declined what he later termed my "twigs and sticks" and went into town to get himself some "real food," probably burgers and fries. When he got back, I had a few ideas. We worked nonstop for twelve hours, 7:00 p.m. to 7:00 a.m., starting the genesis of six songs that would become the core of EW&F's next album, *I Am*. I would tap my palm on the side of the baby grand piano, setting the rhythm while he played and I sang. We recorded it all on a small handheld cassette recorder. The first songs we wrote were "In the Stone" and "Let Your Feelings Show." It was a fresh experience for both of us, and our collaboration rolled like a raging river. Our compositions weren't just harmonic and melodic; they were groove-oriented, too. David drew upon his piano skill and training—his left-hand bass lines added a lot to the way we could write—and I drew upon my melodies and groove.

In the few days we spent together, the spirit was truly with us. I'd get up in the middle of the night, and David would already be up too, smoking and banging away on the piano.

We were all in New York when I brought the material to the band. David boastfully asked, "You guys think you can handle these chords?"

Verdine said, "Man, we can handle your shit. Chill out and relax." No one was intimidated by the complicated music

charts. The rhythm section is ground zero to everything, and that all starts with Fred. Baby brother was absolutely killing it on those recording dates. He laid down such a consistent drum feel throughout the entire album that it really made the music shine. David Foster, who would be part of our recording band for about a year and a half, played piano, and Larry played the Fender Rhodes.

I, David Foster, and Allee Willis wrote the majority of the *I Am* album. The other writers were Eddie Del Barrio, Jon Lind (who cowrote "Boogie Wonderland" with Allee), and a young kid by the name of Bill Meyers. The limited number of writers is one of the components that made *I Am* a focused record. But that focus came with a serious price.

Besides myself, no other member of EW&F composed a song on *I Am*. Especially since on our previous album, *All 'N All*, they had cowritten several songs, the other band members perceived this as a slight. *All 'N All*, with its distinctive sound, had turned out to be such a success that the band thought I would stay with the same process for the next record, especially when it came to the songwriting. Again, it was one of those things that weren't personal. David Foster had simply brought me the goods, and I'd run with that. But I knew the cats were feeling very funny about it.

I got the reputation—wrongly, I believe—for being autocratic with my creative choices, especially after Stepney died. I wanted EW&F to exhibit a musical innovativeness in the marketplace. I had to continually prioritize what that leading edge would look like. Consequently, I couldn't listen to too much of anyone, the band included, for the direction EW&F was to go in. Philip hadn't liked "September"; some of the cats didn't like "After the Love Has Gone," believing it was too schmaltzy. I also turned down some songs that became hits for other artists. After Skip Scarborough played "Love Ballad" for me, and I passed, it became a hit for Jeffrey Osborne's LTD.

I listened to every song the band and outside songwriters gave

me. I also listened to just about every cassette tape that made its way into the Kalimba production office. Song selection was my job, and I took it seriously. I probably was more right than I was wrong. Whether it was esoteric lyrics as in "Serpentine Fire" or mystical album covers, I had to follow my own path. That does not mean, however, that anyone else but that band—especially that rhythm section—could have executed that direction. We could have given "Mary Had a Little Lamb" a smoking groove. We were that strong. But in terms of leadership, I needed to have the freedom to execute what I wanted to do and not have a debate about it.

But even with my need for freedom as a leader, everybody in the band had a role, big or small. By 1979 those roles were defined. Johnny Graham continued to always tell me what he thought, bad or good, and a seemingly little thing—that he was always on time—played a huge role in the band; it set a tone. My baby brother Fred remained master of the groove. His feel was delicious and undeniable. Ralph Johnson's consistency of personality and heart made me feel that I could always count on him. Larry Dunn was the quintessential peacemaker and very funny, always keeping things light. We were over in Germany, and two guys got into a scuffle over the same girl. When I heard what was going on, I ran into the room and exerted my so-called moral authority, saying, "Hey, are we out here for the music or the women?" When Larry replied, *"For the women!"* everybody just busted out laughing, and the two guys made peace, and that was it. Just as in a great championship sports team, what some guys do in the locker room is just as important as what they do on the court. Larry Dunn's humor and Verdine's inexhaustible "let's go get them" energy were indispensable in the life of Earth, Wind & Fire.

But from the band's perspective, the more I used outside folks, the more shaky the band members' indispensability seemed. David Foster and Allee Willis's dominant writing contribution to the *I Am* album caused a rupture in the creative life of EW&F.

In my mind at least, the rupture was minor. I felt I had always done things the same way. I was consistent. I was always bringing new energies to the band—whether it was calling in Charles Stepney to the scene, or getting Eddie Del Barrio, Milton Nascimento, and Eumir Deodato to help me with the Brazil vibe, or, now, using David and Allee as writers. Later it would be Wayne Vaughn, Beloyd Taylor, Martin Page, and others. Even musicians like percussionist Paulinho da Costa and guitarist Marlo Henderson made very significant contributions. Tom-Tom Washington gave us some stellar arrangements and introduced a fanfare to our sound. I believe these individuals greatly helped EW&F achieve its diverse sound. There were always a lot of writers, arrangers, and musicians around in the Earth, Wind & Fire recording camp. It was always about enhancing and growing the band's sound.

David Foster's horn and string arranging ability embellished our sound as well. But yet another rupture was created when he came in to conduct his first horn session for *I Am*. Being from Canada, Foster had to work twice as hard to be taken seriously. He was young, brash, and talented, a first-call studio musician desperately trying to become a first-call record producer too. He walked confidently into my horn session with all African American horn players and said, "All right, boys, let's take one from the top." Man, I saw the horn players scowl at him, and one cat pulled out a gun and just said, "Motherfucker." I literally ran from the control room into the studio, grabbed David by the arm, and said, "Hey, man, let me talk to you." I firmly pulled him into the Xerox room and shut the door behind us.

"David, I know you don't know this, because you're from Canada, but don't ever use the word *boy* again," I said.

"Maurice, I didn't . . ."

"I know you didn't mean any harm. I know where your heart is, but there's no way you know what that word means to black men like us."

When David came to Carmel months earlier, we'd had a

heart-to-heart talk. He grew up on Vancouver Island, where there were no black people anywhere. He didn't see one of us until he left. Growing up, he didn't know who Marvin Gaye or Smokey Robinson was. But in Davlen Sound Studio's Xerox room, I didn't have time or energy to give David a lesson in the history of slavery, Jim Crow, and the fight to be called a man and not a boy. The resentment we feel as blacks toward some of our white counterparts is well founded. Black folks don't get the credibility that is afforded whites based on their skin alone. Racism is easy to understand for whites. Understanding white skin privilege is way more elusive.

"Reece, what's up with the white boy in the studio?" one of the horn players said to me at the end of the session.

"Man, it's all about the chops! Did you hear those parts he wrote? They're badass."

"Yeah, but a brother could have done that!"

"Man, right now I just don't give a damn about that."

I know my statement came across as arrogant. Truth is, though, I sincerely didn't care whom I had to enlist to get to the next level. Foster had extremely strong jazz, classical, and pop sensibilities, and he had the creative hunger to try and squeeze all his knowledge into every arrangement he did for me. Yes, some cats I brought to the EW&F table were white. I was not going to let race determine whom I would call or not call to get the best job done. It was not personal.

It was also not personal that from the very early days of EW&F, I never really hung out with the guys. After the gig, I was done. When we were off the road, I didn't see the band much at all. It's not that I didn't like the guys. I did. But I savored my alone time. I needed to regenerate. Some of them never understood that. They thought I was trying to separate myself in some way. My perceived remoteness was simply an extension of my straight-ahead, move-forward mentality, a survival and coping mechanism that I learned from Mama and my life in Memphis. That moving-forward mentality helped the band. It kept the

divergent attitudes, ideas, and motivations in EW&F all moving forward to a productive end. Problem is, though, with my allegiance to that kind of mentality, some people are not treated with the sensitivity that is needed in certain situations.

Since attitudes in group dynamics often come from the top, my misinterpreted aloofness trickled down. The cohesiveness of the band was fraying. That was natural—we were all developing our own interests and our own lives. As early as 1977 we started to be divided—not in a conflicted way, but in a practical way. When we recorded the rhythm section, it was a restricted session. No one was allowed but the guys involved. When we recorded vocals, it was just Philip and I. With horns, it was only the arranger, the horn players, and myself. For Andrew's and Johnny's overdubs or solos, it was just them and me. The only constants in the studio were George Massenburg and myself. The band never knew what I was going to add to the tracks. Only when an album was completely finished did they hear the final mix, with lyrics, melodies, and horn arrangements.

Even our tour rehearsals became segmented. Larry Dunn would rehearse the rhythm section for weeks before Philip and I came to the set. The horn players rehearsed separately. It was just practical for a band and operation as big as ours. The only time we were all together was onstage or on the plane.

23 / I Am

Infinite striving to be the best is man's duty; it is its own reward.
Everything else is in God's hands.

—MAHATMA GANDHI, QUOTED IN ANURADHA KUMA,

MAHATMA AND THE MONKEYS

In late September of 1978, the last thing we recorded for the the *I Am* album was Don Myrick's saxophone solo on "After the Love Is Gone." George Massenburg did a masterful editing trick where he let Myrick's solo overlap into the next song on the record, "Let Your Feelings Show." With that finished, we were finally done and could start mixing—or so I thought.

"Let Your Feelings Show" was supposed to be the first single from *I Am*. I knew for sure that it was the hit. "Let Your Feelings Show" gave a new meaning to the power in the band's sound. Chugging along, the song is straight masculine energy. It vamps out with a tribal talking drum and African-chant-like vocals. George and I fought over that mix for weeks, but we had gotten it right.

Around the same time that we were finishing *I Am*, Al McKay was producing another artist for ARC, Curtis, The Brothers. They had spent a bunch of money and in my estimation still didn't have a hit. Jon Lind and Allee Willis came to their rescue and submitted a song for the project called "Boogie Wonderland." I stepped in as a coproducer with Al on this song, utilizing the EW&F rhythm section, along with David Foster on piano. We started jamming the song, and since Al was producing, I just

mostly laid back. Jon Lind and I were singing the melody behind a partition as the band was playing. We did this for continuity's sake and vibe. As it was coming together, I whispered in Jon Lind's ear, "This is going to be a great track." The demo that Jon Lind had recorded was very disco-laden, almost like "Disco Inferno" by the Trammps, but with the band involved, the EW&F musical diversity was starting to shine through.

As we started to carve out the track, it took on more and more of a greasy Latin/samba vibe. Our bossa nova elements were emerging. By the time Larry Dunn suggested dynamic Latinesque hits for the intro, I knew it was going to be happening. I called Benjamin Wright to do the arrangement. I was familiar with Ben's work. Studio owner Paul Serrano, back in Chicago, had turned me on to him. As a matter of fact, when Stepney died years earlier, I had considered him to take Step's place as our principal arranger, but I took Step's advice and went with Tom-Tom Washington instead. Ben was a master at making things sound big and majestic, using the full range of the orchestra.

Ben used timpani drums and dramatic melodies that added strength, thematic character, and power to "Boogie Wonderland." It was a masterful arrangement and a great orchestral recording session. When it was finished, I whispered excitedly to Ben, "This has got to be for Earth, Wind & Fire." But the song was promised to Curtis, The Brothers. I didn't want to squash their thing, and I thought it was going to be a hit record for them and in turn a big success for ARC.

A day or two later we brought in Curtis, The Brothers to do their lead vocals on "Boogie Wonderland." It was like pulling teeth. Their pocket was way off; their energy was subpar. Al and I worked hard to get the right performance out of them, but it was taking way longer than it should have. Still, we got through the session, and I believed it was going to work out after all.

Later that night Anthony Curtis requested to see me. "Man, I really appreciate this opportunity you're giving us," he said, "but we just don't feel 'Boogie Wonderland' fits us."

"I think you're making a big mistake—it could be a smash for you. But I won't force it down your throat."

Right then the possibility of "Boogie Wonderland" becoming an EW&F song was rising. Even with my love of Ben Wright's thunderous arrangement, though, I still had major misgivings about EW&F releasing a disco song, especially one titled "Boogie Wonderland."

Larry and Verdine, who weren't any fans of disco either, cornered me in the studio. "Reece, we can do this, but just do it our way," Larry said. "The EW&F foundation is already there."

"Guys, I like the track, but I want to find someone else on ARC to give it to. I'm just not sure if it's for the Fire."

Larry and Verdine persisted. And I couldn't deny that the track was smoking. Their suggestion to do it our way had merit. As an experiment, Philip came in and we cut background vocals on it. But it needed more vocal guts in the hook. I called the Emotions, and their vocals gave the song punctuation. Larry and Verdine had won. "Boogie Wonderland" was in.

I'm proud of "Boogie Wonderland" for two reasons. One, the track is burning with musicality and virtuosity. We even won a Grammy for the instrumental version. Two, the lyrics are a rejection of the hedonism and narcissism that disco (rightly or wrongly) had come to represent.

> *Midnight creeps so slowly into hearts of men who need more than they get*
> *Daylight deals a bad hand to a woman who has laid too many bets*
> *The mirror stares you in the face and says, "Baby, uh uh, it don't work"*
> *You say your prayers though you don't care; you dance and shake the hurt*
> —"BOOGIE WONDERLAND," *I AM*, 1979

As I said earlier, I had completely ignored and detested disco. Many of our singles, like "Getaway," "Serpentine Fire," "Fan-

tasy," and "Got to Get You into My Life," were greatly diverse rhythmically and musically. Since those tunes had become hits in the disco era, I was afforded the luxury to not go anywhere near disco. I did not want to be trendy, and Columbia Records stayed out of my way. By 1979 it seemed every popular act had recorded one or two disco songs. Artists as varied as Neil Diamond, the Rolling Stones, and Rod Stewart were riding the disco bandwagon, releasing at least one song in the genre.

Additionally, by now the word *disco* had become poison. It killed itself by being so generic, uncreative, and overexposed. It also represented excess and bad clothing. Despite all of that, when Columbia Records heard "Boogie Wonderland," they smelled money and wanted to release it as the first single from the new album. "Boogie Wonderland" is considered one of the last so-called worldwide disco hits. By the time it was released, people had started having "Disco Sucks" record-burning parties, and folks were wearing "Kill the Bee Gees" T-shirts.

Without question, when the *I Am* album was finished, I knew we had a winner, full of musical diversity. It had Dixieland swing in "Star," and 1950s doo-wop in "Wait." Of course it also had the Afro-Cuban/funky/pop/percussive vibe only Earth, Wind & Fire could do in the mystical anthem "In the Stone." The songs were happening, the mixes were stellar, and the band never sounded better. Before its release, both Prince and Quincy Jones told me it was our finest record.

In January, "September" was certified as a gold single. On February 15, 1979, we picked up three Grammys. Two were for EW&F: Best R&B Vocal Performance by a Duo, Group or Chorus for "All 'N All," and Best R&B Instrumental Performance for "Runnin'," both from the album *All 'N All*. The third was mine, for Best Arrangement Accompanying Vocal(s) for "Got to Get You into My Life." For the third year in a row we won the American Music Award for Favorite Soul/R&B/Band Duo/ Group. Predictably, we were not in attendance, except for Verdine, who was late. When Kristy and Jimmy McNichol say,

"And the winner is Earth, Wind & Fire," there's a slight pause, and then the camera turns wildly to the left, catching Verdine in full track-sprinting mode. Running down the aisle from the very back of the theater (and not falling, thank God), he sprints up the steps, taking the stage to accept the award. After a quick complaint about LA traffic, he catches his breath and graciously accepts the award on behalf of the band, ARC Records, and myself.

Awards aside, EW&F's music was always intended to uplift and bring divergent races together. If someone gleaned from Earth, Wind & Fire's music a certain political disposition, more power to them. I gave to charities, and I lent the name of EW&F to several causes I believed in, like the Muscular Dystrophy Association and several national voter registration drives. But my friend from Chicago, Jesse Jackson, was always trying to get me to donate Earth, Wind & Fire's time to do this or that. He would show up at Hollywood Sound, Studio B, so many times unannounced and tell me what he wanted the band to come play for, or ask, Could you record this song for the project? I would tell him that I was selective about what the band was politically aligned with, which in reality was nothing. I wanted the universal persona of Earth, Wind & Fire to be above the ever-changing winds of politics.

But UNICEF was not political; it was only about the welfare of children worldwide. In early 1979 we performed a medley of "September" and "That's the Way of the World" for *The Music for UNICEF Concert: A Gift of Song*, a television special and benefit concert held at the General Assembly of the United Nations to raise money and awareness for UNICEF as well as kicking off UNICEF's International Year of the Child. We prerecorded the track and sang the lead vocals live. Along with EW&F, ABBA, the Bee Gees, John Denver, Olivia Newton-John, Donna Summer, Rita Coolidge, Kris Kristofferson, and Rod Stewart shared in this history-making, hope-filled event. There wasn't much drama between the stars. I do remember

Rod Stewart had on a full-length mink sable coat, and everybody wanted host Henry "The Fonz" Winkler's autograph for their kids.

For some reason or other the producer, Robert Stigwood, wanted us to dress casually for the performance, not in our stage wear. That wasn't going to happen. I think Stigwood didn't want us to upstage his client, the Bee Gees, and he still may have been pissed about us having the only success out of the *Sgt. Pepper's Lonely Hearts Club Band* movie fiasco. When we returned to the hotel, I instructed Leonard to tell the guys to dress there and not at the UN, so they would have no option but to film us that way.

Roughly three months later, "Boogie Wonderland" would be released as the first single from *I Am*. That record and "After the Love Has Gone" quickly became gold singles.

Nineteen seventy-eight was a year of incredible professional highs, but it ended in considerable sadness. Mother Dear gathered the entire family in Chicago for Christmas, and broke the news that her cancer had returned. She had all of her children there with her until the very next day, when she went into the hospital. As has been the case for most of my life, I chose to keep my concern for her locked up deep within myself.

After Mother Dear's revelation, I went to Carmel for a few weeks. I had to make some decisions about the tour in support of the *I Am* album. I needed Carmel's peace and quiet to chill me out. I hired a tennis instructor, and we played every day right before sunset. Before I left LA, I was given a banker's box full of materials I needed to look over for the tour. After some lengthy phone calls with Verdine and Cavallo, I decided not to have an opening act—just Earth, Wind & Fire for two-plus hours of our musical theater. I hoped that having no opening act would cut down on the cost. Since "Boogie Wonderland" had exploded, I opted to take three young ladies—Carla Vaughn, Sylvia Cox, and Judy Jones—on the tour to do the Emotions' vocal parts on the song. They would also help take some of the background vocal responsibilities off the band.

I told the guys to keep their hands off the girls, a demand that I could not adhere to myself. Judy Jones was beautiful, smart, and sweet. During that tour we fell into a relationship. By the end of the tour, I had real and genuine feelings for her. I continued to see her for a while. I even thought briefly about making her "the one." But my noncommittal stance would eventually drive us apart.

For what we called the Tour of the World 1979, we would do America in the winter and then go on to London, Denmark, Sweden, Germany, Holland, Belgium, France, and finally Japan. We tapped David Copperfield for our illusions this time. Copperfield had come up under Doug Henning but had branched out on his own. He didn't have Doug's forcefulness. Doug was like a general, a shut-up-and-pay-attention kind of cat, but Copperfield didn't have that personality. Everybody would continue to horse around while he patiently stood with his hands folded behind his back, waiting for the guys to calm down. His illusions were very technical in execution. We had an astonishing disappearing escapade that boggled the mind—to give any more details would reveal his secrets. Some of this high-tech growth was Copperfield's genius; some of it was the technology that was moving fast in show business. As with everything else, we moved along with it. Once, when we were on the soundstage rehearsing one of his illusions, and it did not work properly, Copperfield stormed outside almost in tears. Some of the guys were kind of laughing at his outburst. But I took it as a sign of his total dedication to what he was doing for us.

The one thing that stayed the same for our tour preparation was George Faison and his incessant hollering, giving us direction. He felt we had gotten sloppy in our time off between tours. Forever the schoolmaster, he set out to abolish any thought that his moves might be any easier than the last time. He didn't let up on us one bit. I remember him hollering, "You ain't sold no tickets yet—get back to work!" He had us doing dancer-type exercises to limber up. There was more spinning around, more

symmetry with the lighting and explosions, not to mention sing-
ing and playing instruments.

As a result, there was more rehearsing and coordination
between the entire team. Additionally, the staging, the rehears-
als, the magic, the advanced pyrotechnics, the wardrobe, the
trucks, the lights, and the sound all fell under the EW&F finan-
cial umbrella. We didn't rent anything, as most rock acts did.
The trucks, the stage, the lights, the sound—they were all owned
in-house. It was at this time that I got some real serious push-
back from my management team and accountants. Sitting in my
office, I was shown a spreadsheet with all the costs laid out and
calculated: band and crew salaries, Copperfield, Faison, ward-
robe, hotel transportation, and a bunch of other stuff. I looked
at it briefly and tossed it back at Art Macnow.

"Unless you want to come home broke, you've got to cut
some of this stuff back," Art said, trying to scare me for what he
thought was my own good.

"Man, I can't give the audience the same thing as last year," I
said. "I've got to up the ante."

"These costs are freaking me out! Look at Whitten and Cop-
perfield's bill."

"Yeah, but what I'm paying for is the dramatic effect—the
magic and costumes are a big part of that."

"I'm telling you, you'll be lucky if you break even—and you
won't."

I thought back to the beginning of the EW&F odyssey, when I
had wanted all those things that were now on the financial spread-
sheet. The drive for a better and better live show was especially
important to me, and it had happened. Each tour I was upping
the ante, and yes, that required some significant money—over a
half a million dollars up front before one ticket was sold. Still, I
knew that eventually I'd win the argument. After all, it was, in
fact, my money. Bill Whitten was the best in the world of rock-
and-roll wardrobe, so I had to have him. His costumes could cost
from $3,000 to $10,000 each, and each member needed more

than one. But his African-themed designs made us look and feel like kings. They were meticulous in color and sparkle and were durable. They contained all kinds of materials—Lurex (a kind of metallic yarn), glass stones, metal, plastic, and more. His wardrobe for us overflowed from every stitch with star quality.

The road thing was always financially tricky for me. I had always made a great living off my songwriting and especially publishing royalties. The guys in the band who wrote songs always made out better than the ones who did not. By and large, however, the road monies paid a lot of the supporting cast around me—not only the band but also all the crew, management, accountants, wardrobe, magic, and choreographers. Although the road was a strain for me personally, it did in fact keep the machine of Earth, Wind & Fire rolling along.

One of the great personal joys of this tour was that I took everybody, band and crew, to Egypt for some days of sightseeing and rest. We left Paris on Monday, March 19, 1979, and arrived in Cairo on a clear sunny day. We went to all the great sites—most notably the pyramids and Great Sphinx at Giza and the Abu Simbel temples, which had been the inspiration for the *All 'N All* album cover.

It wasn't a secret to anyone that I was fascinated with Egypt. But this trip was jolting for the band. This was not the Egypt of our album covers or the Egypt of travel brochures. Cairo was chaotic—crowded, noisy streets and people hustling us for money at every turn. I believe it was a letdown to many of the guys. We were over there to see the foundation of civilization, but the people of Egypt looked at us like we were tourists looking at the names of the stars in the sidewalk on Hollywood Boulevard. The band had been around the world a time or two, but they weren't that worldly. I wanted everyone to enjoy this as much as I did. Some of the guys did, and some did not. Many of them just stayed in the Mena House Hotel or its beautiful grounds. I believe some of the cats saw me as imposing my interest on the band, but that wasn't the case. I just believed that it would be

something for them to look back on with joy. I could have just taken Verdine and a few others who were interested and left the rest of the guys in Paris—which might have been fine with them.

For me, my time in Egypt was a historical as well as a spiritual pilgrimage. Walking into the pyramids gave me a feeling of destiny. The instant the guide motioned to me as if to say, Come this way, I got a feeling that I was stepping into my heritage, my DNA, my ancestors' true greatness. It validated my inclination to link the public persona of EW&F to the planet's ancestral home—black folks' ancestral home, my ancestral home.

We went back to Egypt and Israel some time later. Fifty of us went on that first trip to Egypt—five went the second time. That pretty much says it all.

By 1979, our music was selling well in America, and in many cases we were even stronger sales performers internationally. In Germany, Holland, Belgium, Sweden, Spain, Italy, Canada, and especially Japan and South America, *I Am* was breaking new sales records all over the world for CBS International. It was our biggest album ever.

It seemed like nothing could stop us.

★

THE CHANGING TIMES

PART V

THE CHANGING
TIMES

24 All in the Creator's Hands

Choose rather to be strong of soul than strong of body.

—PYTHAGORAS

When we went to Mother Dear's Christmas gathering a few months earlier, Verdine had brought Shelly Clark to Chicago to meet Mother Dear and Dad. I know it made Mother Dear happy that Verdine was ready to settle down. I think every mother wants to see her son find the right girl, and Shelly and Verdine seemed to be such a good energetic match. It didn't hurt their relationship that she had a show business history of her own. She was the lead singer in the Honey Cone, who scored a huge No. 1 pop and R&B hit with "Want Ads" back in 1971. Verdine, Shelly, and Mother Dear came to Carmel often in the early spring of 1979. There was a sense of family that maybe I hadn't experienced before. Marilyn and my son Kahbran occasionally came up, as well as Patt, Fred, Monte, and Geri. I can't remember everyone who was there, but it was a special time. Mother Dear was well enough to explore the grounds of the compound. She loved that place. I believe its expanse and fashionable decor gave her a feeling that her and Dad's journey had been blessed. It's hard to put into words how beautiful that time of year was in the Carmel Mountains of California.

When Mother Dear returned to Chicago, she became ill. There were times she felt good, then bad. It was back and forth.

The last time I saw Mother Dear, she was in the hospital. It

was bedlam. Somehow the word got out that I was coming, and the corridor was so jam-packed with people that they had to call the police. I had a good friend, Fred McKinley, who worked for the Chicago Police Department and would kind of take care of me when I was in Chicago. He rushed there and rode with me up the elevator. People actually clapped when I got off the elevator and entered the hospital corridor. It was an insufferable display of fan rudeness. It's a hospital, for Christ's sake! Where was the professional dignity? For the first time I felt how disruptive and destructive success could be.

When I walked into Mother Dear's room, the sight of her shocked me. She looked weak, and was heavily bandaged. I reached for her hand, saying, "I'm here, Mother, I'm right here." She responded some. I just caressed her hand while looking into her eyes, trying to provide any comfort. I knew I was helpless. It was all in the Creator's hands.

Mother Dear made her transition on July 16, 1979. She was only fifty-six years old.

My biggest regret in life is that I didn't spend more time with Mother Dear. A few years before all this, she and Dad were supposed to move to California, but Dad changed his mind at the very last minute. I wish to God I had pushed Dad to do otherwise. It's human to assume you have more time than you do. My mother's mortality, her vulnerability, is a part of me. In many ways you see a mirror of yourself when your parent dies. Her passing reflected back to me that my own time on the physical plane is limited—everybody's days are numbered, and Father Time has the last say. The morning of her funeral, Verdine and I played a particularly vigorous game of tennis on top of the hotel to try to clear our minds—to no avail, of course. But we talked in a way we had not talked in a long time.

In the corner of the tennis court on that sad morning, our very private and personal conversation revolved around what Mother Dear meant to us personally and what her loss meant for

us collectively. I revealed to Verdine how much I had connected my career aspirations to creating a sense of family for myself. Family had eluded me, but since I was a boy, my musical pals had always been its substitute. Along with the pain of her loss, there was the pleasure that she had witnessed her family become successful. With Mother Dear gone, I probably had a deeper appreciation for what EW&F had become. Even with all that psycho-emotional reality, I really didn't have time to grieve—we were moving so fast. She died on a Monday and was buried on a Friday, and we were back in Los Angeles rehearsing on Monday. In my usual way of not showing much emotion, I didn't cry at the funeral. One year later, almost to the day she died, I cried. And I cried all day.

When someone you love dies, it's like there is a void. In many ways the underlying core reason for my hard-driving ways was to please Mother Dear. When I moved to Chicago from Memphis, I wanted to show her that I could make it. She of course saw me as a mother would, with her baby ready to be gobbled up by the usual suspects of the street and the Chicago music world of the 1960s. When I started to have success at Chess Records, and then with Ramsey Lewis, and finally with Earth, Wind & Fire, she had become proud of me. Her pride did everything for my manhood, my drive, my faith, and my perseverance. Her absence left me without that unspoken primal motivating factor.

It was decided that it would be best for all concerned to move her youngest children, Karen (sixteen) and Margie (eighteen), to Los Angeles. Karen moved into my home, and Margie moved in with Verdine and Shelly. I believe it gave them a much-needed fresh start. I couldn't have done this if Patt hadn't been there; I was gone so much, and frankly, Karen needed her big sister in a host of ways that I could never provide. Patt and Karen living in my home all those years also gave me a sense of family that I'd never had. By the same token, despite all my need for freedom, space, and solitude, in these

years family would be a large component of my life—a component I was comfortable with.

On the other hand, I used my new living situation as an excuse to keep any woman from ever trying to move in with me. I wanted my home to be my sanctuary, unencumbered by my romantic life.

25 Don't Make My Band Your Crusade

Fifty million voices mumbling from the street
Talking about the eighties and who it will mistreat

—"LET ME TALK," FACES, 1980

The music business began changing in 1980. The change was precipitated by a decline in music sales overall, starting in late 1978. In the summer of 1979, CBS Records had massive layoffs; by year's end, all the majors were cutting back on personnel, promotion budgets, and manufacturing. Even though all the majors were having a dry spell, EW&F's fortunes seemed to be unaffected.

Our releases in 1978 and '79—*The Best of Earth, Wind & Fire, Vol. 1*, with "September" and "Got to Get You into My Life," and *I Am*, with "Boogie Wonderland"—had been the best sellers of our career. We started 1980 with "After the Love Is Gone" from *I Am* becoming another huge hit.

EW&F had done well enough over the years that I always had a blank check for our recording budget. It wasn't a big deal for me (or any major white act) to spend a million dollars or more to record an album. There was no interference from the record company. When I delivered an album, they would promote it with all the resources within their power—even if the reach of those resources was segregated.

One change that did affect EW&F greatly was that Dick Asher was brought in from CBS International to rein in the budgets. The domestic division had been losing money badly. The mild-

mannered Asher was given the title of deputy president and chief operating officer of CBS Records Group. I think the corporate suits were starting to view Walter Yetnikoff as wild and loose in his management style. Although I never witnessed them, Yetnikoff's temper tantrums were legendary. Now, I could not have cared less about what Yetnikoff was doing because up to that point he hadn't given me any grief. After all, he and Bruce Lundvall had given me ARC. But if I was at the top of the heap, that heap was still the black heap. After all the crossover success we had, we still had to do it like every other black act on the planet. Our records were first shipped to black radio and promoted there. After they reached the top ten on the black charts, they were then promoted on pop or white radio. This meant a lot of independent promotion. Now some of that "independent promotion" for all intents and purposes was a form of payola. But even in 1980, independent promotion was segregated because a lot of the process was relationship based. All the indie promoters and radio station program directors involved felt safe passing an envelope of cash to one another because it had been done by the same people over and over, year after year. It could be very expensive; paying $50,000 to $200,000 for one single song to be promoted nationally was not uncommon.

Under pressure to cut costs, Dick started snooping around in the financial books of CBS. The high expenditure of independent promotion immediately popped out. If he could rein in that mammoth price tag, Dick wouldn't have to lay more people off. He wanted Earth, Wind & Fire to be his first test case. Why? Because he figured we were enormous enough to overrule the stations' allegiance to independent promoters—that radio would have to play EW&F whether or not these promoters paid them cash. Essentially, he planned to use EW&F's next single as a test case—or a hostage—on black and pop radio.

When I got wind of this, I immediately flew to New York. I went straight from JFK to Dick Asher's office at Black Rock, the CBS Records headquarters at the corner of Sixth and Fifty-

Second Street—unannounced. Dick shook my hand and then sat down, making small talk.

I abruptly interrupted him. "What's this mess I hear about changes to my independent promotion?"

"Well, Earth Wind & Fire is so great, Maurice, you don't need these promoters anymore."

"Dick, you're a decent guy. I actually like you—but this experiment to end Earth, Wind & Fire's independent promotion, I cannot accept. Go on and do your experiment, but do it with someone else, like Springsteen, James Taylor, or Aerosmith."

Yes, there was definitely a racial connotation in my communication. All those artists I mentioned were white. EW&F was probably the top moneymaker for Columbia Records, black or white. Why experiment with us? Walking out of Asher's office, I turned, looked him straight in his eyes, and said, "Don't make my band your crusade—you got a hundred other acts, but I have only one career."

Whether Asher was going to lose or win the battle with Yetnikoff over cutting independent promotion—and ultimately over control of CBS Records—was out of my hands (he ultimately lost, and Yetnikoff won). What *was* in my control was that, since EW&F was on my own label, the American Recording Company, Asher could go on and do what he wanted—but I could get around it. I hired my old pal from Chicago, Ron Ellison, to become vice president in charge of marketing for ARC. He could keep a close eye on what was going on with the independent promoters. This way I would always know if Columbia was trying to slight me. By 1980 ARC had about twelve artists signed and maybe fifty employees. Also in January of 1980, "Rappers Delight," considered to be the first rap hit, rose to No. 36 on the *Billboard* Hot 100.

I have learned in a long life that knowing what the word *acceptance* means becomes paramount. We have to accept that the ties that bind are often beyond our understanding. In retrospect, the passing of Mother Dear was a brief resting time for Earth, Wind

& Fire at the top of the rock-and-roll mountain. We had started to climb that mountain in 1973 at Caribou Ranch Studios in the Colorado Rockies, but soon we would start our long traverse back down the cliffs.

In terms of popularity, accomplishment, and musical sense, we could do no wrong. We were international superstars, but tensions were building. ARC was floundering, and there was a lot of hope that Earth, Wind & Fire's next album would be its salvation. That double album, *Faces*, is one of our best. It has it all—the polyrhythms of *All 'N All*, the sonic quality of *I Am*, and the supreme musicianship of the EW&F recording family. The artwork of the gatefold album cover, picturing many different races of people from around the globe, continued our effort to promote the family of man, the idea that we are all one.

> In respect, to these changing times, this offering of our creative efforts is presented to acquaint man with his many brothers and sisters around the world. We live so close, yet so far away, fear has been our separator.
>
> We live now in a new age dawning upon computer technology, higher consciousness, higher elevation of space, and higher ideas. In this age the true essence of sharing should be acknowledged.
>
> It is time for man to understand that we share the same sun, and we all are essentially the same with different names. All around the world the most enjoyed vibration is that of a smile. Through our smiles we touch the heart of our fellow man. Together, let's lift our planet to a higher vibration. In love we stand.
>
> —MAURICE WHITE, LINER NOTES FROM EW&F'S ALBUM *FACES*, 1980

Since we were big moneymakers at Columbia, I spared no expense taking the rhythm section, several of the outside songwriters, and George Massenburg to George Martin's new recording studio on the Emerald Isle—Montserrat, West Indies.

Montserrat is a tiny island in the Caribbean Sea, 1,350 miles southeast of Miami. Just as the isolation of Caribou Ranch was a turning point in the life of Earth, Wind & Fire seven years earlier, I hoped the white sand beaches of this remote idyllic paradise would be a new start for the band. But it wasn't. This wasn't Caribou Ranch and 1973; this was 1980. All the spoils of success were in place, as were its pitfalls.

Aside from all the life changes, music remained the emphasis, and we had some incredible sessions in the two months down there. We flew musicians and songwriters in—David Foster, Jerry Peters, Marlo Henderson, and a wonderful new songwriter, Garry Glenn, whom I would work with off and on in the mid-1980s. He would later go on to write the hit song "Caught Up in the Rapture" for Anita Baker. Outside songwriters as diverse as Eddie Del Barrio, James Newton Howard, Brenda Russell, and Ross Vannelli contributed songs with rich chords and global rhythms. Some of the charts were complicated, but there was a flow within the band that made those intricate songs easy. We were musically focused as never before. Often we would take a break in the sessions and walk out before sunset to watch the sun go down into the Caribbean Sea, the music from the day's recordings ringing in our ears.

But the *Faces* recording sessions were not without strain. Tensions were escalating between Al McKay and myself. Most of the conflict revolved around how the music was being produced, but there was an underlying current of built-up frustration. Al had had it with my leadership. We were clashing hard and had some serious heated disagreements. It got so bad that a few times we had to take it outside, so as to not completely ruin the vibe in the studio.

As much as I didn't like the conflict between Al and me, I couldn't help but believe that it contributed to the heat of the recordings. Our fiery rhythm section still prevailed. We returned to Los Angeles and finished out the album. With *Faces* mixed and completed, I tried to adjust to the changing financial winds

of the music business. Columbia Records offered me much less tour and promotional support, and sales were still down at all the major labels. Some would call this era the rise of "corporate rock," which I'm sure is true. As a result, I needed some additional funding. As fate would have it, a go-getter by the name of Jay Coleman reached out to me. Jay owned Rockbill, which was really the first company to merge Madison Avenue and the rock-and-roll business. Corporate sponsorships were relatively new in 1980. At that time—before Pepsi and Michael Jackson—Earth, Wind & Fire had the largest corporate sponsorship any band had received. I was all for this new way of subsidizing tours, as long as the product wasn't something like alcohol, or overtly sexual. I signed on to a $500,000 television campaign, in which EW&F would endorse Panasonic products, and Panasonic in turn would use various vehicles to promote our latest release, *Faces*.

Still, I was cautious about commercialization. I didn't want Earth, Wind & Fire to stand too close to any brand. Some call that sentiment "the Woodstock mentality," in that you lose some of your authenticity as an artist when you become a pitch man for, let's say, Wonder Bread. But Panasonic wasn't Wonder Bread; it was an electronics giant. We would be associating ourselves with its new line of boombox cassette music players. To me, Panasonic felt like a part of the music business.

I knew we had a great album in *Faces*. It was global in its musical approach. The two-record set had something for everyone. The tour support from Panasonic inspired my confidence. To add to my wide-eyed expectations for the album, ABC-TV approached me about producing a feature on the band for its newsmagazine program *20/20*. I agreed. Thomas Hoving was the correspondent. He and a film crew came to my place in Carmel and spent some time in the studio with us. I quickly became skeptical; Hoving's questions made me suspect that they were going to portray me as weird.

"You guys sleep in pyramids, don't you?"

"No," I responded flatly.

"Don't you guys use psychics to help you write your songs?"

"Man, that's a weird question, but no."

No need to worry, though—the oddball questions were left on the editing-room floor, and the segment turned out fine. But even with the *20/20* piece, the Panasonic promotional tie-in, and the requisite radio promotion, the first single from *Faces*, a world-music-flavored song called "Let Me Talk," bombed. I was shell-shocked. Stunned. This was my first taste of the 1980s music-business reality: if your first single doesn't do well, it's difficult to trumpet the same promotional enthusiasm for the second single. The album went gold, selling half a million copies, but at this point, a gold album for EW&F was a huge commercial disappointment, and a shock that was hard on everybody. We had some great songs. "Turn It into Something Good," "And Love Goes On," "Share Your Love," and "You Went Away" are some of the finest songs in the EW&F songbook. Radio just did not embrace *Faces*. It was a huge letdown that our audience didn't respond to it.

I loved "Let Me Talk." It probably sits next to "Serpentine Fire" as our most ambitious first single release. I always felt that EW&F should lead in some kind of creative way. "Let Me Talk" is like an EW&F–meets–Peter Gabriel record, in the sense that its percussive dominance put it so close to world music. Still, it's jazzy and soulful. These world musical elements may have been too much for radio to hold on to, since records in 1980 were getting simpler and simpler. Drums, claps, vocals, bass, a dominant synthesizer part, and very little else became the radio formula.

Earth, Wind & Fire would not be the only big act caught in the crosshairs of trying to top a successful previous album in an environment of label decline and changing musical taste. Fleetwood Mac had a smash with *Rumors* in 1977, and then in '79 released a double album called *Tusk*. Stevie Wonder put out the classic *Songs in the Key of Life* in '76 and three years later, in '79, did the personal *Secret Life of Plants*. Both *Tusk* and *Secret Life of Plants* were seen as commercial disappointments. Stevie was

blamed for being too esoteric, whereas Lindsey Buckingham and I were blamed for being too ambitious in our production style— too polyrhythmic, too big of a sound palette. In my eyes, that just meant we were too damn good. It was the first time in years that Earth, Wind & Fire didn't have a big new hit on the radio.

Right before Ronald Reagan refused to speak at the NAACP convention, we got an offer to go to South America to perform. I accepted. On October 9, roughly a month before Reagan was elected president, we played our first show in São Paulo, Brazil. I was glad to be out of the USA.

This was a special time for the band. We were always popular in South America, but for some reason or another we'd never gone beyond Mexico City. The people of Brazil loved us, and we loved them. I believe they embraced Earth, Wind & Fire on some primal musical level, because there's so much of a Latin feel in all of our music. I would also be remiss in not mentioning that Brazilian women are some of the most beautiful in the world. The food, the women, and the music . . . my, oh my. I saw some of the guys in the band walking around the hotel with women, and they just had their mouths wide open, as if to say, I can't believe how stunning she is. Even some of the business staff and crew disappeared on our days off. We all enjoyed ourselves immensely.

Coming back from South America through Mexico, we encountered a problem. We were working with a promoter who was not experienced. He had done more Broadway theatrical-type shows in Mexico than rock concerts. This was the time when, if you went into Mexico, you got a little white ticket, and you needed that ticket to get back out. Upon our arrival the promoter collected the tickets from everybody, or at least he thought he did: Art Macnow and Al McKay wisely kept theirs. After the gig was over and it came time to leave, we couldn't find the promoter. He had disappeared, and they wouldn't let us out of the country. Macnow and McKay left; the hope was that Art could do something to get us home once he got back to LA.

We got stuck in Guadalajara, Mexico—or, as we called it, Guadalahorror. After two or three days of squabbling, Steve Fargnoli, one of our managers, found an official who was willing to take a $5,000 cash bribe to get us passes out of the country. The official lowered his head, looked at Leonard and me, and sternly said, "You guys have to leave . . . NOW." We hurried everybody—about sixty of us band and crew—together. We landed in Texas, chartered two small jets there, and flew everybody back to LA. The whole experience—the waiting, the rushing, the bribery, and the clandestine way we left—left everybody crazy and out of sorts.

A few weeks later, we had to go back to South America for one more gig. The band took a jet down. Al McKay, Art Macnow, and Leonard Smith were to catch a commercial flight the next day.

When Art and Leonard arrived, I knew immediately that something was wrong. They looked worn out and shell-shocked. They pulled me aside and told me that they had waited and waited for McKay, right up until the very last second before they had to board the plane and leave him behind. I was quiet—but boy, was I incredibly pissed off. I told the guys the show must go on, and we went out and did the gig. With me being pissed, and that attitude rubbing off on the band, coupled with missing McKay's pulsing guitar, it was not the best show for us.

Now, I knew Al wasn't happy. After our clashes during the recording of *Faces*, I thought he may have wanted out. I knew through the tiny whispers of other members that for years he had been threatening to leave. I think all the years of touring had gotten to all of us. I knew years earlier that my position as a leader was always going to be challenged. But by now Al was pissed off with me, and I wasn't backing down. He was my contemporary in age, and since I was the leader, I think from the very beginning there was always a natural built-in tension between us.

As I was rushing to leave the Complex on a very hot summer

day, Marlo Henderson, a great guitar player who had done a ton of work for me at ARC, followed me outside. "Man, let me play on some EW&F stuff," he said. I laughed, and said, "Are you going to help me fight Al?" That kind of summed up the vibe between Al and me in late 1979 and early 1980.

When I returned to Los Angeles after the South American fiasco, I had calmed down considerably. A week later I met with Bob Cavallo. He simply said, "Maurice, you've got to let McKay go."

I knew he was right, but it was still a tough decision. McKay was an integral member of Earth, Wind & Fire. We had good writing chemistry that had resulted in some big hits. McKay's distinctive rhythm guitar style was one of the glues in our rhythm section, and something that we had come to rely on. Al was emotional yet strong, funny as hell yet serious. This wasn't the cold side of business, where decisions are made devoid of feeling. No matter what bad vibes existed between Al and me, there was still that brotherhood of "the boys in the band."

"Let me reconstruct his contract," I said. "He may feel better then."

"Maurice, if you let him come back, it would set a very bad precedent."

"I don't think it will."

"Trust me, if you do this, everyone will pull this shit."

I was silent, knowing Bob was right. I had no choice. With all the people and money involved, I couldn't take that risk. The studio is one thing, but missing gigs is an entirely different matter. It put in jeopardy the entire financial machine of the band. I sent Al McKay a letter of termination.

No matter what anyone says, Al's not showing up for the gig was the straw that broke the camel's back. However, in retrospect I think he probably wanted to leave anyway. Years later I found he had a lot going on besides his dissatisfaction in being in EW&F. He was hypoglycemic and really wanted to spend time

with his son. His leaving should not have been the biggest surprise to the guys. Roland Bautista, who had been in the band ten years earlier, replaced Al McKay on guitar in Earth, Wind & Fire. Roland was good, but he wasn't Al. Al's departure from the band was a big loss, and the end of an era.

26 The Groove

Can somebody tell me why it takes so long to see
Does anyone know the why of life and its decree
Will somebody tell me why life goes the way it goes
Somebody may tell, but I don't think nobody knows

<div align="right">—"IN TIME," FACES, 1980</div>

There was a blessing in disguise in Al McKay's departure from Earth, Wind & Fire. His style of rhythm guitar playing had been a staple of R&B ever since James Brown came on the scene. But by the early '80s, those types of guitar parts were being replaced in pop and R&B by synthesizers. Music was becoming simpler. There was much less sonic room for McKay's style of rhythm guitar.

As a result of the musical times, our next album, *Raise!*, was stripped way down compared to *All 'N All*, *I Am*, and *Faces*. EW&F had a big sound palette. Stripped down, for us, meant less percussion, less rhythm guitar, louder hand claps and drums, and more dominant keyboards and synthesizers. The musical elements that remained consistent were the vocal sound, Verdine's bass style, and of course the horn arrangements.

I kicked off the process of producing the *Raise!* album by having a conversation with Beloyd Taylor in early February of 1981 at the Complex.

"Beloyd, your song 'Getaway' in 1976 ushered in a fiery new era for our sound."

"Yeah, man, I loved what y'all did with it."

"I need you to do it again."

"What, another 'Getaway'-type song?"

"Oh, no, something futuristic—still Earth, Wind & Fire, but a new, simpler sound."

Beloyd knew Earth, Wind & Fire's sound, but his interpretation of that sound brought in a different energy. He was a good singer and guitarist, and ideas just poured out of him. The songs he submitted to me were forward thinking and had a distinctive vibe. I loved Beloyd. I had every intention of doing a solo album with him, but I just didn't have the time. For the next three years, however, Beloyd would be involved in many projects that came ARC's way.

Beloyd was part of the Complex family at 2323 Corinth Street in West Los Angeles. He hung out with all the guys and became good friends with Larry Dunn and Roland Bautista. All the guys had nice clean cars, and Beloyd had a blue Moped. They would tease him: "Here comes Beloyd on his Moped." He was hungry for success, to the point that he would sometimes sleep on the studio couch. Since he hung around the Complex so much, Beloyd was my main go-to guy in those early '80s years. Beyond his writing skills, he sounded a lot like me vocally, which made it really productive to have him around to do background vocals for EW&F and other projects. I took him under my wing.

As a result, Beloyd got somewhat caught in the crosshairs of the band's frustrations. He told me late one night that some were calling him "Maurice's boy," which he hated—absolutely detested. I told him not to worry about it—it had nothing to do with him and everything to do with a band that had been together awhile. Song selection for albums was my job, but there was always unspoken competition within the band. Some guys constantly submitted songs, while others became discouraged and stopped. What added to the mix was that I was perpetually looking for songs outside of the band as well. Around this time, it was inevitable that anyone getting creatively close to me would catch some grief. It was like a little passive-aggressive attack

on me. The band saw Beloyd as someone who was going to get more songs on the album, and in this case they were right. But I always moved into the creative direction that I felt was best for the group.

Beloyd came through, giving me exactly what I had asked for. He self-composed three songs for the *Raise!* album: "Lady Sun," "The Changing Times," and "You Are a Winner." His songs set a tone for the album. Everyone assumed that "You Are a Winner," with its aggressive contemporary bass line and forceful background vocals, was going to be the first single. Everyone who heard it loved it.

Still, I was open to new writers, musicians, and arrangers. Even if I often went with the tried and true, it always seemed that right around the corner there was some new cat ready to lay it on me.

Wayne Vaughn did just that. Wayne entered my life via my play baby sister, Wanda Hutchinson of the Emotions, whom he had married a few years earlier. Wayne had an over-the-top personality and was down-home too. I felt an instant kinship to him. Our friendship was like a return to a much younger, more innocent time in my life—before success, before money, before leadership and its responsibilities. Wayne felt like Memphis.

Wayne kept a studio in the back of his parents' house in the heart of the hood, South Central Los Angeles. When I first started to go over there, I was always surprised that my Porsche was still there when it came time to leave! Wayne's parents were the warmest people. They reminded me of Arkansas and Tennessee, down-home good people. His mom could cook so good, her food made you want to take off your shoes and rub your feet together!

Creatively, Wayne and I were in sync. In the early spring of 1981 I asked him to put some ideas together for the band. In about a week he gave me four tracks. Three of them I would record on *Raise!*: "My Love," "Wanna Be with You," and the little idea that would ultimately become "Let's Groove."

The minute I heard the demo of "Let's Groove," I knew it had massive potential. It was just a track, but the bass line and chords were so locked together that it just, well, grooved. I immediately heard various hooks. The "You can boogie down—down" talk box/vocoder overdub is one hook. The falsetto "Let this groove get you to move" is another hook. And the low-voiced "Let's groove tonight" is still another. The multiple hooks over that one great groove gave the song an exciting yet simple approach. The horns are held back until the bridge, which added a 1940s big-band swing sound. Bill Meyers's horn arrangement turned up the joyous vibe, which is why I think the song feels so good. "Let's Groove" was the last song to be recorded for the album *Raise!*

When I finished most EW&F albums, I would always try to be objective, putting away all previous thoughts about what was going to be the single. But there was no pondering or objectivity here. "You Are a Winner" was out, and "Let's Groove" was in.

I was surprised when Cavallo told me that pop radio had immediately jumped on "Let's Groove." The jump was so quick and unexpected that Columbia had to redo its whole marketing plan.

"Let's Groove" became a huge multiformat worldwide smash, peaking at No. 3 pop and at No. 1 R&B for so many weeks that it became the longest-running No. 1 R&B record to that point in history. Later, we would have other songs do OK for us, but nothing like "Let's Groove." It has only grown in popularity as the years have gone by. "Let's Groove" gave EW&F the wheels to cross yet another bridge. "Shining Star" was the bridge into one world; "After the Love Is Gone" was a bridge into another. Of course there were many hits in between, but to a generation of younger people born in the mid-1970s, "Let's Groove" would be our signature song. In addition, the second single from *Raise!*, "Wanna Be with You," won a Grammy for Best R&B Vocal Performance by a Duo or Group that year.

I felt vindicated. Our previous album, *Faces*, had probably been our best work and yet was viewed as a commercial disappointment, but this new win said to the suits that EW&F could still come up with a big-ass hit.

"Let's Groove" put wind in our sails, and we hit the road. The *Raise!* tour was our most expensive stage production yet, costing about $700,000 in preproduction alone. Once it was up and running, it cost $60,000 a night to do the show—and this was in 1981. We had a crew of around sixty people, fourteen tractor-trailers, buses, plane costs, hotel bills, band salaries, and a host of other expenses, but we sold out just about every show in advance. I still came off the road with a loss, but not nearly as large as with previous tours.

In late December we played four sold-out nights at the the Forum in Los Angeles. Two of the Phenix Horns—Louis Satterfield and Don Myrick—cornered me before the show. "If we don't get more money, we're not going onstage tonight," they said. I said nothing in response to this ultimatum, this hostage taking. I knew that saying anything at that point wouldn't do a damn thing. But I looked at Satt and Don, my old friends, with great exasperation. Then I smiled a little and said OK. But in my slight smile they knew what I knew—that this was the beginning of the end of my association with the Phenix Horns. I had Art Macnow talk to them, and they worked something out. They would play on a few more recording sessions after that, but the business relationship was soon to be over. On the road, I could not allow anyone to hijack me before a show.

Beyond the money issue with the Phenix Horns, I believe that there was a racial component too. Since we were on the road so much, the African American Phenix Horns were part of the band. But in the studio, increasingly they were not being used as much, which I think created a little business insecurity among them. I started to use what the band not so affectionately called "the white mob"—Jerry Hey and Chuck Findley on trumpet and Bill Reichenbach on trombone. As much as I got "Hey, Maurice,

why are you using those white boys?," the Phenix Horns still respected the talent of the white mob—you had to. They could swing and were very accurate on their sixteenth-note riffs—not easy to play, and an important part of the EW&F sound. The Phenix Horns felt as if they were being pushed out—and to be pushed out by white dudes, no less, was an added sting.

In fact, those decisions were increasingly left up to whoever was hired as the arranger, whether it was Tom-Tom Washington, Bill Meyers, David Foster, or Jerry Hey. Some arrangers preferred the white mob on certain songs, some preferred the Phenix Horns. I've said it before—this wasn't personal.

Despite the tensions with the horn players, the *Raise!* tour had some special moments for me. Beloyd Taylor was on the road with us, doing background vocals and playing percussion. I noticed that every night he would leave when we were getting dressed before a show. One night, early in the tour in Greensboro, North Carolina, I followed him into the bathroom.

"Why are you disappearing, Beloyd?" I said.

He sighed. "Reece, you know I'm handicapped."

"I know, but I don't know if I would label it handicapped."

Slowly taking off his shirt, he revealed one shoulder that had no muscle. It was severely deformed.

"Man, I was teased my whole life because of this deformity, and I don't want to dress in front of you guys."

"Beloyd, never be ashamed of what you think is your shortcoming. As much talent as you have, you should never be ashamed of anything like that."

What I didn't divulge to Beloyd is that I could somewhat relate. Being teased as a kid is something I knew intimately. Yellow boy, half-breed—all that shit had its effect on me too, though at that time I had too much pride to admit it to Beloyd.

The US leg of the *Raise!* tour ended in Denver on January 7. We then went to Europe and finally back home. The Complex studios and offices were busy around this time. George Massenburg's custom-designed recording studios were up and running,

and there were many artists coming in and renting the studios. Prince, Lionel Richie, Quincy Jones, and others were also renting the soundstage for rehearsals, as well as for the new world of music videos.

But it was the 1980s, and there was a lot of cocaine around the Complex too. In the early college tour years of EW&F, some of the guys had smoked pot, but that fell by the wayside. Philip stopped smoking because he felt that it affected his vocals. As our live shows became more complicated, the remaining cats who were still doing a little weed had to stop. Between magic, choreography, and explosions, our shows required focus.

Now, though, around the time of *Raise!* and the subsequent tour, it became apparent that my brother Fred had developed a substance abuse problem. Fred had always had a daredevil spirit; it was what made him a great drummer. He had also started out very young in the music business. He became a professional early, so he was always hanging out with cats ten, twenty, thirty years his senior. This is not an older brother making an excuse for his younger brother; it's just to acknowledge what I believe to be the full background of the issue.

Throughout his period of drug use, Fred missed only two gigs, one in Oakland and one in London. On both occasions Ralph Johnson, being the reliable foot soldier that he was, came to our rescue and stepped in to play.

Everyone in the band was supportive of Fred and hoped he would get clean, but there were grumblings among the band about my blatant nepotism. They knew that anyone else would have been fired—and fast. Ordinarily Fred would have been fired too. Yet, beyond the fact that he was my baby brother, I retained him because of his monster talent. As hypocritical as that sounds, it overrode everything—the public image of the band, my own feeling toward drugs, and my integrity as a bandleader. Fred was the brick wall. He provided a rock-solid tempo and a rock-solid feel, priceless qualities in a drummer. He was one of the best things going for us. In those days in the studio, if your

drum track and groove weren't killing, you had nothing. There was no way to salvage the record. Now you can cut and paste, quantize—electronically correct—rhythm, and do all kinds of computer manipulations. But back then, he was the foundation. I had to have it. Despite Fred's temporary troubles, he never relented in kicking major ass on the drums. I chose the groove.

27 / Black Tax

I have learned that success is to be measured not so much by the position that one has reached in life as by the obstacles which he has overcome while trying to succeed. Out of the hard and unusual struggle through which he is compelled to pass, he gets a strength, a confidence, that one misses whose pathway is comparatively smooth by reason of birth and race.

—BOOKER T. WASHINGTON

MTV debuted in August of 1981, and overnight it became the premier way to promote a music act and give a high profile to a hit record. Problem was, the network was unapologetically racist. Rick James and EW&F had two of the biggest records in the country at that time—James with "Superfreak" and us with "Let's Groove." Despite our outcry, MTV refused to play either video. In other words: "Get to the back of the bus."

Michael Schultz directed the "Let's Groove" video, using the then-state-of-the-art visual effects created by a visionary Ron Hays. It would be the debut video on BET's new show *Video Soul*. This wasn't our first video; it's just that before MTV truly exploded, videos were just called "promotional clips." We made these clips for earlier songs like "Serpentine Fire," "September," and "Boogie Wonderland." They were not elaborate in any way—usually just us on a soundstage, lip-synching to the song. The video for "Let Me Talk," the first single from *Faces*, had been our first with effects and more complicated editing.

MTV tried to hide behind the lie that they played only

album-oriented rock (AOR), as an AOR radio station would. But it was clearly playing pop music too. God bless Rick James, because he was out front on this issue before everybody, including me. He and I appeared in a segment on *Entertainment Tonight* on the subject of racism and MTV. Bob Pittman, then head of MTV, said in the segment that EW&F and Rick James videos weren't played because we were clearly middle-of-the-road (MOR) artists. That was complete and total bullshit, since MTV was playing MOR music. On the day of MTV's premiere in 1981, it played "Is It You" by Lee Ritenour, which is so R&B/pop it's ridiculous. But it also played "Rapture" by Blondie, which is pop, funk, new wave, and rap. Both of those artists got a pass because they had white skin. Hall & Oates and Phil Collins were MOR artists too, and they benefited greatly from early MTV exposure. I said much earlier that historically our best foot forward has meant a subservient, lesser foot forward—that's the black tax. Here I was, after all: despite Earth, Wind & Fire's worldwide and crossover success, we were still shut out.

The dispute turned the R&B/pop world upside down. A few white artists publicly came to black artists' defense, David Bowie and Keith Richards most notably. But only two long years later, in 1983, when Walter Yetnikoff finally threatened to pull MTV's access to all CBS's product, did MTV cave. The result was that Michael Jackson got to sit at the front of the bus. Overnight, MTV claimed that "Billie Jean" was suddenly in their format. Now if "Billie Jean" is album-oriented rock, not R&B/pop, the sun won't rise in the east tomorrow. Michael's album *Thriller* went from being just a good follow-up to Jackson's *Off the Wall* to the record-setting Michael Jackson phenomenon of the decade.

The exposure of artists on MTV made a *huge* difference in sales and visibility. Our albums of the early 1980s—*Raise!*, *Powerlight*, and *Electric Universe*—would probably have fared better with MTV's support. By the time "Billie Jean" desegregated MTV in 1983, Earth, Wind & Fire was slowing down. Not too

long after the racial walls at MTV came tumbling down, I put the band on hiatus. Timing is something else.

Life teaches you many things. One of the big lessons of the MTV battle was that we are not going to get very far on racial equality if the starting point is that we've already gotten past the original problem. This touches a raw nerve. It was fascinating to me that nearly twenty years after the civil rights movement, something so blatantly discriminatory could operate out in the open. MTV had the attitude in 1981 that racism was yesterday's news. In a way it was like a return to the segregated record business of the 1950s. No apologies, just irrational justifications.

The questions raised by the racist roots of MTV are still with us. They largely hinge on what is pop music and what is black music. Why are certain acts labeled pop, while others are labeled R&B? Today, like then, sometimes the musical distinctions are negligible. Is a white face on a black-sounding song pop, and a black face on the same song R&B? As the Internet changes the game, maybe there's hope. Unsigned young artists—and established artists, for that matter—no longer have the mass media gatekeepers between their music and the public.

Race has colored so much of my business struggle. MTV's brazen racism really hurt the band at a very critical time; that can't be denied. And the segregated world of record promotion was a battlefield I had to fight on my entire career. Since we were crossover maestros, many thought pop radio was in our command. But it was surely not. We still had to go through the rear door called R&B radio before we had the opportunity to be heard on pop radio. I was vocal about it, and I got the feeling that people in the music business thought my global success meant it was wrong for me to be so vocal. I was not deterred. My feeling was, If not me, then who?

Furthermore, we were mostly nominated for Grammys in the best R&B group category, not the pop group category. It was another black tax. Since the mid-1970s, many of the R&B Grammys were given out in the pre-telecast, so they were not

broadcast on TV. After a while, we stopped showing up. In a twist of racial fate, one year George Massenburg was at the ceremony, and he went up to accept our award in our absence. They got pissed off and snatched the Grammy right out of George's hands, because he was white and didn't look like Earth, Wind & Fire.

I was catching it from both sides of the racial divide. Early on, after we had a few hits, we put most of the black concert promotion talent in America on the map, pretty much singlehandedly. Yet we were called into a meeting in Philadelphia, hosted by the black promoters' association. A bunch of big and little acts were there with their managers. It was clear they had summoned us to put Earth, Wind & Fire and our white booking agency in its place. They wanted to boycott Madison Square Garden and some other venues unless we used black promotion talent. I just listened, but Leonard Smith, who was with me, was absolutely fuming. He'd had enough. Standing up after someone had taken a dig at EW&F, he asked to be recognized.

"Earth, Wind & Fire is a California corporation, a member of corporate America," Leonard said. "We have a product for sale. If you like it, you can buy it. If you don't, you can pass on it. No one has the right to tell Earth, Wind & Fire how to operate their business."

Gradually Leonard then went down the line one by one, pointing people out by name, reminding them how we helped them when they couldn't get any piece—not even a morsel—of the arena rock pie. We had given them a piece of our concert promotion dollars because we, as independent free black men, knew it was good business. It would assist us in reaching our core audience, as well as being the right thing to do. Now they were going to try to hold us hostage? I didn't mind helping in any way I could, but I damn sure wasn't going to be told what to do. Leonard was more than great that day. He didn't take any shit, even from his own people.

At the same time, some black folks, in the business and out,

were upset because I had white management and associates. They were misinformed. I wasn't some black man who became famous and then switched to a white manager. Bob Cavallo was with me almost from the start; we rose up together. I hired magician Doug Henning because he was the best at what he did; he also happened to be white. I hired choreographer George Faison because he was the absolute best, and he happened to be black. Bill Whitten was black. David Copperfield was white. Excellence—not pleasing the black or white establishment—was always my goal. My attitude pissed a lot of people off, for a long time. I got the label of being a bit of a highbrow, and it didn't help that I was introverted.

Fighting the white record company powers that be, with their segregated promotion—and, to a lesser degree, some black folks—was draining. I didn't let it get me down, though. I just kept moving forward, like Mama trained me to do.

It was 1982, and I had turned forty in December of the previous year. I didn't feel forty, or even thirty. As a matter of fact, I had never felt better. I was playing tennis almost every day I could, and, man, was I enjoying it. I had thoughts about being on some kind of senior tour one day. I was enjoying a more balanced life. I went to the movies more often. At Verdine's insistence, I saw *Raiders of the Lost Ark* twice. I was still in demand as a record producer, turning down way more work than I accepted. I got to Carmel more often. Forty was fine by me.

March 18, 1982: Wembley Arena, London, England, the final night of six sold-out shows for the *Raise!* tour. Getting ready to come home for a little while. Walter Yetnikoff, the undisputed king of CBS Records worldwide, reached me in London.

"Maurice, Earth, Wind & Fire is receiving the CBS Records Crystal Globe Award for five million in sales outside of the US. Congratulations, Guru!"

("Guru" had become Yetnikoff's teasing name for me.)

"Thanks, Walter. You guys helped—a little!" I teasingly shot back.

"You're the first black act on the roster to ever do that."

Even with all the racial qualifiers and barriers, Earth, Wind & Fire had been one the biggest bands on the planet for about seven years. I don't know if there was anyone, including me, that really savored what we had done. It was hard work, and the years went by in a flash. Just as interestingly, Ronald Reagan gave four EW&F albums as one of the customary gifts of state to the president of China. At the same time, in a twist of fame fate, Larry Dunn had a guy roaming around LA and NYC, impersonating him, taking advantage of women and freebasing cocaine in nightclubs. The FBI had to get involved. It was a mess. Additionally, EW&F, along with KISS, the Rolling Stones, and other rock acts, was accused of having demonic messages via backward masking on our recordings. For us, it was a damnable lie. They were actually going to pass legislation in California to try to prove it. All this happened within the first few months of 1982. It was the noise of popularity and the price tag of success.

Meanwhile, back in Los Angeles, the acceptance of EW&F made the Complex a pretty popular place to record and do music videos. In late 1982 and early '83 George Duke was producing a new album for Deniece Williams and Philip Bailey's first solo record, *Continuation*. David Foster was producing an album for the rock band the Tubes; Linda Ronstadt was recording with the great Nelson Riddle and a fifty-piece orchestra on the soundstage. Earth, Wind & Fire was recording a song for the animated film *Rock & Rule*. Cheap Trick, Debbie Harry, and Iggy Pop also participated. In addition, I was putting the finishing touches on *Powerlight* for EW&F. Next to *Faces*, *Powerlight* is probably one of our best and most overlooked albums.

In between all of this, in Studio B, I was producing Jennifer Holliday's debut album, *Feel My Soul*, for David Geffen's label. Jennifer was the newest and brightest thing on Broadway. She had just been in *Your Arms Too Short to Box with God* and *Dreamgirls*, which made her a star. David Foster, Allee Willis, and I wrote a beautiful, theatrical ballad for her called "I Am

Love." She sang the hell out of it. It was a hit on the black chart, but it did not achieve the same level of success on the pop charts.

I did have a certain amount of healthy pride in the Complex facility. While working on Jennifer Holliday, strictly by happenstance Quincy Jones, David Foster, Wayne Vaughn, and I all found ourselves at the Complex on a late Friday night in January. We were all working on different projects, and I had our staff chef prepare us a sumptuous late-night meal.

"This is a beautiful place, Reece," Quincy said.

"Thanks, Q. It took a long time to get here!"

"You know I know."

Q winked at me. His wink was an acknowledgment of what most black entrepreneurs know: to achieve anything in the white world, you've got to work that old African American expression of "making a way out of no way." Quincy had been an early mentor, and now he was a great friend. He knew personally how difficult it could be to be a black achiever in America. He loved EW&F, and I loved and respected his chutzpah and his rich musical legacy. Years later, when he produced the Will Smith vehicle *The Fresh Prince of Bel-Air*, he named Uncle Phil's imaginary law firm Firth, Wynn and Meyer as a joke to me.

The Complex was a fulfilled dream but, although busy, it was still running at a financial deficit. ARC, my record label, was failing too, largely due to the fact that the record business was failing. We had gotten $3 million for the label deal and a couple million more to build the Complex, which wasn't anywhere near enough for either. And I was becoming an increasingly absentee landlord. I had a beautiful all-glass office that overlooked the soundstage. For all the years that I had the Complex, I can count on one hand the number of days I spent sitting at the desk from ten to six. One day I popped in to sign some papers, and as I was leaving, Art Macnow cornered me.

"Hey, man, where are you going?"

"Home."

"Maurice, do you enjoy this? Do you need this? Do you care?"

"This what?"

"The Complex, your office, ARC. Other than coming in to record, you're never, ever here."

"Art, I'm here when I need to be."

I let the large metal doors slam behind me. As I drove up the hill on Beverly Glen Boulevard, I reflected on Art's words. I wanted ARC to succeed for ego and financial reasons, but I didn't equate those reasons with having to sit behind a desk and deal with the day-to-day operations. It's not that I didn't have teachers who taught me how to run a record label, or how not to. I just believed that Marshall and Leonard Chess, Calvin Carter at Vee-Jay, Billy Davis, Clive Davis, Bruce Lundvall, and all the promotion, publicity, and marketing people in between were businesspeople, and I was a *musician*. I probably had too much of that boy from Memphis in me who found a father and mother in music. My boyhood pride was deeply rooted in being called a musician. Once my young heart had found music, I would be damned if I was going to let go of it. I loved being an artist, producer, writer, and bandleader. Maybe all that was playing itself out in a subconscious way in my not showing up at the office. Maybe it was a little snobbery or a little youthful rebelliousness gone awry. Regardless, ARC was running out of time.

Earth, Wind & Fire, and to a lesser degree Deniece Williams, carried the American Recording Company. In many situations, that would have been enough. But between us starting the label at the beginning of the downturn in the record business and, to a lesser degree, my lack of interest, it may have been doomed from the start. The record executives at all the major labels were blaming it on kids spending their quarters on video arcade machines, and on what they called counterfeiting, or home taping with cassettes. I don't believe that was the cause, nor was the music itself. It was simply that the overall economy was not doing well. Between the dollar plummeting, unemployment, and bank failure after bank failure, there was no way to predict how deep the

record business slump would go. Not to mention the growth of the record business at large had already taken place in the 1970s: sales jumped from 2 billion to 4 billion between 1970 and 1978. Independent of that, I think the entire staff, myself and Bob included, had a false sense of security regarding ARC because the first two EW&F albums on ARC—*The Best of Earth, Wind & Fire, Vol. 1* and *I Am*—were so successful.

Still, the slumping economy was only one side of it. At the roots of ARC's crumbling fortunes was a lack of musical focus. After Jerry Peters initially turned down my offer to make him head of ARC A&R, I stopped looking, thinking that somehow it would magically work out. That's what success can do: make you betray the very thing that made you successful in the first place. In my case, this was an attention to detail. I was naive. My neglect and inability to properly delegate was one side of it. There was a lot of black executive and A&R talent available, but I did not seek it out. I needed someone who had R&B/pop music sensibilities and administrative chops, all rolled into one.

We had solid R&B talent on the label. Deniece Williams and the Emotions, of course, and then there was D. J. Rogers, Pockets, Caston & Majors, and others. We released what I thought was a good album that Verdine and Beloyd Taylor produced by a group called Afterbach. I was also openly thrilled when we signed the iconic jazz group Weather Report, a prestigious move for the label, releasing four albums. I had so much musical respect for Joe Zawinul and Wayne Shorter.

But in my naive belief that it would magically all work out, I gave over the A&R reins to my management, essentially giving away the very thing that made Kalimba Productions rise in the first place—an emphasis on R&B/pop music. This decision was at the root of ARC's demise.

With that lack of musical focus, we released a lot of albums in the rock/pop/AOR genre—artists like Larry John McNally, John Hall, Gerard McMahon, and Peter McIan, who did a good record called *Playing Near the Edge*—though Valerie Carter's

Wild Child, produced by future prolific film composer James Newton Howard, was the standout of the rock/pop albums released on ARC. There's no reason that *Wild Child* should not have been a smash album for Valerie, who was a standout writer and a badass singer. She had all the promise and talent in the world. But the label was bloated with too many artists in divergent genres, who dragged the numbers down.

There were also fits and starts at the label. We did an album with Renn Woods, an actress best known for her role as Fanta in the groundbreaking miniseries *Roots*. The television miniseries, a riveting depiction of the evil of slavery, was widely successful—a cultural phenomenon that captured America's attention. We also started but never released an album by Todd Bridges, who played Willis on the hit TV show *Diff'rent Strokes* (this was before his much-publicized struggle with drugs). By the time his album was finished, the American Recording Company had folded. It was over.

There was so much promise when ARC was launched. All the producers, writers, and artists involved—including some of the band—would have benefited if only the label had generated some big hit records. It also pained me because it was my name on the line. I was president of the label, even if I was an absent one. If ARC had succeeded, I would have gotten the credit for it. Since it failed, I had to take the blame.

It's strange how your mind associates certain people with certain events. For me, ARC's end will always be linked with Deniece Williams. I remember her asking me, "Are we okay? What's happening to our family?" She even flew to New York to ask Walter Yetnikoff what was going on with the label. When ARC started, her career, the Emotions, Pockets, and EW&F were all affiliated. She felt the hope and promise more than anyone because she was a highly visible artist. According to her, "At ARC's start, it was on the lips of everybody in the music industry." I told Niecy, "You'll be fine"—and she was. Her best days were in front of her. Crossover hits with Johnny Mathis would

pave the way for "Let's Hear It for the Boy," the biggest smash of her career, in 1984.

While I was frustrated with the collapse of ARC, my never-let-them-see-you-sweat mentality was still firmly locked in place. I just kept moving on.

After the demise of ARC, in February of 1983, *Powerlight*, our twelfth album on Columbia Records, was released. *Powerlight* had a minor R&B hit, "Fall in Love with Me," but I felt the album had not been promoted properly. Although it went gold, it was viewed as a commercial disappointment. By the fall of 1983 I was getting bored with R&B. Records like "She Blinded Me with Science" by Thomas Dolby, "Owner of a Lonely Heart" by Yes, and "I Can't Go for That" by Hall & Oates were turning me on. A year or two later it would be "Things Can Only Get Better" by Howard Jones. All four songs had a European flavor—pared-down, electronic, and yet very song-driven. This was the direction I felt that Earth, Wind & Fire should go. I wanted to take EW&F into a modern era, to capture the new wave sound out of Europe. It was a risk.

Earth, Wind & Fire had had a bunch of hit records and B-sides playing on the radio ever since 1974. I knew the public had decided for itself what the Earth, Wind & Fire sound was. But I could not let our fans, or anyone else, dissuade me from moving into new musical horizons. A part of my motivation as well was that I heard Earth, Wind & Fire's sound in a lot of songs on the radio. I heard it in songs like "Get Down On It," "Big Fun," and "Steppin' Out" by Kool & the Gang, as well as in the huge hits "Boogie Down" by Al Jarreau, "Turn Your Love Around" by George Benson, and many others. I also heard it in DeBarge and their debut album *All This Love*, in the title track and "I Like It." Truth be told I was hearing it as early as 1978 with Con Funk Shun's "Loveshine" and later the Gap Band's "Are You Living" and the Brothers Johnson's "The Real Thing."

Bottom line, I felt like some artists had copped some of our

unique mixture of melodic R&B and pop. The big, jazzy, brassy EW&F horn arrangements became one of the easier ways to imitate our sound. I made a gutsy decision to not use horns on our next album. I wanted to create the power and syncopation of the brass instead with harder-edged synthesizers. To me it was a good idea for a creative shift, and I hoped that radio would respond.

To bring about this transformation, I looked to two young and hungry British guys to help me carve out our next musical journey. Martin Page and Brian Fairweather were part of a European group called Q-Feel. The group had had a moderate hit called "Dancing in Heaven," which I was not crazy about. They got to me through Bob Cavallo, who knew I was looking for a new sound. We met and hit it off. I was into the study of UFOs at the time, which I didn't share with too many people. I was fascinated with the depth of the universe and the belief that there must be other worlds, galaxies that could produce life like our own on earth. Turns out Martin Page was also into the idea of UFOs, and we bonded over it. Page and Fairweather were good songwriters, musicians, and singers, and they really understood synthesizers and drum machines. And that was a big part of the new revolution in sound coming out of Europe.

Martin and Brian were creative but uptight as hell. I had to constantly rein in their intensity. Since this new direction was different for EW&F, and there was a bit of a culture divide, it took a minute for everyone to adjust. Verdine and Larry, being the gracious cats they were, welcomed the Brits even if it was with some protest. Soon we were all laughing and working together.

Beyond the experimental musical goals of *Electric Universe*, lyrically the album was a commentary on the limits and pitfalls of technology, which is a core belief of mine. In the early 1980s, Ronald Ray-gun was talking about nuclear Star Wars in the sky. Mechanization was destroying long-held industrial jobs. Personal computing was starting its snowball roll down the mountain, and we began to hear the word *genetics*. I questioned where

instant communication and technological leaps were leading us. My feeling was that if it helps cure cancer, right on—but if it just makes it easier for us to be colder to one another, then it's not a good thing. Bottom line, with all this technology, we had still not ceased to hate one another.

In November of 1983, with much anticipation, Columbia released the first single from *Electric Universe*, "Magnetic." It tanked spectacularly.

Powerlight and Jennifer Holliday's debut were released in 1983, and were both considered flops. By normal standards, I was still selling good numbers, but I was used to having big hits. Jennifer's album sold 400,000 copies. Both *Powerlight* and *Electric Universe* sold just about 500,000, with *Powerlight* going gold. But the commercial disappointment of *Electric Universe* in particular gave music critics, some in the band, a chance to harshly criticize this new supposedly failed direction I had gone in. I had to take it all in stride, because in the climate of the 1980s music business, a miss was damn near like the end of the world.

The 1980s became about having huge record sales—quickly. Along with the advent of blockbuster movies, VCRs, and cable television, instant success and instant glory became the aim of music albums. Conversely, sometimes the aims were linked. Movie sound tracks became cross-promotional vehicles that boosted the sales of both film and the album. The high expectations of the early 1980s had a profound effect on the music business and were diametrically opposed to those of the 1970s, where you were given a chance to build a following and a career. With *Electric Universe*, I think some people outside my camp understood more of what I was trying to do than people inside the camp. Three years later, in 1986, Larry Blackmon's Cameo reinvented themselves, achieving what I had attempted to do in '83. Their own mixture of new wave, R&B, and euro-funk topped the charts with the hits "Word Up" and "Candy." Amusingly and ironically, Cameo, an African American group, got extensive video airplay on MTV with those two songs.

With the failure of *Electric Universe* I had to relearn a profound lesson: not to push, not to rush. We had released *Electric Universe* only eight months after our previous album, *Powerlight*. By this time in the 1980s, most major artists went two or three years in between album releases. I now believe my haste had a deep and personal motivation. The sting of *Faces'* poor reception still hung over me psychologically—a lot. *Powerlight* had underperformed, ARC had failed, and I felt like I had something to prove. This feeling was spiritually disastrous. I did not trust the Creator. If I had just slowed down and taken time to reflect, I believe I would have waited a year or two, maybe three, to spring a musical change like *Electric Universe* on the public. I had had so much success, and my so-called failures threw me. I was wrongly clinging to an idea that Earth, Wind & Fire's outward success had something to do with my inner value. This was a complete breakdown of my spiritual work. I had somehow gotten away from the core ideal that I was enough. It was a strong reminder of something I once heard: that spirituality is like an always-moving dimmer switch. Your light is either getting brighter or darker, moving back or forward. It does not stay static.

28 Something's Got to Give

As you discover changing times you must have the strength to
endure
As you discover a changing world you can't be guessing, you must
be for sure
In these ever changing times you must learn to stand up on your own
—"THE CHANGING TIMES," *RAISE!*, 1981

Band psychology is dicey and difficult on its best day. Earth,
Wind & Fire was no different. From the beginning, I was
very clear on what I was doing, and I didn't get discouraged. I
believe that the guys drew strength from that in the early years.
But as time went on, I believe that my clarity about what I
wanted to do and how I wanted to do it became a source of some
of their frustrations.

I continued my routine of meeting with the guys one-on-one,
so they could talk freely. Sometimes they would voice their com-
plaints or frustrations to me; sometime they would voice their
frustrations with others within the band. Sometimes they would
talk about personal frustrations, and sometimes we'd just go at
it toe to toe.

I believe my style of leadership worked for Earth, Wind &
Fire. What works in a band is clearness of direction—keeping it
simple and straightforward. Simplicity is a beautiful thing when
you're dealing with complicated operations. David Foster called
me when he was in the midst of working with the band Chicago
and said, "Man, I long for the days of working with EW&F,

because I only had you to answer to!" Foster was greatly frustrated trying to make the horn players, the vocalist, and everybody else in Chicago happy, and still he had to please the record company and himself. It was driving him absolutely crazy.

At least I never had those kinds of frustrations. The tight ship I was running gave me comfort. I liked the predictability that organization brings, especially in the unpredictable, unorganized world of rock and roll. And yet I was big on "vibe." I remember telling the cats on so many different occasions, "Man, you brought the right vibe," or "Man, you messed up the vibe."

EW&F was a big band—nine guys, twelve if you include the Phenix Horns, and I do—with big personalities and very strong-willed individuals. Each person had an idea about how things should be run. I'm aware that some bands vote on everything. What songs to record, what outfits to wear, what songs to play live, how a mix should sound, what kind of pictures to take—I could go on forever. Trust me, if EW&F had been a decision-by-committee band, we would not have survived beyond 1975. I was the producer, lead singer, principal writer, and I shared the drum chair. And yet with all that, I was still a part of "the group."

By 1984, this was all starting to take a toll. I began to feel a heaviness; my mental temperature was starting to rise. I had come to the end of a long road, from 1966 to 1984—fourteen years building EW&F, and four years before that on the road with Ramsey. I was worn out, physically, psychologically, and emotionally. Just flat-out whipped. In early 1984, I called a rare group meeting at the Complex.

When the band arrived, the vibe in the room was normal and cordial. We hadn't seen each other in a while, and I could sense that they were anxious to find out what was the next adventure for the group. Without much fanfare, I informed them that I was disbanding Earth, Wind & Fire. Some looked shell-shocked, others dismissive. The decision was right for me, but maybe wrong for the band. And truth be told, looking back, I probably

was insensitive in how I brought it to the guys. I have some guilt about that. If I had told them a year or two earlier, maybe they would have saved more money. Even with the two less successful years we had just had, the band felt we were stopping at our peak. To some, this shutdown was a screaming halt, blunt and without warning—and perhaps they were right. Truth was, I didn't know myself about this stoppage until Christmas of 1983. I just couldn't take it anymore. Something had to give.

Had I known what lay ahead, I would have taken a break earlier—maybe after the commercially disappointing *Faces* or the triumph of "Let's Groove." The EW&F machine was now a *big* machine, a small corporate empire with lots of salaries, day-to-day responsibilities, and at this point lots of hot and cold feelings between the band members, management, accountants, staff, and family. The tension was partly what kept me away from ARC, especially in its last two years of operation.

Additionally, the pace and failures of 1983 had left scars. I didn't go on the road that year, which gave me the opportunity to check out what was going on at the office. I didn't like what I saw. There was more and more cocaine, even among people I respected. I saw misappropriated funds, and the majority of the faces I saw at the Complex I did not even know. Everyone in that office, in a large or tiny way, was benefiting from the success of EW&F.

Around Christmas, Joe Ruffalo, my co-manager, who didn't work as closely with me as I did with Bob, was having a party at his new house in Bel-Air. His then wife was showing me the house. As we were walking downstairs I saw that the walls were covered with gold and platinum Earth, Wind & Fire albums. She turned to me: "Keep those platinum records coming, baby—that way we can pay for the courtyard we're having built!" Her words were in poor taste, in my view. It's not that I was comparing how they were living with me or the band; whatever money my managers were making, it was a business deal I had agreed to. But I did get a whiff of the Hollywood cesspool of crassness, exploita-

tion, and unfettered rudeness. That night I felt it was swirling around me. After that scene, I must admit I was more cynical and cautious regarding my relationship with Cavallo, Ruffalo, and Fargnoli.

As if that reality wasn't bad enough, putting Earth, Wind & Fire on hiatus set off a chain reaction of broken feelings. By now everything seemed black and white between the band and me—no shades of gray. On one hand, publicly, I would be called a successful, no-nonsense leader, and, on the other hand, an ego-maniac. I felt that most of the guys had lost their musical edge. They felt I had lost my mind and gone Hollywood. None of this was true on either side.

I understand why some in the band felt that way toward me. To them, they couldn't tell me shit—jack! My truth was that I listened to many things the band and others on my business team said. Some I agreed with; most I didn't. EW&F should do *Johnny Carson*. EW&F should not spend money on going to Royce Hall to record strings. EW&F should record this or that song. EW&F should do *Soul Train*. EW&F should stay longer on tour. Nine African American men with nine strong opinions, not to mention the business faction—there was never a time when there were less than three strong and different opinions about what Earth, Wind & Fire should or shouldn't do next.

And of course everyone wanted more money, from the top of the organization to the bottom. I definitely made the big-gest piece of the pie; I had some publishing interest in most of the songs that became EW&F hits and I had control over how the artists' share of points was distributed. But my portion of pie was subdivided many ways. Tours, especially, drained me financially—but tours were what paid the band, crew, and some of the business apparatus.

It was all coming to an end. The hiatus, breakup, or whatever the band or the press called it was the end of the EW&F glory years. In those glory years, anybody associated with the name Earth, Wind & Fire could have gotten what they wanted from

the music business. Prince sought out Cavallo-Ruffalo because he wanted the guys who managed us. David Foster was a part of our studio band for about a year and a half. Right after working with us, he took off like a rocket, possibly becoming the most prolific record producer of his generation. Many unknown songwriters, after coming through the EW&F world, went on to write massive hits for other artists and gain massive money. I used to feel that the band didn't take the opportunities it could have, especially hustling to get songs placed with other artists. Philip Bailey and I have had brief moments of strain in our relationship. At one time I felt he was a front-runner, supportive when I was winning, quick to disparage when I wasn't. But one thing I respect Phil for is that whenever there was a break, he was always branching out. It started with his gospel thing, and it just grew from there. For all of Al McKay being pissed with me, he too branched out early. He eventually had an office on Sunset Boulevard, composing and submitting songs to different artists. I didn't stand in anyone's way as long as his opportunities didn't interfere with the band or the band's brand. I used to judge some of the cats in the group as having what I saw as a lack of initiative. But I see it differently now. They probably didn't go get those opportunities because they, like me, were on the road so much.

By 1984 it was very apparent that there were people who had gained more from their association with Earth, Wind & Fire than Earth, Wind & Fire had gained. That stung the band. And as a result, some in the band began, I believe, to resent the very nature of the very tough music business. They also counted me as an enemy because they believed that I was making a lot more money than I really was.

I didn't say or do much to defend myself. I knew I had been fair. I honored my contractual agreements with each band member. But my silence was taken as snobbery, especially in the Hollywood music world of hearsay and innuendo. There was an R&B syndicated radio show that referred to the band after

we broke up as "Reese's Pieces." That was unfair to them, and to me.

I know some in the band feel they didn't get the credit they deserved for the very unique and important roles they played in the Earth, Wind & Fire success story. That's a basic problem in band dynamics. Whether it's Paul McCartney wanting to put his name in front of John Lennon's, years after the fact, or the famed battles between the Rolling Stones' Mick Jagger and Keith Richards, it's just the way it is in a band. Pink Floyd's David Gilmour–Roger Waters war is legendary, as is the one between the Beach Boys' Mike Love and Brian Wilson. People are going to feel underappreciated, the leader is an easy target, and histories get rewritten through each individual's eyes.

Still, it is true that the guys didn't get the credit they deserve, especially Larry, Al, Verdine, and George Massenburg. But Earth, Wind & Fire as a whole didn't get the credit it deserved. For all our success, we still paid that "black tax."

I must add that one of my major failures as a bandleader was that I did not share with the group especially after 1980 my own personal misgivings and doubts—about the music business, and about the shelf life of the band. I always wanted to appear strong, decisive, and in command. Again, that never-let-them-see-you-sweat mentality. My need to keep up appearances made me seem coldhearted and indifferent to the changes some of the cats were going through.

Even so, I continued to handle my business. But with so many people's livelihood depending on EW&F, I couldn't help but feel like a big brother. When the band broke up, I believed everyone would be OK. They all had houses. Johnny Graham had a speedboat and lived around the corner from me. Philip and Andrew lived in the beautiful Cheviot Hills of Los Angeles, and Philip had done his first solo record and was gearing up for another. Larry Dunn lived in a ranch-style house in Brentwood and was doing productions on his own, and Verdine had produced the band Pockets. Also, together, Larry and Verdine

teamed up to produce Level 42's album *Standing in the Light*. Al McKay worked with Ralph Johnson to produce the Temptations' album *Truly for You*. "Treat Her Like a Lady" became the Temptations' biggest hit since 1975! Why Ralph and Al McKay didn't continue producing together, I don't know. Everyone was working.

Still, with the band's road money gone, some of the guys were hit hard. A couple had tax trouble. Another was burned financially and emotionally in a divorce. The guys who had written some of the hits made out better as time went on due to royalties—as I like to call it, the gift that keeps on giving.

29 On the Solo

Seeing
Seeing is believing
It's the greatest feeling
Knowing in your heart

Just trust yourself
Look ahead
Feel the motion growing
Love is where it's going
This is where our real journey starts

—"EVOLUTION ORANGE," *RAISE!*, 1981

With the band suspended, I felt my psychological tempera-
ture slowly falling. The heat that had been building since
1980 started to abate. This cooling felt like a deep-rooted calm-
ing of my spirit, a sweeping feeling that put me into a much
lighter and freer place. I had never felt this way before. I couldn't
believe that there wasn't something on my plate to do with the
band. I didn't have to think about the microscopic details of an
EW&F album or tour.

Billy Joel and I had been talking about doing a record together.
We thought his Americana thing would be a great match with
my Chicago roots thing. We just couldn't coordinate the time.
Regardless, I still had a lot of producer work lined up. But in the
summer of 1984, an urgent project came up that took priority:
Barbra Streisand. I rarely got those kinds of calls. This Strei-

sand job was a rare exception. I was brought in at the very end of the project. Columbia felt it did not have a strong first single. For a project like this, in many cases, the company will give you the songs it wants you to record. That wasn't the case this time. I was kind of shocked that they didn't have it together; this was Barbra's first studio/pop album since *Guilty* in 1980. I had to find the songs and get going in a hurry.

After we put the word out, a lot of songs poured in. I picked four and cowrote another with Martin Page and Brian Fairweather. In the end we recorded five songs. Three were released: "When I Dream," "Heart Don't Change My Mind," and "Time Machine."

"Time Machine" had to be sold to Streisand because of the theme. The song title was unusual for her, but not for me. Martin Page and I drove out to Malibu to pitch the concept of the song. I explained that it was a story about having the ability to look back over your life and understand its changes, the theme being that your life makes sense in the end. As much as Martin and I were thinking about her when we wrote the lyric, in the end it could have been about her or myself.

> *I remember when my voice was never heard*
> *Many listened but they never heard the words*
> *In my mind I can travel back in time*
> *Relive the memories that kept my faith alive*
> —"TIME MACHINE," FROM BARBRA STREISAND, *EMOTION*, 1984

The recording process went smoothly. Streisand is a perfectionist, and so am I, and I was happy with our work. My happiness was short-lived. I felt we had a couple of singles, and the Columbia people agreed, but Columbia didn't have the final say; Streisand's team did. The songs I produced were not released as singles, and that was a disappointment. Streisand doesn't need any particular producer to do a good record. The bell-like purity of her voice stands alone in pop music. I do feel the songs we

recorded were a new direction for her, and had way more feel and emotion than the other material on her album.

The ultimate disappointment came when I discovered that they had gone in behind my back and changed one of the mixes. Now, I have absolutely no problem with an artist wanting to change a mix, which basically means, Turn this up, and turn this down. No big deal. But to go behind my back was beyond the pale of common courtesy. To this day, I don't know what that was really about. The album was not considered a major success, even though it quickly sold over a million copies.

By 1984 I had decided officially to do a solo record. I had been thinking about it even before the band disbanded. I was in good company. A lot of singers—Phil Collins of Genesis, Jeffrey Osborne of LTD, and Don Henley of the Eagles, to name a few—were coming out of bands to do solo albums. Still, everybody thought I was trying to follow in Lionel Richie's footsteps, since Lionel came out of the Commodores and I came out of EW&F. I admired Lionel's success, so from a marketing standpoint, that might have been true. In reality, though, Lionel had the personality to be a star, and I was a bandleader, not a star. Moreover, Lionel's early foray into country music had laid the perfect foundation for his crossover and MTV-driven success.

There were big changes all around. I decided after much soul-searching to end a long managerial relationship with Bob Cavallo. Prince was Cavallo, Ruffalo, and Fargnoli's new vehicle, and I was kind of old hat to them. It's just the nature of the biz. Prince loved EW&F. He had been coming to see the band every time we came to Minneapolis. He got rid of Owen Husney and hired my team to lead him to the promised land in 1979. Prince wanted his own facility like the Complex and more control over his career. By 1982 he'd released his fifth album, *1999*, his milestone in terms of musical focus, success, and that inevitable word, "crossover." Songs like "Little Red Corvette" and "1999" firmly established him as the most important pop artist of the era, even over Michael Jackson. MJ had more fame, but Prince had a far

greater musical influence over his time. After *1999* came *Purple Rain*, and the rest is history. Even after Bob and I parted, we still remained close.

The process of finding a new manager was bloated. I interviewed over twenty prospects. The top music managers in LA wined and dined me, picking me up in limos, renting out restaurants so that we were alone. They all made grand projections and big promises. Too bad I wasn't impressed with that nonsense. I got the complete opposite approach from Shep "Supermensch" Gordon. Shep was managing Luther Vandross and Alice Cooper. Unpretentious with a quiet presence, he didn't make any flashy presentations or promises.

"Maurice, Earth, Wind & Fire's music means something of depth," he said. "It's more than just another successful rock act."

"I appreciate that. But what does that mean in terms of my solo record?"

"It simply means that we should present you in a classy way."

Shep Gordon was straight with me. No high-flying Hollywood bullshit. He concluded by saying, "We may or may not make a lot of bread, but we're going to have a lot of fun." I signed a contract with him two weeks later.

After signing with Shep, I became excited about doing a solo record. I felt no strain or urgency, nothing that would encourage my high-strung nature. I felt free, as if I were at the beginning of a new romance. With Martin Page and Brian Fairweather, I felt I was on to something different energetically and creatively. I knew for sure that I didn't want to use the Complex to record my solo record. I had to break out of the inertia of the EW&F world. I did a lot of recording at Soundcastle Studios in the Silver Lake area of LA, all the way in the northeast part of town. It was good to be in a funkier neighborhood and have a longer late-night drive home. It was like starting over in a way.

I was feeling what Martin Page as a creative person was bringing to the table on my solo album. We had worked together on different projects for more than three years. Since I came from

an acoustic way of doing things, and he and Brian Fairweather came from this synthesizer-based trip, I wanted to blend the two worlds, the contemporary with the traditional, and experiment along the way. I had to school Martin on balancing the two.

I recruited some great musicians for the record. When we were recording "Children of Afrika," I had Vinnie Colaiuta on drums, David Williams on guitar, and Abraham Laboriel on bass. Martin had done the preprogramming, and I was letting him guide the session. Martin heard things more synthesized and he was getting a little perturbed because the musicians were playing things differently than what he programmed. Martin is about six foot two, with a big voice. With his British accent, he could be intimidating. He was making the studio feel tense and tight; it was getting thick as concrete. I pulled him into the hallway, closing the door behind us.

"Hey, Martin, just let the band feel their way through the song," I said.

"My demo is dead on," he replied defensively.

"Martin, you are going to have to chill—just lay back, and you may be surprised."

Martin hung his shoulders low and just went into the back of the control room and sat down. He was sullen. After about thirty minutes he came out from the corner because a new song was emerging. The groove turned from a techno song to a kind of Talking Heads feel, where Abe's bass part just opened things up. Even though Martin had to learn about the divine spark of musicians, he was always expressive musically, and that's what I was looking for. It was always about a band vibe for me—the interaction of the musicians, the collaborations, and the unexpected results.

"Stand by Me," a remake of the Ben E. King hit of 1961, was the leadoff single for my debut solo album *Maurice White*. The single was getting good reception across the board, but I had to do way more publicity than I was used to. By the late 1970s Philip, Verdine, and Larry Dunn had been doing as many inter-

views as I was on EW&F's behalf. Therefore I had a somewhat misguided view on how much press one had to do to promote a record in the mid-1980s heyday. In this new solo career, it was a bit of an unnatural place for me to be. One person wanted me to throw a party at my house for about a hundred people for publicity. That was definitely not going to happen.

I had always emphasized to the band that we had to maintain a mystique about what we were doing. I thought it was the best way for the band to have longevity and not overexpose ourselves. Steely Dan, Rush, and Pink Floyd did it that way too; they were really faceless bands. It's not that people didn't know who EW&F were, visually, it's just that they knew the music more than the personalities.

In the 1980s some in the band, as well as my business partners, felt that I took the mystique thing too far, cheating EW&F and myself personally out of a more viable place in the music business. My longtime business manager Art Macnow, in particular, always felt that I spent the better part of my career— when I was the most successful—being the most secretive, elusive, and hidden person in Hollywood. He always was pushing me to be more like my good friend Quincy Jones, who's everywhere, knows everybody, and goes to many events. But that just wasn't me.

Like many people who have been in entertainment a long time, I may have been stubborn. I was completely out of touch with the publicity demands of being a solo artist in 1985, and I did take my usual disposition into my solo record. But I think it's critical to understand who you are, maximizing the strengths and diminishing the weaknesses. My reclusiveness came naturally to me; I never truly got over my shyness as a child. I was never that half-hug Hollywood type. I didn't go to parties and palm-press and tell perfect strangers "I love you" after one conversation. I had admired Berry Gordy from afar. Berry too was seldom seen, but when he was, he made it special. When EW&F started to rise, I discovered that I didn't have to do all that stuff to be suc-

cessful, and I made that discovery a part of my life, for better or worse. And yes, EW&F probably paid a huge price for that.

Don't get me wrong—I loved success, not fame and what it brings. Success gave me resources, freedom, and the chance to meet my heroes. There was no greater honor than for Miles Davis to say many times publicly in his scratchy voice, "Earth, Wind & Fire is by far my favorite group—you can't miss with those guys." Since I was a jazz cat at heart, the great ones always motivated me. I wanted a friendship with Miles beyond a professional one, and we crossed paths a hundred times. A few years earlier, I had just gotten home from a tour in Europe where Miles Davis had come to see EW&F several times. The phone rang.

"Yo, motherfucker, it's Miles."

I was elated. "Hey, man, what's happening?"

"Where did you get those yellow leather pants from that you had on in Belgium?"

"Oh, man, they were custom made. So how have you been—"

"Later."

Click!

That was Miles.

Meanwhile my initial solo single, "Stand by Me," got into the top ten on the black chart and to No. 11 on the adult contemporary chart, and then it stalled. As I've said before, in the '80s, if your first single didn't do well, it was difficult to get the promotion department fully behind the second single. The ballad "I Need You," the next release, did far better on adult contemporary stations, but it stopped there. I didn't criticize Columbia at the time, but I did feel they could have done a more across-the-board campaign—a less segregated approach to the promotion of my album.

Of course I was disappointed with that album's lack of success, but I am proud of it. Still, I was more hurt than I ever let on. I wish I had done a few more solo records. I was a little shell-shocked at its nonperformance. I had put almost a year into recording it, and I just didn't know if I was prepared to give

up another ten months to do another solo record, and subject that work to the whims of the music business, whims that were increasingly out of my control. I took it personally.

After my solo record came and went, I just dove into more work. I worked with a young jazz/R&B trio, Pieces of a Dream, on a smooth jazz record called *Joyride*. Soon after that, I got a call from my old pal Neil Diamond. He wanted me to produce some songs on his upcoming album. Neil understands his gift as a stylist and was not afraid to use that gift in new and different ways. We had fun and laughed an awful lot during the recording.

In the summer of 1986 I produced the sound track to *Armed and Dangerous*, a comedy starring John Candy and Eugene Levy. Bill Meyers worked closely with me, and he also did the score.

In the meantime, Philip Bailey had started calling. He had moved back to Denver during our hiatus to have a more normal life and regain his financial bearings. At first the calls were just getting-reacquainted kind of chats, laughing at the same old jokes and so on. But after a few conversations, he got to his real agenda. He wanted to do another Earth, Wind & Fire record.

When I disbanded the group in '84, I had every intention of putting it back together, but my enthusiasm had waned—greatly. I wasn't sure about it, creatively, financially, and psychically. At that time I loved being in the studio and going home without having to soon go on tour for five months. I was enjoying my life as it was. It was not that I didn't miss working with the band, but it didn't seem to be the right time to put it back together. Verdine and I were going through a tough period. We were not getting along. We'd barely spoken for a few months. The problem revolved around the responsibilities of the Carmel property, and we had reached an impasse. At the same time, we probed Al McKay and Larry Dunn to see if they were up to rejoining the band. They both declined. Without Larry and Al on board, I realized that the previous era of Earth, Wind & Fire was truly over. I already felt this on some level, but their decision not to come back crystallized it for me.

Philip was persistent, though, and eventually I relented. I agreed to do this comeback record, and Philip and I formed a mini partnership for the album. Columbia Records was definitely all for it. I would like to say it was all a creative decision, but things were getting tight for Philip financially, and they were really getting tight for me, so a part of my decision was monetary.

What nobody knew but Art Macnow and my lawyer was that Columbia/CBS—soon to be Sony Music Entertainment—was squeezing me hard. Columbia wanted to offset some of the money that it had lost on the ARC investment by going after my royalties. Consequently, my royalty stream was very dramatically reduced. I had assets, but I had an awful lot going out and very little coming in. The Carmel property was expensive to maintain. Originally the costs were going to be shared by Verdine, Fred, and myself but we never reached an agreement on what would work for them financially. I had bought Marilyn and my son, Kahbran, a house up in Laurel Canyon, and I bought a house for myself in the Beverly Glen section of Bel-Air. And those were just a few of my expenses. Fortunately, I got a royalty check just in the nick of time. It wasn't gargantuan, but with it, I was able to restructure things. I sold some assets and started to rebuild my financial world.

To bring a new energy into this comeback album, I asked a young cat I had recently been working with, Sheldon Reynolds, to join the re-formed EW&F. Sheldon had been in the Commodores' backup band for a few years. A guitarist, vocalist, and all-around good guy, he brought in a youthful and creative spirit. The first song we cut was the title track, "Touch the World," a gospel song written by the Reverend Oliver Wells. It was a great session, with Ricky Lawson on drums, Nathan East on bass, Sheldon on guitar, and the one and only George "Daddy" Duke on piano. To top it off, my good brothers Edwin Hawkins and the late Walter Hawkins sang with us. I had always loved the Hawkins brothers; we had a friendship for over twenty-five years. There was so much heart and so much light between

them. My Christian brothers and sisters would call that session anointed, and I say amen to that.

> *She walks with a beat as she works the street in the dead of night*
> *She's been laid off and her kids must eat and his money's right*
> *A world away beneath the sun the earth goes dry*
> *A hungry starving people search for food as their babies die*
> *I tell you, we can touch the world*
> *When we can meet them all at their need*
> *We can touch them where they are*
> *Help them to believe, touch the world*
> —"TOUCH THE WORLD," *TOUCH THE WORLD*, 1987

"System of Survival," the first single from *Touch the World*, quickly became a No. 1 R&B record. With the *Touch the World* album in the marketplace, I started to plan a tour. Ralph Johnson and Andrew Woolfolk were back on board. I hired a drummer for the ages in Sonny Emory. He is the best live drummer post–Fred White EW&F ever had. The other great thing about this period is that Verdine and I had settled our differences, and he was back playing bass. He greatly assisted in brainstorming for the tour. There is no Earth, Wind & Fire live show without Verdine White, period. We rekindled and continued our highly unique personal and professional bond. From the start, V was a true believer in my vision of Earth, Wind & Fire. He was a source of energy and endurance that I needed to have in the band. Years earlier, on our live album *Gratitude*, after Verdine takes a monster bass solo, I say to the crowd, "That's my main man." He was, and he is.

Regretfully, the *Touch the World* tour planning soon became the same old story of me writing large checks. I'd cut a deal with Philip in which his money was guaranteed no matter what the financial outcome of the tour. This made my mini-partnership with him end when it came to financial responsibility for the tour. I don't blame him. If I could have gotten that deal, I would

have taken it too! Ron Weisner, who was EW&F's manager for a brief time, and promoter Tom Hulett of Concerts West were convinced that everybody was waiting for an Earth, Wind & Fire comeback tour. They blew all that smoke, and I sucked it right up. They truly believed it, and I went all in with them. We built the biggest and costliest stage that we ever took out on the road—a white horseshoe-shaped behemoth designed for big arenas. I hired LeRoy Bennett of Prince fame as lighting director, Michael Peters of Michael Jackson *Thriller* fame for choreography, and James Earl Jones of *Star Wars* fame to record a Darth Vader–like dialogue for the introduction to the show. Big money all around.

We were on the road for most of 1989, but the Touch the World Tour had its troubles. We were not selling out the big arenas, as Weisner and Hulett had envisioned. A month in, we stopped the tour for six weeks. Cutting the stage almost in two, we retooled for smaller venues: six to ten thousand seaters. Once we'd overhauled our expectations, we did well. But I still came off the road in major debt; I never financially recovered from the initial outlay of cash for the original tour concept. Damn.

30 Blindsided

Your living is determined not so much by what life brings to you as by the attitude you bring to life; not so much by what happens to you as by the way your mind looks at what happens.

—KAHLIL GIBRAN, THE PROPHET

I woke up one day in 1990 shaking.

Just like that. I felt fine in every other way besides this uncontrollable tremor in my hand. Looking back, however, I had little telltale signs. Around 1986 I started getting tiny hand tremors. Years earlier, my leg would sometimes shake in bed. I just thought it was stress or something. It stopped, and I forgot about it. But this morning was clearly different.

It was a completely new feeling.

It was an odd feeling.

It was a disturbing feeling.

At first I saw health practitioners in the alternative medicine world. Some of them were herbalists, some dealt in mind-body, others were more esoteric. They all basically said I had some kind of nerve disorder. All I could do is what I always did: find my fulfillment in music.

By the early spring of 1991 my tremors had become significantly worse. I could no longer rely solely on alternative medicine. I told Art, and he set up an appointment with a neurologist, Dr. Mark Lew at USC. They did a battery of tests that went on for hours, ruling out multiple sclerosis, Huntington's, and Lou Gehrig's. Finally Dr. Lew said simply, "Mr. White, you have Parkinson's disease."

My heart sank. I had prepared my mind for the worst—but damn, Parkinson's disease? First person I thought of was Muhammad Ali, who had made the public more aware of Parkinson's disease and was now its public face. Of course, I did not tell anyone. I refused to claim the identity of a person with Parkinson's disease. Some of that was ego, and some of it was spiritual. I didn't want the extra mental weight of people seeing me a certain way, especially since I did not want to see myself that way. It's not that I wasn't accepting the truth about my condition; it's just that I didn't want to make it the focus of my life. Not to be positive about it would have been a betrayal of all the spiritual work I had done, and ultimately a betrayal of myself. I also had an ally in Dr. Lew, who told me that staying positive would help with Parkinson's. In any event, the news remained locked up within me. I was trying to ignore the symptoms, trying to ignore the negative thoughts swirling around in my head.

Yet there's something about those nights when you crawl into bed alone, and all you're left with are your thoughts—the thoughts that the demands of the day have kept at bay. But I never panicked. In the weeks following the diagnosis, I wondered: Why Parkinson's? Parkinson's is an old person's disease, right? I was only forty-nine years old, and since I'd had tremors since '86, the disease must have truly started when I was forty-five. I ate impeccably, exercised religiously, took vitamins, and meditated. I knew it didn't do any good to dwell on the cause, but I briefly went through those motions. Was it inherited? I asked myself. Was it unresolved painful emotions from my childhood? Or all that DDT I breathed in as a child in Memphis? Who knows?

I had always rejected the pernicious new age belief that you create your illness. I think that kind of thinking is a complete rejection of the most basic realities of life: shit happens. What I didn't reject was the belief that the thoughts you have around the unexplainable ups and downs of life are important. They say you think 70,000 thoughts a day. With all that chatter going on in

your head, it's hard not to let negativity slip in. It would not be enough to demand of myself, "Stop thinking about Parkinson's disease." I would have to replace the thought with something else. I would have to find the good in this situation, no matter how bad it might appear. Find something I could hold on to. Find something that could help me keep my head skyward. It was the ultimate irony that the very thing I had unfailingly promoted in my music would be the very thing that I would need to radically embrace. Have mercy.

When you hear words like "You have Parkinson's disease," it moves energy all by itself. It moves energy in you. It moves energy in the people who care about you. It moves energy in anyone who knows that you have it. For these reasons, telling folks, at least right then, was not for me. What made my outlook brighter is that my sister Patt accompanied me to Redlands, California, seventy miles east of LA, to see a Parkinson's specialist. He said that it looked like I had an extremely slow progression of the disease. I was ecstatic. He said I could go on and do everything I had been doing for some time to come. That helped me a lot psychologically in those early months of the diagnosis. I had gotten something of a reprieve.

Even with this slow progression of the disease, I would have to come up with a plan to deal with it. For the next nine years of my life, it would remain a secret. My creativity, my health, and my life in public would all have to adjust. But in time it would become a negotiation between keeping a secret and Parkinson's harsh reality.

31 | Not Fitting In

Wanted: a man who will not lose his individuality in a crowd, a man who has the courage of his convictions, who is not afraid to say "No," though all the world say "Yes."

—ORISON SWETT MARDEN

An unexpected metamorphosis took place in the music business in the late 1980s and early '90s. Hip-hop became the dominant form of black music, and any other form of black music was swept to the side. When *Niggaz4Life* by N.W.A. went No. 1 on the *Billboard* 200 album chart in 1991, it was a milestone. Likewise, when Guns N' Roses released their *Appetite for Destruction*, tons of sound-alike artists were signed in the wake of both groups' huge success. No complaint there: that's just the way the small minds of the entertainment industry work. Their flavor-of-the-month mentality doesn't take into account that anyone with a trend-setting sound is highly idiosyncratic. James Brown, the Beatles, Prince, Nirvana, Parliament-Funkadelic, Sly Stone, Led Zeppelin, Stevie Wonder, Elton John, and others all marched to their own individual sound and became legends because of it.

The enormous racial difference of this time was that established adult white artists like Phil Collins, Tori Amos, Celine Dion, and so many others were *not* asked, either outright or subtly, to make their music harder, like Guns N' Roses, or to have the angst of Nirvana. Could you imagine asking Elton John to dress or sound like Kurt Cobain?

On the other hand, black artists, adult and young adult, new and established, were told outright or hinted at by the black A&R guys or their white bosses to make their sound more "street." For over a decade, "street" became the operative word in the black music business for more hip-hop-influenced, or harder. "Street" was code for a certain set of musical, visual, and lyrical sensibilities. In the DNA of that code was a request for blacks to ultimately prove that they were "black enough." Even a successful band like Earth, Wind & Fire was still somewhat scrutinized through that "street" lens.

Some of this "black enough" litmus test was in large part built upon the misguided belief that one African American journey is more authentic or "blacker" than another. I came from the projects of Memphis, Tennessee. But coming from the projects did not make my experience more authentically black than that of someone who did not.

The irony of all this was that I spent a lot of Earth, Wind & Fire's creative capital to erase the idea that black masculinity was a one-size-fits-all concept. I worked hard at establishing the band's identity beyond the stereotypical ideas of black manhood, whether it was the supersexed stud, the criminal, or the super athlete. Nor did I want any part of the hypermasculine crap that seemed to me to be a good portion of the hip-hop culture, all this look-at-me-see-how-tough-I-am bullshit. I wanted EW&F to always represent an intellectual, thoughtful man—a man skilled in his musical craft, independent in his thinking, spiritual and otherwise; a black American and yet a man of the world.

The beautiful elements of hip-hop gave younger artists a wider lyrical palette to draw upon. Their lyrics were not just love songs; they included other aspects of life, even if sometimes these were traumatic ones. Their stories were refreshing for black music. Who needed another song about rockin' me tonight? The larger question became, however, whether they could take those traumatic experiences and portray them from a higher viewpoint—in other words, develop a social consciousness.

The worst elements of hip-hop celebrated the tough-talking, self-glorifying antisocial behavior—or, as I like to say, the "saying nothing, talking loud" attitude. At its zenith, that swagger became what the bona fide black person was. Some say it is still with us. A few years later I saw Don Cornelius, my old acquaintance from Chicago and creator of *Soul Train*, at a restaurant. He had given up the show's hosting duties in 1993. When I asked him why, he humorously said, "Niggers, Reece, niggers!" I fell out laughing.

Sadly, during this era a lot of young black artists were simply trying to fit in when they started calling girls bitches and hos or throwing one-hundred-dollar bills at the video camera or bragging about who they shot last night or what it feels like to wear a $50,000 watch. The overwhelming majority of these kids weren't from the mean streets of Compton or Brooklyn, but from the suburbs. They were just trying to fit in and get paid. Even singers who weren't so-called gangsta tried to appear tough and hard to appeal to the lucrative fetish created by certain expressions of hip-hop. These artists were selling themselves short. They had an opportunity to not only make money but create a legacy of dignity.

Throughout this time, young artists were constantly seeking me out. "How can I achieve greatness and longevity in this business?" they often asked. I told them, one, to create something that their grandchildren wouldn't be ashamed of, and two, to be who they were. Some got it, and some looked puzzled. The problem in the arts, I would tell them, has always been and always will be gatekeepers or people in power telling you that you've got to fit in somehow. And that's a despicable lie.

Ultimately, particular aspects of hip-hop culture will have to answer the question: Do they degrade or uplift black character and culture? Music is more powerful than we can ever know. Neuroscience has now proven what Plato, honorable spiritual leaders, and kids have always known: music has a divine way of getting into your system, into your psychological and emotional DNA.

Despite hip-hop's growing dominance on radio, EW&F reestablished itself with the No. 1 R&B hit "System of Survival." Back in Los Angeles, I met with the Columbia Records vice president of A&R. He was polite, but he more than insinuated that Columbia wanted more from EW&F than just a No. 1 R&B hit and another gold album. Platinum records were our domain, and he was determined to return us to glory. He suggested that we include younger guest artists on our next album to hip things up. To show I had a spirit of cooperation, and that maybe I was hip too, I agreed. Big-ass mistake.

I liked the music on *Heritage*. I liked the tracks we came up with. I even liked the two young guest artists we worked with, the Boys and MC Hammer. But when you're an adult artist who has had a bunch of hits, like Earth, Wind & Fire, it looks like you're trying too hard when you put younger people on your record *for the sake of having younger people on your record*. That makes it not about music, or a new sound; it makes it about marketing. It's not that I was unwilling to embrace change. But when it looks forced, it's over before it starts.

When *Heritage* was released, Verdine, Phil, and I went on the *Today* show, where Bryant Gumbel interviewed us. Toward the end of the interview, he asked,"Do you ever wish you hadn't called a halt to it back when you did?" I responded, "We needed the break." Riding back in the town car to the hotel, I thought deeply about Bryant's telling question. It made me wonder, how relevant could EW&F really be? I knew we could still have a one-off hit, and our past hits would always make us a concert draw. But between our age, pop/R&B being drowned out by hip-hop, and the ever-growing market for all things gangsta, was it even possible for us to regain our position as consistent hit makers?

For all those reasons and more, I chose to move closer to my jazz roots. I wanted to be free of the box of producing singles that ended at 3:24. I yearned for older forms of music, for more live instruments, for letting the music flow freely, unconstrained

by commercial demands. I did some songs on Ramsey Lewis's 1993 record *Sky Island*. A year or so later I did a wonderful jazz album, *Urban Knights*, which featured Ramsey, Grover Washington Jr., Victor Bailey, and Omar Hakim. It was like coming home, though some people were surprised that I would choose to produce an instrumental jazz album. The project was so successful for the record company GRP that we recorded *Urban Knights II* two years later, in '97.

It's not that I abandoned contemporary R&B/pop music. I worked with Barbara Weathers of Atlantic Starr, Prince protégée Jevetta Steele, and the one and only James Ingram. But out of all the albums I produced in this period, I am proudest of the one I did with El DeBarge, *In the Storm*. I knew El from his early days in California. When we started working, he jokingly reminded me, "Maurice, you were always giving me books!"

El always had a beautiful understanding of what works for him. In the more and more restricted framework of 1990s R&B/hip-hop, El still held on to a sense of musical adventure. I was called into his project after his label, Warner Bros., rejected what he turned in. El, for all his troubles, was a giant of a talent—a monster at writing melody and chord changes. His troubles made it challenging to keep him focused and to get him to the studio every day, but when he was there, there was never a more musically expressive cat.

As much fun as I was having returning to my jazz roots and working with creative young people, it was also around this time that I was also subtly reminded of the Hollywood fame game. Since my birthday is close to Christmas, on December 19, for many years the large foyer in my home would be filled to the brim pretty much through December and January with all kinds of gift baskets, international food, wine, flowers, exotic plants, and desserts—baskets upon baskets of unopened gifts. I would give 90 percent of it away. In the late 1980s, however, as the hits stopped coming and my low profile became even lower, I gradually noticed that, year after year, the del-

uge of baskets became less and less. It's the old Hollywood story of fame, fair-weather friends, and where you put your value. You can't win the Hollywood fame game. You can't win because it's inherently inauthentic. It's designed to betray you. It's not about you; it's about what others believe about you and what others want from you. Thanks be to God I didn't have my eggs in that basket. If I had, I would have fallen hard around this time. It can be hard to wash off the superficial love of the entertainment business.

I suppose it's inevitable that what goes up must come down. MTV's beginning attitude toward black music cannot be underestimated in the major role it played in EW&F's dwindling fortunes in the early 1980s. But hindsight being 20/20, of course, maybe I could have done things differently. Nowhere is this more debated than in the leadoff single choices for our albums. As I acknowledged before, in the 1980s the first-released singles were becoming like the box-office opening weekend for movies. If your first single didn't do well, your album was toast. Between radio promotion dollars and music videos that could cost from a quarter million to a million dollars, it was tough to reignite full-throated excitement for your second single. A one-and-you're-done mentality dictated the terms.

David Foster transformed Chicago into an AC powerhouse in the early 1980s by focusing the band's singles on ballads, giving them a second life. This approach extended their recording career into the late 1980s, until their lead vocalist, Peter Cetera, left. Lionel Richie's "Hello" and even unknown groups like Champaign, with their soulful hit "How 'Bout Us," took over AC radio in the early '80s. After our success with the ballad "After the Love Is Gone," the Monday-morning-quarterback thinking is that we should have rammed our lush ballads down radio's throat. This could have sheltered an older EW&F from the fast-food whims of R&B/hip-hop radio and kept us in the friendlier adult contemporary radio format.

But I took a counter position, believing in the essence of the

EW&F sound. EW&F always meant power to me. High energy. Strength and masculinity. Big shows. Bold sound. Electrifying, up-tempo music. I never saw EW&F as a ballad band, with that continuous stream of softness and vulnerability. Ballads were just something you did as a part of your career. That musical disposition drove my psychology. Consequently, Earth, Wind & Fire never released a ballad as the first single to any album, ever. I completely ignored the fact that songs like "Reasons," "Can't Hide Love," "Love's Holiday," and "After the Love Is Gone" were a part of our identity too, and important to who we had become as a band.

I say all this because by the 1980s we were older, established hit makers, not the young lions. We didn't need to power our way into our listeners' psyche. We had their attention. All of our albums from the 1980s and '90s—*Faces*, *Raise!*, *Powerlight*, *Electric Universe*, *Touch the World*, *Heritage*, and *Millennium*— had great ballads. Songs like "You Went Away," "Could It Be Right," "Straight from the Heart," "We're Living in Our Own Time," and "Anything You Want" could have been the leadoff single from any of those albums. But none of those songs ever saw the light of day on the radio. Whether I was blind to changes in the music business or clinging to an outmoded idea, it's still hard to know whether ballads could have extended Earth, Wind & Fire's popularity on the radio in the '80s and '90's. But I do know for sure that I did not give the public, the band, and myself a chance to find out.

Most of the 1990s continued to be about me trying to keep my health issues private, return to my jazz roots, and still make Earth, Wind & Fire records in a very different musical climate. I'm so blessed that EW&F started when it did, at a time when record companies would let you grow into a career. They looked at things long-term back then. On the contrary, starting in the mid-1980s, an artist could sell a million albums, have their next album not do as well, and get dropped by their label, never to be heard from again. One-hit wonders became more com-

monplace. Artists who had genuine talent were becoming dis-
posable as toilet paper. Things had indeed radically changed.
Again, thanks be to God that Earth, Wind & Fire already had
a career.

What most people don't know about the music business is
that when you record an album, the money the record com-
pany puts out is nothing more than a loan. All the money for
the recording, marketing, and anything else must be paid back
to the record label before it starts paying royalties on sales. I
spent millions on recording. As a consequence, in the glory days
of my career, the mid- to late 1970s and some of the '80s, I
would get a $0.00 statement from Columbia Records, which
meant that I did not recoup. Part of the reason, too, was that
whatever money was there was being spent recording the next
album. There was never a long enough lull in recording activ-
ity for the coffers to be filled. The debt was essentially rolled
over. And much to accountants' and managers' chagrin, I would
reach into my own pocket and pay the band something, just to
keep them motivated. To this day, I continue to pay the band
royalties twice a year, based on the individual agreements I have
with each member.

It was a blessing that two positive financial things happened
during this period that made life easier. One, our records finally
started to recoup—all the money had been paid back by my roy-
alties. Likewise, in the '90s, when compact disc players became
affordable, people began buying our entire catalog over again.
Money started flowing in—in a big way. I wasn't the only bene-
factor from the creation of CDs. The compact disc lifted the
entire music business. From 1988 to 1998, worldwide sales grew
from roughly $6 billion to $13 billion.

The second helpful thing that happened is that we started to
go to Japan frequently to perform. The Japanese people have
always loved EW&F. They seem to love the songs and what the
music personifies. In all my years of touring, this was the first
time that I personally made a profit. In all those tours of the

mid-1970s, I'd come off the road roughly $500,000 in debt. I got it down to $300,000 a few times, but never under that. But our tours in Japan in the late 1980s and early '90s were serious moneymakers for me. They put me back in a strong financial position and wiped out all of my debt.

32 A Time of Symbolism

I thirst but never quench
I know the consequence, feeling as I do
We're in a spinning top
Where, tell me, will it stop

 —"I'LL WRITE A SONG FOR YOU," ALL 'N ALL, 1977

On Valentine's Day 1992, my youngest child, Eden, was born. I was fifty years old. Ellene Warren, whom I had been seeing regularly, was the mother.

I had kept the women who were dominant in my life, and in turn my children, at arm's length for most of my life. Much of that was simply the reality of my being gone so much, and some of it was due to my desire to have space for my career. I may have lacked in the romantic commitment department, but I was generous with the mothers of my children.

Throughout the mid-1990s, Ellene gradually became a bigger part of my life. When we casually started up, she never pressed me for any kind of definition of our relationship. That was a breath of fresh air to me. Little by little, any doubts I had that she really loved me—for me—were dissolved. Left standing were my love for her and her commitment to me. It would be over twenty years after Eden's birth before I realized that Ellene was the love of my life.

I have three children by three different women. I did not witness any of my daughter's childhood, and I missed a good portion of my younger son Kahbran's, so I've been trying to do a

better job with my youngest son, Eden. Eighteen years later, the induction ceremony for the Songwriters Hall of Fame in New York was held on June 17, 2010. I truly wanted to attend, even though I didn't like to go to many public events at that point in my life. But when I found out that the event was the night before Eden would be graduating from high school, there was no question where I would be: at Eden's graduation.

About the same time that Eden was born, Bob Cavallo briefly came back into my business life. After the creative interference on *Heritage*, I had had enough and wanted out of my deal at Columbia Records. We met with only one label, Warner Bros. Records. Its president, Mo Ostin, said, "Maurice, it would be an honor to have Earth, Wind & Fire on Warner's." No fuss, no muss. I signed with Mo. This was the end of EW&F's sixteen-album association with Columbia Records. Mo was known to everyone in entertainment as an executive who actually encouraged creativity—a rare breed indeed. Over his career he signed Joni Mitchell, James Taylor, Steely Dan, Prince, and the Talking Heads—all trendsetters in their own right.

In late 1992 we started recording our next album, *Millennium*. In my mind *Millennium* was supposed to be Earth, Wind & Fire's last album, and in many ways it is. I saw it as symbolic that EW&F's career would end where it started, at Warner Bros. I wanted to conclude Earth, Wind & Fire's recording career in a manner that was respectful to our musical legacy. For the most part Mo Ostin gave me complete creative freedom; the whole idea was that this was to be a return to the classic EW&F sound. And I achieved some of that on the album.

Besides Eden's birth, Cavallo being back around, and the return to Warner Bros., there was so much personal symbolism swirling around in my head during that year of recording *Millennium*. Early on in the project, my childhood buddy Booker T. Jones came by to visit me at Studio 55 in Hollywood. We reminisced all day and into the evening about growing up in Memphis and our youthful musical adventures together.

Our reunion was a diving board into what I wanted the lyrics of this final album to be. My old friend Jon Lind, who was experiencing a big hit with Vanessa Williams's "Save the Best for Last," turned me on to lyricist Brock Walsh. Brock and I talked for hours, mostly about my youth. The conversation felt therapeutic. Brock came up with lyrics that set an appropriate tone to where I had been in my life.

> Booker T's at the front door,
> Saying it's time to go
> Coltrane's at the Mother Blues tonight
> 63rd to South Shore
> We're cruising in the Dyna-Flo
> Ain't no way they let us play, but then
> they might
> —"CHICAGO (CHI-TOWN) BLUES," MILLENNIUM, 1993

Even more symbolic was that Don Myrick, my friend from the jazzmen of 1963, saxophone soloist on "Sun Goddess," "Reasons," and "After the Love Is Gone," and band member in Earth, Wind & Fire from 1975 to 1982, was shot to death by police in a case of mistaken identity in Los Angeles on July 30, 1993. Don answered the door with a butane lighter in his hands; the police mistook it for a weapon and shot him dead. At his funeral there was an air of sadness and racial frustration; his death was so senseless. Many of us from the band and the EW&F family were at the memorial. Like many funerals it was a mini reunion, full of reminiscences.

Six weeks after Don Myrick's death, our new album for Warner Bros., *Millennium*, was released. We did two pivotal television performances in the early promotional support of the album. On October 14, 1993, we performed the first single from the album, "Sunday Morning," on *The Arsenio Hall Show*. Later in the month we taped a segment for *The American Music Awards 20th Anniversary Special*. For these two TV appearances, the band was great. I was not. My lackluster performance couldn't be written off as age,

or me toning down my stage persona. People knew something was wrong. After the television appearances, rumors circulated about my health. Some time later, after several inquiries, I had to release a statement saying that I was not sick, just retired from the road. This seemed only to make the gossip worse. People started calling my office, asking if it was true that I had cancer, AIDS, or multiple sclerosis. I began wearing sunglasses all the time. The sunglasses were symbolic for me; I was trying to hide my Parkinson's disease. If I didn't let anyone get close, maybe they could not see that I had this earthquake rumbling in my body.

It was ironic to me that I'd spent my entire life rejecting drugs, and now I would be taking them for the rest of my life. For over a decade I had difficulty getting my drug strategy together, the proper combinations of this one and that one. And the drugs had side effects. In many ways I was worse off in 1993 than in 1996, and I was better in 2003 than in 2000. Parkinson's being a degenerative disease, I should have been getting progressively worse, not better. It was confusing to others, and most of all confusing to me, but it was all a result of my drug regimen.

I was still playing tennis in the early 1990s, and still feeling strong, yet I would get tired suddenly, out of the clear blue. Some of that was due to the side effects of the meds, some due to the disease. My doctors kept explaining to me that Parkinson's is a highly uncertain disease. You can have it for decades and keep doing what you always did, driving, exercising, the whole bit. You also can have it for one year and be completely disabled. That's how wide the variables can be. Since I was fortunate and had a slow progression of the condition, I was still trying some alternative treatments coupled with conventional medicine. By now, however, I had to start negotiating when I would take my medications based on what responsibilities I had during the day. In the studio, if I got a tremor in my hand, I would quickly stick my hand under my thigh and sit on it so no one could see the shaking. I started dropping and breaking glasses at home. Eventually, trying to hide my symptoms became exhausting.

33 Letting Go

The great use of life is to spend it for something that will outlast it.

—WILLIAM JAMES

In spring of 1994 Bob Cavallo, Art Macnow, and I met at the Glen Deli on Beverly Glen Boulevard, near my home. The guys wanted to try to go on the road without me. It would be a trial effort to see how they did, and to see if it was even possible. Since I own the name Earth, Wind & Fire, they would need my blessing. Bob and Art explained to me that if the guys could come up with something respectable, it could be lucrative for me, and the guys in the band could continue to earn a living.

I knew this was coming. A few months earlier, we had been performing in Japan. This was one of those frustrating periods when I did not have the drug regimen together. Physically, I barely got through those performances. My voice wasn't strong. We had to lower the key to "After the Love Is Gone." Right before we left Yokohama to come back home, I was walking to my hotel room, and I passed by an open door. The entire band was in one of the guy's rooms, having a meeting. I stopped for a second or two, looked in the room, and then just kept walking. When they saw me, they looked like they had seen a ghost.

I knew what they were talking about. What would they do if I stopped touring? Would they have a job? Did Philip, Verdine, Ralph, and Sheldon have all the musicians' support to soldier on without me? Would I pull the plug on the whole thing?

I listened to Bob and Art's pitch, and at first I was very—no,

extremely—resistant. I explained to them that despite the financial incentive that they artfully dangled in front of me, I did not want Earth, Wind & Fire to become an oldies act, like an Earth, Wind & Fire revue-style thing. I also didn't want it to become like the Drifters or the Temptations, with several groups out there touring under the Earth, Wind & Fire name. I made it plain that I'd rather retire the name and leave EW&F as a performing act to the memory of our fans. Sensing my doubt, they collectively made one last plea. Bob started talking, with Art chiming in.

"Reece, every day all over the world those songs are played on the radio, television, and in films. That is your legacy, and it is intact. The band couldn't even think of touring if Earth, Wind & Fire didn't have multiple hit records. You conceived Earth, Wind & Fire, you financed it, and you took the risk. Now why not enjoy some of the benefit? Their touring would be a small way of enhancing the Fire's legacy."

I was silent. Art and Bob had made a convincing case. They also added that the tours would not be the kind of tours that had built the Earth, Wind & Fire brand, nor the kind of tour that we had just taken to Japan. They would be at smaller venues, with many corporate bookings. Translation: low overhead and high return.

In the end, after a month of pondering, I agreed. I actually felt I had made the right decision for everyone concerned. This would not be the first time a successful band had soldiered on without their lead vocalist. Philip's songs wouldn't be a problem, because he was still there. But since I sang the lead vocal on 90 percent of our hits, it would be a challenge for them to make it work.

I made a colossal error in not replacing myself as the lead vocalist in the band. I was advised to do so by everyone. The argument went like this: if EW&F were to be relevant as a present-day recording act and not just a touring act, it would need two distinct voices, Philip's falsetto and a strong tenor voice. The signature sound of the band was created with two

different and independent voices. The plan was to hold auditions and find a young cat to sing my parts.

If I found a cat that met the requirements and also exceeded them, it would compensate for whatever loss the band faced in my absence. Still, I knew that replacing a lead vocalist in a band is never an easy thing to do. You are not only replacing a sound; you're replacing a persona. Additionally, I would have to find someone who possessed good stage presence and worked for myself, Philip, Verdine, and Ralph. Bottom line: I could have found someone, I should have found someone. But I just couldn't let go.

At first I felt like my baby was being taken away from me. Despite all the people who contributed to Earth, Wind & Fire's musical and business success, it was still my child—the child in my dreams of 1968, the child born out of a need to express myself, the child that would grow and be nurtured and ultimately render itself to humanity. And now it was being snatched away from me. I believe my feelings were symbolic of a lot of other ruminations, too. One, I loved performing. I loved the ego gratification and the validation. Most of all, I loved being a part of the greatest band on earth. When Magic Johnson retired from the Lakers due to HIV, he said what he would miss the most is "being one of the boys." I can relate to that. To stand backstage with your comrades-in-arms as the houselights go down and 20,000-plus ear-deafening screaming people stand up—now, that's a huge rush and a strong bonding element. I miss that feeling to this day.

Secondly, I was also in a massive full-on denial about my condition. I would have great days and then not so-great days, which gave me the luxury to dance around reality. I could still sing and produce records. In my mind, that meant I could still do everything, which of course I could not. I could not handle the physical toll of being onstage for two hours under hot lights, but in my rigid denial, I could.

As much as I tried to reinvent my life, when the band started

touring without me, I felt a void. I tried desperately to ignore this feeling. The paradox was that I was tired of the road. Even in the years before Parkinson's, I had had enough. And yet, when I was forced to give it up, as opposed to giving it up on my own terms, it messed with my head. For maybe a year or two, a few times a week I would think about being onstage.

Since depression and anxiety can sometimes be the most disabling thing with Parkinson's, my neurologist said that maybe I should see a therapist. I did, and on my second visit, he recommended that I put an end to any and all musical activities. That was the last time I saw that particular therapist. He just didn't get it. Therapists do a wonderful service for our society, but they deal in the psyche, which I believe can carry you only so far. If I were to gain anything from the therapeutic sessions, it would need to have a strong spiritual component as well. Music creation is a part of my spiritual life. Whatever healing would ultimately take place within me would come from the deeper parts of me, the parts beyond my intellect.

My innermost thoughts at that time were a merry-go-round of laughter, sadness, and relief. In a way, I would have never gotten off that treadmill of Earth, Wind & Fire if it had not been for Parkinson's disease. And I needed to. It had been a very long, hard road, a journey for which I sacrificed pretty much everything else in my life.

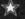

CONTEMPLATION

34 | Time Will Witness What the Old Folks Say

In your eyes the somber blue
Reflects a place from deep inside of knowing not what to do
I'll be your rock when you're about to fall
Together, we'll move on ahead and walk right through it all
—"TURN IT INTO SOMETHING GOOD," FACES, 1980

By the mid- to late 1990s, the glory days of my career were over. They had been over for some years. The struggle of those early years of 1969 to 1975 had been my proving ground. After 1975 and "Shining Star," EW&F hit an unprecedented streak of success no one could have imagined. But it took hard work.

Toward the end of the century, Earth, Wind & Fire experienced a resurgence in popularity. We received the NAACP Hall of Fame Image Award, as well as a star on the Hollywood Walk of Fame. In December of 1999 I found out that Earth, Wind & Fire would be inducted into the Rock and Roll Hall of Fame, class of 2000. This was a distinct honor for the band and for all that we had achieved. As the March 6 ceremony date approached, though, I started to inform people that I did not plan to attend. I didn't want to deal with being at such a high-profile event with Parkinson's disease.

I got a lot of pressure from Art Macnow and friends to attend. Verdine gave it to me hardest. "You've got to go, Reece."

"Don't think I'm up for it, V."

"Man, if you're not there, everybody will be disappointed."

"Ah, man, it's not that heavy."

"The hell it ain't! Reece, I'm telling you—you have got to go!"

I gave in. In the early spring of 2000, however, I was still experimenting with different drug therapies. There was no way I could perform with the band for the induction ceremony in the style that the public was used to. In effect, if I were to attend, I had to come clean.

One week before the Rock and Roll Hall of Fame event, I disclosed to the Associated Press that I had been suffering from Parkinson's disease for eight years. At the various press events before the ceremonies, Parkinson's was on everyone's tongue. Reporters asked me a ton of questions that I did not want to answer, and many that I could not answer. *What's the prognosis? Why did you keep it secret for so long? What's it like for you?* This made me very uncomfortable. I felt that the band's moment in the sun was somewhat eclipsed by my Parkinson's revelation. I feel very bad about that.

Still, on the bright side, it was the first time the original band had been together in twenty years. At first it was a little weird, but after a while we kind of fell into the old routine, telling the same crazy jokes. All this humor reminded me of when we were young. And in fact, for brief moments on that induction weekend, we were all young once again.

When I stepped up to the podium to speak, the crowd got to their feet and applauded for what seemed to me too long. I was sincerely moved by their appreciation. I was even more moved by the eight applauding gentlemen standing behind me—Verdine White, Larry Dunn, Philip Bailey, Al McKay, Ralph Johnson, Andrew Woolfolk, Johnny Graham, and Fred White. These were the men who took the journey with me, creating a new and powerful cross-cultural sound in pop music. On this weekend we were all reminded by colleagues and fans that EW&F had come

to represent something more. We had indeed gained a transcen-
dent respect.

Our new-thought cultural respect was entwined with the feel-
good nature of our music, the philosophical tone of our lyrics,
and our spectacular live shows, which kept pushing the theatrical
envelope. Our small yet constant emphasis on spiritual love and
peace was laced into much of our music. *Still, I have no illusions
that my little corner of creativity is going to change the world—but
I do believe strongly in the continuum of spiritual ideas.* And during
our time on that continuum, we contributed songs that sought to
bring our world together and strengthen the inner man.

We had songs built on simple universal spiritual truths, like
"Keep Your Head to the Sky," "Devotion," "That's the Way of
the World," "Take It to the Sky," and "All About Love." Some—
like "Open Our Eyes," "Burning Bush," "Gratitude," "See the
Light," and "Touch the World"—speak to (but are not limited
to) a Judeo-Christian lineage. Some—"Sing a Song," "On Your
Face," "Turn It into Something Good," "Share Your Love,"
and "Celebrate"—are simply affirmations of positivity.

Still others—"Saturday Nite," "Boogie Wonderland," "Fair
but So Uncool," and "I've Had Enough"—are a repudiation of the
party life. We testify that you can make it if you try with "Shining
Star," "Mighty Mighty," "Getaway," "You Are a Winner," and
others. Still others—"In the Stone," "Evolution Orange," "Jupi-
ter," "Fantasy," "Serpentine Fire," and many more—speak to an
ageless, ancient, and transcendent spiritual wisdom.

The coda to our induction into the Rock and Roll Hall of
Fame was deep gratitude. Still we knew the award was small-
time compared to our legacy—the message in our music. Each
member of Earth, Wind & Fire contributed in his own way to
that heritage. My own Earth, Wind & Fire story, however, starts
and ends with a spiritually motivated idea that I said yes to. And
when you say yes to anything in your consciousness, it is my firm
belief, the universe starts to conspire to bring that yes to fruition.
The EW&F concept was so big and so grand that it would have

existed without the band or myself. To me, the idea was just sitting out there in the ether, waiting to be picked up by someone with the courage to take it on. If another spirit had accepted the Creator's invitation, EW&F would have been different. But I believe it still would have existed.

The morning after the induction ceremony, I had breakfast sent up to my hotel room. A copy of *USA Today* accompanied it, with an article about the previous evening's events. When I read the piece, it was a moment I will never, ever forget. I just stared, transfixed, at the words "Maurice White, who disclosed his battle with Parkinson's disease . . ." I didn't read anything else in the article.

In an instant my situation became real to me in a new way. It wasn't shock. It wasn't fear, and in that moment, it wasn't even relief. Seeing those words in print was like looking into two mirrors that face each other and reflect into infinity, leaving me nowhere to hide. I gazed at the words—it seemed like forever. Somehow I knew my life had changed dramatically.

My never-let-them-see-you-sweat mentality was so much a part of who I was, as a bandleader and as a man. I did not want to be identified as a victim in any way. I wanted none of that "poor Maurice" stuff. To say publicly that I had an incurable vulnerability was my vertical hitting my horizontal. It was the perfect storm of my public life crashing into my private life, the life that I had guarded so meticulously. It was also the beginning of a mourning process. Not for my life, but for the gradual yet persistent loss of some of my physical abilities—a mourning for things that had to be left behind, permanently. I would have to say farewell to the joys of playing tennis and playing the drums. As things fell away, Parkinson's would force me to reassess long-held ideas about myself. Whether as a drummer, a singer, or a record producer, I, like many men, had a lot of self-identity caught up in my work. Music had been the essence of my total expression. In time, I would accept that I was more

than my music calling. This was a monumental psychological and emotional shift. Additionally, I recognized that I was more than Parkinson's, too. I was starting to grow and change in ways I could have never imagined.

I had never been afraid of change. The Buddhist philosophies of nonattachment that I learned in Asia decades ago helped. But human attachment dies very hard. And I knew that whatever lay ahead for me was going to be far different than anything I had experienced up until now. I realized that how I behaved in this wilderness called Parkinson's disease would determine how long I would stay in this wilderness—the wilderness of my mind.

In this phase of my life, contemplation has become a big part of my days. I look back and hear the choir at Rose Hill Baptist Church singing an old Negro spiritual, "Build your hope on things eternal—hold to God's unchanging hand." I believe the Creator's changeless and unceasing energy is still in the driver's seat of my life, and he still has his hands on me. I find comfort in that belief. The vulnerability and frailty of being human, none of us can escape. Life is designed to be humbling. But there is something to be said for having gratitude and devotion to the Almighty for life just as it is, Parkinson's and all. I am confident that this attitude is the way for my soul to evolve to the next level. It helps me accept my uncertainties as friends and not enemies.

Live a long life, and you start to lose people and push to do things while you still can. In February of 2003, my stepdad, Verdine Adams, died in Chicago. At Dad's funeral I was reminded of my deep family truths. In traditional families, stories are told over and over again to one another. In mine, those stories exist too, but I'm not really a part of them. My family's childhood reminiscences were not mine. I wasn't there. As family members and friends described in detail who or what something was like, I couldn't participate. It's not that I felt left out, but I am reminded of the very peculiar circumstances of my role in Dr. Adams's family.

In September of 2004 my pal Louis "Lui-Lui" Satterfield,

who taught me how to assert myself and taught Verdine how to play the bass, died in Chicago. That same year my sister Patt Adams moved out of my home. She had been one of my closest confidantes for more than twenty-five years, and I was sad to see her leave. Life was changing fast.

In some sense I started to take on new responsibilities to acknowledge the speed at which my life was moving. In 2005 I was approached by dancer/choreographer Maurice Hines to do a Broadway show based on the music of Earth, Wind & Fire. *Hot Feet* would be the result. Bill Meyers and I spent about a year working on the music, but the story was lacking. The script was based on Hans Christian Andersen's fairy tale "The Red Shoes." Maurice Hines directed it; his choreography was outstanding, but he didn't have enough of a story line to focus on. It was a commercial and critical flop.

In 2006 I came out of retirement to give my last public performance with Earth, Wind & Fire at the Grammy Awards. I had my drug therapies together, it was a good performance, and I had a great time.

The rest of the 2000s and beyond would be filled with a huge assortment of lifetime achievement awards for EW&F. Verdine, Philip, and Ralph would continue performing, and in their own way they continued to enliven the legacy of EW&F. They played at many significant events, most notably for a state dinner at the White House with President Clinton in 2000, in the 2002 Winter Olympics closing ceremonies in Salt Lake City, in the 2005 Super Bowl pregame show, and at the 2007 Nobel Peace Prize concert in Norway. But none of these was more significant to me than their invitation to perform at the White House Governors' Dinner in 2009 by President Barack Obama. This was the first formal dinner of his administration, and he chose Earth, Wind & Fire.

I couldn't help but feel deep, genuine pride when Verdine told me about the moment he met the president. "We walked in," Verdine said, "and I thought about Mom and Dad. I said, 'Boy, they

would really be proud. Wow, we have come a mighty long way.' The president came down to rehearsal and said, 'What's up, Verdine?' I said, 'Hey, Mr. President.' He said, 'Call me Barack.' He said, 'Where's Maurice? Where's Maurice?' I said, 'He's back in LA.' He said, 'You mean Maurice ain't here?—Darn.' He was truly disappointed. You know what I mean! 'When the president looks forward to meeting you—whoa!'"

I guess time will witness what the old folks say, because Mama told me when I was a boy that I would get the world's attention. She was right.

35 When My Final Song Is Sung

Walk with me, when the stormy nights are cold,
In your hand lies all control.
Master, then when my final song is sung,
With your mercy, I pray that you'll say well done.
Help them see the light.

—"SEE THE LIGHT," *THAT'S THE WAY OF THE WORLD*, 1975

When I was a child, back in Memphis at Rose Hill Baptist Church, people used to get up and "testify" to the goodness of God. The preacher would holler with his hands turned toward the heavens and proclaim, "There can be no testimony without a test." My life lessons, for the most part, have been about tests. Mother Dear leaving me in Memphis when I was four, the first band quitting, and my Parkinson's diagnosis were all tests that were foisted upon me. Leaving Mama for Chicago at eighteen, being called back into music through the spirit of Fred Humphrey, leaving the Ramsey Lewis Trio to form Earth, Wind & Fire—those were tests I chose. But all these tests required faith.

Faith is all about trust. The great paradox of the spiritual life is that the more I control, the less I have to trust. I've controlled the things I could—my space in my home, my business affairs—and I've even tried to control some relationships. But to lose my physical control would be the ultimate test of my faith. It would take the same energies I had used all my life in this fight to stay positive. But God rewards fighters.

The positive values in my music are in fact a big part of my life, not because it's been my life's work to transmit those values, but because I desperately need those values myself.

Tonight Earth, Wind & Fire is performing with an orchestra at the Hollywood Bowl. I stand in the wings, listening to the show. It's rewarding to hear these songs, with orchestral arrangements that were originally recorded decades ago. And I'm appreciating the survival skills of Verdine, Philip, and Ralph. Coming to the end of the song "In the Stone," Verdine swiftly spins and raises his clenched fist in the air as the music suddenly stops and the crowd cheers. In that split second, I abruptly flash back in time to almost forty years earlier—June 29, 1975, to be exact. On that day, right in this same venue, the Hollywood Bowl, Earth, Wind & Fire was playing a sold-out show for more than 17,000 screaming fans.

In this vivid flashback I see everything—the iconic white shell of the Hollywood Bowl, the 1975 band, all smiling and shining brightly and cooking a mad groove. Verdine's shirt is off, and his rhinestone-encrusted bass guitar strap shines against his skinny black body and his white Fender Jazz bass. This mental image is similar to the sketch I drew in 1968 of the Earth, Wind & Fire of my dreams, but the memory is more real, colorful, alive, and vibrant than I could have ever imagined it. Shockingly, I am invisible in this remembrance. I'm not here. Where am I? I miss me.

A tap on the shoulder startles me. I've been awakened from my flashback by my longtime business manager, Art.

"Are you ready?" he says.

"I'm always ready," I say.

I confidently walk out on the massive Hollywood Bowl stage. My face appears on the Jumbotron, and the crowd cheers, acknowledging my presence. I smile widely and wave to the multiracial, very Southern California audience. Turning to make my exit stage left, I walk past Philip's percussion setup. I stop, suddenly pick up the drumsticks, and quickly mimic like I'm

playing. The crowd explodes with cheers. I laugh broadly at the humor of it all. I lay the drumsticks down, step away, and wave to the fans one last time before turning and walking away, my hand still in the air as I disappear behind the backstage curtain.

On the forty-five-minute ride back home, I feel good about the power of the music I was so blessed to create. But I also wonder: Why was I absent in my flashback?

I think now I know why.

For the majority of my life, I believed that Earth, Wind & Fire was my gift to humanity. Now I believe that Earth, Wind & Fire was humanity's gift to me. Its music healed me—healed my childhood and the human politics of my skin color. Earth, Wind & Fire also gave me a life passion, a passion that fueled my determination to want to uplift humanity in some way. And I think I did that.

To the degree that the music just made people feel good, I say amen. To the degree that people heard the words and took them to heart, I say amen to that too. But to my Creator, who guided, energized, and sustained this music, I say a very heartfelt and reverent thank-you. And to the same Creator I will forever be grateful for teaching me, in a cotton field in Osceola, Arkansas, the greatest lesson of them all: that we are immortal, and not to be afraid.

AFTERWORD

As this book was being prepared for publication, Maurice White died in his sleep at the age of seventy-four after his long battle with Parkinson's disease. As his collaborator, my job wasn't to raise my own voice; it was to channel his. Now that he has made his transition, I want to reflect on our friendship, and how that led me to sculpt the story of one of the greats of American music.

Early one morning in late 2009, my phone rang. Maurice White was calling. He wanted to see me—that day. In the intimacy of his home, Maurice sat me down and quickly blurted out, "I believe in my visions. For the last two nights, I've had very clear dreams that you wrote my book." He went on to explain that he had gone through two other writers, and according to him, "They didn't get me." I hadn't written any books, but I wrote the liner notes for a few EW&F albums and worked closely with Reece at his Kalimba Productions office in the late 1990s. Flattered, I took the assignment, knowing that, because he was the most private of men, it wouldn't be easy.

As a preteen, the first concert I saw was Earth, Wind & Fire's *Spirit* tour in 1976 at the coliseum in Richmond, Virginia. After

that night I was never the same. I had a blueprint for life—a dual destiny to become a musician and a cool preacher. Maurice always had that preacher thing, whipping up the crowd, "to get an Almighty groove going." As the son of a great, liberal African American pastor, I related. The songs I grew up on— "Devotion," "Open Our Eyes," "Burning Bush," "Keep Your Head to the Sky"—were essentially secular hymns.

A decade after my first EW&F concert, I sent Maurice a tape of our band's music. Amazingly, he dug it. Though he never produced our band, we began a mentor/protégé relationship that went on for twenty-five years. He gave me advice that encompassed art as well as life.

When we started work on this memoir six months later, I knew how to engage Maurice: *Talk music. Talk spirituality. And make sure the talk is deep.*

Reece began calling me late at night. We talked about everything from Christ consciousness to Kahlil Gibran to Muddy Waters to hip-hop culture to Miles Davis. The talk went on for well over two years. I would keep a pad by the bed so I could follow up on these late-night conversations.

It became evident over time that Maurice respected directness, which was growing between us as our process rolled on. Even though I had known Maurice a long time, he was establishing a trust with me that he seldom showed others. I valued our connection. After I started to interview folks close to him, I heard more than once, "I never knew that about him."

Maurice talked about his personal life to others rarely and reluctantly. When we started the heavy lifting of pulling back the layers of his core emotional and psychological motivations, he was slow to reveal his inner thoughts. He was apt to answer a direct question about some major issue with a one-word answer. One day after an interview in which I was more aggressive than usual, he walked me to his door, put his hand on my shoulder, and said, "This book is my last album, you know."

His last album. Maurice was so in love with music that he saw the story of his life through the metaphor of song. Sifting through his memories, I discovered that music had rescued him from his lonely Memphis childhood. Music also gave him self-esteem, and eventually a platform to express the beliefs he cherished most.

The majority of EW&F's songs express universal truths, affirmations of optimism and ancient spiritual wisdoms, repudiations of the party life. Maurice also wanted to change the lens through which black music was viewed, and in doing so he created something for everybody, a truly world music. He was proud of his creation, resting assured that he'd given his music everything he had. Drop the needle, and you'll hear the meticulous blending of pop, soul, Afro-Cuban, jazz, R&B, and world music—rocked and rolled into one. And he made that fusion of sound taste so delicious.

Maurice, whose first symptoms of Parkinson's disease appeared three decades ago, never lost his direction or his sense of humor. Early in our collaboration, I played him an old TV interview. I asked, "What do you see when you watch that version of yourself?" His answer came quickly. "A very handsome cat!" We laughed long and hard.

Born painfully shy, Maurice was a natural introvert. As his Parkinson's disease progressed, he became even more averse to going out. He'd say, "Thank God I've always liked my own company!"

Reece and I finished this book right before Christmas in 2014. He was pleased with the results, which made me happy. As I was packing up my computer, he stood up, gazed at the beautiful ocean vista from his hilltop home, and said, "You know, my story is really about faith—keeping it in spite of life's circumstances." Then, I swear to God, he turned on his little Tivoli radio, and the Ramsey Lewis Trio's "Wade in the Water" was playing. Maurice had played drums on it in 1966. We looked at each other. He said, "You know that's a sign." I just smiled.

Maurice was definitely not afraid of death. We discussed it often, and he always spoke of it in terms of "going to a better place." I probably spent more time with him in the last five years of his life than just about anyone. I was honored. In his final years, his mind remained razor sharp, his inner strength as luminous as ever. I learned a lot in those precious days about courage, where true strength comes from, and most of all what it looks like to keep your mind in an atmosphere of faith.

When I spoke with him a day before his passing, it was business as usual. We talked music and life. His spirits remained high.

When the call came in the morning that he was gone, although shocked and heartbroken, I said a silent prayer of gratitude for the way this creative man enriched my life. For Maurice's musical life was a confirmation of the beauty of life itself.

Herb Powell
March 1, 2016
Los Angeles

ACKNOWLEDGMENTS

I want to begin by thanking the Creator for blessing me in so many ways, and for being a constant presence in my life.

I extend my gratitude to those musicians who inspired me and my generation: Miles Davis, John Coltrane, Bill Evans, Wynton Kelly, Muddy Waters, Robert Johnson, Sonny Rollins, Cannonball Adderley, Sonny Stitt, Keith Jarrett, Herbie Hancock, Charlie Parker, Thelonious Monk, Duke Ellington, Ahmad Jamal, B. B. King, and especially Ramsey Lewis, who taught me so much.

Clive Davis, Jim Brown, and Bob Cavallo have earned my gratitude for their guidance and assistance in my career. Quincy Jones has been an inspiration and friend to me as well.

It has been my great privilege and honor to be a link in the chain of music's evolution, and I want to acknowledge my appreciation for the other bands, musicians, and singing groups of my generation who brought their own gifts to the world. Especially I want to give my deep appreciation to the members of my band, Earth, Wind & Fire. In particular I thank my brother and copilot Verdine, as well as the collective of Philip Bailey, Larry Dunn, Al McKay, Ralph Johnson, Fred White, Andrew

Woolfolk, Johnny Graham, Roland Bautista, Ronnie Laws, Jessica Cleaves, Sonny Emory, and Sheldon Reynolds. Additionally, I thank the Phenix Horns—Louis Satterfield, Don Myrick, Rahmlee Michael Davis, and Michael Harris—and numerous other artists who all contributed their talents to the mix. A special thanks to the Emotions, who added the feminine note to my creations. Thanks to those who kept us going behind the scenes: Art Macnow, Rich Salvato, Geri White, Monte White, Leonard Smith, Frank Scheidbach, Perry Jones, and many others. I also must thank so many talented people who all made creative contributions, among them Charles Stepney, Tom-Tom Washington, Allee Willis, Skip Scarborough, Bill Meyers, Oscar Brashear, Wayne Vaughn, David Foster, Paulinho da Costa, George Faison, Jerry Hey, George Bohanon, and the great George Massenburg. My thanks to our agent Faith Childs and the entire team at HarperCollins—Jonathan Burnham, Tracy Sherrod, and Laura Brown.

Above all, my deep and sincere thanks to Herb, who kept asking questions, got me to open up about my story, and then put it all together in a way that made sense.

Of course, I applaud all the fans for supporting the music, coming to the concerts, buying the records, and taking the message of the music into their hearts and minds. Those of you who have gone out of your way to let me know that the music touched you, you have brought so much sunshine into my life.

And in closing, I want to acknowledge the "young lions" who are taking what we have accomplished and pushing music forward into the future. I hope my story will serve as inspiration and encouragement for them to stay true to their vision, work hard, and always reach for the highest and best they know.

Maurice White
May 16, 2015
Los Angeles

Herb Powell wishes to thank:

All praise to God, from whom all blessings flow. My deepest thanks go to my parents, Grady and Bertie Powell, who enveloped me with such a bright love. It forever sustains me, and I love you. Much love to my family: Sandra, Dot, Grady, Eric, Albert, Harvey and Danette, Champ, and Grady III. My work in this book is dedicated to my brothers Grady and Eric.

Much respect and gratitude to all my close friends, old and new: Hermon "Blues" Maclin, Wayne Linsey, Herb Jordan, Vivian West, Theresa Anderson, Tom and Laureen Mgrdichian, Verdine White, David and Roberta Ritz, Michael Wells, Leo Sacks, Patt Adams, Bill Hampton, Anita Grant, Grant MacDowell, Larry Dunn, Lynne Fiddmont, Dave Stein, Rich Rene, Jesse C. Williams, Frankie Blue, Erin Holvey, Johnny Fobbs, Janine Bell, Bruce Talamon, and Karen Grigsby Bates, the Tuesday-morning cats, and the members of the band Trussel. Thanks to everyone at HarperCollins—Jonathan Burnham, Laura Brown, and especially Tracy Sherrod, for her generous guidance. Much gratitude to Art Macnow and Rich Salvato at Kalimba. To the members of Earth, Wind & Fire, thank you for being such a consecrated gift to my life and to the world— blessings on each and every one of you. Much respect to my agent, Faith Childs, for being a towering lighthouse of integrity, intelligence, and inspiration.

Lastly, to Maurice, thank you for letting me into your universe. You've been mentor, friend, and a beautiful teacher of what it means to have a deep and abiding faith. God bless you.

Herb Powell

PERMISSIONS

LLC, 424 Church Street, Suite 1200, Nashville, TN 37219. International copyright secured. All rights reserved. Reprinted by permission of Hal Leonard Corporation.

"Runnin' Away." Written by Sylvester Stewart. Copyright © 1971 Mijac Music and Sony/ATV Music Publishing LLC. All rights administered by Sony/ATV Music Publishing LLC, 424 Church Street, Suite 1200, Nashville, TN 37219. International copyright secured. All rights reserved. Reprinted by permission of Hal Leonard Corporation.

"Magic Mind." Written by Maurice White and Albert McKay. Copyright © 1977 EMI April Music Inc. All rights administered by Sony/ATV Music Publishing LLC, 424 Church Street, Suite 1200, Nashville, TN 37219. International copyright secured. All rights reserved. Reprinted by permission of Hal Leonard Corporation.

"Shining Star." Written by Maurice White, Larry Dunn, and Philip Bailey. Copyright © 1975 EMI April Music Inc. and Crowell Music. All rights on behalf of EMI April Music Inc. Administered by Sony/ATV Music Publishing LLC, 424 Church Street, Suite 1200, Nashville, TN 37219. International copyright secured. All rights reserved. Reprinted by permission of Hal Leonard Corporation.

"That's the Way of the World." Written by Maurice White, Charles Stepney, and Verdine White. Copyright © 1975 EMI April Music Inc. All rights administered by Sony/ATV Music Publishing LLC, 424 Church Street, Suite 1200, Nashville, TN 37219. International copyright secured. All rights reserved. Reprinted by permission of Hal Leonard Corporation.

Keep Your Head to the Sky." Written by Maurice White. Copyright © 1973 EMI April Music Inc. Copyright renewed. All rights administered by Sony/ATV Music Publishing LLC, 424 Church Street, Suite 1200, Nashville, TN 37219. International copyright secured. All rights reserved. Reprinted by permission of Hal Leonard Corporation.

"Yearnin' Learnin'." Written by Maurice White, Charles Stepney, and Philip Bailey. Copyright © 1975 EMI April Music Inc. and Embassy Music Corp. Copyright renewed. All rights on behalf of EMI April Music Inc. Administered by Sony/ATV Music Publishing LLC, 424 Church Street, Suite 1200, Nashville, TN 37219. International copyright secured. All rights reserved. Reprinted by permission of Hal Leonard Corporation.

"Devotion." Written by Maurice White and Philip Bailey. Copyright © 1975 (renewed 2003). EMI April Music Inc. All rights reserved. International copyright secured. Used by permission. Reprinted by permission of Hal Leonard Corporation.

"Chicago (Chi-Town) Blues." Written by Maurice White, Jon Lind, Nicky Brown, and Brock Walsh. Copyright © 1993 Cabesaluna Music, Primary Wave Anna, Maurice White Music, WB Music Corp., Big Mystique Music, and the Jonathan Lind Trust. All rights for Cabesaluna Music, Primary Wave Anna and Maurice White Music administered by BMG Rights Management (US) LLC. All rights for Big Mystique Music and the Jonathan Lind Trust administered worldwide by Kobalt Songs Music Publishing. All rights reserved. Used by permission. Reprinted by permission of Hal Leonard Corporation.

"Take It to the Sky." Written by Maurice White, Garry Glenn, and Larry Dunn. Copyright © 1980 EMI April Music Inc., Silver Sun Music, and Cherubim Music. All rights administered by Sony/ATV Music Publishing

LLC, 424 Church Street, Suite 1200, Nashville, TN 37219. International copyright secured. All rights reserved. Reprinted by permission of Hal Leonard Corporation.

"Kalimba Story." Written by Maurice White and Verdine White. Copyright © 1975 (renewed 2003). EMI April Music Inc. All rights reserved. International copyright secured. Used by permission. Reprinted by permission of Hal Leonard Corporation.

"Mighty Mighty." Written by Maurice White and Verdine White Copyright © 1975 (renewed 2003). EMI April Music Inc. All rights reserved. International copyright secured. Used by permission. Reprinted by permission of Hal Leonard Corporation.

"Earth, Wind and Fire." Written by Maurice White and Skip Scarborough. Copyright © 1976 EMI April Music Inc. and Unichappell Music Inc. All rights reserved. International copyright secured. Used by permission. Reprinted by permission of Hal Leonard Corporation.

"Open Our Eyes." Written by Leon Lumpkins. Copyright © 1958 Screen Gems–EMI Music Inc. Copyright renewed. All rights administered by Sony/ATV Music Publishing LLC, 424 Church Street, Suite 1200, Nashville, TN 37219. International copyright secured. All rights reserved. Reprinted by permission of Hal Leonard Corporation.

"Heritage." Written by Maurice White, Lestley Pierce, and Frankie Blue. Copyright © 1980 Maurice White Music, Sony/ATV Music Publishing LLC, Pony Boy Music, Lorna Lee Music, and co-publishers. All rights for Maurice White Music administered by BMG Rights Management (US) LLC. All rights for Sony/ATV Music Publishing LLC, Pony Boy Music and Lorna Lee Music administered by Sony/ATV Music Publishing LLC, 424 Church Street, Suite 1200, Nashville, TN 37219. All rights reserved. Used by permission. Reprinted by permission of Hal Leonard Corporation.

"That's the Way of the World." Written by Maurice White, Charles Stepney, and Verdine White. Words and music by Maurice White, Charles Stepney, and Verdine White. Copyright © 1975 (renewed 2003) EMI April Music Inc. and Eibur Music. All rights reserved. International copyright secured. Used by permission. Reprinted by permission of Hal Leonard Corporation.

"Getaway." Written by Beloyd Taylor and Peter Cor. Copyright © 1976 (renewed 2004) Mburu Music. All rights controlled and administered by EMI April Music Inc. All rights reserved. International copyright secured. Used by permission. Reprinted by permission of Hal Leonard Corporation.

"Spirit." Written by Maurice White and Larry Dunn. Copyright © 1976 (renewed 2004) EMI April Music Inc. All rights reserved. International copyright secured. Used by permission. Reprinted by permission of Hal Leonard Corporation.

"On Your Face." Written by Maurice White, Charles Stepney, and Philip Bailey. Copyright © 1976 EMI April Music Inc. and Embassy Music Corp. Copyright renewed. All rights on behalf of EMI April Music Inc. administered by Sony/ATV Music Publishing LLC, 424 Church Street, Suite 1200, Nashville, TN 37219. International copyright secured. All rights re-

served. Reprinted by permission of Hal Leonard Corporation.

"Don't Ask My Neighbors." Written by Skip Scarborough. Copyright © 1977 (renewed) Relana Denette Flores pub designee, Candace Elizabeth Scarborough pub designee, Plaid Flowers Music, and Sweet Cookie Music. All rights administered by Warner-Tamerlane Publishing Corporation. Used by permission of Alfred Music. All rights reserved.

"Fantasy." Written by Maurice White, Eddie del Barrio, and Verdine White. Copyright © 1977 (renewed 2005) EMI April Music Inc. and Criga Music. All rights controlled and administered by EMI April Music Inc. All rights reserved. International copyright secured. Used by permission. Reprinted by permission of Hal Leonard Corporation.

"Back on the Road." Written by Maurice White and Al McKay. Copyright © 1980 EMI April Music Inc. and Steel Chest Music All rights administered by Sony/ATV Music Publishing LLC, 424 Church Street, Suite 1200, Nashville, TN 37219. International copyright secured. All rights reserved. Reprinted by permission of Hal Leonard Corporation.

"After the Love Is Gone." Written by David Foster, Jay Graydon, and Bill Champlin © 1978 EMI Blackwood Music Inc., Irving Music, Inc., Foster Frees Music, Inc., Garden Rake Music, Noted for the Record and Music Sales Corp. All rights for Foster Frees Music, Inc. in the USA and Canada Administered by Irving Music, Inc. All rights reserved. International copyright secured. Used by permission. Reprinted by permission of Hal Leonard Corporation.

"Boogie Wonderland." Written by Jon Lind and Allee Willis. Copyright © 1979 EMI Blackwood Music Inc., Irving Music, Inc., and Big Mystique Music. All rights for Big Mystique Music administered by Kobalt Songs Music Publishing. All rights reserved. International copyright secured. Used by permission. Reprinted by permission of Hal Leonard Corporation.

"Let Me Talk." Written by Maurice White, Al McKay, Larry Dunn, Verdine White, Ralph Johnson, and Philip Bailey. Copyright © 1980 EMI April Music Inc. All rights administered by Sony/ATV Music Publishing LLC, 424 Church Street, Suite 1200, Nashville, TN 37219. International copyright secured. All rights reserved. Reprinted by permission of Hal Leonard Corporation.

"In Time." Written by Maurice White, Arlene Matza, and Howard McCrary. Copyright © 1980 Universal–Songs of Polygram International, Inc., Saggifire Music, Ninth Music, Charleville Music, Deertrack Music, Emi Blackwood Music Inc., Emi April Music Inc., Island Music Inc. and co-publishers. All rights for Saggifire Music, Ninth Music, Charleville Music and Deertrack Music administered by Universal–Songs of Polygram International, Inc. All rights for EMI Blackwood Music Inc., EMI April Music Inc. and Island Music Inc. administered by Sony/ATV Music Publishing LLC, 424 Church Street, Suite 1200, Nashville, TN 37219. All rights reserved. Used by permission.

"The Changing Times." Written by Beloyd Taylor. Copyright © 1981 EMI April Music Inc. and Modern American Music Co. All rights on behalf of EMI April Music Inc. administered by Sony/ATV Music Publishing LLC,

424 Church Street, Suite 1200, Nashville, TN 37219. International copyright secured. All rights reserved. Reprinted by permission of Hal Leonard Corporation.

"Evolution Orange." Written by Maurice White, David Foster and Nan O'Byrne Copyright © 1981 Irving Music, Inc., Foster Frees Music, Inc., Neches River Publications, EMI April Music Inc. and EMI Blackwood Music Inc. All rights for Foster Frees Music, Inc. administered by Irving Music, Inc. All rights for Neches River Publications administered by BMG Rights Management (US) LLC. All rights for EMI April Music Inc. and EMI Blackwood Music Inc. administered by Sony/ATV Music Publishing LLC, 424 Church Street, Suite 1200, Nashville, TN 37219. All rights reserved. Used by permission. Reprinted by permission of Hal Leonard Corporation.

"Time Machine." Written by Maurice White, Martin Page, and Brian Fairweather. Copyright © 1984 EMI April Music Inc., Imagem London Ltd., and Saggifire Music. All rights on behalf of EMI April Music Inc. Administered by Sony/ATV Music Publishing LLC, 424 Church Street, Suite 1200, Nashville, TN 37219. All rights on behalf of Imagem London Ltd. in United States and Canada administered by Universal Music–Z Tunes LLC. International copyright secured. All rights reserved. Reprinted by permission of Hal Leonard Corporation.

"Touch The World." Written by Rev. Oliver Wells. Copyright © 1988 Sir and Trini Music. All rights administered by by Kohaw Music, c/o the Bicycle Music Company. All rights reserved. Used by permission. Reprinted by permission of Hal Leonard Corporation.

"I'll Write a Song for You." Written by Al McKay, Philip Bailey, and Steve Beckmeier. Words and music by Philip Bailey, Steve Beckmeier, and Al McKay. Copyright © 1977 EMI April Music Inc., Sir and Trini Music, and Steelchest Music. Copyright renewed. All rights on behalf of EMI April Music Inc. administered by Sony/ATV Music Publishing LLC, 424 Church Street, Suite 1200, Nashville, TN 37219. All rights on behalf of Sir and Trini Music administered by Kohaw Music, c/o the Bicycle Music Company. International copyright secured. All rights reserved. Reprinted by permission of Hal Leonard Corporation.

"Turn It into Something Good." Written by Maurice White, James Newton Howard, and Valerie Carter. Copyright © 1980 EMI April Music Inc., River Honey Music, and Newton House Music All rights on behalf of EMI April Music Inc. and River Honey Music administered by Sony/ATV Music Publishing LLC, 424 Church Street, Suite 1200, Nashville, TN 37219. All rights on behalf of Newton House Music administered by Universal Music–Careers. International copyright secured. All rights reserved. Reprinted by permission of Hal Leonard Corporation.

"See the Light." Written by Larry Dunn, Philip Bailey, and Louise Hardy. Copyright © 1974 EMI April Music Inc. and EMI Blackwood Music Inc. Copyright renewed. All rights administered by Sony/ATV Music Publishing LLC, 424 Church Street, Suite 1200, Nashville, TN 37219. International copyright secured. All rights reserved. Reprinted by permission of Hal Leonard Corporation.

INDEX

ABOUT THE AUTHOR

Maurice White (1941–2016) worked in the music industry for more than forty years as a bandleader, songwriter, producer, and musician. He founded the legendary group Earth, Wind & Fire and served as its main songwriter and record producer, and as its co–lead singer. White won six Grammys and three NAACP Image Awards, and was inducted into the Rock and Roll Hall of Fame.